THE GOTHIC

Documents of Contemporary Art

Co-published by Whitechapel Gallery
and The MIT Press

First published 2007
© 2007 Whitechapel Gallery Ventures Limited
Texts © the authors, unless otherwise stated

Whitechapel Gallery is the imprint of Whitechapel
Gallery Ventures Limited

ISBN 978-0-85488-155-0 (Whitechapel Gallery)
ISBN 978-0-262-73186-7 (The MIT Press)

A catalogue record for this book is available from
the British Library

Library of Congress Cataloging-in-Publication Data

The Gothic / edited by Gilda Williams.
 p. cm. – (Documents of contemporary art)
Includes bibliographical references and index.
ISBN-13: 978-0-262-73186-7 (pbk. : alk. paper)
1. Horror in art. 2. Arts, Modern–20th
century–Psychological aspects.
3. Arts, Modern–21st century–Psychological
aspects. I. Williams, Gilda.
NX650.H67G68 2007
700'.415–dc22
 2007010339

10 9 8 7 6 5 4 3 2

Series Editor: Iwona Blazwick
Commissioning Editor: Ian Farr
Project Editor: Sarah Auld
Designed by SMITH
Printed in China

Cover: Andy Warhol, *Skull* (1976) © Licensed by the
Andy Warhol Foundation for the Visual Arts,
Inc/ARS, New York and DACS London 2007.

Whitechapel Gallery Ventures Limited
80-82 Whitechapel High Street
London E1 7QZ
whitechapelgallery.org
To order (UK and Europe) call +44 (0)207 522 7888
or email MailOrder@whitechapel.org
Distributed to the book trade (UK and Europe only)
by Central Books
www.centralbooks.com

The MIT Press
55 Hayward Street
Cambridge, MA 02142
MIT Press books may be purchased at special
quantity discounts for business or sales
promotional use. For information, please email
special_sales@mitpress.mit.edu or write to Special
Sales Department, The MIT Press, 55 Hayward
Street, Cambridge, MA 02142

Whitechapel Gallery

Documents of Contemporary Art

In recent decades artists have progressively expanded the boundaries of art as they have sought to engage with an increasingly pluralistic environment. Teaching, curating and understanding of art and visual culture are likewise no longer grounded in traditional aesthetics but centred on significant ideas, topics and themes ranging from the everyday to the uncanny, the psychoanalytical to the political.

The Documents of Contemporary Art series emerges from this context. Each volume focuses on a specific subject or body of writing that has been of key influence in contemporary art internationally. Edited and introduced by a scholar, artist, critic or curator, each of these source books provides access to a plurality of voices and perspectives defining a significant theme or tendency.

For over a century the Whitechapel Gallery has offered a public platform for art and ideas. In the same spirit, each guest editor represents a distinct yet diverse approach – rather than one institutional position or school of thought – and has conceived each volume to address not only a professional audience but all interested readers.

Series editor: Iwona Blazwick; Commissioning Editor: Ian Farr; Project Editor: Sarah Auld; Editorial Advisory Board: Achim Borchardt-Hume, Roger Conover, Neil Cummings, Mark Francis, David Jenkins, Kirsty Ogg, Gilane Tawadros

The tendency to delight in fantastic & ludicrous as well as in sublime images is a universal instinct of the Gothic imagination

Gilda Williams
Introduction//How Deep Is Your Goth?
Gothic Art in the Contemporary

'Gothic' is a borrowed term in contemporary art, applied liberally to artworks centring on death, deviance, the erotic macabre, psychologically charged sites, disembodied voices and fragmented bodies. A paradigmatic example is provided by Louise Bourgeois' *Cells*, room-sized installations such as *Passage Dangereux* (1997) or *Red Room (Child)* and *Red Room (Parents)* (both 1994). In these dimly lit, inaccessible spaces, phantom bodies, loaded objects and body fragments populate a forbidden world steeped with the artist's memories of an unhappy childhood centring on her overbearing father. 'Each Cell deals with fear',[1] the artist has claimed; particularly the *Red Rooms*, with their blood-red colour and title lifted (accidentally?) straight out of *The Shining* (1980), are Gothic on many levels. Like a Gothic novelist, the artist sets the scene in an unfamiliar and frightening place; the ghost of young Bourgeois occupies the *Cells* like the virginal female trespasser of so many Gothic novels, from Matthew Lewis' *The Monk* (1796) to Bram Stoker's *Dracula* (1897). Bourgeois' *Cells* moreover enact what literary critic Anne Williams considers the core of the Gothic narrative: 'Gothic plots are family plots; Gothic romance is family romance'.[2] A ghastly family secret is similarly the subject of Paul McCarthy's disturbing, mechanized sculpture *Cultural Gothic* (1992), in which a father obligingly passes on to his son the technique (delight?) of zoophilia; *Cultural Gothic* is aptly titled in so far as it performs another standard Gothic theme, i.e., the revelation of an unspeakable family 'curse' by a curious innocent (a plot device present already in Horace Walpole's seminal *The Castle of Otranto: A Gothic Story* [1764]). Along similar lines, artist Charles Ray's *Family Romance* (1993) is a sculpture of a father, mother, young son and toddler daughter all monstrously reaching exactly the same height. With its dwarfed father figure, *Family Romance* can be read as embodying a crisis in the diminishing role of fatherhood, a theme also central to Gothic literature and exemplified in Anne Radcliffe's *The Italian* (1797). Because Gothic literature foregrounded the symbolic rather than biological role of paternity, it has been credited with pre-empting concepts later formalized in Lacanian psychoanalysis as the Law-of-the-Father, itself a notion applied to the unfolding history of modern art.

A recent generation of artists often present a more literal and deliberate updating of the Gothic, witnessed in Banks Violette's sculptural installations exploring a suburban, tabloid Goffick; David Altmejd's werewolves and glitter Goth; and Swiss artist Olaf Breuning's monsters, psychopaths and aliens. The

photographs of Dutch artist Inez van Lamsweerde's semi-human fantasy figures have been likened to contemporary Frankensteins, of the robotic super-model variety. German artist Gregor Schneider's labyrinthine architectural installation cross the Gothic love for haunted houses and uncharted dungeons with a film noir scene-of-the-crime. Many of British artist Tacita Dean's works explore the faded ruins of history – the abandoned Palast der Republik in East Berlin (*Palast*, 2004); a disintegrating modern masterpiece, the Casa Serralves in Porto (*Boots*, 2003); or the shipwrecked boat of the doomed yachtsman Donald Crowhurst (*Teignmouth Electron*, 1999), in a kind of narrative-heavy, modernist Gothic.

Like the original literature, Gothic contemporary art is principally Anglo-Saxon, with a sprinkling of excellent examples from continental Europe as well; however there is also a Latin American, arguably Catholic strain which looks closely at rituals of death, from Mexican artist Teresa Margolles' explorations of the morgues of Mexico City, to Colombian Doris Salcedo's evocative, tomb-like sculptures. Andres Serrano, an American photo-based artist of Afro-Cuban/Honduran origins, is well-known for his large-scale, painterly colour photographs of corpses, the *Morgue* series (1992–). Historically, the precedents stretch from Henry Fuseli (1741–1825) to Edvard Munch (1863–1944) to Francis Bacon (1909–92). Whilst all the artists listed here traffick in Gothic themes – among them death, transgression, patriarchy, ruins, ghosts and the supernatural – it is important to bear in mind that the vast majority of these would never define themselves as 'Gothic' per se. A small group of the artists here knowingly root their work in Gothic sources (Douglas Gordon, Stan Douglas, Banks Violette); but by far the majority in this collection in no way actively claim such a lineage. Even the most Gothic artist here (my vote would have to go to the incomparable, death-obsessed Damien Hirst, who even purchased his very own 'Strawberry Hill', the neo-Gothic Toddington Hall, to house his macabre collection) produces some works which are not Gothic. In the end, 'Gothic' in contemporary art is necessarily a partial term which serves mostly to identify a peculiar, dark sensitivity shared by the artist and the observer who has chosen to respond to the work in this manner.

Although the themes in contemporary Gothic art are grounded in late eighteenth- and nineteenth-century Gothic literature, they are today combined unselfconsciously with, among other things, medievalism, Romanticism, skull imagery, science fiction, Victoriana and punk-derived Gothick subcultures – all without concern for the contradictions and anachronisms therein. Such imprecision in no way damages the term, but in fact contributes to making it so evocative and resilient, enriching the discussion around artists as different as Andy Warhol, Janet Cardiff, Paul Pfeiffer and Raymond Pettibon. Lost in this twenty-first-century usage of the term is the Ruskinian equivalent of 'Gothic'

with 'non-classical', or the elongated stone figures and soaring cathedrals of the Middle Ages (notwithstanding contemporary British sculptor Roger Hiorns' *Copper Sulphate Chartres and Copper Sulphate Notre Dame* [1997], models of these medieval churches with their towers and flying buttresses frosted with cerulean crystals). Much less does it concern 'the Goths', nomadic tribesmen from Germany and the Baltics who terrified Europe in the fifth century; these earlier definitions are almost meaningless in contemporary art. Instead, recent artists blur together anything from Goya's blood-soaked *caprichos* to mid-1990s Goth fashion with the founding themes generated in the early literature.

In sum, 'Gothic' in contemporary art is more atmospheric than neatly defined. Generally anti-intellectual and unscientific, the Gothic can spill easily into related terminology, particularly the uncanny but also the grotesque, the abject and horror – yet 'Gothic' retains its unique, evocative power. The Gothic is a studied, adopted stance, whereas the uncanny is more an accident of the unconscious. If the uncanny is Freudian, then the Gothic is Lacanian. Unlike the grotesque, the Gothic is aesthetic and seductive. Whilst reliant on the human figure, the Gothic can also be manifested in the landscape genre; the grotesque, though sometimes architectural, is almost exclusively figurative. And the art history behind the grotesque stretches as far back as the Roman Emperor Nero; the Gothic's lineage reaches at furthest to the mid-eighteenth century (notwithstanding its eroticized fictionalization of the Middle Ages). Unlike the abject, the Gothic is cultured, sensual and affected. The abject is neglected, the Gothic refined; the abject is filthy, the Gothic merely cobwebbed and dusty. And not all horror is Gothic; for example many slasher films are not. Horror must be to some degree stagey and symbolic in order also to qualify as Gothic. Whilst the Gothic delights in trauma and terror, it asks for more than just straight, uncomplicated gore. Along with 'horror' but unlike the other terms listed above, it is regularly applied to popular culture, in particular to fashion (sweeping, body-conscious, shroud-like black gowns by Thierry Mugler; skull-inspired jewellery by Simon Costin), music (often cousins to heavy metal, e.g., Alice Cooper, Nine Inch Nails, Marilyn Manson, Cradle of Filth, Sisters of Mercy), and a strain of recent television serials (*Buffy the Vampire Slayer, Six Feet Under, CSI, Desperate Housewives, The League of Gentlemen*), all attesting to the Gothic's remarkable ability to update itself perpetually according to current tastes, politics, and fears.

Always present in the Gothic is this: two things that should have remained apart – for example, madness and science; the living and the dead; technology and the human body; the pagan and the Christian; innocence and corruption; the suburban and the rural – are brought together, with terrifying consequences. The Gothic often involves the unravelling of a hideous mystery. Its characters are

secretive; their sins disclosed slowly and suspensefully, with relish. For this reason *American Gothic* (1930) is such an effective title for Grant Wood's austere portrait of that stiff Midwestern couple. Only the title masterfully suggests something sinister is afoot; it is nowhere in sight, existing possibly behind the clean white porch but, like Dorian Gray's sins, mostly in the viewer's mind.

The Gothic is anti-bourgeois and rejects such values as hard work, family, good cheer and common sense. Despite the sadist's and the vampire's exquisite manners, or the middle-class upbringing of the teenagers populating American suburban horror films, the Gothic refuses the norms of bourgeois behaviour. Clarity and wholesomeness are by definition distant from the Gothic. It is anti-capitalist, furnished with un-bought heirlooms, and utterly antithetical to the packaging and the bright lights of the shopping mall. It defies capitalism's laws of real estate; spectacular, unrefurbished properties remain for centuries in the hands of unemployed vampires; castles spread tentacularly via dungeons and secret passageways; disused replicants occupy highly desirable, cavernous warehouse spaces. The Gothic tends towards the dramatic, art-directed and excessive. The cinematic *mise en scènes* of Jeff Wall or Gregory Crewdson are Gothic in part owing to their eerie overtones, but also – importantly – because of their polish and high production values. Similarly, Rachel Whiteread's monumental *House* is Gothic; her small-scale water bottles probably are not. (Her plaster-cast mattresses, borderline.)

The Gothic is escapist, retreating into distant landscapes, lost eras and outlandish personal appearance. It celebrates depression as a kind of desirable, living death. This inclination to transcend the ordinary, cultivate the anti-social and experiment with the sexual unknown makes Gothic a perfect haven for adolescence. It is no accident that artists such as Jake and Dinos Chapman, Sue de Beer and Richard Hawkins indulge in teenage culture and behaviour; or that American horror film has an entire teen-flick sub-genre; or that the protagonist of *American Psycho* flaunts his youth and exhibits an arrested personality. The Gothic is regressive, even juvenile.

Nevertheless, the Gothic can be as elaborate as Matthew Barney's *Cremaster* cycle, or as subtle as Louise Bourgeois' sophisticated, surrealist intertwining of sculptural form, autobiography and personal symbols. Contemporary women artists whose work can be described as Gothic often update the genre's nasty tendency of reducing bodies to pieces (Bourgeois, Cindy Sherman), whilst others follow the Gothic tradition of retelling complex events through the symbolic use of evocative, narrative-laden imagery (Teresa Margolles, Catherine Sullivan – or Stan Douglas and Douglas Gordon, for that matter). Other women artists re-enact the Gothic novel's intrepid female heroine, boldly exploring forbidden landscapes (Janet Cardiff, Tacita Dean, Jane and Louise Wilson). They force their

chosen sites to give up their secrets not unlike Isabella travelling the hidden passages of Walpole's *The Castle of Otranto*, or Clarice Starling seeking out the serial killer's suburban lair in *The Silence of the Lambs*. The performance of still other Gothic stock characters recurs elsewhere among contemporary artists: Mark Dion as 'the mad scientist'; Jonathan Meese as the vampiresque, Poe-like figure concocting tales under the effects of inebriation; Mike Nelson and Gregor Schneider as architects of unwelcoming labyrinths. Jeff Wall stages his own elaborate macabre scenarios, phantom of the opera-like, and Dan Graham builds modernist ruins and follies.

In any case, unlike post-1960s art historical terms such as 'performance art' or 'post-minimalist', the appellation 'Gothic' in art can only ever provide an incomplete picture of an artistic practice. And, just as not all the artists actually apply the term 'Gothic' to their work, likewise not all the anthologized critics literally refer to the Gothic in analysing the art – although some do, among them Jeff Wall on Dan Graham; Nancy Spector on Douglas Gordon; Hal Foster on Robert Gober; and Jonathan Jones on Smithson, Matta-Clark, et al. Many critics discuss Gothic themes without necessarily citing the Gothic per se, i.e., Amelia Jones on the Law-of-the-Father in Paul McCarthy; Andrew O'Hagen on the ghosts occupying Gregor Schneider's inhospitable places. Specialists will note that there is little in this art-oriented anthology drawn from the vast body of Gothic literary theory and film theory; I have only chosen select examples pertinent to the issues which overlap into contemporary art debates, such as post-colonialism (Gayatri Spivak on the latent imperialism in *Frankenstein* and other Gothic classics); Otherness (Kobena Mercer on how Michael Jackson borrows from the Gothic to portray his own multi-layered cross-identities, between white/black, male/female, innocent/decadent); and gender (Carol Clover on the recurring use in horror film of a stock female character, the Final Girl, to sustain the narrative).

As introduced in the first chapter, 'A Thematic Framework', the Gothic remains indebted to an expansive group of broadly related themes invented by Mary Shelley, Edgar Allan Poe, et al., in the early fiction writing (alongside their many incarnations on the screen). These themes – with subsequent variants and sub-genres – are distilled in Anne Williams' *Art of Darkness: A Poetic of Gothic*, while Mark Edmundson revisits them in contemporary mainstream American culture, from Oprah to US Christian fundamentalism. Some of these (often overlapping) themes form the basis for five chapters of the book, beginning with the most essential: death, excess and terror (chapter 3, 'Modern Gothic'). This is followed by chapter 4, 'The Creature: Alien Beings and Alien Bodies' (monsters, skeletons, mutants, and the Other); chapter 5, 'Transgressing Females and the Name-of-the-Father' (a family curse or secret, often brought to light by an intrepid young

woman, attesting to Gothic's early awareness of paternity's metaphorical function, interpreted by some as an *avant la lettre* dramatization of Lacan's psychoanalytic concept of the Name-of-the-Father); chapter 6, 'The Uncanny: Doubles and Other Ghosts' (split personality, the unconscious, the body in pieces, the return of a ghostly past, and hallucination); and chapter 7, 'Castles, Ruins and Labyrinths' (haunted, hidden or dark places, both symbolic and real). Other Gothic themes also surface in contemporary art, among them persecution and paranoia (for example, in the work of Janet Cardiff); defiance and retribution in the face of Christian morality (Robert Gober); the loss of innocence and squandering of youth (Sue de Beer); a taste for death, ritual and bloodshed (Damien Hirst); and sexual perversions which run to necrophilia, rape, incest and blood-lust (Jake and Dinos Chapman). A significant sub-theme is the mismanagement of technology, which ends up serving death rather than life – a recurrent plot line from *Frankenstein* to *Blade Runner* to *The Blair Witch Project*, in recent art explored by artists as different as Mark Dion and Paul Pfeiffer.

Each chapter begins with the philosophers and theorists who, usually without referencing the Gothic specifically, have intellectually shaped the framework behind recurring Gothic themes: Jean Baudrillard on the incorporation of such phenomena as AIDS, computer viruses, drugs and terrorism in updating our ideas of Evil; Michel Foucault on the relationships between power, body and soul; Jacques Lacan's interpretation of Edgar Allan Poe's *The Purloined Letter*, and Jacques Derrida's deconstruction of it; Sigmund Freud's seminal definition of 'the Uncanny' (which, like the Gothic, is best expressed through literary example, e.g., E.T.A Hoffmann's 'The Sandman'); and Julia Kristeva's equally defining work, *Powers of Horror*, which examines primarily abjection and defilement as signals of outsider status. These excerpts are followed in each chapter by noted cultural theory texts, some of which analyse in depth the very essence of Gothic. These include Judith Halberstam's *Skin Shows*, on the insistent symbolic use of skin in Gothic imagery, from deathly pale Dracula to Leatherface in *The Texas Chainsaw Massacre*; and Eve Kosofsky Sedgwick's fundamental *The Coherence of Gothic Conventions*, which examines the interlocking, formulaic nature of literary Gothic conventions, for example the use of the veil gradually to unmask the central mystery – as well as to barely conceal Gothic's perpetual erotic subtext. Alongside these are critics who examine such central concepts as the uncanny (Mike Kelley); vampirism (Slavoj Zizek); and ruins (Douglas Crimp). Accompanying the analytical texts are examples of the fiction writers who have updated the genre, among them Bret Easton Ellis, William Gibson, Anne Rice, Stephen King, Patrick McGrath and Umberto Eco.

Chapter 2 does not follow the theory-fiction-art/interpretation format of chapters 3–7. Examining specifically the Gothic's manifestations in

contemporary art, it moves from Mike Kelley's post-industrial, late twentieth-century 'Urban Gothic'; to Christoph Grunenberg's sweeping, interdisciplinary catalogue and exhibition, 'Gothic' (1997), a post-human, predominantly figurative Gothic; to post-9/11, escapist American Gothic which peaked around the 2004 Whitney Biennial; and finally to a homelier relationship with death and the supernatural in such 2006 exhibitions as 'Blur of the Otherworldly'[3] and 'Dark'.[4] These are a select sampling of contemporary art exhibitions of a Gothic nature; also worth citing are Jose Luis Brea's 'The Last Days' (1992),[5] examining the image of death in the age of AIDS; 'Apocalypse', curated by Norman Rosenthal (2000),[6] subtitled 'Beauty and Horror in Contemporary Art' and which, like 'Regarding Beauty' (1999),[7] attests to a Gothic-like aestheticization of death in late twentieth-century art. The roster of Gothic-inspired exhibitions would also recall 'In the darkest hour there may be Light: The Murderme Collection' (Damien Hirst, 2006–7, which includes Sarah Lucas' terribly Gothic neon coffin, *New Religion [blue]*, 1999);[8] 'Le Voyage Interieur', with its psychedelic, decadent slant (2005–6);[9] 'All the Pretty Corpses' (2005);[10] 'Belladonna' (1997)[11] and innumerable lesser-known exhibitions with suitably dark titles like 'The Gothic Unconscious', 'Scream', 'Playing Among Ruins', 'American Gothic', 'Darkness Visible' and 'Morbid Curiosity'. Alongside these have been popular, well-received historical surveys in a similar vein, among them 'Gothic Nightmares: Fuseli, Blake and the Romantic Imagination' (Tate Britain, London, 2006) and 'The Perfect Medium: Photography and the Occult' (Metropolitan Museum of Art, New York, 2005), as well as curator Robert Storr's parallel investigation into the contemporary grotesque.[12]

Why Gothic, why now? My sense is that there is among a recent generation of twenty-first-century artists a deliberate turning away from the canons of contemporary art established in the 1960s, which culminated in the late conceptualism of the 1990s. Terms such as 'Gothic' – or, say, 'psychedelia', or even 'beauty' – are refreshingly extraneous to that canon, which has been solidly institutionalized in both the academy and the commercial art system. After Clement Greenberg, in 1947, described Jackson Pollock's paintings of the mid-1940s as 'Gothic' and in the spirit of Edgar Allan Poe,[13] the term fell more or less into disuse for new art until the 1980s, in the wake of deconstructivist literary theory as well as the emergence of cyber-Goth subculture. Having bowed out of contemporary art history for some thirty years only enhances the association of the Gothic as a haven for outsiders – despite its current embrace by the art world – beyond the conventions of history and society; thus it suits a historically independent strand of subjective, highly idiosyncratic art, often labour-intensive and stylized, as informed by popular culture as it is by art history, from pre- to

postmodern. Perhaps Ruskin's Gothic/non-classical pairing in some ways remains valid, with 'classical' broadly replaced by all that is newly conservative in art as in politics and society at large. Gothic remains non-, anti- and counter- by definition, always asserting that the conventional values of life and enlightenment are actually less instructive than darkness and death. The Gothic returns, in sum, as an enduring term particularly serviceable in periods of crisis – today as it did in the late eighteenth century, as an escape valve for the political, artistic and technological crises underway.

1 Louise Bourgeois, *Destruction of the Father Reconstruction of the Father. Writings and Interviews 1923–1997*, ed. Hans Ulrich Obrist (London: Violette Editions, 1998) 205.

2 Anne Williams, *Art of Darkness: A Poetics of Gothic* (Chicago: University of Chicago Press, 1995) 22–3; reprinted in this volume, 26–8.

3 Curated by Mark Alice Durant and Jane D. Marsching (Center for Art and Visual Culture, University of Maryland).

4 Curated by Jan Grosfeld and Rein Wolfs (Museum Boijmans Van Beuningen, Rotterdam).

5 Pabellón de España, Seville.

6 Royal Academy of Art, London.

7 Curated by Neil Benezra and Olga M. Viso, Hirschhorn Museum and Sculpture Garden, Smithsonian Institution, Washington, DC.

8 Serpentine Gallery, London.

9 Curated by Alex Farquharson and Alexis Vaillant, Espace EDF Electra, Paris.

10 Curated by Hamza Walker, The Renaissance Society, Chicago.

11 Curated by Kate Bush and Emma Dexter, Institute of Contemporary Arts, London.

12 The fifth Site Santa Fe International Biennial Exhibition, 2004.

13 Clement Greenberg, *The Collected Essays and Criticism. Volume 2: Arrogant Purpose 1945–49*, ed. John O'Brian (Chicago: University of Chicago Press, 1986) 166.

WHEN THE FISSURES
BETWEEN MIND AND
MATTER MULTIPLY
INTO AN INFINITY OF
GAPS, THE STUDIO
BEGINS TO CRUMBLE
AND FALL LIKE *THE*
HOUSE OF USHER,
SO THAT MIND
AND MATTER GET
ENDLESSLY
CONFOUNDED

Robert Smithson, 'A Sedimentation of the Mind: Earth Projects', 1968

A THEMATIC FRAMEWORK

Edmund Burke
A Philosophical Enquiry into the Origin of Our Ideas of the Sublime and Beautiful//1757

Terror

No passion so effectually robs the mind of all its powers of acting and reasoning as *fear*. For fear being an apprehension of pain or death, it operates in a manner that resembles actual pain. Whatever therefore is terrible, with regard to sight, is sublime too, whether this cause of terror be endued with greatness of dimensions or not; for it is impossible to look on anything as trifling, or contemptible, that may be dangerous. There are many animals, who though far from being large, are yet capable of raising ideas of the sublime, because they are considered as objects of terror. As serpents and poisonous animals of almost all kinds. And to things of great dimensions, if we annex an adventitious idea of terror, they become without comparison greater. A level plain of a vast extent on land, is certainly no mean idea; the prospect of such a plain may be as extensive as a prospect of the ocean: but can it ever fill the mind with anything so great as the ocean itself? This is owing to several causes; but it is owing to none more than this, that the ocean is an object of no small terror. Indeed, terror is in all cases whatsoever, either more openly or latently, the ruling principle of the sublime. [...]

Edmund Burke, 'Terror', extract from *A Philosophical Enquiry into the Origin of Our Ideas of the Sublime and Beautiful* (1757); reprinted, ed. Adam Phillips (Oxford: Oxford University Press, 1998) 53–4.

Mary Shelley
Frankenstein, or The Modern Prometheus//1818

[…] No one can conceive the variety of feelings which bore me onwards, like a hurricane, in the first enthusiasm of success. Life and death appeared to me ideal bounds, which I should first break through, and pour a torrent of light into our dark world. A new species would bless me as its creator and source; many happy and excellent natures would owe their being to me. No father could claim the gratitude of his child so completely as I should deserve theirs. Pursuing these reflections, I thought that if I could bestow animation upon lifeless matter, I might in process of time (although I now found it impossible) renew life where death had apparently devoted the body to corruption.

These thoughts supported my spirits, while I pursued my undertaking with unremitting ardour. My cheek had grown pale with study, and my person had become emaciated with confinement. Sometimes, on the very brink of certainty, I failed; yet still I clung to the hope which the next day or the next hour might realize. One secret which I alone possessed was the hope to which I had dedicated myself; and the moon gazed on my midnight labours, while, with unrelaxed and breathless eagerness, I pursued nature to her hiding-places. Who shall conceive the horrors of my secret toil as I dabbled among the unhallowed damps of the grave or tortured the living animal to animate the lifeless clay? My limbs now tremble, and my eyes swim with the remembrance; but then a resistless and almost frantic impulse urged me forward; I seemed to have lost all soul or sensation but for this one pursuit. It was indeed but a passing trance, that only made me feel with renewed acuteness so soon as, the unnatural stimulus ceasing to operate, I had returned to my old habits. I collected bones from charnel-houses and disturbed, with profane fingers, the tremendous secrets of the human frame. In a solitary chamber, or rather cell, at the top of the house, and separated from all the other apartments by a gallery and staircase, I kept my workshop of filthy creation: my eye-balls were starting from their sockets in attending to the details of my employment. The dissecting room and the slaughter-house furnished many of my materials; and often did my human nature turn with loathing from my occupation, whilst, still urged on by an eagerness which perpetually increased, I brought my work near to a conclusion. […]

Mary Shelley, excerpt from Chapter 4, *Frankenstein, or The Modern Prometheus*, 3 vols. (London: Lackington, Hughes, Harding, Mavor and Jones, 1818); reprinted in *Three Gothic Novels*, ed. Peter Fairclough (London: Penguin, 1986) 314–15.

Edgar Allan Poe
The Fall of the House of Usher//1839

[...] One evening, having informed me abruptly that the lady Madeline was no more, he stated his intention of preserving her corpse for a fortnight, (previously to its final interment), in one of the numerous vaults within the walls of the main building. The worldly reason, however, assigned for this singular proceeding, was one which I did not feel at liberty to dispute. The brother had been led to his resolution (so he told me) by consideration of the unusual character of the malady of the deceased, of certain obtrusive and eager inquiries on the part of her medical men, and of the remote and exposed situation of the burial ground of the family. I will not deny that when I called to mind the sinister countenance of the person whom I met upon the staircase, on the day of my arrival at the house, I had no desire to oppose what I regarded as at best but a harmless, and by no means an unnatural, precaution.

At the request of Usher, I personally aided him in the arrangements for the temporary entombment. The body having been encoffined, we two bore it alone to its rest. The vault in which we placed it (and which had been so long unopened that our torches, half smothered in its oppressive atmosphere, gave us little opportunity for investigation) was small, damp and entirely without means of admission for light; lying, at great depth, immediately beneath that portion of the building in which was my own sleeping apartment. [...]

Having deposited our mournful burden upon trestles within this region of horror, we partially turned aside the yet unscrewed lid of the coffin, and looked upon the face of the tenant. A striking similitude between the brother and sister now first arrested my attention; and Usher, divining, perhaps, my thoughts, murmured out some few words from which I learned that the deceased and himself had been twins, and that sympathies of a scarcely intelligible nature had always existed between them. Our glances, however, rested not long upon the dead – for we could not regard her unawed. The disease which had thus entombed the lady in the maturity of youth, had left, as usual in all maladies of a strictly cataleptical character, the mockery of a faint blush upon the bosom and the face, and that suspiciously lingering smile upon the lip which is so terrible in death. We replaced and screwed down the lid, and, having secured the door of iron, made our way, with toil, into the scarcely less gloomy apartments of the upper portion of the house. [...]

Edgar Allan Poe, excerpt from *The Fall of the House of Usher* (1839); reprint (Penguin, 1986) 150–51.

Robert Louis Stevenson
The Strange Case of Dr Jeckyll and Mr Hyde//1886

Dr Lanyon's Narrative

[...] 'And now', said he, 'to settle what remains. Will you be wise? will you be guided? will you suffer me to take this glass in my hand and to go forth from your house without further parley? or has the greed of curiosity too much command of you? Think before you answer, for it shall be done as you decide. As you decide, you shall be left as you were before, and neither richer nor wiser, unless the sense of service rendered to a man in mortal distress may be counted as a kind of riches of the soul. Or, if you shall so prefer to choose, a new province of knowledge and new avenues to fame and power shall be laid open to you, here, in this room, upon the instant; and your sight shall be blasted by a prodigy to stagger the unbelief of Satan.'

'Sir', said I, affecting a coolness that I was far from truly possessing, 'you speak enigmas, and you will perhaps not wonder that I hear you with no very strong impression of belief. But I have gone too far in the way of inexplicable services to pause before I see the end'.

'It is well', replied my visitor. 'Lanyon, you remember your vows: what follows is under the seal of our profession. And now, you who have so long been bound to the most narrow and material views, you who have denied the virtue of transcendental medicine, you who have derided your superiors – behold!'

He put the glass to his lips and drank at one gulp. A cry followed; he reeled, staggered, clutched at the table and held on, staring with injected eyes, gasping with open mouth; and as I looked there came, I thought, a change – he seemed to swell – his face became suddenly black and the features seemed to melt and alter – and the next moment, I had sprung to my feet and leaped back against the wall, my arm raised to shield me from that prodigy, my mind submerged in terror.

'O God!' I screamed, and 'O God!' again and again; for there before my eyes – pale and shaken, and half-fainting, and groping before him with his hands, like a man restored from death – there stood Henry Jekyll!

Robert Louis Stevenson, excerpt from *The Strange Case of Dr Jekyll and Mr Hyde* (New York: Scribner, 1886); reprinted in *Dr Jekyll and Mr Hyde and Other Stories*, introd. Nicholas Rance (London: Everyman's Library, 1992) 58–9.

Anne Williams
Art of Darkness: A Poetics of Gothic//1995

Introduction: Gothic Fiction's Family Romances

[...] The history of commentary of the Gothic suggests that from the beginning critics have unconsciously acknowledged its especially complex, problematic status as a category. Earlier critics tried repeatedly to resolve Gothic into satisfactory subdivisions. Montague Summers (1938) first proposed that there were significant varieties of Gothic, and some of these still influence critical thinking. (He spoke of 'historical Gothic', 'sentimental Gothic' and 'terror Gothic'.)[1] But this strategy is problematic because the concept resists classification; it appears that all attempted classifying systems are both inconsistent and incomplete and evade the problem of its historical development. Subsequent critics provided additional categories, which seemingly might be spawned ad infinitum: some have suggested 'parody Gothic', 'explained Gothic' and 'Oriental Gothic'; why not add 'Romantic Gothic', 'Victorian Gothic', 'Southern Gothic', 'Hollywood Gothic', 'New England Gothic', 'Lone Star Gothic', and so on? More recently, some critics have addressed the problem by attempting to re-categorize the entire entity as something else, usually an already familiar genre. William Patrick Day (1985) renames it 'Gothic fantasy', George Haggerty (1989) argues that Gothic narratives are 'tales', while Elizabeth Napier can announce *The Failure of Gothic* (1986) because she implicitly assumes that all Gothic fiction aspires to the condition of realism.

Some sense of Gothic's apparent chaos may be acquired by glancing through the motifs indexed by Ann B. Tracy in her instructive appendix to *The English Gothic*, 1790–1830. A sample includes 'abduction', 'blood', 'cave', 'dreams (prophetic and erotic)', 'earthquake', 'feeblemindedness', 'gaming', 'harem', 'inquisition', 'laudanum', 'masking', 'noble savage', 'portrait (animated)', 'reputation (lost)', 'suicide', 'twins', 'usury', 'vengeance, vow of' and 'wedding (aborted prior to ceremony, clandestine, counterfeit, forced, interrupted, by spectre clergyman)'. And these features represent Gothic only until 1830; Victorian Gothic would demand the addition of 'the mad scientist' (such as Dr Jekyll), while twentieth-century (post-Freudian) Gothic requires the term 'demonic child'.[2]

According to Lakoff, however, such apparent disorder should be surprising only to those who hold to traditional, 'classical' assumptions about categories. [...]

If we return to the exceedingly complex category 'Gothic' with Lakoff's argument in mind, some principles of order begin to appear. Most important,

Gothic conventions represent the culture's 'then' and 'there' (as opposed to its 'here' and 'now'); i.e., Gothic systematically represents 'otherness', which is, of course, always a relative term. This Gothic 'other' is broadly consistent with some of the most ancient categories of otherness in Western culture. Consider, for instance, the following paradigm attributed to the Pythagoreans by Aristotle, who quoted it in his *Metaphysics*. According to this scheme, reality consists of the following ten pairs of opposites:

male/female; limited/unlimited; odd/even; one/many; right/left; square/oblong; at rest/moving; straight/curved; light/darkness; good/evil

These two columns, once commonly called 'the line of good' and 'the line of evil', were familiar in intellectual discourse well into the Renaissance.[3] The list beginning with 'female' and concluding with 'evil' contains several elements now generally associated with a Gothic (or, indeed, a Romantic) aesthetic, whereas the first, 'male', 'line of good' emphasizes those qualities privileged by 'classicism' and to a lesser extent by the more modern concept of 'Realism'. (The 'line of evil' also contains many qualities eighteenth-century theorists assigned to the category of 'the sublime'.)[4] [...]

In the early stages of planning this book [*Art of Darkness: A Poetics of the Gothic*, 1995] I surmised that this association of Gothic with cultural notions of 'the female' was the only key required; 'Gothic' is an expression (in the Freudian 'dream-work' mode) of the ambivalently attractive, 'female', unconscious 'other' of eighteenth-century male-centred conscious 'Reason'. Although this insight is useful, even fundamental, the task of defining Gothic is ultimately not so simple. For one thing, the heterogeneous (and always changing) set of Gothic conventions expresses many dimensions of 'otherness'. (The 'other' is culture specific, as indeed, the unconscious itself may be.)[5] As various modes of poststructuralist analysis have shown, language, psychoanalytic conceptions of the self and post-Enlightenment culture at large all depend upon some idea of the 'other', whether it be the 'signified', the 'unconscious' or the 'Orient'.[6] [...]

I shall argue that 'the Gothic myth', the *mythos* or structure informing this Gothic category of 'otherness', is the patriarchal family. This thesis has been widely intimated – for instance, in much discussion of 'female Gothic'. And as Eve Kosofsky Sedgwick notes, 'certain features of the Oedipal are consistently foregrounded' in Gothic. But the power of the patriarchal family structure is far greater and more extensive – more *central* – than has been recognized.[7] Assumptions about the family, what Lakoff would call an 'idealized model', organizes human experience at many levels. This model holds the disparate and

unequal 'male' and 'female' forces in tension, in a balance that may be disturbed, in a distribution of powers that may be defied, and perhaps even invite defiance.

We might think of this informing family structure as analogous to the Freudian 'latent content' of the dream or as the linguistic 'deep structure'. In part one [op. cit.] we will explore the haunted castle as an embodiment of this structure and its dynamics, hence its role as a 'central' term of the category Gothic in the early days. 'Gothic', in contrast to other forms of romance (or any mode of literary expression), is determined – indeed 'over-determined' – by the rules of the family. Simultaneously, however, family structure also generates the plots that occur within Gothic, for it imposes a certain balance of power, both personal and political: power that may rebound through the generations as surely as fortunes – or family curses – may be inherited. Literally and metaphorically, Gothic plots are family plots; Gothic romance is family romance.[8] [...]

1 [footnote 40 in source] Montague Summers, *The Gothic Quest: A History of the Gothic Novel* (London: Fortune Press, 1938; reprinted, New York: Russell and Russell, 1964) 17–56.

2 [41] As James Twitchell rightly points out in *Dreadful Pleasures: An Anatomy of Modern Horror* (New York: Oxford University Press, 1985), the demonic or possessed child has become a stock character of mid-twentieth-century horror: books include *Rosemary's Baby* (1965) and *Carrie* (1974); both were made into movies, and other films such as *The Exorcist* (1973), *The Omen* (1976), and their numerous sequels, pursue this new focus of anxiety.

3 [44] Ian Maclean, *The Renaissance Notion of Woman* (New York: Cambridge University Press, 1980) 13.

4 [45] For instance, among the qualities Burke lists as sources of the sublime are obscurity, infinity, darkness and suddenness.

5 [47] Both Juliet Mitchell and Nancy Chodorow make this suggestion.

6 [48] As Alice Jardine notes in *Gynesis*, 'The Other has been a major preoccupation of French thought for the past fifty years' (105). Edward Said's *Orientalism* analyses the study of the East as a discourse of the Other.

7 [51] Eve Kosofsky Sedgwick, *Between Men: English Literature and Male Homosocial Desire* (New York: Columbia University Press, 1985) 91.

8 [52] Ian Watt makes a similar point in relation to a considerably more constricted claim about Gothic in his essay 'Time and Family in the Gothic Novel', *Eighteenth-Century Life*, 10, no. 3 (October 1986) 167.

Anne Williams, excerpt from 'Introduction: Gothic Fiction's Family Romances', *Art of Darkness: A Poetics of Gothic* (Chicago and London: University of Chicago Press, 1995) 17–19; 22–3.

Mark Edmundson
Nightmare on Main Street: Angels, Sadomasochism and the Culture of Gothic//1997

[…] One of the major repositories for 1990s Gothic is the afternoon talk show. Onto Oprah's stage troop numberless unfortunates, victims and villains. The victims have been pursued, harassed, mistreated. They are sublimely innocent (as any reader of Gothic novels knows they would have to be). The villains present a more interesting case. At first they come across to us as evil incarnate, or simply as monstrous creatures who have gone beyond evil and good. But eventually we learn that they themselves have been victims. They too are haunted by some form of past abuse, so that their bad behaviour takes on an air of inevitability. At times, Oprah is an apostle of fate worthy of Edgar Allan Poe: if you were molested by your father, you'll be a molester in turn. There's no way out.

But Oprah speaks in two voices. For at other times, she's a prophet of the will. 'I was a welfare daughter just like you … how did you let yourself become welfare mothers? Why did you choose this? I didn't'.[1] In her second, pseudo-Emersonian guise, Oprah teaches that all is possible, simply through exertions of vital force. It's not hard; just repeat after me.

Oprah's guests are frequently addicted – our current word for the traditional Gothic term 'haunted'. They're addicted to drugs, sex, shopping, abuse, whatever, and it sometimes seems there is no hope for them. But periodically Oprah breaks through her nearly Calvinist commitment to predestination and fate. She up and affirms freedom in the most facile terms: you are what you will yourself to be. […]

American Gothic

[…] In the middle of our millennium's final decade, all of America became transfixed by a Gothic slasher production made, it often seemed, for TV. I mean, of course, the O.J. Simpson case. Simpson was habitually cast as an archetypal Gothic hero-villain. He was rendered as a man with a divided nature, intermittently possessed by a demon within. *Newsweek* put it this way: 'Simpson lived a double life. The corporate spokesman who drank an occasional beer with Hertz executives was also a hard partyer … who cruised bars and indulged in drugs and random sex. His wife believed he was a cocaine addict; his friends, who saw him on the prowl at wild parties in Los Angeles, thought his real addiction was white women. The smooth talker took lessons to make his diction more "white". The family man was seldom home.'[2]

Simpson leads a double life. He's black inside and white outside, to cut through to the magazine's central and repugnant thesis. *Newsweek*'s Simpson is

haunted by the needs of his black self. ('Addiction' is one of our contemporary words for haunting, the Gothic state proper, just as 'obsession' was one of Freud's.) This motif of the double, of two persons in one, is, as I suggested [cf. Mark Edmundson, *Nightmare on Main Street*, 1997], essential to the Gothic vision. [...]

The psychological theory of the double is both reductive and powerful. It assumes that we are all playing a role in life, that inside a raving beast waits for the chains to loosen or snap. Doubles stories seem to proliferate when people sense an unnegotiable divide between the true or natural self and society, between nature and culture. From the charisma that Radcliffe confers on Montoni, which invites some measure of reader identification, to the I-camera technique that lets the audience see through the serial killer's eyes in slasher films, Gothic works invite the audience to acquaint themselves with, and to fear, the shadow that dwells within. (Freud, brilliant horror writer that he was, called his version of the shadow the 'id'; all of us have an 'it', a hungering, formless, ungendered thing, living within us.) The premise of Gothic's double psychology is that we ought to be very afraid – and of nothing so much as ourselves.

No Gothic narrative can work unless the villain is in some way an admirable figure. 'He is the animus regarded as forgivable victim of passion and circumstance, as admirable sufferer,' writes Leslie Fiedler. 'His brow furrowed, his face frozen in the grimace of pain, his eyes burning with repressed fury, his mind tormented with unspeakable blasphemies,' the Gothic hero-villain of Lewis and Radcliffe is, Fiedler observes, the ancestor of Byron's Giaour, of Ahab, Heathcliffe, Rochester, and a thousand other 'ungodly god-like' men. So too, we might add, is that Gothic hero-villain incarnated as the media's O.J. Simpson and many of his supposedly newsworthy contemporaries.[3] [...]

In the 1990s, apocalyptic Gothic often comes in an ecological mode. Thus one encounters the fear that, as a punishment for human excess, especially of the technological sort, the world is doomed to become a flyblown waste some time in the next decade or two. This scenario divides the field into two parts: the cultural, made up of polluting humanity and all of its institutions and works, and the natural, the once-pristine world. Nature, despoiled and outraged by humanity's wrongs, turns from the sweet nurse described by Wordsworth and Rousseau into a decaying, foul monster, seeking vengeance. [...]

Most disturbing is the discourse of AIDS, surely our major public occasion for indulgence in apocalyptic Gothic. And AIDS does lend itself readily to Gothic depictions. It's a condition that inhabits its victims, haunts them, often for more than a decade before making itself manifest. It is associated with some act in the distant past, often a socially stigmatized act. The cultural availability of the Gothic plot makes AIDS sufferers easier to demean than they would have been

without it. They become the objects of a well-deserved curse for past crimes committed against nature and propriety.

In the Gothic worldview, every crime is punished: you can run, but not hide. Susan Sontag captures the compatibility between AIDS and the Gothic idiom when she describes the effect the epidemic must inevitably have on post-AIDS sex. 'The fear of AIDS imposes on an act whose ideal is an experience of pure presentness (and a creation of the future) a relation to the past to be ignored at one's peril. Sex no longer withdraws its partners, if only for a moment, from the social sphere: It cannot be considered just a coupling; it is a chain, a chain of transmission, from the past.'[4] [...]

The 1990s saw the rise of the recovered-memory movement, in which young people all over America, mainly women, began to uncover long-repressed memories of being molested by their fathers, the Gothic villain in the house. The recovered-memory scenario is Freudian, internalized Gothic at its most intense. The hero-villain, the father-molester, haunts the inner life of the child, who cannot remember the incident. What cues her, or the helpful therapist, to the truth is a certain array of symptoms: eating disorders, insomnia, depression, anxiety. The therapist plays the role of rescuer (another Gothic archetype), making the repressed memories manifest, and freeing the patient from the grip of the past. [...]

Academic intellectuals, for their part, have begun to develop an interest in pop culture and so, inevitably, in Gothic. With the advent of what's come to be called cultural studies, media renderings of the Wayne Bobbitt case are stuff to be analysed, as is the persona of Michael Jackson, and the many books about the O.J. Simpson trial. These phenomena tend to be approached with some scepticism, as emanations of a deceptive consumer culture. Intellectuals want to pause and check the ingredients in the delights on offer in contemporary Wonderland.

But the terms of contemporary intellectual analysis are themselves worth some scrutinizing. For the *fin de siècle* academic world has a Gothic mode of its own. Much, though surely not all, of what is called theory draws on Gothic idioms. Its subject is haunting. In the language of theory the virtuous villain, the monster of morality, gets renamed. Like the Gothic novelists, academic theoreticians often presume to identify the brutal and coercive, but apparently civilizing, good. In Freudian thinking, I suggested, the virtuous sadist takes the name of the superego. Since *Civilization and Its Discontents*, some of the most talented intellectuals in the West have been at pains to rename and re-characterize Freud's masterpiece of Gothic invention, the over-I.

Jacques Derrida's antagonist is the metaphysics of presence, the phantom-form of truth that haunts Western culture. Though strain as one will to exorcise

the text of Western philosophy, metaphysics, like the relentless poltergeist it is, always reappears elsewhere, sometimes in the body of one's own writing. Thus the work of deconstruction, like the work of psychoanalysis strictly conceived, is never-ending. Haunting is interminable. The Freudian-Marxist members of the Frankfurt School denounce the hubris of Enlightenment, in which reason banishes all emotion, myth and tradition. Feminists assault the omnipotent patriarch in the front office and in the psyche.

Slavoj Zizek, of the former Yugoslavia, finds his Gothic antagonist in the Father of Enjoyment, a rapacious, cruel id that enjoins endless consumption (he's capitalism's huckster), though without satisfaction, and does so in the voice of the authoritative superego. Buy or die! Zizek speaks once in fact of 'the obscene and revengeful figure of the Father-of-Enjoyment, of this figure split between cruel revenge and crazy laughter, as, for example, the famous Freddie [sic] from *Nightmare on Elm Street*.[5]

But the most intriguing exponent of Gothic theory is surely Michel Foucault, who is also, arguably, the 1990s' most influential thinker for both the social sciences and the humanities. His haunting agency, which is everywhere and nowhere, as evanescent and insistent as a resourceful spook, is called Power. Power enforces circumscribed identities on us and compels us to work at maximum intensity, squeezing out every productive juice. But it does so not through confrontation, not through denial and coercion, but through perpetual surveillance. Power works by exploiting the many institutional means at society's disposal to observe and evaluate individuals. Working through the mechanisms of ongoing scrutiny and analysis, Power generates sets of terms, vocabularies, that lock us all into inert roles. They lock us in because they are institutionally enforced. The student *is* her grades, and transcript, and psychological profile. Power's terms are also the most ready – for some of us they are the exclusive – means through which we can represent ourselves to ourselves. [...]

But why should the Gothic mode be reaching a point of intensity in the 1990s? Why do we need it now? I might begin to answer this question by drawing an analogy between the first flourishing of Gothic and the one we now witness. Late eighteenth-century Gothic was the literature of revolution. From the perspective of Leslie Fiedler, revolutionary literature tended in two apparently opposed directions. The Gothic writers were, in the main, progressives, Monk Lewis was, give or take, a man of enlightened political views. He disliked absolutism and superstition, and unresponsive state, and an unbending church.

But the Gothic writers also greatly feared the upshot of their iconoclasm. They feared the freedom they ardently desired, lest it result in chaos or isolation. Thus Fiedler, writing at his hyperbolical best: 'The guilt which underlies the

gothic and motivates its plots is the guilt of the revolutionary haunted by the (paternal) past which he has been striving to destroy; and the fear that possesses the gothic and motivates its tone is the fear that in destroying the old ego-ideals of Church and State the West has opened a way for the irruption of darkness: for insanity and the disintegration of the self. [...]

If I were pressed to submit one reason for the contemporary proliferation of Gothic, that reason would in a certain sense be religious. Though most of us Americans claim to believe in God, few of us seem able to believe in God's presence. That is, we do not perceive some powerful force for good shaping the events of day-to-day life in accord with a perceptibly benevolent master plan. Most of us don't have a story that we can believe about the way God's designs are unfolding among us. Whatever God is up to, he is not busying himself unduly with worldly events.

Many of us have, I think, turned from hope in benevolent religion to fascination with the Gothic. There is something to gain in accepting the harsh belief that the world is infested with evil, that all power is corrupt, all humanity debased, and that there is nothing we can do about it. With the turn to contemporary Gothic – no-fault, dead-end, politically impotent though it may be – we recover a horizon of ultimate meaning. We recover something of what is lost with the withdrawal of God from the day-to-day world. With Gothic, we can tell ourselves that we live in the worst and most barbaric of times, that all is broken never to be mended, that things are bad and fated to be, that significant hope is a sorry joke, the prerogative of suckers. The Gothic, dark as it is, offers epistemological certainty; it allows us to believe that we've found the truth. [...]

1 [footnote 2 in source] Barbara Grizzuti Harrison, 'The Importance of Being Oprah', *The New York Times Magazine*, (11 June, 1989) 28.

2 [3] Evan Thomas, 'The Double Life of O.J. Simpson', *Newsweek* (29 August, 1994) 43–9.

3 [7] Leslie Fiedler, *Love and Death in the American Novel*, 3rd ed. (New York: Anchor Books, 1992) 133.

4 [19] Susan Sontag, 'AIDS and Its Metaphors', *The New York Review of Books* (27 October 1988) 88–89 (quotation on page 94).

5 [29] Slavoj Zizek, *Looking Awry: An Introduction to Jacques Lacan through Popular Culture* (Cambridge: Massachusetts: The MIT Press, 1991) 23.

Mark Edmundson, excerpts from 'Preface' and 'American Gothic', *Nightmare on Main Street: Angels, Sadomasochism and the Culture of Gothic* (Cambridge, Massachusetts: Harvard University Press, 1997) 17–21; 28; 32; 39–41; 64–5; 67–8.

The
presence of the
vampire
in the
consciousness of modern, liberal men
signifies
the
presence of an unresolved
crisis
in the
creation of the
modern
era itself

Jeff Wall, 'Dan Graham's *Kammerspiel*', 1985

Mike Kelley
Urban Gothic//1985

Decadent Beauty Sightseeing Tour

All aboard! We're loading up the plane for a flight around America: through the deserts of the Southwest, over the South Bronx and down into a Twinkie factory and a shopping mall. Sometimes we go at fast speed – sometimes we go in slow motion. The tour has an American Indian name, a name both ancient and indigenous. The name refers to the end of the world.[1] This is a tour of comparisons. Towering tenements sit next to ancient rock formations. Everything is made one. The effect is like a well-printed, glossy calendar. The sheen of the photos is more apparent than what is pictured. Factories pump out products to the beat of trance music. You are sucked into the rhythm and hum along. There is a studiousness in the extremes pictured that verges, ludicrously, on polarity. Come now, join in the group suspension of disbelief, don't think about it any more. All things are beautiful when viewed through the Vaseline-smeared lens.

First stop. South Bronx. Yes, great white hunter! I see the similarity, now, Bwana, that you have so kindly pointed out. These buildings do bear an amazing resemblance to the buttes of Utah. And it is wonderful how things have sped up. When the condemned structures are dynamited, I can see in a few minutes the erosion that in nature would take countless eons. The sight is indeed awe-inspiring.

While there we notice the curious pictographic markings made by the natives. Spray-painted scrawls cover everything.[2] Could these be the work of Lovecraft's Dark Brotherhood of impenetrable Oriental minds? We are lucky enough to capture some of these primitive artists as well as a few *bruit* musicians. We plan to bring them back with us to our own neighbourhoods for entertainment. Perhaps this happy blanket of colour will soon cover all of our houses as well. Sometimes a dark day needs a little brightening. Bury a corpse in loud clothes and paint the exterior of prisons plaid, I say. On the way home we take time to stop again in the desert and name all of the stones. Titling them after crumbling pseudo-Gothic structures seems most appropriate. *Dracula's Lair, Usher's Haunt, Strawberry Hill, Fonthill Abbey, Charles Dexter Ward's Address* and *The Folly* are just a few that are rescued from obscurity.[3] Some of these gnarled rocks are used to decorate my Chinese garden. The twisted nature of the Oriental mind has already been referred to – instead of raking leaves they rake sand. The garden is also dotted with fake ruins of castles made of chicken

wire coated with plaster. They are constructed and painted by professional stage set builders. The cheap construction is an asset, for with the first rains they sink into a heap and become even more poetic. Scattered among them are similar models of factories based on the paintings of Charles Sheeler.[4] These I am not so sure of – they are still a little too new, too modern. Perhaps my mind is still over-steeped in eighteenth-century gardening theory and must be updated. Modernist architecture is the most popular out-of-date architecture at the moment, but I haven't grown accustomed to the relevance of its dinosaur qualities yet, though I am making an effort. The radio blares out a song by Johnny 'Guitar' Watson, 'We got to strike on computers before there ain't no jobs to find.'[5] He tells the tale of a music store salesman who attempts to sell him a guitar that plays itself. He resists, knowing that buying it would ultimately result in the extinction of his profession. On the TV there is a story about workers striking to prevent the technical upgrading of their factory. Modern machines mean no work. They are unhappy. Having a foreign worker steal your job is bad enough, but having a machine do it is worse. My sentiments exactly. I like the old machines – the first ones – if I have to like them at all. As I said earlier, I'm trying to get adjusted to things modern. Now that they are dead, and the new things are postmodern, I am slowly becoming acclimated to them. [...]

1 [footnote 6 in source] Kelley is referring here to the film *Koyaanisqatsi* (dir. Godfrey Reggio, 1983), with music by Philip Glass. Taking its title from the Hopi word meaning 'life out of balance', this film, the first of the *Qatsi* trilogy, offers an apocalyptic vision of the natural and urban worlds in collision.

2 The allusions here are to the origins of hip hop and graffiti culture in the South Bronx, and to representations of its interface with the East Village art scene such as Charlie Ahearn's film *Wild Style* (1982), with music by Grandmaster Flash, Busy Bee, and co-star Fab 5 Freddy.

3 [8] Kelley consulted M.J. MacInnes, *Nature to Advantage Dress'd, Being a Study of the Sister Arts of Painting, Poetry & Gardening as Practis'd in Diverse Countries of Europe during the Years 1700 to 1800 with Remarks on Architecture...* (Minneapolis: Ross and Haines, 1960), which reproduces James Wyatt's Fonthill Abbey (1796–1807); Sir Horace Walpole's Strawberry Hill in Twickenham (1750–1776); as well as artificial Gothic ruins or 'follies'.

4 Charles Sheeler (1883–1965), the American painter and photographer of machines and industrial subjects, was associated with the precisionist movement.

5 Johnny 'Guitar' Watson (1935–1996) was a virtuoso blues, jazz, funk and R&B guitarist. Kelley's reference is to his 1984 album *Strike on Computers*.

Mike Kelley, excerpt from 'Urban Gothic', *Spectacle*, no. 3, 1985; reprinted in Kelley, *Foul Perfection: Essays and Criticism*, ed. John C. Welchman (Cambridge, Massachusetts: The MIT Press, 2003) 4–7.

Christoph Grunenberg
Gothic: Transmutations of Horror in Late Twentieth-Century Art//1997

The Gothic in contemporary art grows on the fertile ground of an excessive imagination, springing from a surplus of fantasy and desire and giving rise to images of horror, lust, repulsion and disgust. Gothic art today speaks of the subjects that transgress society's vague definitions of normality, discreetly peeling away the pretences of outmoded conventions and transversing the amorphous border between good and evil, sanity and madness, disinterested pleasure and visual offensiveness. The Gothic reacts aggressively against the current 'anti-intensity emotionology', as Peter N. Stearns has termed the protective withdrawal from authentic expression and display of profound affections. It challenges the anxious adherence to smooth operation and undisturbed functionality, and to 'the requirement of a corporate, service-oriented economy and management structure; small-family size, with emphasis on leisure and sexual compatibility between spouses; consumerism; and anxiety about hidden forces within the body that might be disturbed by emotional excess'.[1]

The internal characteristics that unite the contemporary Gothic have been defined as a preoccupation with 'paranoia' ('the "implicated" reader is placed in a situation of ambiguity with regard to fears in the text'), 'the notion of the barbaric' (bringing us up 'against the boundaries of the civilized' and 'fear of racial degeneracy') and 'the nature taboo' (addressing 'areas of socio-psychological life which offend, which are suppressed').[2] The production of 'horror and terror' in contemporary art manifests itself in a plurality of stylistic modes and presentational strategies. Gothic comes in the shape of formless and horrendous images of mutilated and rotting bodies with limbs covered in boils and wounds as, for example, in Cindy Sherman's disconcertingly repulsive-attractive photographs. It may also enter consciousness quietly – almost hesitantly – with the realization of terror being subtly evoked. Robert Gober's reductive reconfigurations of simple everyday objects or body parts are transformed into nightmares, disturbing the illusion of domestic comfort. The old Gothic themes of the uncanny, the fantastic and pathological, and the tension between the artificial and organic are infused with new potency as contemporary artists address concerns about the body, disease, voyeurism and power.

Gothic artists subvert the notion of agreeable, inoffensive beauty administered as an anaesthetic sedative in 'therapeutic' cultural and educational institutions.[3] However, the ability to be shocked and moved by real or fictitious

images of horror has been showing positive signs of attrition. Bombarded for years with the most graphic and explicit imagery, the public's tolerance threshold has been raised higher and higher. The spiral of ever more stunning special effects, direct brutality and sexual innuendo might finally have reached its limits. The Disneyfication of culture provides us instead with a steady stream of bland second- and third-hand experiences, sanitized and hygienic entertainment that can be easily and absent-mindedly consumed. Even authentic images of atrocities and human suffering on television, as in reports about Bosnia, no longer seem to have the calculated effect and are met with lack of passion.[4] The search for ever more provocative or shocking images must inevitably lead into the dead end of pure sensationalism and sensory induration, the images exhausting themselves in the 'obscenity of the visible, of the all-too-visible … It is the obscenity of what has no longer any secrets, of what dissolves completely in information and communication.'[5] Even the art world's potential for arousing controversy has diminished considerably since the culture wars of the late 1980s and early 90s. Many artists today again play out their 'death wish': they want to be attacked and ridiculed in newspapers, magazines and on television (the latter unlikely in America), indulge in notoriety and achieve celebrity status. In Britain, class still functions as creative catalyst and the recent renaissance of contemporary art in London and other British cities can be partly ascribed to the healthy antagonism of an often fiercely hostile press, a continually suspicious public and artists that thrive on rejection, scandals and their continuing ability to shock. Some reluctantly accept, others deliberately adopt, the persona of the artist as *enfant terrible*, cultivating a 'schizophrenic' Dr Jekyll and Mr Hyde personality, preying for attention and fame. However, while some strategic manoeuvring and strong attitudes may occasionally influence the (necessary) self-promotion in the art world, most artists are weary of the 1980s example of instant burnout following celebrity status. Many artists today display a sincere belief in the power of art as they act out the old avant-garde drama of provocation and shock, resistance and unwanted cultural glorification as the inevitable final act: 'Their [British artists'] work has been called nihilistic, but they embrace as much as they deny. They operate from a romantic, nearly nostalgic faith in the avant-garde assertion that art should entertain and disturb and question its own rituals while probing life's.'[6]

Dinos and Jake Chapman's art, for example, presents itself in the demeanour of puerile schoolboys indulging in provocative and gratuitous displays of genitalia, violence and blood, to be enjoyed in their very own entertainment park, 'Chapmanworld' (the title – in Gothic type – of their 1996 exhibition at the London ICA). The carefully crafted and painstakingly painted models rely on the transformation of historical sources or are graphic materializations of

psychoanalytical concepts, such as Georges Bataille's 'penial eye': 'a final but deadly erection, which blasts through the top of the human skull and "sees", the overwhelming sun'.[7] In *Disasters of War* (1993) the artists translate Goya's etchings from his *Disasters of War* series (c. 1808–14) into 83 miniature models with the 'intention of detracting from the expressionist qualities of a Goya drawing and trying to find the most neurotic medium possible', while selecting one particular image to be blown up to a life-size, realist sculpture (*Great Deeds Against the Dead*, 1994).[8] *Cyber-iconic Man* of 1996 transforms a blurred black-and-white documentary photograph from Bataille's classic *Tears of Eros* into a high-tech torture scene complete with realistic wounds and splattering fake blood, representing the epitome of 'divine ecstasy and its opposite, extreme horror'.[9] Combining the sacrilegious transmutation of classics from art history, authentic documentary sources and their own genetic laboratory games, the artists succeed in their objective to reduce 'the viewer to a state of absolute moral panic'.[10]

The domestic sphere continues as the primary site of the inversion of assumed normality into a battlefield of the monstrous. Robert Gober's suggestive *Untitled (Closet)* of 1989 revives childhood memories of secrets explored in locked cupboards or closets. Here the space is open and empty, apparently stripped of any traces of past inhabitants. However, the small claustrophobic room becomes permeated with the visitors' own memories and responses. The closet, as Gober's other transformations of furniture, doors or sinks, are 'objects you complete with your body, and they're objects that, in one way or another, transform you. Like the sink, from dirty to clean; the beds, from conscious to unconscious, rational thoughts to dreaming; the doors transform you in the sense ... of moving from one space through another'.[11] [...]

Horror film's grip on the imagination has been one of the most powerful influences – on a formal, stylistic and thematic level – on contemporary art over the last decades: from the 'High Gothic' of *The Cabinet of Dr Caligari*, to the psychological themes and distinct artificiality of American *film noir*, to Hitchcock's masterful, teasing production of suspense, to the seemingly liberating battle of special effects and graphic depiction of violence and sexuality since the late 1960s. Douglas Gordon's *Twenty-Four Hour Psycho* (1995) simultaneously fetishizes and deconstructs Hitchcock's classic horror film, both expanding suspense to an excruciating length and delivering a disenchanting shot-by-shot, frame-by-frame analysis. In his installation *30 Seconds Text* (1996), he again plays with time and the careful sequencing and orchestration of perception. Using a short description of a scientific experiment, the time required to read the text (30 seconds), and a mechanism alternating light and darkness in intervals of the same length, Gordon produces a feeling of terror equal to the

most powerful movie.[12] Tony Oursler's recent video installations (for example *4*, 1997) are investigations into the history and present state of vision, voyeurism and scopophilia. The close-ups of eyeballs projected on large, variously-sized spheres floating in space scrutinize the process of perception of 'performers' watching horror films on television. The work alludes to the classic filmic exploration of voyeurism, Michael Powell's *Peeping Tom* (1959), about a sadistic cinematographer who films his female victims as he kills them while they, at the same time, are forced to watch their own agony in a mirror (one shot in the film shows a large face distorted in a parabolic mirror). Oursler investigates the complexity of vision as through a magnifying glass, with the cinematic apparatus (an essential element in theories of voyeurism) doubled in the video camera used in filming and the video projector as part of the installation.[13]

The inspiration of horror and science fiction film, for example by the intestinal-anthropomorphic-technological monstrosity of *Alien*, presents a subliminal force for many artists. Gregory Crewdson both references David Cronenberg's explorations of disease, mutation and social disintegration, as much as he understands himself 'working in the American landscape tradition'.[14] In his elaborately constructed photographic tableaux, the peacefulness of suburban and rural America becomes the scene for mysterious rituals or is corrupted by the traces of death, crime, physical decay and environmental disasters. In his dioramas the sublimity of nature is subverted by the artificiality of close-ups on rotting legs, dead foxes, giant moths or robins watching an egg circle, throwing off-balance the equilibrium of the miniature and gigantic, macro- and microcosm. [...]

Keith Edmier's monstrous fabrications of human beings or plants, Robert Gober's realistic legs protruding from walls, Abigail Lane's wax corpse or Cindy Sherman's assemblages of body parts all attest to a crisis of coherent selfhood. The uncertainty of 'whether a lifeless object might not in fact be animate', was already cited by Freud as a primary source in the production of the effect of the uncanny.[15] The exact differentiation between human being and machine, robot or cyborg has become impossible, giving rise to a 'doubling, dividing and interchanging of self'.[16] In her multiple views of the *Preserved Head of a Bearded Woman*, Musée Orfila (1991), Zoe Leonard insinuates the feeling of unease produced by the indefinite state between life and death, awake and asleep, which is nowhere more evident than in a wax museum. The ambiguous gender of the head subverts the fetishizing gaze of the observer, blocking the transference of desire as exemplified in the Pygmalion myth in which a beautiful female statue comes alive.[17] It is in the 'in-between, the ambiguous, the composite', as Julia Kristeva has defined, that the abject manifests itself, here enforced by the literally

dismembered, 'monstrous' female body put on display in a museum.[18]

Abjection in art produces rejection, disgust, repulsion and severs 'the identificatory bonds between the viewer and the image'.[19] It is evident, for example, in Mike Kelley's soiled and worn out dolls, sad objects of unfulfilled affection, or in his scatological drawings that exemplify contemporary art's 'fixation not simply on sexual organs but, as well, on all bodily orifices and their secretions'.[20] It has also been associated with the 'monstrous-feminine' as externalized in Cindy Sherman's photographs of dismembered and incongruous composite bodies, rotting food, excrements and vomit. In her most recent photographs of grotesque demons and masked faces, Sherman has returned to her earlier investigation into contemporary (female) identity as an enactment of codified roles. Both the pictures of externalized bodily substances and identities disguised behind frozen masks are concerned with the mechanics and pressures of constructing and destroying feminine identity: 'The images of decaying food and vomit raise the spectre of the anorexic girl, who tragically acts out the fashion fetish of the female as an eviscerated, cosmetic and artificial construction designed to ward off the "otherness" hidden in the "interior"'.[21]

One of the enduring characteristics of the Gothic can be found in its emphasis on fragmentation, inconsistent narratives and an excess of morphological, disjoined and decentralized forms and shapes – an 'uncanny pathos which attaches to the animation of the inorganic', as Wilhelm Worringer defined the essence of the expressive Gothic.[22] The aesthetics of the grotesque and formless is present in much of contemporary art. [...]

For the 'Gothic' exhibition, Mike Kelley and Cameron Jamie have chronicled, in documentary-style photographs, the phenomenon of the contemporary Goth club scene in Los Angeles with its adherence to dress codes and manners that have characterized the subculture from its beginning. In a collaboration with artist Aura Rosenberg, Mike Kelley painted the face of the photographer's daughter in the style of a Goth, combining a childish delight in masquerade with the themes of disguise, alluding to double nature and role play in the Goth movement. [...]

Oscillating between attraction and repulsion, recent art continues to explore the negative pleasures of the sublime which, as Edmund Burke defined it in the eighteenth century, is 'productive of the strongest emotion which the mind is capable of feeling. I say strongest emotion, because I am satisfied the ideas of pain are much more powerful than those which enter on pleasure.'[23] The Gothic in contemporary art captures, through a heightened sensibility, the shifts and mutations in the moral and intellectual fabric of society as permutated through

media, culture and politics. No longer concerned with the production of grand or majestic terror, the Gothic sublime today reflects a hesitant and apprehensive state of mind obscured by a deep fear of the unfamiliar future: 'It is the threat of the apocalypse that is the spectacle of the sublime; it is the threat of self-extinction and "self-dissolution" that forces the subject to retreat back into the comfortable frame of the beautiful'. In a final ecstatic *danse macabre*, we are slowly waltzing toward the end of the millennium, verging upon the edge of an eternal abyss, closer and closer until swallowed by an all-consuming vortex. It is the year 2000 – and we are still here.

1 [footnote 68 in source] Peter N. Stearns, *American Cool: Constructing a Twentieth-Century Emotional Style* (New York: New York University Press, 1994). Quoted in James Atlas, 'The Fall of Man', *New Yorker*, 72 (18 November 1996) 65; 70.

2 [69] David Punter, *The Literature of Terror: A History of Gothic Fictions from 1765 to the Present* (London and New York: Longman, 1996) vol. 2; 183–4.

3 [70] The term was coined by Dave Hickey in *The Invisible Dragon: Four Essays on Beauty* (Los Angeles: Art Issues Press, 1993).

4 [71] 'For this season, however, the television image is largely a clutter of advocates calling up frightful scenes in hopes of igniting some passion in a nation that can't seem to get very passionate over what used to be Yogoslavia.' Walter Goodman, 'Horror vs. Hindsight: A War of TV Images', *New York Times* (4 December 1995) C16.

5 [72] Jean Baudrillard, 'The Ecstasy of Communication', in Hal Foster, ed. *The Anti-Aesthetic: Essays on Postmodern Culture* (Seattle, Washington: Bay Press, 1983) 131.

6 [73] Roberta Smith, 'A Show of Moderns Seeking to Shock', *New York Times* (23 November 1995) 14.

7 [74] Allan Stoekl, 'Introduction', Georges Bataille, *Visions of Excess: Selected Writings, 1927–1939*, ed. and trans. Allan Stoekl (Minneapolis: University of Minnesota Press, 1985) xii.

8 [75] Jake Chapman quoted in Martin Maloney, 'The Chapman Bros.', *Flash Art*, no. 186 (January–February 1996) 64. See also The Chapman Bros., 'When Will I Be Infamous', *Flash Art*, no. 187 (March–April 1996) 35.

9 [76] Georges Bataille, *Les Larmes d'Éros* (1961); trans. Peter Connor, *The Tears of Eros* (San Francisco: City Lights, 1989) 207.

10 [77] Jake and Dinos Chapman quoted in Douglas Fogle, 'A Scatalogical Aesthetic for the Tired of Seeing', *Chapmanworld* (London: Institute of Contemporary Arts, 1996) n.p.

11 [78] Interview with Robert Gober by Craig Gholson, *Bomb* (Autumn 1989) 34; quoted in Joan Simon, 'Robert Gober and the Extra Ordinary', in *Robert Gober* (Madrid: Museo Nacional Centro de Arte Reina Sofia, 1992) 20.

12 [84] The text describes an experiment executed in 1905 by a French scientist, which measured the time a decapitated person responds to being addressed by his name (25 to 30 seconds).

13 [85] For a recent assessment of theories of vision and voyeurism in film see Kate Linker,

'Engaging Perspectives: Film, Feminism, Psychoanalysis, and the Problem of Vision', in Kerry Brougher, et al., *Hall of Mirrors: Art and Film Since 1945* (Los Angeles: The Museum of Contemporary Art, 1996) 216–42.

14 [86] Conversation with the artist, November 1995.

15 [88] Freud, 'The Uncanny' (1915), *The Standard Edition of the Complete Psychological Works of Sigmund Freud*, ed. and trans. James Strachey, vol. 17 (London: Hogarth Press/Institute of Psychoanalysis, 1955) 245.

16 [89] *Ibid.*, 234.

17 [90] 'In fetishism, sex abandons the barriers between the organic and inorganic.' Walter Benjamin, 'Das Passagen-Werk', *Gesammelte Schriften* [Collected Works], vol. V, 1, ed. Rolf Tiedemann (Frankfurt am Main: Suhrkamp Verlag, 1982) 118.

18 [91] Julia Kristeva, *Pouvoirs de l'horreur* (Paris: Éditions du Seuil, 1980); trans. Leon S. Roudiez, *Powers of Horror: An Essay on Abjection* (New York: Columbia University Press, 1982) 9–10. 'If there is a subject of history for the culture of abjection at all, it is not the Worker, the Woman or the Person of Colour, but the Corpse.' Hal Foster, 'Obscene, Abject, Traumatic', *October*, no. 78 (Fall 1996) 123.

19 [92] *Abject Art: Repulsion and Desire in American Art* (New York: Whitney Museum of American Art, 1993) 62.

20 [93] Rosalind Krauss, '*Informe* without Conclusion', *October*, no. 78 (Fall 1996) 90.

21 [94] Laura Mulvey, 'A Phantasmagoria of the Female Body: The World of Cindy Sherman', *New Left Review*, no. 188 (July/August 1991) 146. For a discussion of the 'monstrous-feminine' see Barbara Creed, *The Monstrous-Feminine: Film, Feminism, Psychoanalysis* (London and New York: Routledge, 1993).

22 [95] Wilhelm Worringer, *Abstraction and Empathy. A Contribution to the Psychology of Style* (1908), trans. Michael Bullock (New York: International Universities Press, 1953) 77.

23 [96] Edmund Burke, *A Philosophical Enquiry into the Origin of our Ideas of the Sublime and Beautiful* (1757), ed. James T. Boulton (Oxford: Basil Blackwell, 1987) 39.

Christoph Grunenberg, 'Unsolved Mysteries: Gothic Tales from Frankenstein to Hair Eating Doll', in Grünenberg, ed. *Gothic: Transmutations of Horror in Late Twentieth-Century Art* (Boston: The Institute of Contemporary Art/Cambridge, Massachusetts: The MIT Press, 1997) 169–60 [the pagination runs backwards as a feature of the book].

Michael Cohen
The New Gothic: Scary Monsters and Super Creeps//
2003

A darker mood has begun to emerge from the art world's next generation. Themes of menace, witchcraft, ghosts, mutation and teen fratricide have all become manifest with the murky resonance of an old horror flick. Recently these practices have been linked by references to 'The New Gothic'. In an aesthetic shared by goth-rock and medieval cathedrals, angst, camp, a critical use of the supernatural and an overarching visuality are the hallmarks of this type of art. Melancholic in vision and ecstatic of emotion, these young artists are making some of the most imaginative and provocative art today.

It only makes sense that artists are channelling a more intense aura: 9/11, the war in Iraq, the turbulent global economy and the recent SARS viral outbreak in Hong Kong have all left society and culture in a paranoid state. The mantras of art as entertainment and decoration are unsuitable for interpreting or embodying these new social developments. Rather, younger artists reject affirmative, conformist culture and embrace the mysterious, the negative, the subconscious and the unknown in order to reinvent visual culture so that it may reflect who and what we are in this dark post-millennial state.

The Bad Seed

Mixing the bad vibes of 1970s slasher films, Stockhausen's abrasive tones and photographer Richard Kern's sleazy rock vignettes, Aïda Ruilova's videos have breathed new life into the somnolent video genre. Ruilova's shards of video narrative express unspeakable psychic conflicts with a bittersweet grit reminiscent of old New York bands like Sonic Youth and French *Nouvelle Vague* cinema. An anti-MTV video, *ah ahh ah*, flashes quick granulated rushes of a hippie horror house oozing with dread. The tape's creepy long-haired couple inhabits a hypnotic milieu of unlit staircases, cult-like chanting, anxious gestures and implied interpersonal violence. The mixing of MTV-style quick-cuts with the torpid monster genre boils down the essence of horror into brief abstract rhythms, recontextualizing the psychological violence produced by both media.

The free-floating anxiety in Ruilova's work communicates to us feelings that are too base for words and lie below the radar of mass communications. It is the way she captures that mysterious apprehension of living in New York, waiting for the next terrorist attack, the creep in the subway, the unearthly silence upstairs, that allows Aïda Ruilova's videos to transmit the current zeitgeist.

The Mutant Cell

Faced with the unresolved sorrow of 9/11 and the political monstrosity of the terrorist cell and state, we find two more Gothic elements, melancholia and mutation, in Christian Holstad's work. Holstad's 2-D output is split between 'eraserhead drawings', small black-and-white, drawn and erased photos, and rapturous, if ominous, collages. The drawings turn tabloid accounts of political and everyday life into spectral and dreamy tableaux. Bodies warp, meld and regenerate according to unspeakable boundaries. Each figure seems caught between spiritual disease and revelation. The collages depict a psychedelic orgy of gay pleasure. Holstad infects fleshly acts with an other plane of reality – an orgasm, an acid trip, electrostatic energy from the beyond. The subject of Holstad's recent exhibition was David Vetter, the 'Boy in the Bubble' whose absent immune system kept him isolated from human contact for twelve years. Like the hybrid tree branch/deer/skull totem which lay in the installation's version of Vetter's bed, the bubble-boy was a freak – freakishness being an icon of rapture in Holstad's cosmological state. [...]

Buffy The Vampire Slayer

According to the 'Goth Handbook', the most important Gothic work in recent years has been the TV series *Buffy the Vampire Slayer*. Beneath the drug-like scrim of staged reality, 'Buffy' utilized vampires and demons as metaphors for a variety of adolescent traumas – from mortality to libidinal and political turmoil. Olaf Breuning's dark portraits and installations operate the same way. From within the veneer of fashion and voyeuristic photography, Breuning exposes the tribalism, hybridization and abjection festering inside 'reality'-based media.

A photo of Breuning's: a fashion model with no eyes, one foot, a clown nose, Kenneth Noland circles for nipples and body hair run amok. Behind the contemporary spectacle of mass communication, Breuning unearths a Frankenstein monster: half-humans whose identities are made up of historical hybrids, jumbled fashion accessories and mechanical prostheses. The shifts in representation caused by his dime-store Freddy Kreugers and fashionista cavemen destabilizes the original tropes within mediated reality. Just like 'Buffy', Breuning uses Gothic tropes to reveal a repressed instability (for her erotic, him semiotic) beneath the bland surface of public life.

The Devil Inside

Goth-punk bands from the 1980s like Siouxsie and the Banshees and The Cure not only sported doomy lyrics, but also a campy obsession with supernatural imagery. Pentagrams and ghosts provided a useful emblem for teen dissatisfaction and half formed sexuality. Likewise, Miami-based artist Hernan Bas' recent drawings result

from his fascination with love sought by occult means: with the supernatural possibility standing in for the taboos of gay love. As Gothic as the doomed couples in *Wuthering Heights*, the scenario ends in tragedy when the young man's witchcraft backfires, creating a number of horror-comic style disasters.

Bas has always been interested in ghost stories with a romantic angle. 'Spectres roaming hallways in search of lost mates, dead war widows appearing in windows waiting for husbands to return'. Just as the vampire myth has sexual and xenophobic tones beneath its narrative myth, *The Hardy Boys* and Gothic tales of terror become metonyms for Bas' own queer romantic fantasies. Bas' photos of young men adorned with satanic symbols and drawings of witchcraft sissify the symbols of heterosexual adolescence and rebellion, transforming them into icons of desire and resistance.

Heavy Metal

Satanic music and images also provided the basis for Banks Violette's recent ode to heavy metal murder, *Arroyo Grande 7–22–95*. The installation operated as an elaborate memorial to the 1995 murder of a fifteen-year-old California teenager by a trio of her classmates. The boys wished to emulate the perceived lifestyle of the band Slayer and sacrificed the girl to Satan with the hope of gaining his assistance for their music careers.

Much of the art in the show was inspired by Slayer album cover art. The 'boys" half of the gallery was black and adorned with painted Motörhead skulls and satanic crystals. The 'girls" room was white and dominated by a life-size sculpture of a weeping unicorn with a melted, bludgeoned head.

Normally the images in heavy metal music express harmless power-fantasies for youth. Violette's installation makes us wonder how empty signs of evil can actually instigate destruction. Post-Columbine, has our society become so repressive that symbols like this can channel teen frustration into outlets where it seems normal to take a life? The artist himself seems transfixed by this artifice of evil in his own obsessively crafted rendering, providing the installation with a bleak and thought-provoking amoral streak.

In both cases, the Gothic operates not as kitsch, but as a mechanism for discussing operatic sensations of lust, mourning and despair: the high-ranges of human emotion that are left out of corporate-entertainment. The re-emergence of critical emotion and complex visuality in 'The New Gothic' provides positive evidence for the continued relevance of art, in this moment.

Michael Cohen, 'The New Gothic: Scary Monsters And Super Creeps', *Flash Art International* (July–September 2003) 108–10.

Jerry Saltz
Modern Gothic//2004

[...] So why Gothic now? First, we need to remember that ever since the Enlightenment killed off Satan in the eighteenth century, the artistic imagination has relished filling the void. The Gothic has never really left; one hell was replaced by another. Still, the present materialization has a sense of timing to it. On September 11 we all witnessed what could be described as a manifestation of the demonic. Even before then, the bright, busy globalism of the 1990s was wearing thin. Since 9/11, America has experienced an alarming reawakening of fundamentalist religiosity, and events have unfolded with an air of inevitability.

None of us knows what will hit us next, but things feel heavy. In the art world, fear and confusion have brought about a return of the metaphysical, even if it's only skin-deep. There's been a shift from the big picture to the little one, from the cultural to the subcultural, the outer world to the inner one. Cults are more absorbing to artists than society; optimism has turned into scepticism. But things aren't black and white. Although many claim it's dead, irony thrives. Indeed, almost all art that could be called Gothic has an ironic edge: It's aware of its position, even the absurdity of its position [...]

The Gothic has always had a contradictory relationship to authority: It believes in hierarchy, but also sees itself as transgressive. In the Gothic, the hero and the villain resemble one another; the wicked can be redeemed. Thus, fluid definitions of sexuality, self and subject matter are typical. This keeps the Gothic elusive, deluded and chic. Forerunners to the present moment include Cady Noland, Karen Kilimnik, Mike Kelley, Richard Prince, Paul McCarthy and the abject art of the early 1990s. Punk figures too, although it was always more proletarian. Still, we're talking about suburbia, Dungeons and Dragons, Doom, Anne Rice, teenage angst, masculine overdrive and The Cure, *not* Poe and Hawthorne.

Modern Gothic is many things, some of them promising. Lest we forget, however, most art that is primarily Gothic is and always has been schlock. It's campy, corny, nostalgic and shallow. Indeed, any art that is essentially one thing is in danger of becoming monotonous. Forms stagnate; cheap thrills and clichés predominate; potent symbols and mock horror are readily embraced. The best Modern Gothic art is way more than Gothic, and that's what makes it worth looking at and thinking about right now.

Jerry Saltz, excerpt from 'Modern Gothic', *The Village Voice* (4–10 February 2004).

Shamim M. Momim
Beneath the Remains: What Magic in Myth?//2004

The number of pages in this book is literally infinite. No page is the first page; no page is the last ... A prisoner of the book ... I realized the book was monstrous. It was cold consolation that I, who looked upon it with my eyes and fondled it with my ten flesh-and-bone fingers, was no less monstrous than the book ... I considered fire, but I feared the burning of an infinite book might be similarly infinite and suffocate the planet in smoke.
– Jorge Luis Borges, 'The Book of Sand'[1]

Fluid connections, the celebration of ambiguity and a sense of ritual in chaos are central concerns of another prominent type of mythmaking in contemporary art: the re-emergence of a Gothic psyche. Deeply invested in the notion of complexity, this work explores the arena of the monstrous as an entrée to rapture. Artists working in this mode push the deconstruction and dissolution of centre, definitions and boundaries to reach the sublime terror of placelessness. This impulse coexists with a desire for physicality and sensuality, however dark. Set against inky blackness with the just-perceptible shapes of woods beyond, the protagonist of Chloe Piene's video *Blackmouth* (2003) occupies what the artist calls a 'pre-lingual world'. Slowed to haunting pace, a young girl crawls through the mud like a loose-limbed tiger, beating the ground or throwing her arms into the air as if releasing a primordial power that transcends her physical being. Her mouth stretches and yowls an impossibly deep, guttural roar (her own scream also slowed) that suggests not an individual voice, but a sound that speaks the hidden drives or forces of humanity. Within this reinvented space of origin, both claustrophobic and depthless, it is unclear whether she strives to break free of containment or asserts her control. Boundaries between human and animal, nature and culture dissolve into a raw, unrestrained totality. Seeking the darkness, 'the idea was that she was coming out of the grave', Piene says, 'but as it turns out, she is trying to get back in'.[2]

Though somewhat evasive of a succinct definition, the Gothic sensibility seen in much popular culture today reads as profoundly opposed to the progressive aspirations of modernity. Where the modern strove ahead, the Gothic looks back, in its opaque and shadowy way, distinct from the modernist rhetoric of clarity. Historically, it is a counter-Enlightenment impulse, emerging in response to pervasive cycles of conservatism or repression, and often following periods of consumer boom and related moments of perceived moral,

emotional or socio-political limitation. The word itself originates with the fifth-century peoples called the Goths, who in Greek and Roman culture came to represent the 'Other'- outside of civilized culture, warlike and barbarous. Over time the term became associated with darkness, cruelty and death as well as opposition to classical order (as invoked by the thirteenth-century Gothic period).

The Gothic psyche surfaces in many different forms of art and culture throughout history, from such seminal nineteenth-century Gothic texts as Mary Shelley's *Frankenstein* and the writings of Edgar Allan Poe, to the *fin-de-siècle* decadence that pervaded the social climates of Paris, Berlin and Vienna. More recent manifestations can be seen in the search for the repressed unconscious or the dissolution/construction of self that persists in much twentieth-century art, such as Dada and Surrealism, or even what Clement Greenberg called the 'gothic, morbid and extreme' canvases of Jackson Pollock. 'Goth' music and fashion of the 1970s and 80s made the aesthetic fascination with the darker realms of humanity more culturally visible. In art of the past thirty years, the recurrence of the Gothic sensibility has often been characterized by an investigation of physical space, especially notions of imprisonment and claustrophobia, in conceptual practices by artists from Bruce Nauman to Lawrence Weiner.[3] By the early 1990s, this sensibility had become more materially apparent in work by artists such as Mike Kelley, Paul McCarthy, and Raymond Pettibon, among many others, which explored the abject, the aggressive and the obsessively anxious unpacking of the repressed.[4] As the decade passed, the ability to situate a cultural critique in the recesses of social and psychological abjection was cut off at the knees by a shift in theoretical discourse and an economically driven, broadly realized love affair with technology and high-end production. Nevertheless, the presence of a darker underbelly has persisted and even expanded as we have entered into the new millennium.

The current resurgence of the Gothic exists in part as a response to the historically cyclical conservatism of American society, characterized recently by the elevation of an imagined virtuous, sanitized existence. An obsession with hygiene, a desire for clear definitions of identity and emotion, and the ostensible rejection of corporeal pleasures and true sensory (as opposed to material) excess of any kind, coupled with the near-godlike privileging of the work ethic, has resulted in an institutionalized hostility toward pleasure and its inherent complexities. Yet despite what Jean Baudrillard called 'the condescending and depressive power of good intentions, a power that can dream of nothing except rectitude in the world, that refuses even to consider a bending of Evil, or an intelligence of Evil',[5] the full range of behavioural responses continues to exist. Whether controlled, unseen and undiscussed, or treated as deviant, abnormal and low-class, the public fascination with the grotesque, evil and dysfunctional exists

in part as a symptom of this repression of the full scope of human emotion.

The apocalyptic mood associated with the turning of the millennium has stretched into the new century, and emerged prominently in the work of a younger generation unpacking a fascination with horror and death. These artists engage a Gothic sensibility that revels in a voluptuous, sensual materiality. Decay and fragmentation, ruin and dissolution describe both the specific forms as well as their allegory of a moral, corporeal, emotional or socio-political state. They explore familiar transgressive symbols, often mined from contemporary culture – heavy metal music, video games, horror and science fiction movies – not as ironic appropriation, but as ritualistic emblems for alienation and nihilism. Simultaneously melancholic and ecstatic, their work materializes ruptures in mainstream society that acknowledge both sides of the coin: themes of menace, death, repression and violence can be both chilling reminders of the state of the world and an inverse means of access to the passionate sublime through dark beauty, melancholy and explorations of extremes (such as lust, fear and despair). Ultimately, they seek the extremes of human experience lost in the emotional 'blanding' holding contemporary society in its grip.

Like other artists discussed here, David Altmejd creates mythic new worlds that suggest the creation of a new species, bound by specific rules but evoking a supernatural state. Altmejd's sculptural installation *Delicate Men in Positions of Power* (2003) also plays on spatial theatricalities, which he constructs as a modular stage set-cum-sepulchre, its wholeness pierced by hidden, labyrinthine intrusions. In an evolution of his previous sculptures of dismembered werewolf heads, Altmejd's Frankensteinian creation is presented as a skeletal body in advanced decay, a hybrid creature that is partially human and definitely monstrous. The artist gives shape to Freud's definition of the uncanny, the uncertainty of 'whether a lifeless object might not in fact be animate'.[6] The rigorous authenticity of the figure conflates a visceral grotesquerie with a sumptuous sensuality, as glittering tendrils, bejewelled organisms and crystal formations seem to feed and grow from the decaying forms. Morphological opulence exists in uneasy concert with the rational geometric structures of the work's support, scrambling the myth of a harmonic coexistence of man and nature predicated on distinct spatial demarcations. As these dichotomies (arguably only ever superficially maintained) collapse, the wild and uncontrollable seeps into the ordered and rational, thrumming with possibility.

A friend of mine, a heavy-metal fanatic, once described his ideal, musical experience this way: It should approximate the sensation you'd have during the split second between the time you saw an atomic bomb falling and the moment you were vaporized. (Barry Schwabsky)[7]

The Gothic desire for sublimity through sensation often takes form as the annihilation of the individual and the embrace of the apocalyptic. Personal identity is an ongoing and improvised performance, not an essential state. As Francisco de Goya (himself a strong precedent for the contemporary Gothic) stated, 'The world is a masquerade, face, dress, voice, everything is feigned'.[8] Presented on multiple monitors arranged to create a physical space, Aïda Ruilova's series of short-format videos plays directly on this artifice. Inspired in part by the B-movie horror genre, her videos resemble outtakes from slasher movies, but recomposed with a syncopated crosscut editing drawn from music videos and alternative film alike. The cinematic montage of Ruilova's tightly framed imagery creates brief but surprisingly complete narrative worlds, in which the implicit violence and ambiguously sexual/horrific dialogue evoke paranoiac vulnerability and secret 'unseen' activity. The quick glimpses of imagery create a sensation of breathless, claustrophobic space, and the aggressive soundtracks attack from different directions, melding symphonically to create a new composition of tension and suspense.

Less concerned with the production of grand and majestic terror, the current Gothic sublime reflects an apprehensive, morally ambiguous state of mind, characterized by the possibilities of self-dissolution, a sense of waltzing on the edge of the eternal abyss. Annihilation can make viable the desire to transcend the particularities of one's existence, a transformation achieved via extreme emotion. As the eighteenth-century philosopher Edmund Burke described the sublime: 'The passion caused by the great and sublime ... when those causes operate most powerfully, is astonishment; and astonishment is that state of the soul, in which all its motions are suspended, with some degree of horror. In this case the mind is so entirely filled with its object, that it cannot entertain any other, nor by consequence reason on that object which employs it. Hence arises the great power of the sublime, that, far from being produced by them, it anticipates our reasonings, and hurries us on by an irresistible force.'[9]

Also pushing the boundaries of emotive, aesthetic absorption and conventions of dark theatricality engaged by Ruilova and Altmejd, Banks Violette probes the fluid border in the American cultural psyche where fictional worlds – the private, personal fantasies engendered by adolescent subcultures and obsessive music fandom – pierce the fabric of reality. [...] In a recent installation, a slick, liquid epoxy melts over the surfaces of a destroyed drum set being devoured by stalagmites emerging from the forms. In the near-sculptural depths of his large-scale graphite drawings one can discern an oblique view of familiar images – from Kurt Cobain passed out onstage to a herd of galloping wild stallions as ciphers of freedom and sovereignty – inverting light and dark to resemble an X-ray. [...]

Though perhaps particularly evident in the exploration of Gothic space, one defining distinction of the contemporary mythic sensibility is that it no longer retains the Pop art rhetoric of a high/low hierarchy as its critical content, but assumes the dissolution of this opposition and the freedom to engage cultural forms on their own terms.[10] Raymond Pettibon continues to be an important pioneer in this arena; his obsessive drawings have long merged an avant-garde discourse with an adolescent, subcultural one. His unique tone prefigured the deadpan wit and simultaneous conviction that characterizes the work of more recent artists, as well as the sceptical and adolescent purposiveness they exhibit. Barnaby Furnas, for example, employs art-historical forms from the compositions of nineteenth-century history painting, the temporal simultaneity of Futurism and Cubism, and the painterly gesture of Abstract Expressionism, combining these with the figurative flatness of cartoons and the notion of 'off-canvas' space that he attributes to video games. In his paintings, aestheticized, ecstatic violence results in a fracturing of the figure and of the self at climactic moments of musical rapture, sex or death. Similarly, the lyrical portraits of Hernan Bas – all depicting young boys in enigmatically childish or sexual endeavours based on images from Boy Scout manuals, *Hardy Boys* novels, and, recently, *Moby Dick* – meld romance, sensation and playful enactments of the occult as chapters in what he calls his 'coming of age of queers novel'.[11]

The persistence of this 'adolescent impulse' in art should not be understood as a childish regression, nor as the commercialized persona of capitalist desire that defines youth-obsessed media. Rather, it is the state of being from which mythic space is best created: fluid and fluctuating, awkward and antagonistic, creative and experimental. It represents an open realm of possibility in which violence and vulnerability, vision and destruction, desire and anguish coexist.[12] Sue de Beer also locates her work in the centre of this adolescent maelstrom. In her videos, installations and photographs, she fearlessly mines popular culture and visual history, appropriating densely loaded imagery to examine still-taboo subjects. Drawing from the extreme aesthetics of horror film, the sumptuous visuality and electronic soundtracks of high-definition video games and the fatalistic credos of adolescence, de Beer's work revels in artifice without sacrificing emotional intensity. Her two-channel video installation *Hans und Grete* (2002) weaves the narratives of two pairs of teenagers (played by the same two actors), whose agonies of self-determination are expressed through both harmless desires for fame and violent enactments of powerlessness. The poetic lyricism of the individual monologues is a tender exploration of the protagonists' alienation, and the unflinching look at the horror and attraction of violence evokes a deeper understanding of the nature of belief. Like Violette, de Beer explores the extreme identification with appropriated narratives –

historical antiheroes like the Baader-Meinhof terror activists referred to in the video, or the euphoric aggression of the rock star – from an ambiguous position between critique and celebration.

Projected onto two angled screens, framed in pink, the images in *Hans und Grete* mirror and fragment across the two surfaces, reinforcing the fractal denouement of the narrative that itself mimics the conflicted, hybrid identities of the characters. The rosy shag rug and oversize animal beanbags of the viewer's environment reflect the video stage set of the female protagonists' hyper-referential bedrooms. De Beer embraces a kind of deeply feminist, heartfelt girliness that equally announces complexities of gender articulation as inextricable, glittering threads in her kaleidoscopic weave of individuality and cultural contextualization. Simultaneously unpacking the articulation of self through one's most personal histories and the social structures that we all navigate, de Beer recontextualizes widely accepted clichés of violence, aggression, sexuality and adolescence with a rigorous honesty. A deep sense of the artist's personal investment in the content combines with the formally rigorous elegance of the work to enhance these acknowledged tensions of contemporary existence.

Many of the artists in the exhibition occupy a space articulated between and among those complexities. Rigid structures of belief have been dismantled, but gaping voids remain; the simplified dichotomies of right and wrong, good and evil, do not adequately address the realities of social or political identity. In many of the works in the exhibition, the artists cultivate a semi-metaphysical commitment to the re-imagined world that makes it difficult to avoid comparison to the metaphorical structures of religion; however, they seem to search for evolution rather than absolution, purposeful rather than teleological. In these mythic spaces, as in the 'real' world, safety is revealed as an illusion, but possibility need not be. William Burroughs has posited the potential existence and use of the 'pirate utopia' – any sovereign mental or physical realm that liberates one from the conditions of control. That there is no real outside in contemporary culture is old news to these artists. They are tenaciously balanced in an intact, autonomous space carved from within, risking the ever-present security breach, perimeters necessarily unsecured. Perhaps these new forms of myth can be described as such: liminal, transitional spaces, unmoored, unfixed and resistant. The Borgesian terror of monstrous infinity that such a position suggests is, however, only a partial reaction. It can also breed new arguments, with a web of multiple answers that can illuminate where falsely polarized choices plunged us into darkness. As Francis Bacon proclaimed, 'That fashion of taking few things into account, and pronouncing with reference to a few things, has been the ruin of everything ... The world is not to be narrowed till it will go

into the understanding (which has been done hitherto), but the understanding to be expanded and opened till it can take in the image of the world.'[13]

1 Jorge Luis Borges, 'The Book of Sand', *Collected Fictions* (New York: Penguin USA, 1999) 482–3.

2 [footnote 19 in source] Artist's statement, 23 September 2003.

3 [20] The persistence of the Gothic psyche in modern art has been explored by Jan Tumlir in *Morbid Curiosity* (New York: 1–20 Gallery, 2002), in which he characterizes a concurrent flipside to modernist theory.

4 [21] A critical exhibition isolating this development was organized early in the decade by Paul Schimmel, *Helter Skelter: L.A. Art in the 1990s* (Los Angeles: Museum of Contemporary Art, 1992).

5 [22] Quoted in Richard Davenport-Hines, *Gothic: Four Hundred Years of Excess, Horror, Evil and Ruin* (New York: Farrar Straus & Giroux, 1999). Davenport-Hines maps the cycles of the Gothic sensibility through its historical cultural presence and explores its psychosocial roots.

6 [23] E. Jentsch, quoted in Sigmund Freud, 'The Uncanny' (1919), *The Standard Edition of the Complete Psychological Works of Sigmund Freud*, trans. and ed. James Strachey, 24 vols. (London: Hogarth Press, 1953–74), vol. 7; 226.

7 [24] Barry Schwabsky, 'Aïda Ruilova', *Artforum* (December 2000) 148.

8 [25] Quoted in Richard Davenport-Hines, *Gothic*, op. cit., 7.

9 [26] Edmund Burke, *Philosophical Enquiry into the Origin of Our Ideas of the Sublime and Beautiful*, ed. Adam Phillips (New York: Oxford University Press, 1998) 53.

10 [28] The particular attraction to American vernacular forms (i.e. specific genres of music and film) as a frequently appropriated model for contemporary artists may speak to their greater fluidity to transform themselves, unburdened by the historical weight of 'high art' imagery.

11 [29] E-mail exchange with the artist, 8 October 2003.

12 [30] For a more complete anthologizing of this sensibility, see Francesco Bonami and Raf Simons, eds, *The Fourth Sex: Adolescent Extremes* (Florence: Fondazione Pitti, 2003).

13 [31] Francis Bacon, *Preparative Toward Natural and Experimental History* (1620), in *The Works of Francis Bacon*, coll. and ed. James Spedding, Robert Leslie Ellis, and Douglas Denon Heath (Boston: Brown and Taggard, 1860–64) vol. VIII.

Shamim M. Momim, excerpt from 'Beneath the Remains: What Magic in Myth?', *Whitney Biennial* (New York: Whitney Museum of American Art, 2004) 46–51.

Marina Warner
Insubstantial Pageants//2006

Action at a Distance

Showmen who toured the phantasmagoria in Europe – Etienne-Gaspard Robertson and 'Philidor' – projected apparitions onto a screen using a rolling projector; the popularity of their eerie, frequently macabre spectacles foreshadows the coming popularity of spirit visitations in the home. From the 1840s onwards, spirit messages from other worlds, rapped by revenants on walls or 'apported' at spiritualist séances, provided evidence of life after death, of thought transmission and the transmigration of souls, in a reinvigorated spirit language couched in modern terms. The acoustic phenomena were accompanied by apparitions – veiled phantoms, dancing balls of light, strokes and kisses from spectral hands and lips; photography came to play a crucial part in verifying the truth of such experiences, and then the images themselves became charged with numinous power, as artefacts themselves made by spirit presences.

Spirit photography in the nineteenth century expanded in two connected fields of inquiry, both of them adumbrated by the theories of consciousness and the optical speculations of such earlier thinkers as Fludd and Kircher, Descartes and Locke. Spiritualists who wanted to summon the dead sought for evidence of phantoms and spirit activity: they produced proofs through technology. [...]

Several mediums from the early twentieth century transformed themselves into living cameras: Eva Carrière collaborated with the sculptor Juliette Bisson and the psychiatrist Albert von Schrenk-Notzing in Bavaria from 1913 until the 1920s, and together they created one of the most alluring, bizarre sequences of psychic phenomena. Sitting in a veiled cabinet inside a darkened room, Eva C, as she was known, functions as the photographic plate or paper, receiving the energies beyond the range of human perception to produce ectoplasmic strings and veils, themselves frequently imprinted with images of faces – materialized ghosts.

'Apports' also materialized through the powers of mediums: the poet Elizabeth Barrett Browning was delighted to receive a garland of clematis from a spirit raised in a séance in Ealing around 1859; towards the end of the century, in Manchester, the successful medium Mlle. Elisabeth d'Espérance (who, like Eva Carrière, has inspired the contemporary artist Zoe Beloff), produced fully formed flowers, including a 'Golden Lily', which lasted a week, then 'dissolved and disappeared'.[1]

None of these pioneers of psychic projection attempted to transmit images from memory, however, as Chicago bellhop Ted Serios did in the 1960s. But the

fundamental enterprise in these cases – to propel by the power of thought objects into the world (the physicists call this 'action at a distance') – has become a potent and fruitful metaphor for artistic activity for many artists working today.

So although until about ten years ago ectoplasms, ghost photographs, apports and psychic stuff generally raised a smile, embarrassment or even an appalled response, these traces of preceding generations' endeavours have now gained a new seriousness and refreshed interest, as testified by numerous exhibitions of archival material from the decades of psychic experiment, as well as the tributes of artists mining this strand in the history of consciousness. Such exhibitions do not present this activity as scientific, but either as chapters in the history of science, or, as in the case of *The Blur of the Otherworldly*, as forerunners of aesthetic preoccupations today. Yet contemporary spirit images, as created by Susan Hiller, for example, or Chris Bucklow, do belong to another branch of scientific inquiry, into human psychology in general, and into the workings of fantasy and the unconscious in particular.

Artists mirror the activity of creation in itself when they inaugurate in the world of appearances the phantasms of the mind. These lines of development keep rhythm with a new emphasis on the unreliability of sense perceptions – the pervasiveness of illusion (in a universe of the spectacle where the real has become a desert)[2] and the corresponding rise in what Zygmunt Bauman has called 'liquid modernity' – which throws huge weight on individualism and simultaneously undoes the bonds that hitherto helped the self to achieve self-definition.[3] Virtual technologies have established a different relationship of the percipient to data perceived by the senses, and photography has performed fictions since Julia Margaret Cameron began creating images of angels 'From Life' in the 1860s. A hundred years after, Duane Michals staged ethereal visitations, unfolding in story sequences; the trend is growing stronger. Gregory Crewdson's *mises en scène* masquerade as tabloid occurrences or clips from newsreels, and the images' weirdness intensifies because he captures the enactment he has staged through effects of enhanced realism – polychrome, surplus detail and a strong sense of locale. Artworks of this kind probe those mysteries about the borders between reality and illusion, preternatural marvels and supernatural operations, which Athanasius Kircher confronted with his first magic lantern projections. The camera no longer plays its conventional part as mute and objective recorder of facts (its 'indexical' character) and has become instead a paramount expressive vehicle of inner fantasy – the modern *dream machine*, to use a title Susan Hiller gave to an exhibition she selected. New means of speaking and picturing have refigured the soul and spirit; modern technologies communicate the imagination's make-believe, its desires and terrors, and

continue to shape them as they deliver them into collective consciousness.

The phantasmata that are now projected into the world, in still or moving images, gain in eerie impact through the photographic medium's traditional deep identification with truth-telling. It is one of the most profoundly shaping paradoxes of the media age that the unprecedented achievements of communications technology, which have changed the world and everyone in it, have led us through the gates of dream.

1 [footnote 14 in source] Elisabeth d'Espérance, *Shadow Land, or Light from the Other Side* (London: 1897) 259–65; the performance artist Zoe Beloff has created an elaborate tableau inspired by this medium's work; see her essay 'Two Women Visionaries'.

2 [15] The greeting of Morpheus, from the film *The Matrix*, was borrowed by Slavoj Zizek in his essay *Welcome to the Desert of the Real* (London; New York: Verso, 2002).

3 [16] Zygmunt Bauman, *Liquid Love: On the Frailty of Human Bonds* (Cambridge: Polity Press, 2003).

Marina Warner, excerpt from 'Insubstantial Pageants', in Mark Alice Durant and Jane D. Marsching, *Blur of the Otherworldly* (Baltimore: Center for Art and Visual Culture, University of Maryland, 2006) 107–13.

Gianni Jetzer
Vanitas and Lifestyle: A Relaxation in Our Relationship to Symbols of Death//2006

For centuries, art has employed bony skulls as symbols of death and mortality. Many masterpieces have used this most obvious of symbols, from Hans Holbein the Younger with his positively psychedelic depiction of a skull in his famous painting *The Ambassadors* (1533; National Gallery, London) to the works of seventeenth-century painters like Michael Sweerts and Philippe de Champaigne. In all such works the message is clear, especially when the skull is teamed with an hourglass: your time is running out! Someday we will all sport the same gruesome grin! This tradition is still with us, most impressively demonstrated by Robert Mapplethorpe's photographs, with all their tragic implications of the artist's own biography. In his final self-portrait from 1988 Mapplethorpe, emaciated by AIDS, holds a walking stick crowned with a skull. Here it has become the symbol of a social phobia, of discrimination against a misunderstood illness and, indeed, the American artist's own personal *memento mori*. [...]

Freakish Beauty
The once unambiguous symbolism of the anatomical skull has clearly given way to the ambiguity of countless graphic variations within the framework of a completely new aesthetics. An early illustration of this new development in modern times is the flag flown by pirate ships – the Jolly Roger. Its most popular subject – the skull and crossbones – was a common *memento mori* on tombstones in Britain in the sixteenth and seventeenth centuries. For the first time, the symbol of death was transferred from a religious to a profane context in a singular act of piracy. Divorced from the 'comforts' of the Church and extreme unction, it morphed into a fearsome sign, the embodiment of a terrifying code of lawlessness and ungodliness. Pirates were 'outlaws', dropouts from Christian society and its system of values and beliefs. Having since been appropriated by Hollywood and Disneyland, the sign has sacrificed much of its subversive appeal.[1]

Folkert de Jong's installation *It all Began in the Sea*, shown at the Centre for European Art in Xiamen, China (2003) can be seen both as a pirate monument and a *memento mori*. The skull and crossbones are depicted next to amphorae, starfish and finger-like steles, recalling the treasure islands of pirate-story renown. Despite the frightening symbolism, there is something genuinely romantic about the 'monument'. The artist stresses the importance of contextual

ambivalence in the interpretation of his work: 'Throughout the history of art in my country, which goes back hundreds of years, it was commonly held that if you long for too much beauty, it can be very dangerous, because one day you may die. You cannot live forever. So I was trying to strike a balance between beauty and danger in my artwork, bringing together the visual beauty and the fear of beauty.'[2] Although de Jong brings age-old vanitas symbolism into play, his installation looks more like a bloody battle among pirates than any art-historical representation. Displaying an ambivalent form of beauty in the midst of bony skulls needs no explanation; death suddenly acquires an easy-going nonchalance.

Skulls are a leitmotif in Folkert de Jong's work. They are plaited in to chandeliers; they embellish a fictitious grave (*Skulls & Bones*, 2004) in the garden of Villa Massimo in Rome; there are bones and skulls in almost all of his installations, often carved out of baby-blue Styrofoam. Folkert de Jong rises above the level of the straightforward *memento mori*. He uses skulls to tell stories (of life); he turns them into freakish pop characters who seem to live life dangerously on the presumption of their immortality. They have transcended us and our dreams of eternal youth, for they have reached another stage of consciousness, a kind of stable condition while we, the living, have to deal day after day with the inexorable decay of our own bodies. Folkert de Jong operates on the razor's edge between theme park and dark conscience, where fun and torture, sex and death, war and archaeology collide head-on.

Rebel Yell and Halloween

Even so, the skull still owes its popularity more to tattooing than to the fine arts. Tattoos spoke a secret language long before primitivism became trendy, before every small town boasted a high-street tattoo parlour and every indie-rocker and office worker willingly submitted to the needle. They were the domain of a special society, the underworld of criminals and inmates. The skull has always been a popular motif in tattooing. The prison guard Danzig Baldayev made drawings of tattoos with a felt-tip pen, collecting some 3,600 designs in the course of his professional career. It became the most important project in his life: 'Tattoos were his entrance into a secret world, a world in which he acted as an ethnographer, recording the rituals of a closed society. The icons and tribal languages he documented are artful, distasteful, sexually explicit and sometimes simply strange, reflecting as they do the lives and mores of convicts. Skulls, swastikas, harems of naked women, a smiling Al Capone, assorted demons, medieval knights in armour, daggers sheathed in blood, benign images of Christ, mosques and minarets, sweet-faced mothers and their babies, armies of tanks, and an honoured Lenin – these are the signs with which this hidden world of people mark and identify themselves.'[3] Today tattoos are no longer signs of

affiliation with the underworld, but purely a lifestyle accessory. They are distinguished only by the degree of visibility on the wearer's body. The skull continues to enjoy great popularity, except that it now has precious little to do with vanitas symbolism or the *memento mori*. It merely serves to embellish the body, to demonstrate defiance in the face of death or simply to make a show of rebellion. The skull has become an ambivalent rhetorical figure in contemporary society, possibly through the influence of other cultures. In Mexico, the 'Day of the Dead' is celebrated with thousands of little skeletons. Death is seen as the ultimate liberation from all earthly burdens. No wonder then that skeletons and skulls play such a central role during this festival where, rather than symbolizing death, they are viewed as symbols of life and regeneration. In order to confront death and make light of it, people eat marzipan, sugar or chocolate skulls and stage scenes populated with skeletons. And in North America, where black suits printed with white skeletons enjoy great popularity, it looks as if Halloween will soon outshine Christmas.

Church of Chaos

Heavy metal has added another successful chapter to the growing independence and popularity of the skull's symbolism. Nowadays emblems and stylised depictions of death are incorporated into the insignia of virtually every band[4] and the sub-genre 'death metal' even explicitly incorporates the term itself. A unique symbolism has emerged, typically represented by such elements as bones, flames, zombies or monsters. Like the pirates of old, single bands establish free zones that attract like-minded individuals and groups with a penchant for civil disobedience. In the meantime websites and even dissertations are devoted to the encyclopaedic study of such phenomena. The movement thrives on a dualism that defines the good as a weak, lifeless force, which must be defeated by evil – its dark and mighty counterpart – in pursuit of destruction, ceaseless change and chaos. The now defunct performance collective, Angelblood, which comprised the two artists Rita Ackermann and Lizzi Bougatsos, took a flirtatiously playful approach to this worldview. They mixed 'Bohemia' with 'speed metal', performance art with motorcycles, and burlesque with lifestyle. *Purple*, the French bible of all modern fashion magazines, frequently printed reproductions of their collages and photographic self-representations. The new muses à l'Américaine are vaguely reminiscent of Serge Gainsbourg's artificial persona, the American heroine Melody Nelson, except that Ackermann and Bougatsos are faster, less restrained and more emancipated. The press release accompanying their curatorial project at Kenny Schachter in New York was presented in the form of a poem:

When the moral laws empty their pockets for a last sort of existential grasp of

thought, for man will be visible and visitable and one will wish to know more than can be seen. The humanly thinkable will turn aside and backwards, spinning on its tracks of the new and laws of chance and humour, a morphed weep.

A comedy-like skit on dilapidated thought, a timelessness neubauten of the hateful/properly thinkable which each day adds another stone to the millstone

Of shit,

Of the bore of the cycle,

Of our times' indigestible correctness,

Of a desperate final stature.

This church of chaos is Angelblood,

The shit-eating system of immortality,

The tower of Babylon obsessors of desire.

Although deliberately cryptic, the text hardly conceals the call for anarchy and rebellion against the hegemony of 'proper' society. *Church of Chaos* became the two artists' battle cry and their choice of works for the exhibition revealed a fascination not only with agendas that espouse 'darkness' (Kembra Pfahler) in stark contrast to Republican America, but also with those of artists like Inez van Lamsweerde and Vindoodh Matadin, who draw their subject matter from the worlds of fashion and lifestyle. Angelblood managed to cultivate a unique mix of low and underground culture and high fashion.

The presence of heavy metal in contemporary art is no longer restricted to the subtleties of social criticism. In *Made in England*, the Turner Prize winner Jeremy Deller has created a multiple for the art market by ousting Motörhead's name above the horned skull on their classic black T-shirt and replacing it with his own.[5] The band stands for undying independence and the dark side of the music business, in sharp contrast to the test-tube bands and music starlets of the hit industry. Projected onto the art world Jeremy Deller subtly positions himself as a nonconformist in British art.

The curator of the last Whitney Biennial, Chrissie Iles, described the work of Banks Violette as 'the dark side of the Heavy Metal American Dream'. The young artist was one of the discoveries at this major exhibition. The strong colour contrasts in his drawings, his onyx-like sculptures and the reference to the satanic ritualistic murders of suicidal Judas Priest fans evoke a dark counter-world. [...]

This Is the End

Given such a widespread preoccupation with death and the skull, it is not surprising that Scottish artist Douglas Gordon's *Proposal for a Posthumous Portrait* (2004) also refers explicitly to the traditional vanitas symbol. It shows a carved skull mounted on a mirrored shelf, clearly referring to both the Baroque

and to a seminal twentieth-century work of art: the star carved into the back of the skull has exactly the same measurements as the star-shaped tonsure on Marcel Duchamp's head in the famous photograph by Man Ray (1919). The work is of a conceptual nature and the artist even proposes making a long-term project out of it: 'It involves buying a skull, a real one, for every year of my life, 38 in all, and making a trepanation into the skull, one star shape for each year. The first one would have one, the second two, the third three, and so on. And by the time I'm fifty years old, it will become very difficult to have a skull with fifty stars. Imagine, when I get to be an old man and I'm very fragile, then my little birthday present to myself is going to be extremely fragile. So you could say that my interest in defeating death is inevitably some kind of vanity.'[6]

Douglas Gordon's portrait closes the circle. At the same time, it reveals a revival of interest among contemporary artists in the traditional concerns of art history, although their study and treatment of symbols of death have no doubt become more pragmatic. Having jettisoned the relationship to Christian symbolism, the skull, with its diversity of cross-references to youth subcultures, rock music, rituals and celebrations, has almost acquired a homely familiarity. Today's tendency to focus on the dark side of life has become a strategy to escape a society that is inundated with positive slogans but also a means of discovering the secret of life; explorations undertaken with the obsessiveness of a Frankenstein.

1 See David Cordingly, *Under the Black Flag, the Romance and the Reality of Life Amongst Pirates* (Harvest Books, 1995).

2 Enid Chen, 'It all began in the Sea', interview with Folkert de Jong, Xiamen Municipal Government, 2003.

3 Danzig Baldayev, *Russian Criminal Tattoo Encyclopedia* (London: Steidl, 2005).

4 For the iconography of heavy metal see the film *Lost in Music: Metal Mania*, 1993.

5 Available at www.paulstolper.com

6 Interview with Douglas Gordon, 'The Opposite Dorian Gray – Douglas Gordon on vanity, death and wax figures', by Ulrich Clewing, in *DB Artmag*, issue 29, (14 July–26 September 2005) archived at http://www.deutsche-bank-kunst.com/art/2005/5/e/5/359.php

Gianni Jetzer, 'Vanitas and lifestyle: A relaxation in our relationship to symbols of death', trans. Catherine Schelbert, in Jan Grosfeld and Rein Wolfs, eds, *Dark* (Rotterdam: Museum Boijmans Van Beuningen, 2006) 75–115.

STUNG BY THE WHIPLASH OF A

MONSTROUS

CATASTROPHE, I AWAKE IN THE MIDDLE OF THE NIGHT, SHOCKED TO
BE PRESENT AT THE MOMENT OF COMPLETE TERMINATION. JUST A

BAD
DREAM

THE PERSISTENT NIGHTMARE OF OUR TIMES

MODERN GOTHIC: DEATH, EXCESS AND TERROR

Jean Baudrillard
The Transparency of Evil//1990

Prophylaxis and Virulence

[...] The high degree to which AIDS, terrorism, crack cocaine or computer viruses mobilize the popular imagination should tell us that they are more than anecdotal occurrences in an irrational world. The fact is that they contain within them the whole logic of our system: these events are merely the spectacular expression of that system. They all hew to the same agenda of virulence and radiation, an agenda whose very power over the imagination is of a viral character: a single terrorist act obliges a reconsideration of politics as a whole in the light of terrorism's claims; an outbreak of AIDS, even a statistically insignificant one, forces us to view the whole spectrum of disease in the light of the immunodeficiency thesis; and the mildest of computer viruses, whether it vitiates the Pentagon's memory banks or merely erases a shower of online Christmas messages, has the potential to destabilize all data contained in information systems.

Whence the special status of such extreme phenomena – and of catastrophe in general, understood as an anomalous turn of events. The secret order of catastrophe resides in the affinity between all these processes, as in their homology with the system as a whole. Order within disorder: all extreme phenomena are consistent both with respect to each other and with respect to the whole that they constitute. This means that it is useless to appeal to some supposed rationality of the system against that system's outgrowths. The vanity of seeking to abolish these extreme phenomena is absolute. Moreover, they are destined to become more extreme still as our systems grow more sophisticated. And this is in fact a good thing – for they are the leading edge of therapy here. In these transparent, homeostatic or homeofluid systems there is no longer any such thing as a strategy of Good against Evil, there is only the pitting of Evil against Evil – a strategy of last resort. Indeed, we really have no choice in the matter: we simply watch as the lesser evil – homeopathic virulence – deploys its forces. AIDS, crack and computer viruses are merely outcroppings of the catastrophe; nine-tenths of it remains buried in the virtual. The full-blown, the absolute catastrophe would be a true omnipresence of all networks, a total transparency of all data – something from which, for now, computer viruses preserve us. Thanks to them, we shall not be going straight to the culminating point of the development of information and communications, which is to say: death. These viruses are both the first sign of this lethal transparency and its

alarm signal. One is put in mind of a fluid travelling at increasing speed, forming eddies and anomalous countercurrents which arrest or dissipate its flow. Chaos imposes a limit upon what would otherwise hurtle into an absolute void. The secret disorder of extreme phenomena, then, plays a prophylactic role by opposing its chaos to any escalation of order and transparency to their extremes. But these phenomena notwithstanding, we are already witness to the beginning of the end of a certain way of thinking. Similarly, in the case of sexual liberation, we are already witness to the beginning of the end of a certain type of gratification. If total sexual promiscuity were ever achieved, however, sex itself would self-destruct in the resulting asexual flood. Much the same may be said of economic exchange. Financial speculation, as turbulence, makes the boundless extension of real transactions impossible. By precipitating an instantaneous circulation of value – by, as it were, electrocuting the economic model – it also short-circuits the catastrophe of a free and universal commutability – such a total liberation being the true catastrophic tendency of value.

In the face of the threats of a total weightlessness, an unbearable lightness of being, a universal promiscuity and a linearity of processes liable to plunge us into the void, the sudden whirlpools that we dub catastrophes are really the thing that saves us from catastrophe. Anomalies and aberrations of this kind recreate zones of gravity and density that counter dispersion. It may be hazarded that this is how our societies secrete their own peculiar version of an accursed share, much after the fashion of those tribal peoples who used to dispose of their surplus population by means of an oceanic suicide: the homeopathic suicide of a few serving to maintain the homeostatic balance of the group.

So the actual catastrophe may turn out to be a carefully modulated strategy of our species – or, more precisely, our viruses, our extreme phenomena, which are most definitively real, albeit localized, may be what allow us to preserve the energy of that *virtual* catastrophe which is the motor of all our processes, whether economic or political, artistic or historical.

To epidemic, contagion, chain reactions and proliferation we owe at once the worst and the best. The worst is metastasis in cancer, fanaticism in politics, virulence in the biological sphere and rumour in the sphere of information. Fundamentally, though, all these also partake of the best, for the process of chain reaction is an immoral process, beyond good and evil, and hence reversible. It must be said, moreover, that we greet both worst and best with the same fascination. [...]

Jean Baudrillard, excerpt from 'Prophylaxis and Virulence', first published in *Le Transparence du Mal: Essai sur les phénomènes extremes* (Paris: Editions Galilée, 1990), trans. James Benedict, *The Transparency of Evil* (London: Verso, 1993) 67–9.

Judith Halberstam
Skin Shows: Gothic Horror and the Technology of Monsters//1995

Skin Shows

In *The Silence of the Lambs* (1991) by Jonathan Demme, one of many modern adaptations of *Frankenstein*, a serial killer known as Buffalo Bill collects women in order to flay them and use their skins to construct a 'woman suit'. Sitting in his basement sewing hides, Buffalo Bill makes his monster a sutured beast, a patchwork of gender, sex and sexuality. Skin, in this morbid scene, represents the monstrosity of surfaces and as Buffalo Bill dresses up in his suit and prances in front of the mirror, he becomes a layered body; a body of many surfaces laid one upon the other. Depth and essence dissolve in this mirror dance, and identity and humanity become skin deep.

My subject is monsters and I begin in Buffalo Bill's basement, his 'filthy workshop of creation', because it dramatizes precisely the distance travelled between current representations of monstrosity and their genesis in nineteenth-century Gothic fiction. Where the monsters of the nineteenth century metaphorized modern subjectivity as a balancing act between inside/outside, female/male, body/mind, native/ foreign, proletarian/aristocrat, monstrosity in postmodern horror films finds its place in what Baudrillard has called the obscenity of 'immediate visibility'[1] and what Linda Williams has dubbed 'the frenzy of the visible'.[2] The immediate visibility of a Buffalo Bill, the way in which he makes the surface itself monstrous transforms the cavernous monstrosity of Jekyll/ Hyde, Dorian Gray or Dracula into a beast who is all body and no soul.

Victorian monsters produced and were produced by an emergent conception of the self as a body which enveloped a soul, as a body, indeed, enthralled to its soul. Michel Foucault writes in *Discipline and Punish* that 'the soul is the prison of the body' and he proposes a genealogy of the soul that will show it to be born out of 'methods of punishment, supervision and constraint'.[3] Foucault also claims that, as modern forms of discipline shifted their gaze from the body to the soul, crime literature moved from confession or gallows speeches or the cataloguing of famous criminals to the detective fiction obsessed with identifying criminality and investigating crime. The hero of such literature was now the middle- or upper-class schemer whose crime became a virtuoso performance of skill and enterprise. [...]

Within the nineteenth-century Gothic, authors mixed and matched a wide variety of signifiers of difference to fabricate the deviant body – Dracula, Jekyll/Hyde and even Frankenstein's monster before them are lumpen bodies,

bodies pieced together out of the fabric of race, class, gender and sexuality. In the modern period and with the advent of cinematic body horror, the shift from the literary Gothic to the visual Gothic was accompanied by a narrowing rather than a broadening of the scope of horror. One might expect to find that cinema multiplies the possibilities for monstrosity but in fact, the visual register quickly reaches a limit of visibility. In *Frankenstein* the reader can only imagine the dreadful spectacle of the monster and so its monstrosity is limited only by the reader's imagination; in the horror film, the monster must always fail to be monstrous enough and horror therefore depends upon the explicit violation of female bodies as opposed to simply the sight of the monster.

Furthermore, as I noted, while nineteenth-century Gothic monstrosity was a combination of the features of deviant race, class and gender, within contemporary horror, the monster, for various reasons, tends to show clearly the markings of deviant sexualities and gendering but less clearly the signs of class or race. Buffalo Bill in *The Silence of the Lambs*, for example, leads one to suppose that the monstrous body is a sexed or gendered body only, but this particular body, a borrowed skin, is also clearly inscribed with a narrative of class conflict. To give just one example of deviant class in this film, the heroine, Clarice Starling, is identified by Hannibal Lecter as a woman trying to hide her working-class roots behind 'bad perfume' and cheap leather shoes. Given the emphases in this film upon skins and hides, it is all too significant that cheap leather gives Starling away. Poor skin, in this film, literally signifies poverty, or the trace of it. As we will see, however, the narrative of monstrous class identity has been almost completely subsumed within *The Silence of the Lambs* by monstrous sexuality and gender.

The discourse of racialized monstrosity within the modern horror film proves to be a discursive minefield. Perhaps because race has been so successfully gothicized within our recent history, filmmakers and screenplay writers tend not to want to make a monster who is defined by a deviant racial identity. European anti-Semitism and American racism towards black Americans are precisely Gothic discourses given over to the making monstrous of particular kinds of bodies. [...]

Moving from nineteenth-century Gothic monsters to the monsters of contemporary horror films, my study will show that within the history of embodied deviance, monsters always combine the markings of a plurality of differences, even if certain forms of difference are eclipsed momentarily by others. The fact that monstrosity within contemporary horror seems to have stabilized into an amalgam of sex and gender, demonstrates the need to read a history of otherness into and out of the history of Gothic fiction. Gothic fiction of the nineteenth century specifically used the body of the monster to produce

race, class, gender and sexuality within narratives about the relation between subjectivities and certain bodies. [...]

Skin, I will argue with reference to certain nineteenth-century monsters, becomes a kind of metonym for the human; and its colour, its pallor, its shape mean everything within a semiotic of monstrosity. Skin might be too tight (Frankenstein's creature), too dark (Hyde), too pale (Dracula), too superficial (Dorian Gray's canvas), too loose (Leatherface) or too sexed (Buffalo Bill). Skin houses the body and it is figured in Gothic as the ultimate boundary, the material that divides the inside from the outside. The vampire will puncture and mark the skin with his fangs, Mr Hyde will covet white skin, Dorian Gray will desire his own canvas, Buffalo Bill will covet female skin, Leatherface will wear his victim's skin as a trophy and recycle his flesh as food. Slowly but surely the outside becomes the inside and the hide no longer conceals or contains, it offers itself up as text, as body, as monster. The Gothic text, whether novel or film, plays out an elaborate skin show. [...]

In relation to Gothic monstrosity, it is all too easy to understand how the relation between fear and desire may be Oedipalized, psychologized, humanized. Psychoanalysis itself has a clinical term for the transformation of desire into fear and of the desired/feared object into monster: paranoia. Freud believed that his theory of paranoia as a repressed homosexual desire could be applied to any and all cases of paranoia regardless of race or social class. This, of course, is where the psychoanalytic crisis begins and ends – in its attempt to reduce everything to the sexual and then in its equation of sexuality and identity. The process by which political material becomes sexual material is one in which the novel plays a major role. And the Gothic novel, particularly the late-Victorian Gothic novel, provides a metaphor for this process in the form of the monster. The monster is the product of and the symbol for the transformation of identity into sexual identity through the mechanism of failed repression.

One Lacanian account of monstrosity demonstrates simultaneously the appeal and the danger of psychoanalytic explanations. In Slavoj Zizek's essay 'Grimaces of the Real, or When the Phallus Appears', he reads the phantom from *The Phantom of the Opera* alongside such enigmatic images as the vampire, Edvard Munch's *The Scream* (1893) and David Lynch's *Elephant Man* (1980).[4] Zizek attempts to position images of the living-dead as both mediators between high art and mass culture and as 'the void of the pure self'.[5] Zizek is at his most persuasive when he discusses the multiplicity of meaning generated by the monster. The fecundity of the monster as a symbol leads him to state: 'The crucial question is not "What does the phantom signify?" but "How is the very space constituted where entities like the phantom can emerge?"'.[6] The monster/phantom, in other words, never stands for a simple or unitary

prejudice, it always acts as a 'fantasy screen' upon which viewers and readers inscribe and sexualize meaning. [...]

The Power of Horror

In Gothic, as in many areas of Victorian culture, sexual material was not repressed but produced on a massive scale, as Michel Foucault has argued.[7] The narrative, then, that professed outrage at acts of sexual perversion (the nightly wanderings of Hyde, for example, or Dracula's midnight feasts) in fact produced a catalogue of perverse sexuality by first showcasing the temptations of the flesh in glorious Technicolor and then by depicting so-called normal sex as a sickly enterprise devoid of all passion. One has only to think of the contrast between Mina Harker's encounter with Count Dracula – she is found lapping at blood from his breast – and her sexually neutral, maternal relations with her husband.

The production of sexuality as identity and as the inversion of identity (perversion – a turning away from identity) in Gothic novels consolidates normal sexuality by defining it in contrast to its monstrous manifestations. Horror, I have suggested, exercises power even as it incites pleasure and/or disgust. Horror, indeed, has a power closely related to its pleasure-producing function and the twin mechanism of pleasure-power perhaps explains how it is that Gothic may empower some readers even as it disables others. An example of how Gothic appeals differently to different readers may be found in contemporary slasher movies like *The Texas Chainsaw Massacre* (1974) and *Halloween* (1978). Critics generally argue that these films inspire potency in a male viewer and incredible vulnerability in a female viewer. However, as we shall see in the later chapters of this book [*Skin Shows*, 1995], the mechanisms of Gothic narrative never turn so neatly around gender identifications. A male viewer of the slasher film, like a male reader of the nineteenth-century Gothic, may find himself on the receiving end of countless acts of degradation in relation to monstrosity and its powers while the female reader and spectator may be able to access a surprising source of power through monstrous forms and monstrous genres.

In her psychoanalytic study of fear, *Powers of Horror*, Julia Kristeva defines horror in terms of 'abjection'. The abject, she writes, is 'something rejected from which one does not part, from which one does not protect oneself as from an object. Imaginary uncanniness and real threat, it beckons to us and ends up engulfing us.'[8] In a chapter on the writings of Celine, Kristeva goes on to identify abjection with the Jew of anti-Semitic discourse. Anti-Semitic fantasy, she suggests, elevates Jewishness to both mastery and weakness, to 'sex tinged with femininity and death'.[9] [...]

In an introduction to *Studies on Hysteria* written in 1893, Freud identifies the

repressed itself as a foreign body. Noting that hysterical symptoms replay some original trauma in response to an accident, Freud explains that the memory of trauma 'acts like a foreign body which, long after its entry, must continue to be regarded as an agent that is still at work'.[10] In other words, until an original site of trauma reveals itself in therapy, it remains foreign to body and mind but active in both. The repressed, then, figures as a sexual secret that the body keeps from itself and it figures as foreign because what disturbs the body goes unrecognized by the mind.

The fiction that Freud tells about the foreign body as the repressed connects remarkably with the fiction Gothic tells about monsters as foreigners. Texts, like bodies, store up memories of past fears, of distant traumas. 'Hysterics' writes Freud, 'suffer mainly from reminiscences'.[11] History, personal and social, haunts hysterics and the repressed always takes on an uncanny life of its own. Freud here has described the landscape of his own science – foreignness is repressed into the depths of an unconscious, a kind of cesspool of forgotten memories, and it rises to the surface as a sexual disturbance. Psychoanalysis gothicizes sexuality; that is to say, it creates a body haunted by a monstrous sexuality and forced into repressing its Gothic secrets. Psychoanalysis, in the Freudian scenario, is a sexual science able to account for and perhaps cure Gothic sexualities. Gothicization in this formula, then, is the identification of bodies in terms of what they are not. A Gothic other stabilizes sameness, a gothicized body is one that disrupts the surface-depth relationship between the body and the mind. It is the body that must be spoken, identified or eliminated.

Eve Sedgwick has advanced a reading of Gothic as the return of the repressed. She reads fear in the Gothic in terms of the trope of 'live burial' and finds in Gothic 'a carcaral sublime of representation, of the body, and potentially of politics and history as well'.[12] Live burial as a trope is, of course, standard fare in the Gothic, particularly in eighteenth-century Gothic like Matthew Lewis' *The Monk* and Ann Radcliffe's *The Mysteries of Udolpho*. Live burial also works nicely as a metaphor for a repressed thing that threatens to return. Sedgwick's example of the repressed in Gothic is homosexuality. She characterizes the 'paranoid Gothic novel' in terms of its thematization of homophobia and thus, she describes *Frankenstein*'s plot in terms of 'a tableau of two men chasing each other across the landscape'.[13] [...]

The Technology of Monsters

This book [Halberstam, *op. cit.*], will argue that Gothic novels are technologies that produce the monster as a remarkably mobile, permeable and infinitely interpretable body. The monster's body, indeed, is a machine that, in its Gothic mode, produces meaning and can represent any horrible trait that the reader

feeds into the narrative. The monster functions as monster, in other words, when it is able to condense as many fear-producing traits as possible into one body. Hence the sense that Frankenstein's monster is bursting out of his skin – he is indeed filled to bursting point with flesh and meaning both. Dracula, at the other end of the nineteenth century, is a body that consumes to excess – the vampiric body in its ideal state is a bloated body, sated with the blood of its victims.

Monsters are meaning machines. They can represent gender, race, nationality, class and sexuality in one body. And even within these divisions of identity, the monster can still be broken down. Dracula, for example, can be read as aristocrat, a symbol of the masses; he is predator and yet feminine, he is consumer and producer, he is parasite and host, he is homosexual and heterosexual, he is even a lesbian. Monsters and the Gothic fiction that creates them are therefore technologies, narrative technologies that produce the perfect figure for negative identity. Monsters have to be everything the human is not and, in producing the negative of human, these novels make way for the invention of human as white, male, middle class and heterosexual.

But Gothic is also a narrative technique, a generic spin that transforms the lovely and the beautiful into the abhorrent and then frames this transformation within a humanist moral fable. A brilliant postmodern example of what happens when a narrative is gothicized is Tim Burton's surrealistic *Nightmare Before Christmas* (1993). *Nightmare* is an animated fantasy about what happens when Halloween takes over Christmas. Halloween and Christmas, in this film, are conceived as places rather than times or occasions and they each are embodied by their festive representatives, Jack Skeleton and Santa Claus. Indeed religious or superstitious meanings of these holidays are almost entirely absent from the plot. Jack Skeleton is a kind of melancholic romantic hero who languishes under the strain of representing fear and maintaining the machinery of horror every year. He stumbles upon the place called Christmas one day after a stroll through the woods beyond his graveyard and he decides that he wants to do Christmas this year instead of Halloween.

The transformation of Christmas into Halloween is the gothicization of the sentimental; presents and toys, food and decorations are all transformed from cheery icons of goodwill into fanged monsters, death masks and all manner of skullduggery. Kids are frightened, parents are shocked, Santa Claus is kidnapped and mayhem ensues. Of course, a pathetic sentimental heroine called Sally uses her rag-doll body to restore law and order and to woo Jack back to his proper place but, nonetheless, the damage has been done. Christmas, the myth of a transcendent generosity, goodwill and community love has been unmasked as just another consumer ritual and its icons have been exposed as simply toys without teeth or masks that smile instead of grimace. The naturalness and

goodness of Christmas has unravelled and shown itself to be the easy target of any and all attempts to make it Gothic.

While *Nightmare* suggests that, at least in a postmodern setting, gothicization seems to have progressive and even radicalizing effects, it is not always so simple to tell whether the presence of Gothic registers a conservative or a progressive move. [...]

Gothic, I argue, marks a peculiarly modern preoccupation with boundaries and their collapse. Gothic monsters, furthermore, differ from the monsters that come before the nineteenth century in that the monsters of modernity are characterized by their proximity to humans. [...]

1 Jean Baudrillard, 'The Ecstasy of Communication', in *The Anti-Aesthetic: Essays on Postmodern Culture*, ed. Hal Foster (Port Townsend, Washington: Bay Press, 1983) 130. Baudrillard writes: 'Obscenity begins precisely when there is no more spectacle, no more scene, when all becomes transparence and immediate visibility, when everything is exposed to the harsh and inexorable light of information and communication.'

2 Linda Williams, *Hard Core: Power, Pleasure and the 'Frenzy of the Visible'* (Berkeley and Los Angeles: University of California Press, 1989).

3 Michel Foucault, *Discipline and Punish: The Birth of the Prison* (1975), trans. Alan Sheridan (New York: Vintage, 1979) 30; 29.

4 [footnote 13 in source] Slavoj Zizek, 'Grimaces of the Real, or When the Phallus Appears', *October*, no. 58 (Cambridge, Massachusetts: The MIT Press, Fall 1991) 44–68.

5 Ibid., 67.

6 Ibid., 63.

7 [29] Michel Foucault, *The History of Sexuality*, vol. 1, *An Introduction* (1976), trans. Robert Hurley (New York: Vintage, 1980).

8 [30] Julia Kristeva, *Powers of Horror: An Essay on Abjection* (1980), trans. Leon S. Roudiez (New York: Columbia University Press, 1982) 4.

9 Ibid., 185.

10 [31] Sigmund Freud and Josef Brauer, *Studies on Hysteria* (1893); reprint, trans. and ed. James Strachey (New York: Basic, 1987) 6.

11 Ibid., 7.

12 Eve Kosofksy Sedgwick, *The Coherence of Gothic Conventions* (New York: Methuen, 1980) vi.

13 Ibid., xi.

Judith Halberstam, 'Parasites and Perverts: An Introduction to Gothic Monstrosity', *Skin Shows: Gothic Horror and the Technology of Monsters* (New York: Vintage, 1991) 1–7; 9–10; 17–23.

Anne Rice
Interview with the Vampire//1976

Part I

[...] 'I would like to tell you the story of my life, then. I would like to do that very much.'

'Great', said the boy. And quickly he removed the small tape recorder from his brief case, making a check of the cassette and the batteries. 'I'm really anxious to hear why you believe this, why you …'

'No', said the vampire abruptly. 'We can't begin that way. Is your equipment ready?'

'Yes', said the boy.

'Then sit down. I'm going to turn on the overhead light.'

'But I thought vampires didn't like the light', said the boy. 'If you think the dark adds to the atmosphere…' But then he stopped. The vampire was watching him with his back to the window. The boy could make out nothing of his face now, and something about the still figure there distracted him. He started to say something again but he said nothing. And then he sighed with relief when the vampire moved towards the table and reached for the overhead cord.

At once the room was flooded with a harsh yellow light. And the boy, staring up at the vampire, could not repress a gasp. His fingers danced backwards on the table to grasp the edge. 'Dear God!' he whispered, and then he gazed, speechless, at the vampire.

The vampire was utterly white and smooth, as if he were sculpted from bleached bone, and his face was as seemingly inanimate as a statue, except for two brilliant green eyes that looked down at the boy intently like flames in a skull. But then the vampire smiled almost wistfully, and the smooth white substance of his face moved with the infinitely flexible but minimal lines of a cartoon. 'Do you see?' he asked softly.

The boy shuddered, lifting his hand as if to shield himself from a powerful light. His eyes moved slowly over the finely tailored black coat he'd only glimpsed in the bar, the long folds of the cape, the black silk tie knotted at the throat and the gleam of the white collar that was as white as the vampire's flesh. He stared at the vampire's full black hair, the waves that were combed back over the tips of the ears, the curls that barely touched the edge of the white collar.

'Now, do you still want the interview?' the vampire asked.

Anne Rice, excerpt from *Interview with the Vampire* (London: Raven Books, 1976) 5–6.

Bret Easton Ellis
American Psycho//1991

End of the 1980s

[...] I close my eyes, three words fall from my mouth, these lips: '"Kill ... All ... Yuppies"'.

She doesn't say anything.

To break the uncomfortable silence that follows, I mention all I can come up with, which is, 'Did you know that Ted Bundy's first dog, a collie, was named Lassie?' Pause. 'Had you heard this?'

Jean looks at her dish as if it's confusing her, then back up at me. 'Who's ... Ted Bundy?'

'Forget it', I sigh.

'Listen, Patrick. We need to talk about something', she says. 'Or at least I need to talk about something'.

... where there was nature and earth, life and water, I saw a desert landscape that was unending, resembling some sort of crater, so devoid of reason and light and spirit that the mind could not grasp it on any sort of conscious level and if you came close the mind would reel backward, unable to take it in. It was a vision so clear and real and vital to me that in its purity it was almost abstract. This was what I could understand, this was how I lived my life, what I constructed my movement around, how I dealt with the tangible. This was the geography around which my reality revolved: it did not occur to me, *ever*, that people were good or that a man was capable of change or that the world could be a better place through one's taking pleasure in a feeling or look or a gesture, or receiving another person's love or kindness. Nothing was affirmative, the term 'generosity of spirit' applied to nothing, was a cliché, was some kind of bad joke. Sex is mathematics. Individuality no longer an issue. What does intelligence signify? Define reason. Desire – meaningless. Intellect is not a cure. Justice is dead. Fear, recrimination, innocence, sympathy, guilt, waste, failure, grief were things, emotions, that no one really felt anymore. Reflection is useless, the world is senseless. Evil is its only permanence. God is not alive. Love cannot be trusted. Surface, surface, surface was all that anyone found meaning in ... this was civilization as I saw it, colossal and jagged...

'... and I don't remember who it was you were talking to ... it doesn't matter. What does is that you were very forceful, yet ... very sweet and, I guess, I knew then that...' She places her spoon down, but I'm not watching her. I'm looking out at the taxis moving up Broadway, yet they can't stop things from unravelling,

because Jean says the following: 'A lot of people seem to have ...' She stops, continues hesitantly, 'lost touch with life and I don't want to be among them'. After the waiter clears her dish she adds, 'I don't want to get ... bruised'.

I think I'm nodding.

'I've learned what it's like to be alone and ... I think I'm in love with you.' She says this last part quickly, forcing it out.

Almost superstitiously, I turn toward her, sipping an Evian water, then, without thinking, say, smiling, 'I love someone else'.

As if this film had speeded up she laughs immediately, looks quickly away, down, embarrassed, 'I'm, well, sorry ... gosh'.

'But...' I add quietly, 'you shouldn't be ... afraid'. [...]

Bret Easton Ellis, excerpt from *American Psycho* (New York: Vintage, 1991) 360–3.

Trevor Fairbrother
Skulls: On Andy Warhol//2004

III

Warhol's thematic treatment of death began in 1962 with *129 Die (Plane Crash)*, a very large hand-painted rendering of a tabloid front page wholly devoted to the crash of a Boeing 707 jet at Orly Airport, Paris. That accident took place in June, just two months before Marilyn Monroe's suicide, which not only kept his thoughts on death, but inspired Warhol's elegiac 1962 *Marilyns*. Within a year he had formulated an idea about the escalation of violence that would be realized in his new silkscreen style: 'My show in Paris is going to be called *Death in America*. I'll show the electric-chair pictures and the dogs in Birmingham and car wrecks and some suicide pictures.'[1] Warhol gave his 'death series' two parts: the famous and the 'people nobody ever heard of'. He said of the latter, the suicides and car crash victims, 'It's not that I feel sorry for them, it's just that people go by and it doesn't matter to them that someone unknown was killed ... I still care about people, but it would be so much easier not to care, it's too hard to care'.[2] The *Skulls* might be thought of as a third part of the series, not overtly lurid or topical, but universal.

Even though much of Warhol's classic sixties imagery – money, green stamps, consumer products, pulp publications, popular idols – is read primarily in terms of the opium of the American middle class, his sense of the impermanent occasionally slipped into these subjects. For example, the paintings and drawings of soup cans with torn labels, of opened cans and of flattened cans; or those showing rows of Coca-Cola bottles whose contents range from full to empty. We accept his need for The American Dream, but are still learning the extent to which morbidity and The American Way of Death informed his personality. One might speculate that his Central European-Czechoslovakian-heritage predisposed him to the grim and the anguished (and to the humorous, for that matter).

His childhood was impoverished, plagued by illness, and dominated by Catholicism. Henry Geldzahler remembers midnight phone calls from Warhol in the mid-sixties: '... he would say that he was scared of dying if he went to sleep'.[3]

The shooting of Warhol in 1968 brought him close to death, and changed him forever. In 1969 Richard Avedon made photographs of the scars as they healed. In 1970 Warhol also bared himself for an Alice Neel portrait (Whitney Museum of American Art, New York, Gift of Timothy Collins): his clasped hands and closed eyes suggest saintly withdrawal from the wounded body into world of

prayer or meditation. No stranger to the voyeuristic impulse, Warhol allowed these other artists to explore their fascination with him, knowing how their images would embellish his *outré* celebrity. It is not surprising that over fifteen years later he had himself photographed in the lobby of a new studio wearing his latter-day ratty wig and standing behind a clotheshorse hung with brilliantly coloured examples of the corsets his wounds forced him to wear.[4]

The medieval attitude to death is recalled by the untender, unsentimental look Avedon took when he photographed Warhol's body. A detail of a late Gothic tomb sculpture (*Tomb of Louis XII and Anne de Bretagne*, by Antonio and Giovanni Giusti, Abbey Church, Saint-Denis, 1516-31), shows the *sutures* on two royal corpses made after the entrails and heart have been removed in preparation for burial. In 1980 Warhol said that the kind of eulogy he would like ('a Pop eulogy ... just the surface of things') was the kind Larry Rivers had given at Frank O'Hara's funeral: apparently Rivers described the poet's mutilated body and the effects of surgery until the mourners screamed for him to shut up.[5] Following his accident, Warhol took a closer look at the ageing and occasionally the scars of his friends. For example, in his 1985 book *America*, he included a profile shot of the late Truman Capote, showing off gruesomely large facelift scars across the temple and around the ear. Strongly reminiscent of Warhol's 1964 *Most Wanted Men* paintings, this image of Capote exemplifies the artist's examination of fame, sexuality and death as fates in the lives of people to whom he was drawn. On the facing page Warhol admitted that he had felt like a nobody at Capote's costume ball with the densest concentration of celebs in the history of the world, but concluded 'I wonder if anybody ever achieves an attitude where nothing, and nobody, can intimidate them'.[6] Warhol evidently empathized with Capote's fear of ageing and death, but to ward off self-righteous interpretations he included on the text page a smaller photograph of Capote in a saucy mood, sticking his tongue out and being kissed by a dog.

In *America*, Warhol used several graveyard photographs as an accompaniment to a commentary on his shooting: 'I always wished I had died, and I still wish that, because could have gotten the whole thing over with ... I never understood why when you died, you didn't just vanish... I always thought I'd like my own tombstone to be blank. No epitaph, and no name. Well, actually, I'd like it to say "figment."'[7] This laconic attitude found the perfect expression in his idea of the blank: this was either a large section of canvas which was not silkscreened or else an additional monochrome panel that created a diptych, as in the 1963 *Blue Electric Chair*. With chilling, minimal matter-of-factness, this formal device allowed him to articulate the antagonism of life and death, the idea of death as the nothingness of a blank afterimage, and the perception of that bare garment of colour as escape from a society that commits electrocution. [...]

Although Warhol never used the blank for his *Skull* paintings, its spirit was certainly evoked by the empty space enveloping the subject. The skull occupies a setting of isolation, otherness and separation. And in such a charged space the skull's shadow takes on similar associations. Shadow connotes death, or ghost or spirit. [...]

1 [footnote 14 in source] Quoted in Gene Swenson, 'What is Pop Art?', *Art News*, no. 7 (November 1963) 60. Immediately before this remark, Warhol described having recently been in a crowd on 42nd Street when a cherry bomb was thrown; 'I felt like I was bleeding all over. I saw in the paper last week that there are more people throwing them – it's just part of the scene – and hurting people'.

2 [15] Quoted in Gretchen Berg, 'Nothing to Lose: Interview with Andy Warhol', *Cahiers du Cinéma in English*, 10 (New York, May 1967) 42–3. In *POPism* (60), Warhol explained that, unlike all his friends, he did not stay distraught by President Kennedy's assassination because he was 'bothered ... [by] the way television and radio were programming everybody to feel so sad'. In this situation he felt more inclined to follow a Hindu custom: '[Once] I was walking in India and saw a bunch of people in a clearing having a ball because somebody they really liked had just died and ... I realized then that everything was just how you decided to think about it'.

3 [16] Quoted in Jean Stein and George Plimpton, *Edie: An American Biography* (New York: Alfred A. Knopf, 1982) 201.

4 [17] Photo by Jonathan Becker reproduced in *Vanity Fair*, 50, no. 7 (July 1987) 74.

5 [18] Warhol and Hackett, *POPism: The Warhol Sixties* (New York: Harper & Row, 1983) 186.

6 [19] Andy Warhol, *America* (New York: Harper & Row, 1985) 66–7.

7 [20] Ibid., 126–9.

Trevor Fairbrother, 'Skulls', essay based on a lecture delivered at the Dia Art Foundation, New York, in 1988. First published in *The Work of Andy Warhol*, ed. Gary Garrels (Seattle: Bay Press, 1989) 93–114.

IT'S LIKE
CREATING
EMOTIONS
SCIENTIFICALLY
WHAT DO YOU DO
IF AN ANIMAL IS
SYMMETRICAL?
YOU CUT IT
IN HALF
AND YOU CAN SEE
WHAT'S ON THE
INSIDE AND
OUTSIDE
SIMULTANEOUSLY
IT'S BEAUTIFUL
THE ONLY PROBLEM
IS THAT IT'S
DEAD

Damien Hirst, Interview with Stuart Morgan, 1996

Damien Hirst
Skullduggery: On Steven Gregory//2005

[...] Wooom-ba-diddly wooom-ba-diddly, woomb-ba-diddly woomb-ba-diddly, wah-oooo-oo... Steven Gregory's work reminds me of the opening sequence of the TV series *Dr Who*; it was about 1970 and I was five years old. That was the music coming from the TV and there was also a really weird, amorphous, formless, hurtling-through-space and time and darkness at millions of miles per hour visual thing filling the screen, with lots of black and swirling shapes. This abstract combination tapped into something primordial in me as a child and I used to panic and cry and ultimately end up cowering in fear behind the sofa or behind my mother's cardigan unable to watch. I wasn't alone; a lot of children my age had the same reaction.

I have a theory about it; I think it was the first purely abstract thing that I came into contact with. As it came into contact with the newly organizing mind inside me it must have seemed rudely detached from the logical bright new world I was discovering and making sense of, a thing impossible to categorize, it was simply unfathomable using the information I had gleaned in my five years of life so far, a simple thing that created terror not just in me but behind the eyes of all the uninitiated. Call it what you like but to me it was instantly, like the work of Steven Gregory, a face-off with abstraction. A kick in the head from the edges of the universe and the beginning of time. Maybe even a vision of death. Since then I've always loved art that deals with figuration hand in hand with the abstract, content with form, because I truly believe that you can't have one without the other; they go together like love and kisses, like life and death, like ramalamadingydong. Gregory pushes these twin envelopes brilliantly and at the same time he reminds us that we have to laugh otherwise we'll cry.

Steven Gregory has many irons in the fire, a great asset in these visually bombarding, morally conflicting times; seemingly effortlessly he creates art that prods and pokes, ignores and strokes and slaps and stuns us into submission. My own personal favourites are the real human skull and bone pieces where, just as many humans and pre-humans have done before us for tens of thousands of years, he uses decoration to try to deal with the complexity of human death, a brave attempt to celebrate the unimaginable. I don't understand death, don't think any of us do, I doubt we ever will, but let's never stop trying. [...]

Damien Hirst, 'Skullduggery: On Steven Gregory', in Mark Cass, ed. *Steven Gregory* (Goodwood: Cass Sculpture Foundation, 2005) n.p.

'Effigies are not just dolls and figures, but are understood in the world of the uncanny to include the deformed, the mutilated, corpses and madmen, those poor souls who remind "normals" just how fragile, transient and partible they are', according to William Ian Miller's *Anatomy of Disgust*:

> There are few things that are more unnerving and disgust-evoking than our partibility. Consider the horror motif of severed hands, ears, heads, gouged eyes. These do not strike me as so many stand-ins for castration. Castration is merely an instance of severability that has been fetishized in psychoanalysis and the literary theoretical enterprises that draw on it. Severability is unnerving no matter what part is being detached... Part of death's horror is that it too is a severance of body and soul and then, via putrefaction, of the body's integrity.

The Chapmans have represented the horror of partibility in one of their most arresting, intellectually exciting creations, *Great Deeds Against the Dead* (1994). When this fibreglass, resin and paint installation was exhibited in 1997 at the Royal Academy's *Sensation* exhibition, it was denounced as obscene by prudish journalists and demotic critics. The outcry was shrillest from those who confuse art, which exists to make people uncomfortable and to spur them to new thinking, with entertainment, which is meant to gratify, relax and confirm preconceptions of decorum, prettiness or good citizenship. No art is great if it makes its consumers feel comfortable. *Great Deeds Against the Dead* is the Chapmans' reminder that the badge uniting humanity, as the shrewder goth revivalists have always known, is horror; it is their heckling cry that trust in humaneness or pride in human dignity rests on human self-infatuation. Previously, in 1993, they had exhibited their own diorama sculpture of plastic figurines, *Disasters of War*, staging scenes from Goya at the Victoria Miro Gallery in London. In this subsequent work they reworked Goya's image of mutilated corpses left exhibited on a tree during the Peninsular War (plate 39 of *Los Desastres de la Guerra* for which Goya provided the caption 'Great Courage! Against Corpses!'). Goya scorned the Spanish liberals' aspirations after what he had seen in his country's wartime killing-fields, and *Great Deeds Against the Dead* is a reaction against the bogus hopes of the 1990s represented by Hillary Rodham Clinton's manifesto *It Takes a Village: And Other Lessons Children Teach Us*. The Chapmans' quintessentially gothic image shows the cruelty that Sade imagined in the castle at Silling, the inhumanity which in the twentieth century has so ferociously been perpetrated by Nazis, Stalinists, Maoists, Pol Pot's Cambodians, Serbs in Bosnia, Argentinean secret policemen, anti-Armenian Turks, anti-Biafran Nigerians and Irish vigilantes. In *Great Deeds Against the Dead* the Chapmans have used lumber imagery in ways that Lynch has never

dared. Arrayed on a stunted Salvatorian tree there is a grisly spectacle. One naked man has been severed into pieces: his head is impaled on a branch, his bound hands and wrists hang from a twig, and the rest of his mutilated, castrated cadaver is tied upside-down on the tree's limb. The tree trunk supports another bound and naked corpse, again castrated, so that although the body is that of a handsome young man, its genital area resembles a woman's. A third man, again naked, handsome and castrated, is also inverted: he is tied upside-down to the stunted tree by his bound feet, which are delicately crossed at the end of strong legs. The installation is intensely theatrical. Though its immediate impact is of dead calm, one feels intense, nervous energy behind it. There is nothing foetid about *Great Deeds Against the Dead.* [...]

Richard Davenport-Hines, excerpt from 'Wild Mood Swings', *Gothic: Four Hundred Years of Excess, Horror, Evil and Ruin* (London: Fourth Estate, 1998) 378–9; 381–5.

Nike Bätzner
Human Dignity Shall be Palpable: On Teresa Margolles//2006

[...] The whole range of topics around bodily resources, mortality, the association of death and violence saw a boom in the 1990s. The YBAs (Young British Artists) were the chief proponents here. Damien Hirst exhibited his first animal cadaver in 1991 (*The Physical Impossibility of Death in the Mind of Someone Living*), a tiger shark he had had killed for the purpose, in a vitrine full of formaldehyde. Jake and Dinos Chapman's *Great Deeds against the Dead* (1994) consisted of sculptures made after Goya's series of etchings *Los Desastres de la Guerra*.

But we must return to the 1960s to see how the resources of living bodies, and cadavers, could be used. In conversation with Gerald Matt,[1] Margolles brought up the subject of the Vienna Actionists. In contrast to other performative movements such as Happening or Fluxus, they integrated psychoanalytic elements into their material and corporeal 'actions', and absolutized man's compulsive roots. Violence, destruction, sexuality and death were themes they performed with blood, animal cadavers and food. These actions and ritual feasts aimed at activating all the senses and at exposing the compulsiveness of the conservative, Catholic-Viennese social order. Their systematic violation of taboos and taste was also claimed to harbour an emancipatory potential. In 1962, after immuring themselves for three days in the Perinetgasse (Mühl's Vienna cellar studio), the artists Hermann Nitsch, Otto Mühl and Adolf Frohner published *The Blood Organ Manifesto*, in which they wrote: 'Through my art production (form of mysticism of being) I take upon myself the apparently negative, the disgusting, perverse, obscene, the rut and the resultant victim hysteria so that YOU may be spared the defiled, degrading descent into the extreme. I am the expression of the entire Creation... [A] philosophy of intoxication, of ecstasies, of raptures shows as a result that the innermost of the intensely living vital is ecstatic arousal, orgasm, which represents a configuration of being in which pleasure, torment, death and procreation converge and intermingle'.[2]

Margolles also vicariously takes upon herself death and the socially tabooed. Certain of her works, however, e.g., *Papeles* (*Papers*, 2003), contrast starkly with the ecstatic, orgiastic thrust of Vienna Actionism due to their formal clarity that eschews citation of explicitly clerical motifs (such as the church vestments, Crucifixion scenes, etc., in Nitsch). *Papeles* consists of sheets of Fabriano paper of varying red-brown colouration, 'soaked with water that was used to wash

corpses after the autopsy' (subtitle). Serially hung and integrating a partly lumpy material trace, the sheets look like versions of monochrome watercolour painting. But the trace renders the obscene visible, for it stems directly from the victims. Reactions here easily veer into hysteria (as they did with viewers of the Vienna Actionists' actions and spill paintings in blood).

Margolles also works with body fluids in *Dermis* (*Skin*, 1996, a collaboration with SEMEFO), although this ties in more directly with Christian motifs. Ten cloth sheets show bloodstained imprints of human bodies, while the stitched hospital logo on the sheets references institutional machinery. *Das Leichentuch* (2003) varies this work: a length of material measuring 2 x 24 m bears the impressions of the 'cadavers of unidentified persons who suffered violent deaths',[3] prior to autopsy. It recalls relics that display Christ's blood and sweat, such as Veronica's Veil or the Shroud of Turin. [...]

In her video *El agua en la ciudad* (2004), rubber-gloved hands hose down a cadaver in a morgue. Margolles films the operation laterally, level with the autopsy table edge. The perspective recalls depictions of the dead Christ on *predellas*, one of the most famous being Hans Holbein's *The Body of the Dead Christ in the Tomb* (1521–22).[4] In this painting the clenched fingers, discoloured face, and open eyes and mouth bear witness to the body's suffering. A head-on view of a coffin with the side removed would give the same format and composition. This circumstance, and the way hair and fingers emerge from the picture bring the corpse oppressively close to the viewer. But in Margolles' video the corpse does not stay in the frame. Via drain and sewer, as the title makes clear, the wash water is returned to the city and its water cycle.

What we are dealing with here is a *memento mori*: '*Io fui già quel che voi siete e quel che io son voi ancor sarete*' (I was once what you are and what I am you will also be).[5] These words are inscribed over the anatomically exact depiction of a skeleton at the foot of Masaccio's fresco *La Trinità* at Santa Maria Novella, Florence; in composition it is identical to Holbein's presentation and Margolles' corpse-washing video. The warning of the dead to the living reminds us that our time and scope for action are limited, and that it is our 'duty' to make meaningful use of the time we have.

Death in our mediatized society is taboo, but it is an ambiguous one. On the one hand, the industrial societies repress and marginalize death: the elderly are put away in old-age homes, while in hospitals the last agony is protracted by means of equipment and machines. On the other hand, we are confronted daily with images of crime, mutilation, murder and war – whether in news magazines, action and splatter movies, or in TV series that deal with police work, hospitals, forensic doctors, undertakers, plastic surgeons, and where autopsies

or operations may very well be piped direct into our living rooms. [...]

1 [footnote 8 in source] Gerald Matt in conversation with Teresa Margolles, in Lukas Gehrmann and Gerald Matt, eds, *Teresa Margolles* (Vienna: Kunsthalle Wien project space, 2003) 20–23.

2 [9] 'The Blood Organ Manifesto', *Writings of the Vienna Actionists*, ed. Malcolm Green (London: Atlas Press, 1999).

3 [10] Wolfgang Fetz, Lucas Gehrmann, Gerald Matt, 'Teresa Margolles – Das Leichentuch', op. cit., 5.

4 [13] Predella for the Oberried Altarpiece at Freiburg Cathedral, now in the Kunstmuseum Basel.

5 [14] Literally: '*IO FU GA QUEL CHE VOI SETE: E QUEL CHI SON VOI ACO SARETE*'.

Nike Bätzner, excerpt from 'La dignidad del hombre se puede tocar', trans. Christopher Jenkin-Jones, 'Human Dignity Shall be Palpable', *Teresa Margolles 127 cuerpos* (Düsseldorf: Rhinefeld und Westphalen Kunstverein, 2006) 171–5.

Alex Farquharson
Different Strokes: On Richard Hawkins//2006

[...] Virtually all the work from the 1990s shares the sense of being addressed to and about an object of desire – invariably masculine, young and beautiful (often a composite of several men). At the same time the work has an air of secrecy and encourages the kind of voyeuristic guilt that comes with discovering unsent love letters in a sibling's drawer. Many works also have the shrine-like quality of fan art, whose natural abode, depending on the mood of the piece, is either the teenager's bedroom or a stalker's den.

Pieces falling in the latter category are some of Hawkins' earliest, dating from 1991, and their main element is a ghoulish rubber mask from a novelty shop, shredded and left to hang on a single nail, like kelp or a small Robert Morris 'Anti-Form' sculpture. On it Hawkins has paper-clipped images culled from Heavy Metal magazines of the prettier 'poodle-rockers' of the time: *Slaughter* (1991), for example, features Blas Elias, the drummer in the band Slaughter, and *Trixter* (1991) the lead singer, Pete Loran. Their apparent artlessness suggests they are macabre labours of love. The shredded flesh substitute recalls a cheap special effect from a 'slasher' movie, as if this fan's adoration was about to turn ugly. Given the violence that's a part of this kind of band's image, along with the misogynistic and homophobic attitudes that go with it, the suggestion that these permed pin-ups have a psychotic gay stalker is a darkly ironic instance of beating someone at their own game.

More typically, though, Hawkins' collage works are populated by film stars, male models and porn stars, while their mood, like so much queer art down the ages, is one of longing and languour. Five cinemascope collages of beautiful young men, entitled *Crush I–V* (1993), feature Post-it notes that simply read 'suffering', 'pain', 'jealous' and 'regret'. With just four simple words, insistent to the point of obsession, the collages mark out a novella's worth of emotional incident. At the same time the use of found images shifts the whole idea of appropriation away from 1980s debates around copies without originals and author deaths to psychoanalytic reflections on the interrelationship of individual desire and the images rolled out on the production lines of the culture industry. Hawkins achieves this by making them 'his' in a dual sense: first, 'they' – here meaning these images, these products – become part of 'his' *oeuvre* as an artist (in the manner of Pictures art); second, 'they' – meaning the men they represent – become 'his' objects of desire within the fantasy scenario that the work projects ('his' here meaning the artist's self played out in the work). [...]

French Decadence haunts Hawkins' work of the 1990s, often by way of structural encryptions. For example, *Garage Taizo* (1996), a collage involving just two pictures from magazines, was composed along the lines of a Moreau painting. It consists of the arch-shaped outline of a Japanese model on a catwalk surrounded by an image of a utility room, which we are supposed to consider Hawkins' own. In this manner Hawkins burrows occult tunnels, leading to another continent in another century beneath his domicile, Los Angeles. *City Underground* (1992), a folding metal table beneath which are suspended a dozen or so images of male models and fast food (a paper cup, a ready meal), perhaps alludes to this idea: the cut-out figures, hung like a public execution, are the mirror image of the shaped billboards that famously line the most developed stretch of Sunset Boulevard.

Hawkins' most obviously Decadent works are large digitally manipulated prints of serrated heads of various fashion models, the blood cascading from their necks as if they have been freshly beheaded at the bequest of a modern-day Salome. Works from this series are each dedicated to a single muse – for example, *Disembodied Zombie George White* (1997) – and recall paintings by Moreau, Odilon Redon and numerous lesser Symbolists. The backgrounds are liquescent monochromes in sugary hues – like designer retail interiors inspired by Abstract Expressionism. The beheadings, of course, were done with scissors, the blood with Photoshop. The connection between collage and violence, which underlies all of Hawkins' work of the 1990s, is made explicit, while in Modernism the Sadism implicit in collage and Cubist fracture is sublimated, with the fragment standing metonymically for the whole.

Abstract sections of the collages anticipate Hawkins' first paintings. In a series of 1995 digital prints devoted to Matt Dillon and Wiley Wiggins, images of the actors are surrounded by far larger areas of high-key psychedelic abstraction, suggesting their creator has blissfully zoned out midway through his fantasy. When he began painting, it took a while for his muses to disappear. His first abstracts, blazing with fruity colours, were accompanied by framed magazine images of models on catwalks, lightly daubed with paint, as if Hawkins had been cleaning his brushes on the picture's surface. Drips from the corners of the rhombi, meshes of which filled the canvases, subtly suggested blood from fangs. [...]

Alex Farquharson, excerpt from 'Different Strokes: On Richard Hawkins', *frieze*, issue 97 (March 2006) 136–9.

'I'm less interested in skin than in fascia – connective tissue. Have you ever dissected something?'

Matthew Barney, Interview with Thyrza Nichols Goodeve, *Artforum*, May 1995

Michel Foucault
Discipline and Punish//1975

Torture: The Body of the Condemned

[...] If the surplus power possessed by the king gives rise to the duplication of his body, has not the surplus power exercised on the subjected body of the condemned man given rise to another type of duplication? That of a 'non-corporal', a 'soul', as Mably called it ['De la legislation', 1789]. The history of this 'micro-physics' of the punitive power would then be a genealogy or an element in a genealogy of the modern 'soul'. Rather than seeing this soul as the reactivated remnants of an ideology, one would see it as the present correlative of a certain technology of power over the body. It would be wrong to say that the soul is an illusion, or an ideological effect. On the contrary, it exists, it has a reality, it is produced permanently around, on, within the body by the functioning of a power that is exercised on those punished – and, in a more general way, on those one supervises, trains and corrects, over madmen, children at home and at school, the colonized, over those who are stuck at a machine and supervised for the rest of their lives. This is the historical reality of this soul, which, unlike the soul represented by Christian theology, is not born in sin and subject to punishment, but is born rather out of methods of punishment, supervision and constraint. This real, non-corporal soul is not a substance; it is the element in which are articulated the effects of a certain type of power and the reference of a certain type of knowledge, the machinery by which the power relations give rise to a possible corpus of knowledge, and knowledge extends and reinforces the effects of this power. On this reality-reference, various concepts have been constructed and domains of analysis carved out: psyche, subjectivity, personality, consciousness, etc; on it have been built scientific techniques and discourses, and the moral claims of humanism. But let there be no misunderstanding: it is not that a real man, the object of knowledge, philosophical reflection or technical intervention, has been substituted for the soul, the illusion of the theologians. The man described for us, whom we are invited to free, is already in himself the effect of a subjection much more profound than himself. A 'soul' inhabits him and brings him to existence, which is itself a factor in the mastery that power exercises over the body. The soul is the effect and instrument of a political anatomy; the soul is the prison of the body. [...]

Michel Foucault, extract from *Discipline and Punish: The Birth of the Prison* (1975; trans. Alan Sheridan, London: Penguin Group, 1977) 29–30.

Eve Kosofsky Sedgwick
The Coherence of Gothic Conventions//1980

I

The Gothic convention of ascribing sexual content to surfaces has come closest to attracting critical notice in some studies on the imagery of veils. Even these studies, though, fruitful as they have been, still discuss the veil only as a cloak for something deeper and thus more primal. [...]

The veil itself, however, is also suffused with sexuality. This is true partly because of the other, apparently opposite set of meanings it hides: the veil that conceals and inhibits sexuality comes by the same gesture to represent it, both as a metonym of the thing covered and as a metaphor for the system of prohibitions by which sexual desire is enhanced and specified. Like virginity, the veil that symbolizes virginity in a girl or a nun has a strong erotic savour of its own, and characters in Gothic novels fall in love as much with women's veils as with women. [...]

II

I have discussed the veil in its function of spreading, of extending by contiguity, a particular chain of attributes among the novel's characters [*cf.* Eve Kosofsky Sedgwick, *The Coherence of Gothic Conventions*, 1980]. The bloody 'veil', however, can also be directly referential: it can constitute itself, at least momentarily, as an order of things that is both distinct from and intentionally descriptive of some other order. This situation occurs in a rudimentary way in *The Monk*. When the wife of a bandit in the Black Forest wants to warn her guest that he will be murdered, she carefully makes up the bed and then hisses quietly, 'Look at the Sheets'; the guest, once alone, finds them 'crimsoned with blood!'[1] and takes precautions for his life. Although the bloodstain from a previous murder was not originally a sign but, rather, an instance of the metonymic spread described above, it becomes a sign at the moment that it points to a discontinuity: not, in this incident, between an already constituted code of signifiers and their signifieds but between a distinct and comparable past (what happened to the last guest) and present/future (what will happen to this one). While I call this form of signifying rudimentary, it is admittedly less rudimentary, more meaningful, than the 'written traces' of blood that Emily follows to find her aunt, where writing is simply equated with a spatial attenuation that captures a temporal flight. [...]

Red ink spread over paper signifies, at a comfortable distance, red blood

suffusing white cheek, and this image, in turn, signifies a fantasied encroachment on a fantasy of virgin modesty. The analogy blood:flesh:: writing:ground is here distinct, uncollapsible, denotatively stable, and, by the same token, obviously a fiction. No one would imagine that the red ink *was* blood; no one would even imagine that Leonella [the vulgar aunt in *The Monk*] could blush.

Not every use of a four-part homology, however, is as crisply stable as Leonella's. In fact, it would be possible to define a thematic convention as the collapse or degradation of a four-part homology.[2] There are two ways of collapsing the homology blood:flesh::writing:ground, and each points to a distinct family of Gothic convention. One way is to say that as blood is to the flesh, *so blood is also to the ground* (page, veil, vellum) of writing. This version – the theme of writing in blood – has a special potency in the Gothic novel as elsewhere: it is the token of magic. [...]

Gothic conventions about writing give primacy to surfaces; they by no means exclude depth but admit it in certain slippages. Writing on flesh or other surfaces, for example, can occur by marking *on* the surface with a liquid, by staining *through* the surface, or, finally, by impressing *in* the surface, as with acid or a stylus. (This last method forms the etymological basis for 'character'.) The depth of the inscription, however, does not show that the graphic character is private to, original with, or intrinsic in the bearer. Even when it spells out a true name for the bearer, such as 'villain', its depth merely shows the mutilation caused by the attrition of experience. Again, the 'character', whatever it is, may be written on countenance, brow, fancy, mind or heart – in, one presumes, roughly descending order of visibility and publicness – but its veracity is not at all proportional to how private it is or how deep it lies; to the contrary, the very image of writing or engraving seems to insist that the ground be seen strictly as surface, whatever its real dimensional status. [...]

Writing in blood, writing in flesh – even when the formulae are figurative, they represent a special access of the authoritative, inalienable and immediate; the writing of blood and flesh never lies. What that writing gains in immediacy, though, it loses in denotative range, since writing that cannot lie is only barely writing. The marks traced out in earth, flesh, paper, architecture and landscape are often not part of any language but, rather, circles, blots, a cross, a person's image, furrows and folds. Whether stamps of authenticity or brands of shame, and however rich in symbolism, they act as pointers and labels to their material ground and not as elements in a syntactic chain that could mean something *else*. Even the real words that get spelled out – an unintelligible inscription in Hebrew, 'villain', 'assassin', 'Pride! Lust! Inhumanity!' – though more eloquent

than one would expect of walls or foreheads, nevertheless lack something in discursiveness. (They are less discursive than, say, the 'character' that comes with a new servant.) To the degree that such writing is writing at all, it is like an illustrated lexicon of nouns. Yet it is this imperfect writing, as we shall see, that anchors the Gothic conception of fictional character and lends it its most riveting and influential traits.

What I have been grouping together here is indeed an influential family of Gothic conventions, congruent with one another in important respects and resistant to any psychological reading based on the primacy of depth and content. The self expressed or explored by these conventions is all surface, but its perimeter is neither fixed nor obvious: the veil? the countenance? the heart? This self is at least potentially social, since its 'character' seems to be impressed on it from outside and to be displayed facing outward. And the contagion of characters does more than shape the self that already exists; it presides over the establishment of the self. [...]

III

Thomas De Quincey writes that in the worst throes of opium 'the human face tyrannized over my dreams'. The human face seems also to tyrannize over the Gothic novel, and its insistence, as I will show, is most closely related to what readers see as the flatness, the de-vitalization of character in these novels. Faces tyrannize here neither by beauty nor by ugliness, nor even by an oppressive numerical excess, but by their very freight of meaning. The faces are not memorable in themselves: no funny noses, disturbed complexions, expressive chins or idiosyncrasies of any sort (one redhead is the only exception), but only a succession of designations among a small group of bipolar oppositions. Face highly coloured? – yes or no. Flesh marked by furrows? – yes or no. Eyes fiery? (Fiery eyes go with furrowed flesh, for they are reservoirs of the fury born of mutilation.) Features in motion? – yes or no. Like the characters impressed on them, the faces themselves seem to be halfway toward becoming a language, a code, a limited system of differentials that could cast a broad net of reference and interrelation.[3] Since faces in these novels are said to record history and every social relation, such a language could have a great deal to say. [...]

Faces or fictional 'characters' less dominated by their hieroglyphic function – as in other, more familiar novelistic traditions – might not only look more idiosyncratic and 'human' but might also more freely assume and illustrate the play of different symbolic parts rather than the proliferation of the same one. Ruskin, writing about drawing, describes a threatening imaginary 'society in which every soul would be as the syllable of a stammerer instead of the word of

a speaker, in which every man would walk as in a frightful dream, seeing spectres of himself, in everlasting multiplication, gliding helplessly around him in a speechless darkness'.[4] Against this Gothic-sounding state, where, again, an imperfect or non-syntactic language points straight toward 'everlasting multiplication', Ruskin sets the ideal of 'perpetual difference, play and change in groups of form'. Ruskin's scale of valuation, or Jacques Lacan's congruent one is foreign to the Gothic novel, but the images are the same – not only the images singly considered but also the terms of their conjunction.

That the Gothic novel – or the Gothic convention – does not value 'perpetual difference, play and change' highly as an antidote to the fixities of repetition is evident, not in the absence of figures of play and change, but in their firm subordination to the figures of fixity. In the Gothic, and specifically in Radcliffe, the best thematic representation of 'difference, play and change', as opposed to what inheres and endures, occurs in a typically pictorial image: colour as opposed to outline. Colour is, to begin with, often a lie, a disguise spread over an underlying 'design'. [...]

Twilight is the favourite hour, and 'dubious light' or 'dubious tint' the favourite condition, not because of the growing indistinctness of the view – indeed the main lineaments dominate – but because of the fascination of that moment when the different colours of a scene (*as opposed* to the shape) first become one, then disappear. The shift from the play of different colours to the brooding on the presence or absence of colour (of colour absolutely considered, but usually only one colour, and that one always purple or red) in a perceived scene or tapestry or face or veil represents the magnetism of the bipolar, exercised at the cost of sapping any system that has three irreducible primaries. (The presence or absence of colour in these landscapes is exactly analogous to the presence or absence of music, which very frequently succeeds the withdrawing colours of twilight 'win[ning] on silence' and then 'roll[ing] away in murmurs, which attention pursued to the last faint note that melted into air'.)[5] Of course, the obvious traditional referent of colour symbolism is sexual desire –'His affection assumed stronger and warmer colours'[6] – but especially in the erotic field, where the imagery of blood engorgement is so ready, 'warmer colours' usually means the mono-colour red; in *its* ebbs and flows the bipolar use of colour, the brooding on presence or absence, assumes its most affecting form.[7] And yet even here, even with the fiercest motive of desire, colour stands for the temporally fugitive. The last word is almost always with the linear residue, with structure drained of colour. Sexually passionate characters come to the end of their histories not imbued or suffused or deep-dyed with passion but, often dismayingly, emptied of affective passion, retaining only those etiolating graphic

traces in which, as we have seen, the notion of 'true character' so often inheres.

1 Matthew Gregory Lewis, *The Monk* (1796), ed. Howard Anderson (Oxford: Oxford University Press, 1973) 107.

2 [footnote 8 in source] The four-part homological structure A:B::C:D is useful in apparently making possible a discussion of invariant relations that begins with specific attributes of particular things (A, B) but goes beyond the particular or thematic to play over things that have far different attributes. To give an example, if I look for elements to link thematically with a river in the poem, I am likely to look mainly for 'water imagery' – for example, wet things. But if what I first perceive is an opposition between wet and dry, I can bring into relation other oppositions (A:B::C:D), including ones not based on humidity – fair and dark, for instance. Indeed, an infinite chain of these is possible.

Thematic conventions – such as 'water imagery' – do not offer or invite this floating free of meaning from attributes to relations; instead, they dwell on the attribute, may even seem fixed on it. As they apply the same attribute to different things, their relational structure could be written A:B::A:C. I am suggesting that, while A:B::A:C may be a simply homology than A:B::C:D (in the sense that it is more repetitious, more tethered to the particular, less relational, less open to the orderly free play of the Symbolic), it is not anterior to, or more elementary than, A:B::C:D; rather it assumes the latter structure, which it depends on for meaning.

For a further discussion of convention and its relation to both repetition and fixity, see Sec. 4 and n. 24, Eve Kosofsky Sedgwick, *The Coherence of Gothic Conventions* (New York: Arno Press Inc., 1980).

3 [15] This 'halfway toward' locus shares some traits with Lacan's realm of the Imaginary, which originates in a 'mirror stage' and allows bipolar oppositions to be described psychologically in terms of a fixation at the stage of ocular confrontation. See, for instance, in English, Jacques Lacan, *The Language of the Self*, ed. and trans., Anthony Wilden (New York: Dell, 1968), specifically Wilden's essay, 159–77. But the identification of the pendant, the mirror image, with the phallus, and hence with the entry into the Symbolic system, creates a problem for the Lacanian terms, which define the Symbolic by differentiating it from the Imaginary. We have in the Gothic both a form of language that is arrested at the mirror stage and a mirror object that circulates like language in the realm of the Symbolic. Nor is Gothic unique in displaying these anomalies.

4 [17] 'Sketching from Nature', *The Elements of Drawing* (1857), in *The Works of John Ruskin*, ed. E.T. Cook and Alexander Wedderburn (London: George Allen, 1904) xv; 117.

5 Hannah Moore, 'David and Goliath', *Sacred Dramas* (Philadelphia: Edward Earle, 1818) 45. Quoted in Anne Radcliffe, *The Mysteries of Udolpho*, ed. Bonamy Dobrée (Oxford University Press, 1970) 249.

6 Anne Radcliffe, *The Italian, or the Confessional of the Black Penitents*, ed. Frederick Garder (Oxford: Oxford University Press, 1971) 65.

7 Matthew Gregory Lewis, *The Monk*, op. cit., 419.

8 [19] Joshua Wilner, to whose reflections I am indebted in this section, suggested to me in a conversation that the tripolarity of colour tends to be sublated to the bipolarity presence/absence because the latter is complicit with a wish to see the self and specifically the will as unitary and integral. For some related imagery in Kant, see Eve Kosofsky Sedgwick, *The Coherence of Gothic Conventions* (New York: Arno Press Inc., 1980) 163 and esp. n. 21.

9 [20] Examples: Laurentini in *Udolpho*, esp. 646, and Ambrosio repeatedly in *The Monk*, esp. 304; 387. Even the final satisfactions of sympathetic – i.e. moderate – characters tend to be closer to anaesthesia than to consummation. The fate of *The Monk*'s four successful young lovers, for instance, is announced in these numb lines: 'The exquisite sorrows with which they had been afflicted, made them think lightly of every succeeding woe. They had felt the sharpest darts in misfortune's quiver; those which remained appeared blunt in comparison. Having weathered Fate's heaviest Storms, they looked calmly upon its terrors: or if ever they felt Affliction's casual gales, they seemed to them gentle as Zephyrs, which breathe over summer-seas'. 420.

Eve Kosofsky Sedgwick, excerpt from 'The Character in the Veil: Imagery of the Surface in the Gothic Novel', *The Coherence of Gothic Conventions* (New York: Methuen, Inc., 1980) 143–6; 149–55; 158–63.

Gayatri Chakravorty Spivak
Three Women's Texts and a Critique of Imperialism// 1985

[...] It should not be possible to read nineteenth-century British literature without remembering that imperialism, understood as England's social mission, was a crucial part of the cultural representation of England to the English. The role of literature in the production of cultural representation should not be ignored. These two obvious 'facts' continue to be disregarded in the reading of nineteenth-century British literature. This itself attests to the continuing success of the imperialist project, displaced and dispersed into more modern forms.

If these 'facts' were remembered, not only in the study of British literature but in the study of the literatures of the European colonizing cultures of the great age of imperialism, we would produce a narrative, in literary history, of the 'worlding' of what is now called 'the Third World'. To consider the Third World as distant cultures, exploited but with rich intact literary heritages waiting to be recovered, interpreted and curricularized in English translation fosters the emergence of 'the Third World' as a signifier that allows us to forget that 'worlding', even as it expands the empire of the literary discipline.[1]

It seems particularly unfortunate when the emergent perspective of feminist criticism reproduces the axioms of imperialism. A basically isolationist admiration for the literature of the female subject in Europe and Anglo-America establishes the high feminist norm. It is supported and operated by an information-retrieval approach to 'Third World' literature, which often employs a deliberately 'non-theoretical' methodology with self-conscious rectitude. [...]

Let me say at once that there is plenty of incidental imperialist sentiment in *Frankenstein*. My point, within the argument of this essay, is that the discursive field of imperialism does not produce unquestioned ideological correlatives for the narrative structuring of the book. The discourse of imperialism surfaces in a curiously powerful way in Shelley's novel, and I will later discuss the moment at which it emerges.

Frankenstein is not a battleground of male and female individualism articulated in terms of sexual reproduction (family and female) and social subject-production (race and male). That binary opposition is undone in Victor Frankenstein's laboratory – an artificial womb where both projects are undertaken simultaneously, though the terms are never openly spelled out. Frankenstein's apparent antagonist is God himself as Maker of Man, but his real competitor is also woman as the maker of children. It is not just that his dream

of the death of mother and bride and the actual death of his bride are associated with the visit of his monstrous homoerotic 'son' to his bed. On a much more overt level, the monster is a bodied 'corpse', unnatural because bereft of a determinable childhood: 'No father had watched my infant days, no mother had blessed me with smiles and caresses; or if they had, all my past was now a blot, a blind vacancy in which I distinguished nothing'.[2] It is Frankenstein's own ambiguous and miscued understanding of the real motive for the monster's vengefulness that reveals his own competition with woman as maker:

> I created a rational creature and was bound towards him to assure, as far as was in my power, his happiness and wellbeing. This was my duty, but there was another still paramount to that. My duties towards the beings of my own species had greater claims to my attention because they included a greater proportion of happiness or misery. Urged by this view, I refused, and I did right in refusing, to create a companion for the first creature.[3]

It is impossible not to notice the accents of transgression inflecting Frankenstein's demolition of his experiment to create the future Eve. Even in the laboratory, the woman-in-the-making is not a bodied corpse but 'a human being'. The (il)logic of the metaphor bestows on her a prior existence which Frankenstein aborts, rather than an anterior death which he re-embodies: 'The remains of the half-finished creature, whom I had destroyed, lay scattered on the floor, and I almost felt as if I had mangled the living flesh of a human being'.[4]

In Shelley's view, man's hubris as soul maker both usurps the place of God and attempts – vainly – to sublate woman's physiological prerogative.[5] Indeed, indulging a Freudian fantasy here, I could urge that, if to give and withhold to/from the mother a phallus is *the* male fetish, then to give and withhold to/from the man a womb might be the female fetish.[6] The icon of the sublimated womb in man is surely his productive brain, the box in the head.

In the judgment of classical psychoanalysis, the phallic mother exists only by virtue of the castration-anxious son; in *Frankenstein*'s judgment, the hysteric father (Victor Frankenstein gifted with his laboratory – the womb of theoretical reason) cannot produce a daughter. Here the language of racism – the dark side of imperialism understood as social mission – combines with the hysteria of masculism into the idiom of (the withdrawal of) sexual reproduction rather than subject-constitution. The roles of masculine and feminine individualists are hence reversed and displaced. Frankenstein cannot produce a 'daughter' because 'she might become ten thousand times more malignant than her mate … [and because] one of the first results of those sympathies for which the demon thirsted would be children, and a race of devils would be propagated upon the

earth who might make the very existence of the species of man a condition precarious and full of terror'.[7] This particular narrative strand also launches a thoroughgoing critique of the eighteenth-century European discourses on the origin of society through (Western Christian) man. Should I mention that, much like Jean-Jacques Rousseau's remark in his *Confessions*, Frankenstein declares himself to be 'by birth a Genevese'.[8]

In this overly didactic text, Shelley's point is that social engineering should not be based on pure, theoretical or natural-scientific reason alone, which is her implicit critique of the utilitarian vision of an engineered society. To this end, she presents in the first part of her deliberately schematic story three characters, childhood friends, who seem to represent Kant's three-part conception of the human subject: Victor Frankenstein, the forces of theoretical reason or 'natural philosophy'; Henry Clerval, the forces of practical reason or 'the moral relations of things'; and Elizabeth Lavenza, that aesthetic judgment – 'the aerial creation of the poets' – which, according to Kant, is 'a suitable mediating link connecting the realm of the concept of nature and that of the concept of freedom ... [which] promotes ... *moral* feeling'.[9]

This three-part subject does not operate harmoniously in *Frankenstein*. That Henry Clerval, associated as he is with practical reason, should have as his 'design ... to visit India, in the belief that he had in his knowledge of its various languages, and in the views he had taken of its society, the means of materially assisting the progress of European colonization and trade' is proof of this, as well as part of the European imperialist sentiment that I speak of above.[10] I should perhaps point out that the language here is entrepreneurial rather than missionary:

> He came to the university with the design of making himself complete master of the Oriental languages, as thus he should open a field for the plan of life he had marked out for himself. Resolved to pursue no inglorious career, he turned his eyes towards the East as affording scope for his spirit of enterprise. The Persian, Arabic and Sanskrit languages engaged his attention.[11]

But it is of course Victor Frankenstein, with his strange itinerary of obsession with natural philosophy, who offers the strongest demonstration that the multiple perspectives of the three-part Kantian subject cannot cooperate harmoniously. Frankenstein creates a putative human subject out of natural philosophy alone. According to his own miscued summation: 'In a fit of enthusiastic madness I created a rational creature'.[12] It is not at all far-fetched to say that Kant's categorical imperative can most easily be mistaken for the hypothetical imperative – a command to ground in cognitive comprehension what can be apprehended only by moral will – by putting natural philosophy in

the place of practical reason.

I should hasten to add here that [...] readings such as this one do not necessarily commend Mary Shelley the named individual for writing a successful Kantian allegory. The most I can say is that it is possible to read [this] text, within the frame of imperialism and the Kantian ethical moment, in a politically useful way. Such an approach presupposes that a 'disinterested' reading attempts to render transparent the interests of the hegemonic readership. (Other 'political' readings – for instance, that the monster is the nascent working class – can also be advanced.)

Frankenstein is built in the established epistolary tradition of multiple frames. At the heart of the multiple frames, the narrative of the monster (as reported by Frankenstein to Robert Walton, who then recounts it in a letter to his sister) is of his almost learning, clandestinely, to be human. It is invariably noticed that the monster reads *Paradise Lost* as true history. What is not so often noticed is that he also reads Plutarch's *Lives*, 'the histories of the first founders of the ancient republics', which he compares to 'the patriarchal lives of my protectors'.[13] And his *education* comes through Volney's *Ruins of Empires*, which purported to be a prefiguration of the French Revolution, published after the event and after the author had rounded off his theory with practice.[14] It is an attempt at an enlightened universal secular, rather than a Eurocentric Christian, history, written from the perspective of a narrator 'from below', somewhat like the attempts of Eric Wolf or Peter Worsley in our own time.[15]

This Caliban's education in (universal secular) humanity takes place through the monster's eavesdropping on the instruction of an Ariel-Safie, the Christianized 'Arabian' to whom 'a residence in Turkey was abhorrent'.[16] In depicting Safie, Shelley uses some commonplaces of eighteenth-century liberalism that are shared by many today: Safie's Muslim father was a victim of (bad) Christian religious prejudice and yet was himself a wily and ungrateful man not as morally refined as her (good) Christian mother. Having tasted the emancipation of woman, Safie could not go home. The confusion between 'Turk' and 'Arab' has its counterpart in present-day confusion about Turkey and Iran as 'Middle Eastern' but not 'Arab'. [...]

We will gain nothing by celebrating the time-bound pieties that Shelley, as the daughter of two anti-evangelicals, produces. It is more interesting for us that Shelley differentiates the Other, works at the Caliban/Ariel distinction, and *cannot* make the monster identical with the proper recipient of these lessons. Although he had 'heard of the discovery of the American hemisphere and *wept with Safie* over the helpless fate of its original inhabitants', Safie cannot reciprocate his attachment. When she first catches sight of him, 'Safie, unable to

attend to her friend [Agatha], rushed out of the cottage'.[17]

In the taxonomy of characters, the Muslim-Christian Sate belongs with Rhys' Antoinette/Bertha. And indeed, like Christophine the good servant, the subject created by the fiat of natural philosophy is the tangential unresolved moment in *Frankenstein*. The simple suggestion that the monster is human inside but monstrous outside and only provoked into vengefulness is clearly not enough to bear the burden of so great a historical dilemma.

At one moment, in fact, Shelley's Frankenstein does try to tame the monster, to humanize him by bringing him within the circuit of the Law. He 'repair[s] to a criminal judge in the town and ... relate[s his] history briefly but with firmness' – the first and disinterested version of the narrative of Frankenstein – 'marking the dates with accuracy and never deviating into invective or exclamation. ... When I had concluded my narration I said, "This is the being whom I accuse and for whose seizure and punishment I call upon you to exert your whole power. It is your duty as a magistrate."'[18] The sheer social reasonableness of the mundane voice of Shelley's 'Genevan magistrate' reminds us that the absolutely Other cannot be selfed, that the monster has 'properties' which will not be contained by 'proper' measures:

> 'I will exert myself [he says], and if it is in my power to seize the monster, be assured that he shall suffer punishment proportionate to his crimes. But I fear, from what you have yourself described to be his properties, that this will prove impracticable; and thus, while every proper measure is pursued, you should make up your mind to disappointment.'[19]

In the end, as is obvious to most readers, distinctions of human individuality themselves seem to fall away from the novel. Monster, Frankenstein and Walton seem to become each other's relays. Frankenstein's story comes to an end in death; Walton concludes his own story within the frame of his function as letter writer. In the *narrative* conclusion, he is the natural philosopher who learns from Frankenstein's example. At the end of the *text*, the monster, having confessed his guilt toward his maker and ostensibly intending to immolate himself, is borne away on an ice raft. We do not see the conflagration of his funeral pile – the self-immolation is not consummated in the text: he too cannot be contained by the text. In terms of narrative logic, he is 'lost in darkness and distance'[20] – these are the last words of the novel – into an existential temporality that is coherent with neither the territorializing individual imagination (as in the opening of *Jane Eyre*) nor the authoritative scenario of Christian psychobiography (as at the end of Brontë's work). The very relationship between sexual reproduction and social subject-production – the dynamic nineteenth-century topos of feminism-in-

imperialism – remains problematic within the limits of Shelley's text and, paradoxically, constitutes its strength.

Earlier, I offered a reading of woman as womb holder in *Frankenstein*. I would now suggest that there is a framing woman in the book who is neither tangential, nor encircled, nor yet encircling. 'Mrs Saville', 'excellent Margaret', 'beloved Sister' are her address and kinship inscriptions.[21] She is the occasion, though not the protagonist, of the novel. She is the feminine *subject* rather than the female individualist: she is the irreducible *recipient-function* of the letters that constitute *Frankenstein*. I have commented [earlier in the essay] on the singular appropriative hermeneutics of the reader reading with Jane in the opening pages of *Jane Eyre*. Here the reader must read with Margaret Saville in the crucial sense that she must *intercept* the recipient-function, read the letters as recipient, in order for the novel to exist.[22] Margaret Saville does not respond to close the text as frame. The frame is thus simultaneously not a frame, and the monster can step 'beyond the text' and be 'lost in darkness'. Within the allegory of our reading, the place of both the English lady and the unnamable monster are left open by this great flawed text. It is satisfying for a postcolonial reader to consider this a noble resolution for a nineteenth-century English novel. This is all the more striking because, on the anecdotal level, Shelley herself abundantly 'identifies' with Victor Frankenstein.[23] [...]

1 My notion of the 'worlding of a world' upon what must be assumed to be uninscribed earth is a vulgarization of Martin Heidegger's idea; see 'The Origin of the Work of Art' (1950, revised 1960), *Poetry, Language, Thought*, trans. Albert Hofstadter (New York, 1977) 17–87.

2 Mary Shelley, *Frankenstein; or The Modern Prometheus* (1818) (New York, 1965) 57; 115.

3 Ibid., 206.

4 Ibid., 163.

5 [footnote 24 in source] Consult the publications of the Feminist International Network for the best overview of the current debate on reproductive technology. [Now The International Network on Feminist Approaches to Bioethics. http://www.fabnet.org]

6 For the male fetish, see Sigmund Freud, 'Fetishism' (1927), *The Standard Edition of the Complete Psychological Works of Sigmund Freud*, ed. and trans. James Strachey et al., 24 vols. (London, 1953–74), 21: 152–7. For a more 'serious' Freudian study of *Frankenstein*, see Mary Jacobus, 'Is There a Woman in This Text?', *New Literary History*, 14 (Autumn 1982) 117–41. My 'fantasy' would of course be disproved by the 'fact' that it is more difficult for a woman to assume the position of fetishist than for a man; see Mary Ann Doane, 'Film and the Masquerade: Theorizing the Female Spectator', *Screen*, 23 (September–October 1982) 74–87.

7 Mary Shelley, *Frankenstein*, op. cit., 158.

8 Ibid., 31.

9 Ibid., 37; 36; [26] Kant, *Critique of Judgement* (1790); trans. J.H. Bernard (New York, 1951) 39.

10 Mary Shelley, *Frankenstein*, op. cit., 151–2.

11 Ibid., 66–7.

12 Ibid., 206.

13 Ibid., 123–4.

14 Ibid., 113.

15 [27] See, Constantin François Chasseboeuf de Volney, *The Ruins, or Meditations on the Revolutions of Empires*, trans. pub. (London, 1811). Johannes Fabian has shown us the manipulation of time in 'new' secular histories of a similar kind; see *Time and the Other: How Anthropology Makes Its Object* (New York, 1983). See also Eric R. Wolf, *Europe and the People without History* (Berkeley and Los Angeles, 1982), and Peter Worsley, *The Third World*, 2nd ed. (Chicago, 1973); I am grateful to Dennis Dworkin for bringing the latter book to my attention. The most striking ignoring of the monster's education through Volney is in Gilbert's otherwise brilliant 'Horror's Twin: Mary Shelley's Monstrous Eve', *Feminist Studies*, 4 (June 1980) 48–73. Gilbert's essay reflects the absence of race-determinations in a certain sort of feminism. Her present work has most convincingly filled in this gap; see, e.g. her recent piece on H. Rider Haggard's *She* (1887) ('Rider Haggard's Heart of Darkness', *Partisan Review*, 50, no. 3 (1983) 444–53).

16 Mary Shelley, *Frankenstein*, op. cit., 121.

17 Ibid., 114 (author's emphasis); 129.

18 Ibid., 189; 190.

19 Ibid., 190.

20 Ibid., 211.

21 Ibid., 15; 17; 22.

22 [28] 'A letter is always and *a priori* intercepted ... the "subjects" are neither the senders nor the receivers of messages... The letter is constituted ... by its interception' (Jacques Derrida, 'Discussion', after Claude Rabant, 'Il n'a aucune chance de l'entendre', in *Affranchissement: Du transfert et de la letter*, ed. René Major (Paris, 1981) 106; author's translation). Margaret Saville is not made to appropriate the reader's 'subject' into the signature of her own 'individuality'.

23 [29] The most striking 'internal evidence' is the admission in the 'Author's Introduction' that, after dreaming of the yet-unnamed Victor Frankenstein figure and being terrified (through, yet not quite through, him) by the monster in a scene she later reproduced in Frankenstein's story, Shelley began her tale 'on the morrow ... with the words "it was on a dreary night of November"' (*Frankenstein*, xi). Those are the opening words of chapter 5 of the finished book, where Frankenstein begins to recount the actual making of his monster (see *Frankenstein*, 56).

Gayatri Chakravorty Spivak, excerpt from 'Three Women's Texts and a Critique of Imperialism', *Critical Inquiry*, 12 (Fall 1985) 248–54.

Kobena Mercer
Monster Metaphors: Notes on Michael Jackson's *Thriller*//1986

Beauty and the Beast – Masks, Monsters and Masculinity

The conventions of horror inscribe a fascination with sexuality, with gender identity codified in terms that revolve around the symbolic presence of the monster. Women are invariably the victims of the acts of terror unleashed by the werewolf/vampire/alien/'thing': the monster as non-human Other. The destruction of the monster establishes male protagonists as heroes, whose object and prize is of course the woman. But as the predatory force against which the hero has to compete, the monster itself occupies a 'masculine' position in relation to the female victim.

Thriller's rhetoric of parody presupposes a degree of self-consciousness on the part of the spectator, giving rise to a supplementary commentary on the sexuality and sexual identity of its star, Michael Jackson. Thus, the warning, 'I'm not like other guys' [Jackson's line to his female companion], can be read by the audience as a reference to Jackson's sexuality. In as much as the video audience is conscious of the gossip that circulates around the star, the statement of difference provokes other meanings: is he homosexual, transsexual or somehow pre-sexual?

In the first metamorphosis Michael becomes a werewolf. As the recent *Company of Wolves* (directed by Neil Jordan, 1984) demonstrates, werewolf mythology – lycanthropy – concerns the representation of male sexuality as 'naturally' bestial, predatory, aggressive, violent – in a word, 'monstrous'. Like *Thriller*, *Company of Wolves* employs similar special effects to show the metamorphosis of man to wolf in 'real time'. And like the Angela Carter story on which it is based, the film can be read as a rewriting of the European folktale of 'Little Red Riding Hood' to reveal its concerns with subjects of menstruation, the moon and nature of male sexuality. In the fictional opening scene of *Thriller* the connotation of innocence around the girl likens her to Red Riding Hood. But is Michael a big, bad wolf?

In the culmination of the chase sequence through the woods, the girl takes the role of victim. Here, the disposition of point-of-view angles between the monster's dominant position over the victim suggests rape, fusing the underlying sexual relation of 'romance' with terror and violence. As the monster, Michael's transformation might suggest that beneath the boy-next-door image there is a 'real' man waiting to break out, a man whose masculinity is measured by a rapacious sexual appetite, 'hungry like the wolf'. But such an interpretation is undermined and subverted by the final shot of the metamorphosis. Michael-

as-werewolf lets out a blood-curdling howl, but this is in hilarious counterpoint to the collegiate 'M' on his jacket. What does it stand for? Michael? Monster? Macho Man? More like Mickey Mouse. The incongruity between the manifest signifier and symbolic meaning of the Monster opens up a gap in the text, to be filled with laughter.

Animals are regularly used to signify human attributes, with the wolf, lion, snake and eagle all understood as signs of male sexuality. Jackson's subversion of this symbolism is writ large on the *Thriller* LP cover. Across the star's knee lies a young tiger cub, a brilliant little metaphor for the ambiguity of Jackson's image as a black male pop star. This plays on the star's 'man-child' image and suggests a domesticated animality, hinting at menace beneath the cute and cuddly surface. Jackson's sexual ambiguity makes a mockery out of the menagerie of received images of masculinity.[1]

In the second metamorphosis Michael becomes a zombie. Less dramatic and 'horrifying' than the first, this transformation cues the spectacular dance sequence that frames the chorus of the song. While the dance, choreographed by Michael Peters, makes visual one of the lines from the lyric, 'Night creatures crawl and the dead start to walk in their masquerade', it foregrounds Jackson-the-dancer and his performance breaks loose from the video. As the ghouls begin to dance, the sequence elicits the same kind of parodic humour provoked by Vincent Price's rap on the music track. There, humour lay in the incongruity between Price's voice and the argot of black soul culture. Here a visual equivalent of the incongruity is created by the spectacle of the living dead performing with Jackson in a funky dance routine. The sense of parody is intensified by the macabre make-up, casting a ghostly pallor over his skin and emphasizing the contour of the skull, alludes to one of the paradigmatic 'masks' of the horror genre, that of Lon Chaney in *The Phantom of the Opera* (1925).

Unlike the werewolf, the figure of the zombie, the undead corpse, does not represent sexuality so much as asexuality or anti-sexuality, suggesting the sense of neutral eroticism in Jackson's style as a dancer. As has been observed:

> The movie star Michael most resembles is Fred Astaire – that paragon of sexual vagueness. Astaire never fit a type, hardly ever played a traditional romantic lead. He created his own niche by the sheer force of his tremendous talent.[2]

The dance sequence can be read as a cryptic writing on this 'sexual vagueness' of Jackson's body in movement, in counterpoint to the androgyny of his image. The dance breaks loose from the narrative and Michael's body comes alive in movement, a rave from the grave: the scene can thus be seen as a commentary on the notion that as star Jackson only 'comes alive' when he is on stage

performing. The living dead invoke an existential liminality, which corresponds to both the sexual indeterminacy of Jackson's dance and the somewhat morbid lifestyle that reportedly governs his off-screen existence. Both meanings are buried in the video 'cryptogram'.[3] [...]

1 [footnote 19 in source] One of Freud's most famous patients, The Wolf Man, makes connections between animals and sexuality clear. The Wolf Man's dream also reads like a horror film: 'I dreamt that it was night and that I was lying in my bed. Suddenly the window opened of its own accord, and I was terrified to see some white wolves were sitting on the big walnut tree in front of the window'. Cf. Muriel Gardiner, *The Wolf Man and Sigmund Freud* (London: Hogarth Press and Institute of Psychoanalysis, 1973) 173. Freud's reading suggests that the terror in the dream manifests a fear of castration for a repressed homosexual desire.

2 [20] Quoted in Nelson George, *Michael Jackson Story* (London: New English Library, 1984) 83–4.

3 [21] The notion of 'cryptonymy' as a name for unconscious meanings emerges in Nicholas Abraham and Maria Torok's re-reading of Freud's Wolf Man. See Peggy Kamuf, 'Abraham's wake', *Diacritics* (Spring 1979) 32–43.

Kobena Mercer, excerpt from 'Monster Metaphors: Notes on Michael Jackson's *Thriller*', *Screen*, 27 (London, 1986); reprinted in Christine Gledhill, ed. *Stardom: Industry of Desire* (London and New York: Routledge, 1991) 300–16.

Richard Dyer

Children of the Night: Vampirism as Homosexuality, Homosexuality as Vampirism//1988

[...] There is a clear tradition of gay male vampire writing and reading, and a rather more ambivalent lesbian tradition. Why should the vampire image have drawn gay/lesbian attention?

It is possible to suggest historically specific reasons for the association of homosexuality and vampirism. Vampires are classically aristocrats and much of the development of a public face for homosexuality and/or decadent sexuality was at the hands of aristocrats – de Sade, Byron – or writers posing as aristocrats – Lautréamont, Wilde. The female character whose potential vampirism is most threatening in *Dracula*, Mina, is associated with the emergent 'New Woman' in Victorian society, financially and maritally independent.[1] From New Woman to lesbian is but a step in the ideology of the day, leading to the vampiric lesbianism discussed by Faderman.[2] In the German gay writings up to the 1930s vampirism is the consummation of love with a dead young man, who may represent the lost perfect friendship extolled by the youth movements and/or the loved one lost in the slaughter of the First World War, common themes in the writing of the period. Such historically precise connections certainly account for particular inflections of gay/lesbian vampire images, but it is the wider metaphorical possibilities of the vampire that account for its longer hold in lesbian/gay terms.

The image of the vampire has been used to mean many things – such is the nature of popular cultural symbolism. The vampire has represented the weight of the past as it lays on the present, or the way the rich live off the poor, or the threat of an unresolved and un-peaceful death, or the baneful influence of Europe on American culture, or an alternative lifestyle as it threatens the established order, or the way the listless white race leeches off the vigour of the black races. The vampire has been used to articulate all such meanings and more,[3] yet the sexual symbolism of the vampire does seem the most obvious, and many of the other meanings are articulated through the sexual meanings.

The sexuality of the vampire image is obvious if one compares the vampire to two of her/his close relations, as it were – the zombie and the werewolf. The zombie, like the vampire, is 'undead', a human being who has died but nonetheless still leads, unlike the vampire, a mindless existence. Zombies are kept alive in some versions under the spell of voodoo, in others by a purely instinctive drive to savage and eat human flesh. The werewolf, like the vampire, operates only at night and, like the zombie, savages the humans whose flesh he

consumes.[4] All three can articulate notions of sexuality. Robin Wood, and a number of other writers on the horror film, have suggested, adapting Freudian ideas, that all 'monsters' in some measure represent the hideous and terrifying form that sexual energies take when they 'return' from being socially and culturally repressed.[5] Yet the vampire seems especially to represent sexuality, for his/her interest in humans is not purely instinctual, and s/he does not characteristically savage them – s/he bites them, with a bite just as often described as a kiss.

The vampire characteristically sinks his/her teeth into the neck of his/her victim and sucks the blood out. You don't *have* to read this as a sexual image, but an awful lot suggests that you should. Even when the writing does not seem to emphasize the sexual, the act itself is so like a sexual act that it seems almost perverse not to see it as one. Biting itself is after all part of the repertoire of sexual acts; call it a kiss, and, when it is as deep a kiss as this, it is a sexual act; it is then by extension obviously analogous to other forms of oral sex acts, all of which (fellatio, cunnilingus, rimming) importantly involve contact not only with orifices but with body fluids as well. Moreover, it is not just what the vampire does that makes it so readable in sexual terms but the social space that it occupies. The act of vampirism takes place in private, at night, most archetypally in a bedroom – the same space which our society accords to the sex act. [...]

The physical space where the act of vampirism/sex takes place is of course also a symbolic, psychological space, namely the realm of the private. It is at night when we are alone in our beds that the vampire classically comes to call, when we are by ourselves and as we commonly think when we are most ourselves. Equally, it is one of the contentions of the history of sexuality developed by Michel Foucault,[6] Jeffrey Weeks[7] and others, that we live in an age which considers the sexual to be both the most private of things and the realm of life in which we are most ourselves.

The privacy of the sexual is embodied in one of the set-pieces of the vampire tale – the heroine left by herself at night, the vampire at the window tapping to come in. Yet as so often with popular genre conventions, this set-piece is also endlessly being reversed, departed from. Very often, it is not the privatized experience of the act of vampirism that is given us, but those thrilling moments when the privacy is violated. Voyeurism, the act of seeing without being seen, is a central narrative device in the vampire story; it is the means by which the hero discovers the vampirism of the vampire and the sensation lies not only in the lurid description of fangs dripping with blood and swooning victims their clothes all awry, but also in that sense of violating a moment of private physical consummation, violating its privacy by looking at it. [...]

There is nothing inherently gay or lesbian in the ideas of privacy, voyeurism and exhibitionism. Yet homosexual desire, like other forbidden sexual desires, may well find expression, as a matter of necessity rather than exquisite choice, in privacy and voyeurism. The sense that being lesbian/gay is something one must keep to oneself certainly accords with an idea of the authenticity of private sexuality, but it is also something one had better keep private if one is not to lose job, family, friends, and so on. Furtive looking may be the most one dare do. In this context, exhibitionism may take on a special voluptuousness, emerging from the privacy of the closet in the most extravagant act of going public.

Vampirism is not merely, like all our sexuality, private, it is also secret. It is something to be hidden, to be done without anyone knowing. The narrative structure of the vampire tale frequently consists of two parts – the first leading up to the discovery of the vampire's hidden nature, the second concerned with his/her destruction. It is this first part that I want to consider here.

In most vampire tales, the fact that a character is a vampire is only gradually discovered – it is a secret that has to be discovered. The analogy with homosexuality as a secret erotic practice works in two contradictory ways. On the one hand, the point about sexual orientation is that it doesn't 'show', you can't tell who is and who isn't just by looking; but on the other hand, there is also a widespread discourse that there *are* telltale signs that someone 'is'. The vampire myth reproduces this double view in its very structures of suspense.

On the one hand, much of the suspense of the story is about 'finding out'. There are strange goings-on, people dying of a mysterious plague, characters feeling unaccountably weak after a deep night's sleep, noticing odd scratches or a pair of little holes at their neck – what can it all mean? [...]

Such reader-text relations offer specific pleasures to gay/lesbian readers. Much of the suspense of a life lived in the closet is, precisely, will they find out? An obvious way to read a vampire story is self-oppressively, in the sense of siding with the narrator (whether s/he is the main character or not) and investing energy in the hope that s/he will be saved from the knowledge of vampirism (homosexuality). Maybe that is how we have often read it. But there are other ways. One is to identify with the vampire in some sort, despite the narrative position, and to enjoy the ignorance of the main character(s). What fools these mortals be. The structure whereby we the reader know more than the protagonist (heightened in first person narration) is delicious, and turns what is perilous in a closeted lesbian/gay life (knowing something dreadful about us they don't) into something flattering, for it makes one superior. Another enjoyable way of positioning oneself in this text-reader relation is in thrilling to the extraordinary power credited to the vampire, transcendent powers of seduction, s/he can have anyone s/he wants, it seems. Most lesbians and gay men experience exactly the

opposite, certainly outside of the gay scene, certainly up until very recently. Even though the vampire is invariably killed off at the end (except in recent examples), how splendid to know what a threat our secret is to them!

The structure of the narration reinforces the idea that you can't tell who is and isn't, but the descriptive language often suggests the opposing discourse, that you can indeed spot a queer. It is not that they often come on with all the accoutrements of the screen vampires of Lugosi, Lee, et al; perhaps only Dracula and a few very close to him are described like that. What there are instead are give-away aspects of character. Count Vardalek, for instance, in 'The True Story of a Vampire' is tall and fair with an attractive smile. Nothing very vampiric about this, as the narrator herself notes. But along with it is he is also 'refined', with an 'intense sadness of the expression of the eyes'; he looks 'worn and wearied'; above all, he is 'very pale'.[8] There is even less of the vampire about Carmilla, except that – and it is the give-away to alert readers – 'her movements were languid – *very* languid – indeed'.[9]

Not only has it been common to try to indicate that you can always tell a queer/lessie if you know how (indeed, this is one of the functions of gay stereotypes)[10] but very often the vocabulary of queer spotting has been the languid, worn, sad, refined paleness of vampire imagery. This is what makes the lesbianism of the books discussed by Faderman vampiric; it is what used to tell me, in the 1950s and 60s, that a book had a gay theme – if it was called *Women in the Shadows, Twilight Men, Desire in the Shadows* then it had to be about queers. This imagery derives in part from the idea of decadence, people who do not go out into public life, whose complexions are not weathered, who are always indoors or in the shade. It may also relate to the idea that lesbians and gay men are not 'real' women and 'real' men, we have not got the blood (with its very different gender associations) of normal human beings.

The ideas of privacy and secrecy also suggest the idea of a double life – s/he looks normal, but underneath s/he's a vampire/queer. [...]

1 [footnote 20 in source] Carol A. Senf, 'Dracula: Stoker's Response to the New Woman', *Victorian Studies*, no. 26 (1982) 33–9.

2 [added note] Lillian Faderman, ed., *Chloe Plus Olivia: An Anthology of Lesbian Literature from the Seventeenth Century to the Present* (New York: Penguin Group. Viking), 1994, in reference to Sheridan Le Fanu's 1872 lesbian vampire novella, *Carmilla*.

3 [21] See Christopher Frayling, *The Vampyre* (London: Gollancz, 1978).

4 [22] I do not know of a story of a female werewolf, and the majority of werewolf stories are in part about the notion of the beast that dwells in the breast of the apparently civilized man – in other words, the werewolf image seems to articulate part of our culture's concept of masculinity.

5 [23] Robin Wood, 'An Introduction to the American Horror Film', in Bill Nichols, ed. *Movies and*

Methods II (Berkeley: University of California Press: 1985) 195–220.

6 [27] Michel Foucault, *The History of Sexuality* (Harmondsworth: Pelican, 1981).

7 [28] Jeffrey Weeks, *Sexuality and its Discontents* (London: Routledge and Kegan Paul, 1985).

8 [29] Count Stenbock 'The True Story of a Vampire', *Jeremy*, no. 2, (1970) 20–4.

9 [30] Joseph Sheridan LeFanu, 'Carmilla', *In a Glass Darkly* (London: Eveleigh, Nash and Grayson; first published, 1872) 387.

10 [31] Richard Dyer 'Stereotyping', in Richard Dyer, ed. *Gays and Film* (New York: Zoetrope, 1984) 27–39.

Richard Dyer, excerpt from 'Children of the Night: Vampirism as Homosexuality, Homosexuality as Vampirism', in Susannah Radstone, ed. *Sweet Dreams: Sexuality, Gender and Popular Fiction* (London: Lawrence & Wishart, 1999) 53–60.

Andrew Ross
Strange Weather: Culture, Science and Technology in the Age of Limits//1991

Boystown

In the 1980s, the most fully delineated urban fantasies of white male folklore were to be found in a series of novels by writers loosely grouped under the name 'cyberpunk': William Gibson, Bruce Sterling, John Shirley, Lewis Shiner and Rudy Rucker (the expanded circle might include Greg Bear, Richard Kadrey, James Patrick Kelly, Walter John Williams, Paul Di Fillipo, Pat Cadigan, Marc Laidlaw, Lucius Sheperd). Istvan Csicsery-Ronay has gone so far as to describe cyberpunk as 'the vanguard white male art of the age', for its resexing of the 'neutered' hacker in the form of the high-tech hipster rebel who figures as the hard-boiled protagonist in many cyberpunk narratives.[1] One barely needs to scratch the surface of the cyberpunk genre, no matter how maturely sketched out, to expose a baroque edifice of adolescent male fantasies. Here, for example, is Rudy Rucker, tenured professor of mathematics and computer science, SF writer, and author of sophisticated works of non-fiction like *Infinity and the Mind* and *Mind Tools*:

> For me, the best thing about cyberpunk is that it taught me how to enjoy shopping malls, which used to terrify me. Now I just pretend that the whole thing is two miles below the Moon's surface, and that half the people's right-brains have been eaten by roboticized steel rats. And suddenly it's interesting again.[2]

Where does this shard of twisted suburban wit come from? Is it a belated symptom of the North American punk sensibility? The negationist fantasy of class-conscious male privilege? Or the self-projection of some repressed Schreberian desire to terrorize the socialized body? Nothing, it would seem, could be further from the polymorphous, ecotopian fantasies that had prevailed in New Wave writing, which cyberpunk rejected as 'wet', 'hippy' and 'Utopian'.

If punk culture was one of the decisive intervening factors between New Wave and cyberpunk, as Sterling (the movement's chief spokesman) and others have claimed, then this transition was part of the remasculinized landscape of anarcho-libertarian youth culture in the 1980s. Outside of its art-rock origins in the downtown Manhattan club scene, the punk moment in the US (British punk culture was another story) offered an image-repertoire of urban culture in post-industrial decay for white suburban youths whose lives and environs were quite remote from daily contact with the Darwinist street sensibility of 'de-evolved' city life. It is perhaps no coincidence that none of the major cyberpunk writers

were city-bred, although their work feeds off the phantasmatic street diet of Hobbesian lawlessness and the aesthetic of detritus that is assumed to pervade the hollowed-out core of the great metropolitan centres. This urban fantasy, however countercultural its claims and potential effects, shared the dominant, white middle-class conception of inner-city life. In this respect, the suburban romance of punk, and, subsequently, cyberpunk, fashioned a culture of alienation out of their parents' worst fears about life on the mean streets. [...]

In Gibson's novels, armchair theorists of the self-consciousness of the cyberspace matrix (chronologically achieved in his Sprawl trilogy at the end of *Neuromancer*) speak scholastically of 'first causes'. For the less well-informed, like *Count Zero*'s hacker Bobby Newmark, encounters in cyberspace with otherworldly intelligence are awesome moments of grace: 'something *leaned in*, vastness unutterable, from beyond the most distant edge of anything he'd ever known or imagined, and touched him'.[3]

Such moments of contact with the inhabitants of cyberspace were also part of the postmodern rewriting of the SF tradition of 'alien encounters'. Here, the fear of unfamiliar, superior intelligence is situated on Earth, within the known parameters of socioeconomic life, everywhere fixed and defined by the equation of knowledge with power. Here, the aliens are both 'Us' and 'not-Us', evolved hybrids of the corporation as a 'life form' that is the 'planet's dominant form of intelligence' and whose blood 'is information, not people'. By contrast, class-consciousness in the lower social world is less equitably sketched out. [...] Generally, inhabitants of Gibson's Sprawl (the Boston-Atlanta metropolitan strip) are faceless drones, unless they are defiantly marked by membership in the colourful (youth) subcultures like the Lo Teks, the Zionites, the Jack Draculas, the Panther Moderns, the Big Scientists, the Gothicks and the Casuals, whose renegade street knowledge and techno-savvy – 'the street finds its own uses for technology' – serves as a social conduit for acts of anarcho-resistance within the interstices of the cyberspace net. [...]

However coherent its 'narrative symbolization' of modern techno-future trends, it was clearly a limited narrative, shaped in very telling ways by white masculinist concerns. And however rebellious its challenge to SF traditions, the wars, within the SF community, between the cyberpunks, the New Wave and the New Humanists were all played out in boystown.

Consider how the cyberpunk image of the techno-body played into the crisis of masculinity in the 1980s. In popular culture at large, symptoms of the newly fortified contours of masculinity could be found in the inflated physiques of Arnold Schwarzenegger and Sylvester Stallone, and a legion of other pumped-

up, steroid-fed athletes' bodies. Once described as 'condoms stuffed with walnuts', these exaggerated parodies of masculine posture in the age of Reagan were at once a response to the redundancy of working muscle in a post-industrial age, to the technological regime of cyborg masculinity; and, of course, to the general threat of waning patriarchal power. Cyberpunk male bodies, by contrast, held no such guarantee of lasting invulnerability, at least not without prosthetic help: spare, lean and temporary bodies whose social functionality could only be maintained through the reconstructive aid of a whole range of generic overhauls and cybernetic enhancements, boosterware, biochip wetware, cyber-optics, bio-plastic circuitry, designer drugs, nerve amplifiers, prosthetic limbs and organs, memoryware, neural interface plugs and the like. The body as a switching system, with no purely organic identity to defend or advance, and only further enhancements of technological 'edge' to gain in the struggle for competitive advantage. These enhancements and retrofits were techno-toys that boys always dreamed of having, but they were also body altering and castrating in ways that boys always had nightmares about. The new survivalist fantasy of the cyberpunk street guerrilla body would be an expensive one, the consumer mainstay of many a techno-intensive industry. Such a body would be a battleground in itself, where traditional male 'resistance' to domination was uneasily co-opted by the cutting-edge logic of new capitalist technologies. But this body was also part of a failing political economy. If the unadorned body fortress of the Rambo/Schwarzenegger physique expressed the anxieties of the dominant male culture, cyberpunk techno-masculinity suggested a growing sense of the impotence of straight white males in the countercultures. [...]

1 [footnote 13 in source] Isrvan Csicsery-Ronay, 'Cyberpunk and Neuromanticism', *Mississippi Review*, no. 16, 2/ 3 (1988) 267.

2 [14] Rudy Rucker, *Mississippi Review*, no. 16, 2/3 (1988) 57.

3 William Gibson, *Count Zero* (New York: Ace, 1986) 20.

Andrew Ross, excerpt from 'Cyberpunk in Boystown', *Strange Weather: Culture, Science and Technology in the Age of Limits* (London: Verso, 1991) 145–6; 148; 152–3.

William Gibson
Neuromancer//1984

[...] 'It ends here for her, too', Riviera said.

'Maybe 3Jane won't go for that, Peter', Case said, uncertain of the impulse. The derms still raged in his system, the old fever starting to grip him. Night City craziness. He remembered moments of grace, dealing out on the edge of things, where he'd found that he could sometimes talk faster than he could think.

The grey eyes narrowed. 'Why, Case? Why do you think that?'

Case smiled. Riviera didn't know about the simstim rig. He'd missed it in his hurry to find the drugs she carried for him. But how could Hideo have missed it? And Case was certain the ninja would never have let 3Jane treat Molly without first checking her for kinks and concealed weapons. No, he decided, the ninja knew. So 3Jane would know as well.

'Tell me, Case', Riviera said, raising the pepperbox muzzle of the fletcher.

Something creaked, behind him, creaked again. 3Jane pushed Molly out of the shadows in an ornate Victorian bath chair, its tall, spidery wheels squeaking as they turned. Molly was bundled deep in a red and black striped blanket, the narrow, caned back of the antique chair towering above her. She looked very small. Broken. A patch of brilliantly white micro-pore covered her damaged lens; the other flashed emptily as her head bobbed with the motion of the chair.

'A familiar face', 3Jane said, 'I saw you the night of Peter's show. And who is this?'

'Maelcum', Case said.

'Hideo, remove the arrow and bandage Mr Maelcum's wound.'

Case was staring at Molly, at the wan face.

The ninja walked to where Maelcum sat, pausing to lay his bow and the shotgun well out of reach, and took something from his pocket. A pair of bolt cutters. 'I must cut the shaft', he said. 'It is too near the artery.' Maelcum nodded. His face was greyish and sheened with sweat.

Case looked at 3Jane. 'There isn't much time', he said.

'For whom, exactly?'

'For any of us'. [...]

William Gibson, excerpt from *Neuromancer* (London: Harper Collins, 1984) 294–6.

Elisabeth Bronfen
The Other Self of the Imagination:
Cindy Sherman's Hysterical Performance// 1995

[...] In contrast to her earlier work, Cindy Sherman no longer appears as the model in her photographic transformation of the Grimm fairy tale 'Fitcher's Bird'. Her body is replaced by dolls and artificial body parts. Nevertheless, this series is perhaps the most manifest self-portrait by the artist to date. Here, too, she draws on a familiar archive of culture, the image repertoire of fairy tales, and picks out from it the story of a clever and sly girl who, after initial passivity, begins to revolt against the dictate of female obedience. She uses her curiosity as a form of self-protection, so as to act in ways that transcend gender roles. For she not only ignores the magician's prohibition to enter the room with the smallest lock and disobeys his command always to carry the magic egg with her. In this story of violence, dismemberment and resuscitation she also carries out the act of creating artificially, an activity normally relegated to the masculine realm. Without a trace of sentimentality, the sly girl, having shed a few tears, puts back together the body parts of her dead sisters that she finds in the forbidden room. At the same time, she claims the magician's deadly power for herself. He exercised power over other people's lives by hewing intact bodies, above all those of beautiful women, into pieces and then demonstratively putting them in a cauldron, which, consciously placed in the centre of the forbidden chamber, resembles an exhibition display. In her photographic transformation of the fairy tale, Sherman stages this cauldron as the focus of a horrific display, illuminating it with a golden ray of light and placing it in front of a curtain with a skull, an iron chain and barely recognizable instruments of murder. What is then seminal to the required happy-end of the story is the fact that the girl ultimately destroys the wicked magician, this artist of dismemberment, but that apparently she can only do so precisely on the border between life and death.

Firstly, the dead body parts of the demonic artist's victims, with which Sherman recalls her own use of dolls, artificial body parts and prostheses as substitutes for her own body in her recent work, are put together again by the sly girl so as to form new body units. The sisters are once again resuscitated. In the photos, however, it is still only fragments – hands, hair, nose, mouths – that are visible, as if, in contrast to the fairy tale's plot, Sherman uses her photographic language to insist on an analogy between the fragmentation of female bodies by the wicked magician and the fragmentation of the represented body as an object in any aesthetic image. Secondly, the girl transforms herself

The image of the **dead & deadly** substitute **bride** *is staged by Sherman as though it were a self-portrait. The face is reproduced frontally,* **looking with** *with almost impudent candour, directly at the spectator;* **her** *other self of the imagination represented by the image of a* **decorated skull**

Elisabeth Bronfen, 'The Other Self of the Imagination', 1995

into a fantasy figure, a feathered hybrid between animal and human being. In this image, too, Sherman only represents a section of the body from waist to knee, illuminated from behind. The two hands are held in front of the stomach, the left one hovering slightly above the navel while the right one almost rests on the hipbone. Some fingernails are visible through the feathers. Thanks to this mimicry, the sly sister is able not only to leave the magician's house with impunity, but also to entice the evil bridegroom to his death. Significantly, she does this by creating one last time on the threshold between life and death. She decorates a skull with flowers and jewels, and, placed on a small pedestal, she exhibits it from her window. This composite body also resembles an art display. The decorated skull becomes a dual representation. It functions as a stand-in for the sly bride, but is also an inverted rendition of the magician's conceptual coupling of bride and corpse, given that it corresponds to the dismembered body parts of the other beautiful women he courted.

In both acts of creation – the magician's murderous performance of dismembering and displaying his brides, and the girl's self-protecting act of exchanging a substitute body, the decorated skull, for her own bodily presence – the concept of bride is linked to dead body parts and to aesthetic display. If in Sherman's photographs of these brides, the feminine body appears to be inanimate – the artificial body parts of the two dismembered sisters decoratively arranged in a pattern, the feathered body of the third, in which a human form is barely recognizable – the substitute bride, the decorated skull, by contrast, gives the impression of being animate. Both bride substitutes, however, the bird-woman and the skull bride, render the boundary between what is animate and what is inanimate fluid. Upon approaching his home, the wicked bridegroom asks the bird-woman where his bride is and she tells him that she is sitting at the window waiting for him to return. 'The bridegroom looked up, saw the decorated skull, thought it was his bride, and nodded to her, greeting her kindly.' With this statement, the sly daughter, working with, but also against, death, introduces a death performance of her own. Her correlate site to the magician's forbidden chamber of death scenarios, where she found herself confronted with the traumatic spectacle of her dismembered sisters, is the magician's entire house. Set on fire by her father and her kinsmen, it has become the site of death for the magician himself. By emphasizing the nipple of the dead artist, Sherman offers one last blurring of gender boundaries – the magician, too, is a hybrid, bearded and female.

The fairy-tale photographs thus also serve to illustrate the revenge art can take. Sherman presents us with images of violence meant as an apotropaic gesture against a fatal art project, but also as a statement about the cost of creativity. Art needs dead bodies, art creates dead bodies. In the images of the

beautiful but dead female faces, the sisters' chopped-off heads, as well as in the decorated skull, the perfection of aesthetic idealization meets its opposite, monstrosity. The former represent the traumatic spectacle of what the sly girl found in the cauldron. As such they stand for death as the prerequisite for the masculine artists' creative act. They function as the representation of a destructive fragmentation externally imposed by an artist on his medium. The latter image, by contrast, offers an aestheticized rendition of what the sly sister sets up against this spectacle of horror, a representation of death, which stands for herself, and which constitutes her self-representation.

For 'Fitcher's Bird' one can, then, isolate three aspects of the performative in Sherman's artistic practice, each thematizing how the survival of the self is coterminous with the destruction of the intact body as well as its transformation into a new body. First, the image of the sisters' dead body parts points to the concrete materials Cindy Sherman uses in her performed scenes, to the inanimate set pieces, dolls and props, but also to the iconographic bits and pieces she borrows from a collective image repertoire. On two scores the production of her photographs can, therefore, be seen as an act that consciously employs the process of assembling body parts and image fragments. Second, the image representing Fitcher's bird is a radical reference to Sherman's multifarious masquerades, to her playing with disguise, mimicry, as a screening of the self, as though she wanted to demonstrate how it is only with the help of such a strategy of displacement that she can offer herself to the view of the photographic lens. Finally, the image of the dead and deadly substitute bride is staged by Sherman as though it were a self-portrait. The face is reproduced frontally, looking, with almost impudent candour, directly at the spectator; her other self of the imagination represented by the image of a decorated skull.

But the decorated skull allows a further association to emerge, namely the report of one of Sigmund Freud's hysteric patients, Emmy von N., in which she told him that the night before she had had horrible dreams. She had had to lay out and decorate a number of dead people and put them in coffins, but would not put the lids on (1893–95). The role that this hysteric ascribes to herself in the dream fantasy is that of a woman who refashions dead bodies, dresses them and adorns them, indeed one could say embellishes the dead, at the same time that she also commemorates the presence of the dead amongst the living by virtue of the fact that she is compelled to leave the coffins open. [...]

Elisabeth Bronfen, excerpt from 'The Other Self of the Imagination: Cindy Sherman's Hysterical Performance', in Zdenek Felix and Martin Schwander, eds. *Cindy Sherman, Photographic Works 1975–1995* (Munich: Schirmer Art Books, 1995) 16–8.

James Meyer
The Macabre Museum: On Mark Dion//1997

Of what strange nature is knowledge! It clings to the mind when it has once seized on it like a lichen on the rock.
- Mary Shelley, *Frankenstein* (1818)[1]

[...] A ubiquitous topos of science fiction and Hollywood film, the unnatural is a subject of much recent American art. Alexis Rockman's painterly fantasies; Brian D'Amato's mounted butterflies; Laura Stein's altered cacti; Lawrence Beck's pictures of fake flowers; Zoe Leonard's photos of developmental 'mishaps' on display in anthropological collections (such as her bearded lady); and Daniel Faust's photographs of wax museums all explore this theme. The unnatural, as Roland Barthes has observed, is that which exceeds accepted systems of knowledge and taxonomies of nature. The sixteenth-century *Wunderkammer*, a prototype of the modern museum, reserved a special place for the bizarre. In the cabinet of curiosities the visitor came upon 'strange objects: accidents of nature, effigies of dwarfs, of giants, of hirsute men and women', or even (we read in another source) a wolf 'stuffed, clothed, bearded and masked' so as to resemble a deceased burgomaster, who according to local legend enjoyed a posthumous existence as a werewolf. Presenting the monster as 'a wonder, a marvel', a blurring of the 'separation of realms', the *Wunderkammer* explores the epistemology of the freak show, where the exception to the rule defines the normative. The project of taxonomy is itself a ferreting out of difference, a containment of the bizarre under the rubric of natural order. In the *Wunderkammer* the monstrous emerges as the end point of knowledge, its limit; it is the gruesome outcome of the violent attempt to know. 'All knowledge is linked to a classifying order', Barthes writes. 'To aggrandize or simply to change knowledge is to experiment, by certain audaxious operations, upon what subverts the classification we are accustomed to.'[2]

The attempt to 'change' knowledge, to subvert the order of things, is the subject of Dion's *Frankenstein in the Age of Biotechnology* (1991). Presented at the Christian Nagel Gallery in Cologne, Dion's installation was conceived in terms of a structure of opposition. On one side of the room Dion installed reminders of an archaic relationship to nature, a relationship of physical contact and proximity: farming tools (rakes, flower pots), a boar's head and furs (spoils of the hunt), stirrups and a rocking horse (equestrian motifs). Primitive methods of husbandry and biotechnology were represented by a beer barrel (for

fermentation) and a churn used for separating milk from cream. A reproduction of a still life by the nineteenth-century German-American painter Severin Roesen, and empty frames suspended on the wall thematized the archetypally 'immediate' encounter of the figurative artist and the natural world. On the other side of the room was a mock laboratory of today's bio-technician: a shiny white desk and stool; countless beakers, Petri dishes and flasks filled with coloured liquids, including shades of violet (an allusion to Cologne's role in the biotechnical revolution, where the genetic alteration of Viol flowers in 1990 caused an uproar); syringes, tweezers and forceps; rubber gloves; plastic bags for bio-hazardous waste; an anatomical chart of the brain; a human skull. A pig's heart and brain floated in a pickling jar. Nearby, a line of rubber tubing descended into a glass tank filled with a murky fluid. Buried deep in the tank, and barely discernible, was the fleshy outline of a human arm. [...]

Unlike Shelley's masterpiece, *Frankenstein in the Age of Biotechnology* does not present a Romantic or biblical view of the pursuit of knowledge leading irrevocably to disaster. On the other hand, nor does it manifest an unalloyed Productivist belief in a positive critical agency. Rather, Dion's work analyses the development of biotechnology within a longer history of human efforts to recreate nature 'in our own image'. The practices of Linnaeus and Schieffelin, Frankenstein and Oppenheimer, of the natural history museum and the biomedical corporation, each project an anthropocentric schema onto the natural world. All of these interventions have multiple and contradictory effects. If Dion's work has one lesson it is this: we make nature for ourselves; let us take account of our making. For as he suggests, it is only through such a reckoning that a responsible and effective ecology becomes conceivable.

1 Mary Shelley, *Frankenstein; or, The Modern Prometheus* (London: Lackington, Hughes, Harding, Mavor and Jones, 1818).

2 [footnote 5 in source] Roland Barthes, 'Arcimboldo, or Magician and Rhetoriqueur' in *The Responsibility of Forms*, trans. Richard Howard (New York: Hill and Wang, 1985) 147-48. (The quotations below are from this source). The 'werewolf' display is discussed in Eileen Hooper-Greenhill, *Museums and the Shaping of Knowledge* (London: Routledge, 1992) 79.

James Meyer, excerpt from 'The Macabre Museum', *frieze*, no. 32 (1997) 60–1.

I took white bread, mixed it with spit and moulded a figure of my father. When the figure was done I started cutting off the limbs with a knife. I see this as my first sculpture solution.

Louise Bourgeois, statement in *Louise Bourgeois*, 1994

TRANSGRESSING FEMALES AND THE NAME OF THE FATHER

Jacques Lacan
Seminar on *The Purloined Letter*//1972

[...] There are two scenes [in Edgar Allan Poe's short story *The Purloined Letter*, 1845], the first of which we shall straightway designate the primal scene, and by no means inadvertently, since the second may be considered its repetition in the very sense we are considering today.

The primal scene is thus performed, we are told [...] in the royal *boudoir*, so that we suspect that the person of the highest rank, called the 'exalted personage', who is alone there when she receives a letter, is the Queen. This feeling is confirmed by the embarrassment into which she is plunged by the entry of the other exalted personage, of whom we have already been told [...] prior to this account that the knowledge he might have of the letter in question would jeopardize for the lady nothing less than her honour and safety. Any doubt that he is in fact the King is promptly dissipated in the course of the scene which begins with the entry of the Minister D... At that moment, in fact, the Queen can do no better than to play on the King's inattentiveness by leaving the letter on the table 'face down, address uppermost'. It does not, however, escape the Minister's lynx eye, nor does he fail to notice the Queen's distress and thus to fathom her secret. From then on everything transpires like clockwork. After dealing in his customary manner with the business of the day, the Minister draws from his pocket a letter similar in appearance to the one in his view, and, having pretended to read it, he places it next to the other. A bit more conversation to amuse the royal company, whereupon, without flinching once, he seizes the embarrassing letter, making off with it, as the Queen, on whom none of his manoeuvre has been lost, remains unable to intervene for fear of attracting the attention of her royal spouse, close at her side at that very moment.

Everything might then have transpired unseen by a hypothetical spectator of an operation in which nobody falters, and whose quotient is that the Minister has filched from the Queen her letter and that – an even more important result than the first – the Queen knows that he now has it, and by no means innocently.

A *remainder* that no analyst will neglect, trained as he is to retain whatever is significant, without always knowing what to do with it: the letter, left in exchange by the Minister, and which the Queen's hand is now free to roll into a ball.

Second scene: in the Minister's office. It is in his hotel, and we know – from the account the Prefect of Police has given Dupin, whose specific genius for solving enigmas Poe introduces here for the second time – that the police, returning there as soon as the Minister's habitual, nightly absences allow them

to, have searched the hotel and its surroundings from top to bottom for the last eighteen months. In vain, – although everyone can deduce from the situation that the Minister keeps the letter within reach.

Dupin calls on the Minister. The latter receives him with studied nonchalance, affecting in his conversation romantic ennui. Meanwhile Dupin, whom this pretence does not deceive, his eyes protected by green glasses, proceeds to inspect the premises. When his glance catches a rather crumpled piece of paper – apparently thrust carelessly in a division of an ugly pasteboard card-rack, hanging gaudily from the middle of the mantelpiece – he already knows that he has found what he is looking for. His conviction is re-enforced by the very details, which seem to contradict the description he has of the stolen letter, with the exception of the format, which remains the same.

Whereupon he has but to withdraw, after 'forgetting' his snuff-box on the table, in order to return the following day to reclaim it – armed with a facsimile of the letter in its present state. As an incident in the street, prepared for the proper moment, draws the Minister to the window, Dupin in turn seizes the opportunity to snatch the letter while substituting the imitation, and has only to maintain the appearances of a normal exit.

Here as well all has transpired, if not without noise, at least without commotion. The quotient of the operation is that the Minister no longer has the letter, but far from suspecting that Dupin is the culprit who has ravished it from him, knows nothing of it. Moreover, what he is left with is far from insignificant for what follows. We shall return to what brought Dupin to inscribe a message on his counterfeit letter. Whatever the case, the Minister, when he tries to make use of it, will be able to read these words, written so that he may recognize Dupin's hand: '... *Un dessein si funeste,/S'il n'est digne d'Atrée est digne de Thyeste*', ('So infamous a scheme,/If not worthy of Atreus, is worthy of Thyestes'), whose source, Dupin tells us, is Crébillon's *Atrée*.

Need we emphasize, the similarity of these two sequences? Yes, for the resemblance we have in mind is not a simple collection of traits chosen only in order to supply their difference. And it would not be enough to retain those common traits at the expense of the others for the slightest truth to result. It is rather the intersubjectivity in which the two actions are motivated that we wish to bring into relief, as well as the three terms through which it structures them.

The special status of these terms results from their corresponding simultaneously to the three logical moments through which the decision is precipitated and the three places it assigns to the subjects among whom it constitutes a choice.

That decision is reached in a glance's time. For the manoeuvres which follow, however stealthily they prolong it, add nothing to that glance, nor does the

deferring of the deed in the second scene break the unity of that moment.

This glance presupposes two others, which it embraces in its vision of the breach left in their fallacious complementarity, anticipating in it the occasion for larceny afforded by that exposure. Thus three moments, structuring three glances, borne by three subjects, incarnated each time by different characters.

The first is a glance that sees nothing: the King and the police.

The second, a glance which sees that the first sees nothing and deludes itself as to the secrecy of what it hides: the Queen, then the Minister.

The third sees that the first two glances leave what should be hidden exposed to whomever would seize it: the Minister, and finally Dupin.

In order to grasp in its unity the intersubjective complex thus described, we would willingly seek a model in the technique legendarily attributed to the ostrich attempting to shield itself from danger; for that technique might ultimately be qualified as political, divided as it here is among three partners: the second believing itself invisible because the first has its head stuck in the ground, and all the while letting the third calmly pluck its rear; we need only enrich its proverbial denomination by a letter, producing *la politique de l'autruiche* [the politics of the ostrich, *autrui*, and of Austria, *l'Autriche*], for the ostrich itself to take on forever a new meaning.

Given the intersubjective modulus of the repetitive action, it remains to recognize in it a *repetition automatism* in the sense that interests us in Freud's text. [...]

Jacques Lacan, 'Seminar on *The Purloined Letter*', trans. Jeffrey Mehlman, in *French Freud, Yale French Studies*, no. 48 (1972) 41–4; extract reprinted in Jacques Derrida, *The Postcard: From Socrates to Freud and Beyond*, trans. Alan Bass (Chicago and London: The University of Chicago Press, 1987) 433–6.

Jacques Derrida
The Purveyor of Truth//1975

[...] A break with naïve semanticism and psycho-biographism, an elaboration of a logic of the signifier (in its literal materiality and syntactic formality), an assumption of the problematic of *Beyond the Pleasure Principle*: such are the most general forms of an advance legible in [Jacques Lacan's 'Seminar on *The Purloined Letter*'] at first glance. But the excess of evidence always demands the supplement of inquiry.

Now we must come closer, reread, question.

From the outset, we recognize the classical landscape of applied psychoanalysis. Here applied to literature. Poe's text, whose status is never examined – Lacan simply calls it 'fiction' -, finds itself invoked as an 'example'. An example destined to 'illustrate', in a didactic procedure, a law and a truth forming the proper object of a seminar. Literary writing, here, is brought into an *illustrative* position: 'to illustrate' here meaning to read the general law in the example, to make clear the meaning of a law or of a truth, to bring them to light in striking or exemplary fashion. The text is in the service of the truth, and of a truth that is taught, moreover: 'Which is why we have decided to illustrate for you today the truth which may be drawn from that moment in Freud's thought under study – namely, that it is the symbolic order which is constitutive for the subject – by demonstrating in a story the decisive orientation which the subject receives from the itinerary of a signifier.

'It is that truth, let us note, which makes the very existence of fiction possible'.[1]

Again, illustration, and the illustration of instruction, Freud's instruction: 'What Freud teaches us in the text that we are commenting on is that the subject must pass through the channels of the symbolic, but what is illustrated here is more gripping still: it is not only the subject, but the subjects, grasped in their intersubjectivity, who line up...'[2]

The 'truth which may be drawn from that moment in Freud's thought under study', the truth with which the most decorative and pedagogical literary illustration is coordinated, is not, as we will see, this or that truth, but is the truth itself, the truth of the truth. It provides the 'Seminar' with its rigorously philosophical import.

One can identify, then, the most classical practice. Not only the practice of philosophical 'literary criticism', but also Freud's practice each time he demands of literature examples, illustrations, testimony and confirmation in relation to

knowledge, truth and laws that he treats elsewhere in another mode. Moreover, if Lacan's statements on the relation between fiction and truth are less clear and less unequivocal elsewhere, here there is no doubt about the order. 'Truth inhabits fiction' cannot be understood in the somewhat perverse sense of a fiction more powerful than the truth which inhabits it, the truth that fiction inscribes within itself. In truth, the truth inhabits fiction as the master of the house, as the law of the house, as the economy of fiction. The truth executes the economy of fiction, directs, organizes and makes possible fiction: 'It is that truth, let us note, which makes the very existence of fiction possible.'[3]

The issue then is to ground fiction in truth, to guarantee fiction its conditions of possibility in truth, and to do so without even indicating, as does *Das Unheimliche*, literary fiction's eternally renewed resistance to the general law of psychoanalytic knowledge. Additionally, Lacan never asks what distinguishes one literary fiction from another. Even if every fiction were founded in or made possible by the truth, perhaps one would have to ask from what kind of fiction something like literature, here *The Purloined Letter*, derives, and what effects this might have on that very thing which appears to make it possible.

This first limit contains the entire 'Seminar', and it reprints its marks indefinitely on it; what the literary example yields is a *message*. Which will have to be deciphered on the basis of Freud's teaching. Reprint: 'The Opening of This Collection' (October 1966, ten years after the 'Seminar') speaks of 'Poe's message deciphered and coming back from him, the reader, in that to read it, it says itself to be no more feigned than the truth when it inhabits fiction.[4]

What Lacan analyses, decomposing it into its elements, its origin and its destination, uncovering it in its truth, is a *story* [*histoire*]. [...]

Lacan leads us back to the truth, to a truth which itself cannot be lost. He brings back the letter, shows that the letter brings itself back toward its *proper* place via a *proper* itinerary, and, as he overtly notes, it is this destination that interests him, destiny as destination. The signifier has its place in the letter, and the letter refinds its proper meaning in its proper place. A certain reappropriation and a certain readequation will reconstitute the proper, the place, meaning and truth that have become distant from themselves for the time of a detour or of a non-delivery. The time of an algorithm. Once more a hole will be stopped: and to do so one does not have to fill it, but only to see and to delimit its contour.

We have read: the signifier (in the letter, in the note) has no place identical to itself, it *is missing from its place*. Its meaning counts for little, it cannot be reduced to its meaning. But what the Seminar insists upon showing, finally, is that there is a single *proper* itinerary of the letter which returns to a determinable place that is always the same and that is *its own*; and that if its

meaning (what is written in the note in circulation) is indifferent or unknown for our purposes (according to the hypothesis whose fragility nevertheless supports the entire logic of the Seminar), the meaning of the letter and the sense of its itinerary are necessary, unique and determinable in truth, that is, as truth. […]

1 Jacques Lacan, 'Seminar on *The Purloined Letter*', trans. Jeffrey Mehlman, in *French Freud, Yale French Studies*, no. 48 (1972) 40.

2 Ibid., 60.

3 Ibid., 40.

4 Jacques Lacan, *Écrits*, trans. Alan Sheridan (New York: Norton, 1977) 16.

Jacques Derrida, excerpt from 'Le Facteur de la Vérité', trans. Alan Bass 'The Purveyor of Truth', in Jacques Derrida, *The Postcard: From Socrates to Freud and Beyond*, (Chicago and London: The University of Chicago Press, 1987) 425–7; 436–7.

Carol J. Clover
Men, Women and Chainsaws: Gender in the Modern Horror Film//1992

Final Girl

The image of the distressed female most likely to linger in memory is the image of the one who did not die: the survivor, or Final Girl. She is the one who encounters the mutilated bodies of her friends and perceives the full extent of the preceding horror and of her own peril; who is chased, cornered, wounded; whom we see scream, stagger, fall, rise and scream again. She is abject terror personified. If her friends knew they were about to die only seconds before the event, the Final Girl lives with the knowledge for long minutes or hours. She alone looks death in the face, but she alone also finds the strength either to stay the killer long enough to be rescued (ending A) or to kill him herself (ending B). But in either case, from 1974 on, the survivor figure has been female. In Schoell's words: 'The vast majority of contemporary shockers, whether in the sexist mould or not, feature climaxes in which the women fight back against their attackers – the wandering, humourless psychos who populate these films. They often show more courage and level-headedness than their cringing male counterparts.'[1]

Her scene occupies the last ten to twenty minutes (thirty in the case of *Texas Chain Saw I*) and contains the film's emphatic climax. [...]

The Final Girl of the slasher film is presented from the outset as the main character. The practised viewer distinguishes her from her friends minutes into the film. She is the Girl Scout, the bookworm, the mechanic. Unlike her girlfriends (and Marion Crane) she is not sexually active. Laurie (*Halloween*) is teased because of her fears about dating, and Marti (*Hell Night*) explains to the boy with whom she finds herself sharing a room that they will be using separate beds. Although Stretch (*Texas Chain Saw II*) is hardly virginal, she is not available, either; early in the film she pointedly turns down a date, and we are given to understand that she is, for the present, unattached and even lonely. So too Stevie of Carpenter's *The Fog*, like Stretch, a disk jockey, divorced mother and newcomer in town, she is unattached and lonely but declines male attention. The Final Girl is also watchful to the point of paranoia; small signs of danger that her friends ignore, she registers. Above all she is intelligent and resourceful in a pinch. Thus Laurie even at her most desperate, cornered in a closet, has the wit to grab a hanger from the rack and bend it into a weapon; Marti can hot-wire her getaway car, the killer in pursuit; and the psych major of *Friday the Thirteenth*

II, on seeing the enshrined head of Mrs Voorhees, can stop Jason in his tracks by assuming a stridently maternal voice. Finally, although she is always smaller and weaker than the killer, she grapples with him energetically and convincingly.

The Final Girl is boyish, in a word. Just as the killer is not fully masculine, she is not fully feminine – not, in any case, feminine in the ways of her friends. Her smartness, gravity, competence in mechanical and other practical matters, and sexual reluctance set her apart from the other girls and ally her, ironically, with the very boys she fears or rejects, not to speak of the killer himself. Lest we miss the point, it is spelled out in her name: Stevie, Marti, Terry, Laurie, Stretch, Will, Joey, Max. Not only the conception of the hero in *Alien* and *Aliens* but also the surname by which she is called, Ripley, owes a clear debt to slasher tradition. [...]

The one character of stature who does live to tell the tale is in fact the Final Girl. She is introduced at the beginning and is the only character to be developed in any psychological detail. We understand immediately from the attention paid it that hers is the main story line. She is intelligent, watchful, level-headed; the first character to sense something amiss and the only one to deduce from the accumulating evidence the pattern and extent of the threat; the only one, in other words, whose perspective approaches our own privileged understanding of the situation. We register her horror as she stumbles on the corpses of her friends. Her momentary paralysis in the face of death duplicates those moments of the universal nightmare experience – in which she is the undisputed 'I' – on which horror frankly trades. When she downs the killer, we are triumphant. She is by any measure the slasher film's hero. This is not to say that our attachment to her is exclusive and unremitting, only that it adds up, and that in the closing sequence (which can be quite prolonged) it is very close to absolute.

An analysis of the camerawork bears this out. Much is made of the use of the I-camera to represent the killer's point of view. In these passages – they are usually few and brief, but striking – we see through his eyes and (on the soundtrack) hear his breathing and heartbeat. His and our vision is partly obscured by the bushes or window blinds in the foreground. By such means we are forced, the logic goes, to identify with the killer. [...] We are linked, in this way, with the killer in the early part of the film, usually before we have seen him directly and before we have come to know the Final Girl in any detail. Our closeness to him wanes as our closeness to the Final Girl waxes – a shift underwritten by story line as well as camera position. By the end, point of view is hers: we are in the closet with her, watching with her eyes the knife blade pierce the door; in the room with her as the killer breaks through the window and grabs at her; in the car with her as the killer stabs through the convertible

top, and so on. And with her, we become if not the killer of the killer then the agent of his expulsion from the narrative vision. If, during the film's course, we shifted our sympathies back and forth and dealt them out to other characters along the way, we belong in the end to the Final Girl; there is no alternative. When Stretch eviscerates Chop Top at the end of *Texas Chain Saw II*, she is literally the only character left alive, on either side. [...]

The killer's phallic purpose, as he thrusts his drill or knife into the trembling bodies of young women, is unmistakable. At the same time, however, his masculinity is severely qualified: he ranges from the virginal or sexually inert to the transvestite or transsexual, and is spiritually divided ('the mother half of his mind') or even equipped with vulva and vagina. Although the killer of *God Told Me To* is represented and taken as a male in the film text, he is revealed, by the doctor who delivered him, to have been sexually ambiguous from birth: 'I truly could not tell whether that child was male or female; it was as if the sexual gender had not been determined ... as if it were being developed'.[2] In this respect, slasher killers have much in common with the monsters of classic horror – monsters who, in Linda Williams' formulation, represent not just 'an eruption of the normally repressed animal sexual energy of the civilized male' but also the 'power and potency of a *non-phallic* sexuality'. To the extent that the monster is constructed as feminine, the horror film thus expresses female desire only to show how monstrous it is.[3] The intention is manifest in *Aliens*, in which the Final Girl, Ripley, is pitted in the climactic scene against the most terrifying 'alien' of all: an egg-laying Mother.

Decidedly 'intra-uterine' in quality is the Terrible Place, dark and often damp, in which the killer lives or lurks and whence he stages his most terrifying attacks. 'It often happens', Freud wrote, 'that neurotic men declare that they feel there is something uncanny about the female genital organs. This *unheimlich* place, however, is an entrance to the former *Heim* [home] of all human beings, to the place where each of us lived once upon a time and in the beginning... In this case too then, the *unheimlich* is what once was *heimisch*, familiar; the prefix '*un*' [un-] is the token of repression'.[4] It is the exceptional film that does not mark as significant the moment that the killer leaps out of the dark recesses of a corridor or cavern at the trespassing victim, usually the Final Girl. Long after the other particulars have faded, the viewer will remember the images of Amy assaulted from the dark halls of a morgue (*He Knows You're Alone*), or Melanie trapped in the attic as the savage birds close in (*The Birds*). In such scenes of convergence the Other is at its bisexual mightiest, the victim at her tiniest, and the component of sadomasochism at its most blatant. [...]

1 [footnote 20 in source] Further: 'Scenes in which women whimper helplessly and do nothing to defend themselves are ridiculed by the audience, who find it hard to believe that anyone – male or female – would simply allow someone to kill them with nary a protest', William Schoell, *Stay Out of the Shower: 25 Years of Shocker Films, Beginning with Psycho* (New York: Dembner Books, 1985) 55–6.

2 [35] Further: 'When she [the mother] referred to the infant as a male, I just went along with it. Wonder how that child turned out – male, female or something else entirely?' The birth is understood to be parthenogenetic, and the bisexual child, literally equipped with both sets of genitals, is figured as the reborn Christ. See also *Sleepaway Camp*, a film claimed to be especially popular with sub-teens, in which the mystery killer at the camp turns out to be one of the girl campers, a figure in turn revealed, in a climatic scene in which she is viewed without clothes, to be a boy.

3 [36] Linda Williams, 'When the Woman Looks', in Mary Ann Doane, Patricia Mellencamp and Linda Williams, eds. *Re-Vision: Essays in Feminist Criticism* (Frederick, MD: American Film Institute, 1984) 90. Williams' emphasis on the phallic leads her to dismiss slasher killers as a 'non-specific male killing force' and hence a degeneration in the tradition. 'In these films the recognition and affinity between woman and monster of classic horror film gives way to pure identity: she is the monster, her mutilated body the visible horror' (96). This analysis does not do justice to the obvious bisexuality (or at least modified masculinity) of slasher killers, nor does it take into account the new strength of the female victim. The slasher film may not, in balance, be more subversive than traditional horror, but it is certainly not less so.

4 [37] Sigmund Freud, 'The Uncanny' (London: Penguin Books, 2003) 245.

Carol J. Clover, excerpt from 'Final Girl' , *Men, Women and Chainsaws: Gender in the Modern Horror Film* (New York: Princeton University Press, 1992) 35–6; 39–40; 44–8.

Steven King
Carrie//1974

[...] At 12:10, still seven minutes before the gas-main explosion, the telephone exchange experienced a softer explosion: a complete jam of every town phone line still in operation. The three harried girls on duty stayed at their posts but were utterly unable to cope. They worked with expressions of wooden horror on their faces, trying to place unplaceable calls.

And so Chamberlain drifted into the streets.

They came like an invasion from the graveyard that lay in the elbow creek formed by the intersection of The Bellsqueeze Road and Route 6; they came in white nightgowns and in robes, as if in winding shrouds. They came in pyjamas and curlers (Mrs Dawson, she of the now-deceased son who had been a very funny fellow, came in a mudpack as if dressed for a minstrel show); they came to see what happened to their town, to see if it was indeed lying burnt and bleeding. Many of them also came to die.

Carlin Street was thronged with them, a riptide of them, moving downtown through the hectic light in the sky, when Carrie came out of the Carlin Street Congregational Church, where she had been praying.

She had gone in only five minutes before, after opening the gas main (it had been easy; as soon as she pictured it lying there under the street it had been easy), but it seemed like hours. She had prayed long and deeply, sometimes aloud, sometimes silently. Her heart thudded and laboured. The veins on her face and neck bulged. Her mind was filled with the huge knowledge of POWERS, and of an ABYSS. She prayed in front of the altar, kneeling in her wet and torn and bloody gown, her feet bare and dirty and bleeding from a broken bottle she had stepped on. Her breath sobbed in and out of her throat, and the church was filled with groanings and swayings and sunderings as psychic energy sprang from her. Pews fell, hymnals flew and a silver Communion set cruised silently across the vaulted darkness of the nave to crash into the far wall. She prayed and there was no answering. No one was there – or if there was, He/It was cowering from her. God had turned His face away, and why not? This horror was as much His doing as hers. And so she left the church, left it to go home and find her momma and make destruction complete. [...]

Stephen King, excerpt from *Carrie* (London: New English Library, 1974) 197–9.

Slavoj Zizek
Kant as a Theoretician of Vampirism//1994

There are pipes and pipes

[...] An exemplary case of [...] 'post-realist' playfulness, of course, are the paintings of René Magritte. Today, when one says 'Magritte', the first association, of course, is the notorious drawing of a pipe with an inscription below it: *Ceci n'est pas une pipe*. Taking as a starting point the paradoxes implied by this painting, Michel Foucault wrote a perspicacious little book of the same title.[1] Yet, perhaps, another of Magritte's paintings can serve even more appropriately to establish the elementary matrix that generates the uncanny effects pertaining to his work: *La lunette d'approche* from 1963, the painting of a half-open window, where, through the windowpane, we see the external reality (blue sky with some dispersed white clouds), yet what we see in the narrow opening which gives direct access to the reality beyond the pane is nothing, just a nondescript black mass... In Lacanese, the painting would translate thus: The frame of the windowpane is the fantasy-frame that constitutes reality, whereas through the crack we get an insight into the 'impossible' real, the Thing-in-itself.[2]

This painting renders the elementary matrix of the Magrittean paradoxes by way of staging the 'Kantian' split between (symbolized, categorized, transcendentally constituted) reality and the void of the Thing-in-itself, of the real, which gapes open in the midst of reality and confers upon it a fantasmatic character. The first variation that can be generated from this matrix is the presence of some strange, inconsistent element which is 'extraneous' to the depicted reality, i.e. that, uncannily, has its place in it, although it does not 'fit' in it: the gigantic rock that floats in the air close to a cloud has its heavy counterpart, its double, in *La Bataille de l'Argonne* (1959); the unnaturally large bloom which fills out the entire room in *Tombeau des lutteurs* (1969). This strange element 'out-of-joint' is precisely the fantasy-object filling-out the blackness of the real that we perceived in the crack of the half-open window in *La lunette d'approache*. [...]

The non-intersubjective other

The impenetrable blackness that can be glimpsed through the crack of the half-opened window thus opens up the space for the uncanny apparitions of an Other who precedes the Other of 'normal' intersubjectivity. Let us recall here a detail from Hitchcock's *Frenzy* which bears witness to his genius: in a scene that leads to the second murder, Babs, the soon-to-be victim, a young girl who works

in a Covent Garden pub, after a quarrel with the owner leaves her working place and steps out onto the busy market street; the street noise that for a brief moment hits us is quickly suspended (in a totally 'non-realistic' way) when the camera approaches Babs for a close up, and the mysterious silence is then broken by an uncanny voice coming from an indefinite point of absolute proximity, as if from behind her and at the same time from within her, a man's voice softly saying 'Need a place to stay?'; Babs moves off and looks back – standing behind her is an old acquaintance who, unbeknownst to her, is the 'necktie-murderer', after a couple of seconds, the magic evaporates and we hear again the sound tapestry of 'reality', of the market street bustling with life... This voice that emerges in the suspension of reality is none other that the *objet petit a*, and the figure which appears behind Babs is experienced by the spectator as supplementary with regard to this voice: it gives body to it, and, simultaneously, it is strangely intertwined with Babs' body, as her body's shadowy protuberance (not unlike the strange double body of Leonardo's *Madonna*, analysed by Freud; or, in *Total Recall*, the body of the leader of the underground resistance movement on Mars, a kind of parasitic protuberance on another person's belly...). It is easy to offer a long list of similar effects; thus, in one of the key scenes in *Silence of the Lambs*, Clarice and Lecter occupy the same positions when engaged in a conversation in Lecter's prison: in the foreground, the close-up of Clarice staring into the camera, and on the glass partition-wall behind her, the reflection of Lecter's head germinating behind – out of her – as a shadowy double, simultaneously less and more real than her. The supreme case of this effect, however, is found in one of the most mysterious shots of Hitchcock's *Vertigo*, when Scottie peers at Madeleine through the crack in the half-opened backdoor of the florist's shop. For a brief moment, Madeleine watches herself in a mirror close to this door, so that the screen is vertically split: the left half is occupied by the mirror where we see Madeleine's reflection, while the right half is sliced by a series of vertical lines (the doors); in the vertical dark band (the crack of the half-opened door), we see a fragment of Scottie, his gaze transfixed on the 'original' whose mirror-reflection we see in the left half. A truly 'Magrittean' quality clings to this unique shot: although, as to the disposition of the diegetic space, Scottie is here 'in reality', whereas what we see of Madeleine is only her mirror-image, the effect of the shot is exactly the reverse: Madeleine is perceived as part of the reality and Scottie as a phantom-like protuberance who (like the legendary dwarf in Grimm's 'Snow White') lurks behind the mirror. This shot is Magrittean in a very precise sense: the dwarf-like mirage of Scottie peeps out of the very impenetrable darkness which gapes in the crack of the half-open window in *La lunette d'approche* (the mirror in *Vertigo*, of course, corresponds to the windowpane in Magritte's painting) – in both cases, the

framed space of the mirrored reality is traversed by a vertical black rift. As Kant puts it, there is no positive knowledge of the Thing-in-itself, one can only designate its place, 'make room' for it. This is what Magritte accomplishes on a quite literal level: the crack of the half-open door, its impenetrable blackness, makes room for the Thing. And by locating in this crack a gaze, Hitchcock supplements Magritte in a Hegelian-Lacanian way: 'If beyond appearance there is no Thing-in-itself, there is the gaze'.[3] [...]

What all these scenes have in common on the level of purely cinematic procedure is a kind of formal correlative of the reversal of face-to-face intersubjectivity into the relationship of the subject to his shadowy double which emerges behind him or her as a kind of sublime protuberance: *the condensation of the field and counterfield within the same shot*. What we have here is a paradoxical kind of communication: not a 'direct' communication of the subject with his fellow-creature *in front* of him, but a communication with the excrescence *behind* him, mediated by a third gaze, as if the counterfield were to be mirrored back into the field itself. It is this third gaze which confers upon the scene its hypnotic dimension: the subject is enthralled by the gaze which sees 'What is in himself more than himself'... And the analytical situation itself – the relationship between analyst and analysand – does it not ultimately also designate a kind of return to this pre-intersubjective relationship of the subject (- analysand) to his shadowy other, to the externalized object in himself? Is not this the whole point of the spatial disposition of analysis: after the so-called preliminary interviews, the analysis proper begins when the analyst and the analysand no longer confront each other face to face, but the analyst sits *behind* the analysand who, stretched on the divan, stares into the void in front of him? Does not this very disposition locate the analyst as the analysand's *object petit a*, not his dialogical partner, not another subject?

The object of the indefinite judgement

At this point, we should go back to Immanuel Kant: in his philosophy, this crack, this space where such monstrous apparitions can emerge, is opened up by the distinction between negative an indefinite judgement. The very example used by Kant to illustrate this distinction is telltale: the positive judgement by means of which a predicate is ascribed to the (logical) subject – 'The soul is mortal'; the negative judgement by means of which a predicate is denied to the subject – 'The soul is not mortal'; the indefinite judgement by means of which, instead of negating a predicate (i.e., the copula which ascribes it to the subject), we affirm a certain non-predicate – 'The soul is not-mortal'. (In German also, the difference is solely a matter of punctuation: *Die Seele ist nicht sterbliche – Die Seele ist*

nichsterbliche; Kant enigmatically does not use the standard *unsterbliche*. See *CPR*, A 72-73).

Along this line of thought, Kant introduces in the second edition of the *Critique of Pure Reason* the distinction between positive and negative meanings of 'noumenon': in the positive meaning of the term, *noumenon* is 'an object of a non-sensible intuition', whereas in the negative meaning, it is 'a thing insofar as it is not an object of our sensible intuition' (*CPR*, B 307). The grammatical form should not mislead us here: the positive meaning is expressed by the negative judgement and the negative meaning by the indefinite judgement. In other words, when one determines the Thing as 'an object of a non-sensible intuition', one immediately negates the positive judgement which determines the Thing as 'an object of a sensible intuition'; one accepts intuition as the unquestioned base or genus; against this background, one opposes its two species, sensible and non-sensible intuition. Negative judgement is thus not only limiting, it also delineates a domain beyond phenomena where it locates the Thing – the domain of the non-sensible intuition – whereas in the case of the negative determination, the Thing is excluded from the domain of our sensible intuition, without being posited in an implicit way as the object of a non-sensible intuition; by leaving in suspense the positive status of the Thing, negative determination saps the very genus common to affirmation and negation of the predicate.

Herein lies also the difference between 'is not mortal' and 'is not-mortal'; what we have in the first case is a simple negation, whereas in the second case, *a non-predicate is affirmed*. The only 'legitimate' definition of the *noumenon* is that it is 'not an object of our sensible intuition', i.e., a wholly negative definition which excludes it from the phenomenal domain; this judgement is 'infinite' since it does not imply any conclusions to where, in the infinite space of what remains outside the phenomenal domain, the *noumenon* is located. What Kant calls 'transcendental illusion' ultimately consists in the very (mis)reading of infinite judgement as negative judgement: when we conceive the *noumenon* as an 'object of a non-sensible intuition', the subject of the judgement remains the same (the 'object of intuition'), what changes is only the character (non-sensible instead of sensible) of this intuition, so that a minimal 'commensurability' between the subject and the predicate (i.e., in this case, between the *noumenon* and its phenomenal determinations) is still maintained.

This subtle difference between negative and indefinite judgement figures in a certain type of witticism where the second part does not immediately invert the first part by negating its predicate but repeats it with the negation displaced onto the subject. Let us recall Marx's ironic critique of Proudhon in *The Poverty of Philosophy*: 'Instead of the ordinary individual with his ordinary manner of speaking and thinking, we have nothing but this ordinary manner purely and

simply – without the individual'.[4] This is what the chimera of 'non-sensible intuition' is about: instead of ordinary objects of sensible intuition, we get the same ordinary objects of intuition, without their sensible character. Or, to take another example: the judgement, 'He is an individual full of idiotic features', can be negated in a standard mirror way, i.e., replaced by its contrary 'He is an individual with no idiotic features'; yet its negation can also be given the form of 'He is full of idiotic features without being an individual'. This displacement of the negation from the predicate into the subject provides the logical matrix of what is often the unforeseen result of our educational efforts to liberate the pupil from the constraint of prejudices and clichés: the result is not a person capable of expressing himself or herself in a relaxed, unconstrained way, but an automatized bundle of (new) clichés behind which we no longer sense the presence of a 'real person'. Let us just recall the usual outcome of psychological training intended to deliver the individual from the constraints of his or her everyday frame of mind and to set free his or her 'true self', with all its authentic creative potentials (transcendental mediation, etc.): once the individual gets rid of the old clichés that were still able to sustain the dialectical tension between themselves and the 'personality' behind them, what take their place are new clichés which abrogate the very 'depth' of personality behind them ... in short, the individual becomes a true monster, a kind of 'living dead'. Samuel Goldwyn, the old Hollywood mogul, was right: 'What we need are indeed some new, original clichés...

Invoking the 'living dead' is no accident here: in our ordinary language, we resort to indefinite judgements precisely when we endeavour to comprehend those borderline phenomena that undermine established differences, such as those between living and being dead: in the texts of popular culture, the uncanny creatures which are neither alive nor dead, the 'living dead' (vampires, etc.), are referred to as 'the undead' – although they are not dead, they are clearly not alive like us, ordinary mortals. The judgement 'he is undead' is therefore an indefinite-limiting judgement in the precise sense of a purely negative gesture of excluding vampires from the domain of the dead, without for that reason, locating them in the domain of the living (as in the case of the simple negation, 'he is not dead'). The fact that vampires and other 'living dead' are usually referred to as 'things' has to be rendered with its full Kantian meaning: a vampire is a Thing which looks and acts like us, yet is not one of us... In short, the difference between the vampire and the living person is the difference between indefinite and negative judgement: a dead person loses the predicates of a living being, yet he or she remains the same person; an undead, on the contrary, retains all the predicates of a living being without being one – as in the above-quoted Marxian joke, what we get with the vampire is 'the ordinary manner of speaking and thinking purely and simply – without the individual'.

What one should do here, in the space of a more detailed theoretical elaboration, is to approach in a new way the Lacan-Heidegger relationship. In the 1950s, Lacan endeavoured to read the 'death-drive' against the background of Heidegger's 'being-towards-death (*Sein-zum-Tode*)', conceiving of death as the inherent and ultimate limit of symbolization, which accounts for its irreducible temporal character. With Lacan's shift towards the Real from the 1960s onwards, it is the indestructible life sprouting in the domain of the 'undead' that emerges as the ultimate object of horror. [...]

1 [footnote 3 in source] See Michel Foucault, *This is not a pipe* (Berkeley and Los Angeles: University of California Press, 1982).

2 [4] One encounters the same paradox in Robert Heinlein's science-fiction novel *The Unpleasant Profession of Jonathon Hoag*: when a window is opened, the reality previously seen through it dissolves and all we see is a dense, non-transparent slime of the Real. For a more detailed Lacanian reading of this novel, see Chapter 1 of Slavoj Zizek, *Looking Awry* (Cambridge, Massachusetts: The MIT Press, 1991).

3 [7] Jacques Lacan, *The Four Fundamental Concepts of Psycho-Analysis* (New York: Norton, 1977) 103.

4 [9] Karl Marx, 'The Poverty of Philosophy', in Karl Marx/Frederick Engels, *Collected Works*, vol. 6 (New York: International Publishers, 1976) 163.

Slavoj Zizek, excerpt from 'Kant as a Theoretician of Vampirism', *Lacanian Ink*, 8 (Spring 1994) 21–9.

Jeff Wall
Interview with Arielle Pelenc:
On *The Vampire's Picnic*//1996

Pelenc *The Vampires' Picnic* (1991) is certainly a prose poem. I saw it as a kind of reversed and dark version of the Paris myth, a kind of disintegration of the aesthetic judgement, and this interiorized violence, this emotional and pictorial discord seems to have something to do with the symbolic function.

Wall The feelings of violence in my pictures should be identified with me personally, not with the pictorial form. These images seem necessary to me; the violence is not idiosyncratic but systemic. It is repetitive and institutionalized. For that reason I feel it can become the subject of something so stable and enduring as a picture. The symbolic function we call the Name of the Father appears in a process of masking and unmasking, and perhaps of re-masking. The work of art is a site for this process, and so the work potentially is involved in masking. But, from that it is difficult to move to an essential identification of any artistic form with masking alone. This would be to single out that form as so different that it would have to have a category all of its own. Any image of a male has to include in some way the identity with the Father, and so all the problems involved with that are evoked just in the process of depiction. Rather than dominating and organizing that experience, the picture sets it in motion in an experimental universe, in a 'play', including a play with tropes of depiction, a play of styles. For example, I think that the nude in *The Vampires' Picnic* signifies the Father function. I wanted to make a complicated, intricate composition, full of sharp details, highlights and shadows in the style of German or Flemish mannerist painting. This style, with its hard lighting and dissonant colour, is also typical of horror films. I thought of the picture as a depiction of a large, troubled family. Vampires don't procreate sexually; they create new vampires by a peculiar act of vampirism. It's a process of pure selection, rather like adoption; it's based in desire alone. A vampire creates another vampire directly, in a moment of intense emotion, a combination of attraction and repulsion, or of rivalry. Pure eroticism. So a 'family' of vampires is a phantasmagoric construction of various and intersecting, competing, desires. It's a mimesis of a family, an enactment of one. I thought of my vampire family as a grotesque parody of the group photos of the creepy and glamorous families on TV shows like *Dynasty*. [...]

Jeff Wall, excerpt from 'Arielle Pelenc in dialogue with Jeff Wall', in Thierry de Duve, Arielle Pelenc and Boris Groys, *Jeff Wall* (London: Phaidon Press, 1996) 20–1.

Beatriz Colomina
The Architecture of Trauma: On Louise Bourgeois//1999

Art is the experiencing – or rather – the re-experiencing of trauma.[1]
I cannot get out of the house. I want to. I have to. I would like to. I was planning to, but I gave up at the last minute.[2]
– Louise Bourgeois

I

'Baudelaire', writes Walter Benjamin, 'speaks of a duel in which the artist, just before being beaten, screams in fright. This duel is the creative process itself.'[3] Benjamin could have been writing about Louise Bourgeois, who says, 'At the beginning there is panic, and there is an absolute survival instinct to put order around you in order to escape the panic'.[4] But if, for Baudelaire, the figure of shock is connected to the experience of life in the metropolis, for Bourgeois, shock is connected to domestic spaces. To escape the panic, she reconstructs these spaces, reconstructs them precisely to get rid of them.

All of Bourgeois' work is rooted in memories of spaces she once inhabited, from the houses of her childhood in Paris, Aubusson, Choisy, Antony – to the multiple apartments she lived in New York City, the country house in Easton, Connecticut, her studio in Brooklyn and the brownstone on West 20th Street where she continues to live today. Houses figure prominently in her stories, in the innumerable interviews, the diaries, photographs, drawings, sculptures and even titles of her work. The result is that we know, intimately, where she has lived, more intimately, in fact, than is common with artists (except, symptomatically, in the case of architects). Bourgeois describes herself as 'a collector of spaces and memories',[5] and offers us countless lyrical recollections of spaces going back to her early years. [...]

If all of Bourgeois' work is concerned with the physical locations of her memories, these spaces are all domestic and all associated with trauma. Aubusson, for example, is where the family moved during the war, to a house where Bourgeois' mother and grandmother had a tapestry atelier opposite the Creuze River and the local slaughterhouse. Bourgeois recalls the sound of war coming into the house, invading the very space that was meant to be a refuge from the war:

> I remember the soldiers used to come back from the front in the night. There were
> whole trains full of people who were wounded at the front and you would hear

them in the night ... I was in Aubusson because my parents had packed us away to live in the mountains so that we wouldn't be so near the front, but you could hear the wounded all the time.[6]

The war also starts a lifelong sense of dislocation. When her father volunteers for military service at the outbreak of World War I, the young Louise is repeatedly taken to the front by her mother, who anxiously follows her husband from camp to camp. 'I remember her nervousness', she says, 'and I remember my pain at the time'.[7] The father is wounded. Then wounded again. The disruption of the house becomes a disruption of the body, and a new form of dislocation as Louise travels from hospital to hospital, enveloped by the disturbing sight of fragmented bodies. House, war, slaughterhouse become indistinguishable. The sound of war becomes the sound of her mother crying, as her father returns one more time to the battle, a sound she will 'always remember'.[8]

Bourgeois' lyrical descriptions of domestic life effortlessly slide into descriptions of traumatic events. The artworks emerge out of this slippage between lyrical narrative and traumatic experience. After the war, for example, the family moves to the outskirts of Paris, to a property in Antony that again includes a house and a tapestry atelier and gardens that are separated by the banks of a river (the Bièvre) [...] But soon the idyllic scene is disturbed. Bourgeois discovers, through the gossip of the woman working on the tapestry, that her live-in English tutor, Sadie, is sleeping with her father. Bourgeois will return again and again to this primal scene of betrayal, sometimes suggesting that the rage provoked by that situation, which lasted a decade, is the motor of her work.

How is it that in a middle-class family this mistress was a standard piece of furniture? Well, the reason is that my mother tolerated it! And this is the mystery.[9]

Sadie is a part of the house, a piece of furniture in a house where furniture is not taken lightly. Her father 'had a passion for fine furniture'. Antique chairs, for example, were suspended from the ceiling in the attic, a display that Bourgeois regards as the origin of her hanging pieces.[10] What seems to be the major offence is that Sadie lived in the house, even in a complex household of workers and family members, symptomatically described by Bourgeois as floating body parts '25 petites-mains' working on the tapestry.[11] Sadie will have to be detached from the house, killed outside by the river, twisted like a tapestry. The twisting will be a means of revenge and a means of art, art as revenge:

The spiral is important to me. It is a twist. As a child, after washing the tapestries in the river, I would twist them with three others or more to wring the water out.

Later I would dream of getting rid of my father's mistress. I would do it in my dreams by twisting her neck. The spiral – I love the spiral – represents control and freedom.[12]

The spiral exorcises the out-of-control domestic situation of her parent's house. It becomes a dominant figure in her work. As she often says: 'The spiral is an attempt at controlling the chaos'.[13] The spiral is a means of establishing order, constructing a space that can be entered and yet there is no clear line between inside and outside. The spiral is a space that closes and opens at the same time, a space that progressively reveals itself.

Sadie is not the only piece of furniture turned into art. In a far more sanguine story, Bourgeois describes the dining table of her childhood as the site of her 'first work of art ... *une poupée de pain*:[14]

I was drawn into art because it isolated me from difficult dinner conversations where my father would brag about how good and wonderful he was... I took white bread, mixed it with spit and moulded a figure of my father. When the figure was done, I started cutting off the limbs, with a knife. I see this as my first sculpture solution. It was right for the moment and helped me. It was an important experience and certainly determined my future direction.[15]

Une poupée de pain, a bread doll, a doll of pain. Bourgeois discovers art as therapy, at the age of eight, at the dinner table. It worked for the moment. It helped her. It determined her future direction, conceptually and formally. The connection between art, therapy and domestic space will never leave her. No wonder she received an Honorary Award in 1943 for her tapestry work in 'The Arts in Therapy', an exhibition that promoted artistic and craft activities as part of a rehabilitation program for those who were wounded in the war.[16] She had been practising all her life.

For Bourgeois, art is always a form of therapy. It prevents the artist from going mad, from becoming a criminal. 'To be an artist is a guarantee to your fellow humans that the wear and tear of living will not let you become a murderer.'[17] And the way to avoid becoming a murderer in life is to become one in your work: 'I am my art, I am the murderer. I feel for the ordeal of the murderer, the man who has to live with his conscience.'[18] If in life, Bourgeois sees herself as a victim, in art she regains control by selecting her victim.

In one sense, Louise Bourgeois becomes Louis Bourgeois, the father, who must be 'liquidated' because he 'liquidated' her.[19] Louis Bourgeois had a bad temper and was prone to exploding at the dinner table. These outbursts were such a common experience that Louise's mother kept a pile of saucers near him

at the table, so he would break the crockery rather than yell at the children. Louise will often break things to make art. In fact, she will often break her own art. In a television documentary, *Chère Louise* (1995), Bourgeois breaks a piece crockery as she recounts the story of her father's behaviour at the dinner table, smashing it against the floor to demonstrate the sound, and smiles.[20]

II

More than fifty years later, Bourgeois returns to the scene of her first crime, to the dining table that still haunts her, for one more murderous piece: *The Destruction of the Father* (sometimes titled *Le Repas du Soir [The Evening Meal]*, shown at 112 Greene Street in 1974. Here, the primary materials will not be bread and spit, for Bourgeois will descend upon New York's Meat Market district and buy dozens of animal limbs in order to make the piece out of actual flesh.

> I went down to the Washington Meat Market on Ninth Avenue and got lamb shoulders, chicken legs and cast them all in soft plaster. I pushed them down into it, then turned the mould over, opened it, threw away the meat and cast the form in latex... I built it here in my house. It is a very murderous piece, an impulse that comes when one is under too much stress and turns against those one loves most.[21]

Can we forget that Bourgeois lived across the street from a slaughterhouse during World War I? And what to make of that photograph of her, in the basement of her brownstone on 20th Street, against a brick wall, her shadow merging with a big stain on the wall that suggests blood, below a straight line of animal limbs prepared for *The Destruction of the Father*, looking up to them?[22]

But more important than how the piece was done, and what it represents, is why it was made in the first place, the childhood trauma that triggered the piece (as if crime in art needed an explanation or justification) and how the therapy worked:

> Now the purpose of *The Destruction of the Father* was to exorcise the fear. And after it was shown ... I felt like a different person... Now, I don't want to use the term *thérapeutique*, but an exorcism is a therapeutic venture. So the reason for making the piece was catharsis. What frightened me was that at the dinner table, my father would go on and on, showing off, aggrandizing himself. And the more he showed off, the smaller we felt. Suddenly there was a terrific tension, and we grabbed him - my brother, my sister, my mother – the three of us grabbed him and pulled him onto the table and pulled his legs and arms apart – dismembered him, right? And we were so successful in beating him up that we ate him up... The recall was so strong, and it was such a lot of work, that I felt like a different

person. I felt as if it had existed. It really changed me. That is the reason artists go on – it's not that they get better and better, but they are able to stand more.[23]

But how? By recreating the spaces, the figures, and then mutilating them, dismembering them, cutting their parts out. And if the bodies are identified with the spaces, the spaces will also be cut, as when a guillotine passes right through an exact model of one of the houses of her childhood in *Cell (Choisy)* (1990–93). Arms are sliced off. Rooms are cut in half. It is not that Bourgeois reproduces the houses in order to recreate them as presences, as places to inhabit. She reproduces them in order to liquidate them and consume them. Her sculpture starts at the dinner table with a wounded father who wounds his family and is cut into pieces. The *Destruction of the Father* returns to finish the bloody job that the original bread-and-spit sculpture began. […]

Body parts dominate her work. In fact, they keep returning, even in edible form, at times arranged in banquets. In the artist's installation *Confrontation* (1978), the biomorphic forms from the interior space of *The Destruction of the Father* are laid out on a long dining table. The performance piece *A Banquet/A Fashion Show of Body Parts* is then enacted around this table. The shapes laid out on the table like food are worn as clothing. Unable to eat (not by chance Bourgeois is a vegetarian), the multiple body parts are worn outside rather than consumed inside. Bodies are wrapped in body parts. Or rather, they form whole new bodies. Bourgeois will happily wear one of the costumes from the performance as a new body while standing in public outside her brownstone in New York, and in the even more public space of the pages of *Vogue*.[24]

> This is a sort of 'show off'. I am delighted to have all these, lets call them mammaries… breasts. I made them big, and lots of them. And since I know men like that – they've told me so – I put that cloak on, and if you look at the expression on my face, you can see I am happy.[25]

Let us shift from the dining table to the bed with *Red Rooms* of 1994. Not such a big move, since she has already told us that the bed and the dining table are the same thing. The dining table in *Confrontation* is also a 'stretcher for transporting someone wounded or dead',[26] and *The Destruction of the Father* 'represents both a table and a bed'.[27]

> When you come into a room, you see a table, but also, upstairs in the parents' room is the bed. Those two things count in one's erotic life: dinner table and bed. The table where your parents made you suffer: And the bed where you lie with

your husband, where your children were born and you will die. Essentially, since they are about the same size, they are the same object.[28]

Red Rooms was inspired by the apartment Bourgeois lived in as an infant at 172 Boulevard Saint-Germain on the fourth floor, above the Café de Flore. Her parents' bedroom was decorated in the Directoire style, all in red. 'There was red *toile de Jouy* on the walls, and the curtains had a red decorative motif with red silk lining. The rugs, which were never nailed to the floor so that they could be easily shaken out of the window, were red as well.'[29] Echoing her parents' bedroom, Bourgeois designs two bloody rooms in 1994, *Red Room (Parents)* and *Red Room (Child)*.

They are both labyrinthine, if not claustrophobic, spaces. You enter the *Parents* room through the narrow passage between two curved walls made out of old dark wooden doors until you are suddenly faced with an unexpected scene. The visitor is thrown into a domestic space. A double bed in the centre is covered with a red hard surface, which turns it into a table. Soft red pillows are interrupted by a small white pillow embroidered with cursive red letters that say '*je t'aime*'. On the bed/table, a curiously shaped musical instrument case and the red caboose of a toy train on tracks are sinister, menacing presences. A large oval mirror at the foot of the bed witnesses the disconcerting scene.

The *Child* room is similarly set within a spiral made out of old doors, but a window has been cut in one so that visitors can see into the room before entering. The word 'private' is written on the glass. Inside, nothing can be reconciled with the traditional domestic scene. And yet the space is filled with objects from Bourgeois' domestic world: spools of red and blue thread, red candles, gloves, kerosene lamps, red wax hands... An amputated hand is as domestic here as a typical piece of furniture.

In response to the traumatic architecture of her youth, Bourgeois comes up with another architecture. It is not a therapeutic architecture in the sense of spaces cleansed of horror but rather, an architecture of trauma that re-enacts the horror, exposes it. The table and the bed are scenes of killing.[30] Meat is dismembered, blood flows:

> Red is the colour of blood
> Red is the colour of pain
> Red is the colour of violence
> Red is the colour of danger
> Red is the colour of shame
> Red is the colour of jealousy
> Red is the colour of grudges
> Red is the colour of blame.[31] [...]

1 Louise Bourgeois quoted in Jeremy Strick, 'Sculpting Emotion', *Louise Bourgeois: The Personages* (Saint Louis: The Saint Louis Art Museum, 1994) 8.

2 'The View from the Bottom of the Well', a text from the 1960s first published in 1996 by Peter Blum Editions, New York; reprinted in Marie-Laure Bernadac and Hans-Ulrich Obrist, eds, *Louise Bourgeois, Destruction of the Father, Reconstruction of the Father: Writings and Interviews 1923–1997* (London: Violette Editions, 1998) 343.

3 Walter Benjamin, 'On Some Motifs in Baudelaire', *Illuminations*, ed. Hannah Arendt (New York: Schocken Books, 1968) 163.

4 Bourgeois quoted in Marsha Pels, 'Louise Bourgeois: A Search for Gravity', *Art International* (October 1979) 48.

5 Louise Bourgeois, 'Collecting: An Unruly Passion', artist's review of the book *Collecting: An Unruly Passion* by Werner Muensterberger (1993) first published in *Artforum*, vol. 32, no. 10 (Summer 1994); reprinted in Bourgeois, *Destruction of the Father, Reconstruction of the Father*, op. cit., 276.

6 Unpublished interview with Nena Dimitrijevic, 1994. (Louise Bourgeois Archive.)

7 'I was born at the outbreak of the 1914 war, and the first thing I knew is that my father was mobilized ... it made my mother very nervous ... unhappy. She started to follow my father from camp to camp, and my brother and sister were left home with my grandparents, and I was carried around by my mother to meet him in different places in Eastern France. I remember her nervousness, and I remember my pain at the time'. Lynn Blumenthal and Kate Horsfield, 'Louise Bourgeois', Video Data Bank, Art Institute Chicago, 1975.

8 'I was very young in 1917, but I always remember Maman crying when Papa went back after he was wounded for the second time'. Louise Bourgeois, 'Letters to Colette Richarme, 1937–1940', *Destruction of the Father*, op. cit., 37.

9 [footnote 12 in source] 'Louise Bourgeois: Album', first published in 1994 by Peter Blum Editions, New York, and based on the 1983 film *Partial Recall* (New York: Museum of Modern Art); reprinted in ibid., 283–4.

10 [13] 'There was a *grenier*, an attic with exposed beams. It was very large and very beautiful. My father had a passion for fine furniture. All the *sièges de bois* were hanging up there. It was very pure. No tapestries, just the wood itself. You would look up and see these armchairs hanging in very good order. The floor was bare. It was quite impressive. This is the origin of a lot of hanging pieces'. Louise Bourgeois, 'Self-Expression is Sacred and Fatal Statements', in Christiane Meyer-Thoss, *Louise Bourgeois, Konstruktionen für dein freien Fall/Designing for Free Fall* (Zurich: Ammann verlag, 1992) 185.

11 [14] Louise Bourgeois, speaking of *Cell (Choisy)* (1990–93), says: 'This is the house were we lived and where the tapestry workshops occupied the second wing of the house here and there were 25 *petites-mains*, which worked on the tapestry'. 'Arena', edited transcript of interview with Bourgeois from the 1994 documentary film directed by Nigel Finch for Arena Films, London, and broadcast by BBC2, in *Destruction of the Father*, op. cit., 257.

12 [15] Louise Bourgeois in Paul Gardner, *Louise Bourgeois* (New York: Universe Publishing, 1994) 68.

13 [16] Louise Bourgeois, 'Self-Expression is Sacred and Fatal Statements', in Meyer-Thoss, *Louise*

Bourgeois, op. cit., 179. 'The spiral is completely predictable. A knot is unpredictable.' Bourgeois, 'Statements from Conversations with Robert Storr', in *Destruction of the Father*, op. cit., 220.

14 [17] 'My first work of art was *une poupée de pain*' Louise Bourgeois in conversation with Jerry Gorovoy, 1996. (Louise Bourgeois Archive).

15 [18] Jennifer Anne Luterman, *Louise Bourgeois: Interpreting the Maternal Body*, unpublished thesis, 1995. (Louise Bourgeois Archive).

16 [19] Rainer Crone, Petrus Graf Schaesberg, *Louise Bourgeois: The Secret Life of the Cells* (Munich, London, New York: Prestel, 1998) 33.

17 [20] Louise Bourgeois, 'Select Diary Notes', 27 August 1984, *Destruction of the Father*, op. cit., 131.

18 [21] Louise Bourgeois, 'Self-Expression is Sacred and Fatal Statements', in Meyer-Thoss, *Louise Bourgeois*, op. cit., 195.

19 [22] 'It is, you see, an oral drama. The irritation was his continual verbal offence. So he was liquidated: the same way he liquidated his children.' Louise Bourgeois, 'Statements 1979', *Destruction of the Father*, op. cit., 115.

20 [23] *Chère Louise* (1995), documentary directed by Brigitte Cornand for Canal +.

21 [24] Louise Bourgeois, 'Statements 1979', *Destruction of the Father*, op. cit., 115–6.

22 [figure 16 in source] Louise Bourgeois posing with pieces for *The Destruction of the Father*, 1974.

23 [25] Louise Bourgeois, 'Statements from an Interview with Donald Kuspit', first published in 1988 in Donald Kuspit, *Louise Bourgeois*; reprinted in *Destruction of the Father*, op. cit., 158.

24 [28] Carter Ratcliff, 'Louise Bourgeois', *Vogue*, vol. 170, no. 10, (October 1980) 343–4; 375–7.

25 [29] Interview by Bernard Marcadé for the film *Louise Bourgeois*, by Camille Guichard, Terra Luna Productions, Serie Mémoire / Centre Georges Pompidou, Paris 1993.

26 [30] '*Confrontation* (1978) represents a long table surrounded by an oval of wooden boxes, which are really caskets. The table is a stretcher for transporting someone wounded or dead.' Bourgeois, 'Self-Expression is Sacred and Fatal Statements', in Meyer-Thoss, *Louise Bourgeois*, op. cit., 182.

27 [31] Louise Bourgeois, 'Statements 1979', *Destruction of the Father*, op. cit., 115.

28 [32] Ibid., 115.

29 [33] Louise Bourgeois in conversation with Jerry Govoroy, 1999. (Louise Bourgeois Archive)

30 [34] Bourgeois witnessed her sister Henriette being fondled by a neighbour, resisting him 'for the simple reason that she was menstruating'. She sees blood. She thinks that he is killing her. 1997 comment by the artist on a 1973 diary note, *Destruction of the Father*, op. cit., 71.

31 [35] Louise Bourgeois, quoted in *Louise Bourgeois: Oeuvres récentes/Recent Work* (Bordeaux: capcMusée d'art contemporain de Bordeaux, 1998) 40.

Beatriz Colomina, excerpt from 'The Architecture of Trauma', in *Louise Bourgeois: Memory and Architecture* (Madrid: Museo Nacional Centro de Arte Reina Sofía, 1999) 29–35.

Amelia Jones
Paul McCarthy's Inside Out Body and the Desublimation of Masculinity//2000

Soft Dick

In the performance video *Family Tyranny* (1987) McCarthy, with the help of Mike Kelley, performs a perverted Oedipal narrative wherein, as he chants at the beginning of the videotape, 'the father begat the son; the son begat the father'. The piece enacts an exaggerated narrative of paternal authority and, in so doing, lays bare the failure of its frantic attempt to secure masculinity by repressing the boy's masturbatory pleasure in his (removable) organ. First, McCarthy tortures a 'head' made of Styrofoam, stuffing a funnel into its 'mouth' and pouring in a viscous white liquid; this 'cum' spews out of the mouth end of the funnel as he says in a singsong voice 'my daddy did this to me... You can do this to your son too... Do it slowly... They'll remember it, don't worry...'

Intercut with this scenario of paternal punishment (making the 'son' eat the residue of masturbatory release) are scenes of McCarthy, the 'father', punishing his 'son', played by Mike Kelley. He puts a metal bowl on his son's head saying menacingly 'you're going to be sorry you have me for a dad... You little piece of shit'. The son tries desperately to escape the architectural confines of his family trauma, pushing his head out of a fake 'window' then putting his head in a bag. The sexual dimension of this Oedipal drama is made clear in a penultimate scene wherein the son lies under a small table wrapped in a blanket while the father pounds into a bowl of white liquid above his head; the son mutters 'uh, uh, uh' in concert with the father's thrusts as if the two are copulating.

In masturbating, Freud asseverates, the boy acts to ensure the inexorable presence of his male organ – in this sense it is an act of disavowal (as in, 'I can be castrated and yet I can't because here it is'). And yet it is also masturbation that occasions the parental prohibition instilling the first instance of the fear of castration ('the threat is uttered that this highly valued part of him will be taken away').[1] McCarthy has the son 'masturbate' along with the father: after all, it is not only the father who begets the son – the son also, through his own relationship to paternal authority, begets the father (that is, heterosexual masculinity takes its shape – its coherence and privilege – through those it opposes and subordinates).

In *Family Tyranny*, as in the other works discussed [elsewhere in the essay], the 'private' space of the home, container of the Oedipal drama, becomes a nightmarish cage; the son can only escape by announcing 'time to go to school, Dad' at the end of the story, little knowing that the state institution will

exacerbate rather than relieve his Oedipal trauma, forcing him to transfer his repressive relationship with his father to a sublimatory relationship with state authority. At the same time, while the son *will* escape, and still has a chance to make something (non-patriarchal?) out of himself, it is the father who is truly trapped in the generational malaise that perpetuates masculinity and its privileges. Finally, though, the scariness of McCarthy's brutality is, as usual, mitigated by the buffoonery of his attempts at domination. The son seems to call the shots as the father flails around helplessly, his bark being worse than his bite. The father is forever trapped in the architecture of his own psyche, itself – in patriarchy – predetermined in its structure by the anatomical destiny of his penis-wielding body. [...]

1 [footnote 35 in source] Freud, 'The Passing of the Oedipus-Complex', trans. Joan Rivière, in *Sexuality and the Psychology of Love*, ed. Philip Rieff (New York: Collier Books, 1963) 177.

Amelia Jones, excerpt from 'Paul McCarthy's Inside Out Body and the Desublimation of Masculinity', in Dan Cameron and Lisa Philips, eds. *Paul McCarthy* (New York: New Museum of Contemporary Art and Ostfildern-Ruit: Hatje Cantz Verlag, 2000) 130–1.

Nancy Spector
Only the Perverse Fantasy Can Still Save Us:
On Matthew Barney//2002

Cremaster 2

[...] *Cremaster 2* is structured around three primary interrelated themes – the landscape as witness, the story of Gilmore, and the life of bees – that metaphorically describe the emancipatory potential of moving backward in order to escape one's destiny. The narrative begins and ends in glacial chasms, a device that metonymically suggests the migration of a glacier from northern Utah to southern Canada, its retreat forging the desert-like salt flats, the Great Salt Lake and the dramatic gorges of the Rocky Mountains, which all play roles in the film. The environment depicted is the barren frontier of the early Mormon settlers, religious separatists carving out their own Zion on American soil, where the ten lost tribes of Israel were one day to reunite. An avenging people with occultist tendencies, the original Mormons taught that redemption could only be obtained through 'blood atonement', the actual spilling of a sinner's blood on the earth. Such was the legacy that Gilmore, himself a Mormon, inherited.

Having established the western landscape as a character, Barney proceeds by weaving together Gilmore's biography and the behaviour of the bee colony, symbol of Utah and of Mormonism. Both Gilmore's kinship to Houdini and his correlation with the male bee or drone is established in the séance/conception scene in the beginning of the film. All the participants – Fay; her son, Frank; and Frank's wife, Bessie – wear corsets under their turn-of-the-century garb, and they sit in stylized chairs that reiterate the constriction of their wasp waists. Less a fashion than a fetishistic process promising pleasure through the endurance of pain, corseting is a verb.[1] In Barney's depiction of the Gilmore family, it represents an act of extreme control, and alludes to the questions that Gary's execution will raise about the efficacy of volition in the face of destiny. Summoning forth Houdini's spirit, Fay's psychic intervention – complete with ectoplasm and pollen – induces a meditative sex act between Frank and Bessie, which is intercut with scenes of the magician's metamorphosis. At the moment of climax, Frank's torso begins to putrefy, and a bee flies from the hive at the head of his penis. Destroyed during the act of fertilization, as a drone bee is doomed to death after mating with the queen, Frank creates another drone – his son Gary. From the moment of his inception, then, Gary's destiny is sealed.

Gilmore's profound awareness of his own condemnation, of his irreversible role as drone, is expressed in the ensuing scene through a chain of metonymic signifiers that could only come together within the poetic space of the

Cremaster cycle. The setting is a recording studio where Dave Lombardo, a former member of the thrash speed-metal band Slayer, is pounding out a drum solo to the buzzing sound of thousands of swarming bees. (The score was written by Barney-collaborator Jonathan Bepler.) A man in black leather, with the voice of Steve Tucker, lead vocalist of the death metal band Morbid Angel, growls into a telephone. He is shrouded by bees. Collectively these figures allude to the country star Johnny Cash, who is said to have called Gilmore on the night of his execution in response to the convict's dying wish. The lyrics are Gilmore's own, excerpted from letters published in *The Executioner's Song*:

> The ghosts have descended and set upon me with a force
> I smack 'em down but they sneak back and climb in
> Demons that they are tell me foul jokes
> They want to sap my will, drink my strength, drain my hope
> Lost empty foul dream motherfuckers...
>
> Weave a web of oldness
> Oldness pull in harness
> Like oxen a wood creaking
> Tumbrel a grey wood
> Tumbrel through the cobbled streets
> Of my ancient mind

The transmutation of Cash into the Lombardo/Tucker/death-metal matrix connects Gilmore's lamentations about being haunted by 'oldness' to the dark undertow of heavy metal music's flirtation with satanic lore. It suggests that Gilmore's destiny of being annihilated like a drone had its roots in previous lifetimes, in an ancient curse passed through his paternal lineage.[2] [...]

In Barney's interpretation of the execution, Gilmore was less interested in attaining Mormon redemption than in performing a chronological two-step that would return him to the space of his grandfather Houdini, with whom he identified the notion of absolute freedom through self-transformation. Seeking escape from the bonds of his fate, he chose death in an act of ultimate self-will. 'In about 30 hrs. I will be dead', he wrote to Nicole. 'That's what they call it – death. It's just a release – a change of form'.[3] Gilmore's metaphoric transportation back to the turn of the century is rendered in a dance sequence featuring the Texas two-step accompanied by Nicole Baker's lamentation:

> For lost is my mind

Silent by dawn
Loves away stolen
And hurting is long [...]

1 [footnote 59 in source] 'Endurance is precisely the quality required for body-sculpture, because the tight-lacer's ultimate objective is to extend the erotic experience in time. Unlike "pure" sadomasochists, sculptural fetishists aim less for the momentary violent ecstasy than to prolong a state of just-bearable tension.' David Kunzle, *Fashion and Fetishism: A Social History of the Corset, Tight-Lacing and Other Forms of Body-Sculpture in the West* (Totowa, New Jersey: Rowman and Littlefield, 1982) 37.

2 [60] Mikal Gilmore, younger brother of Gary Gilmore, suggests this notion of a family curse in his memoir *Shot in the Heart* (New York: Doubleday, 1994). The reference to heavy metal music also functions similarly to Barney's use of the Oakland Raiders as a symbol in his work: the Raiders – whose banner 'Commitment to Excellence' appears in the back of the recording studio – are a favourite team of Barney's, just as Slayer is one of his favourite bands.

3 [66] Gary Gilmore, quoted in Norman Mailer, *The Executioner's Song* (New York: Warner Books, 1979) 857.

Nancy Spector, excerpt from 'Only the Perverse Fantasy Can Still Save Us', *Matthew Barney: The CREMASTER Cycle* (New York: The Solomon R. Guggenheim Foundation, 2002) 36–40.

Hal Foster
American Gothic: On Robert Gober//2005

Robert Gober once described his installations as 'natural history dioramas about contemporary human beings', and, like many dioramas, they mix the real with the illusionistic in ways that both fascinate and disorient us. With his recent project at Matthew Marks Gallery, his first New York show in more than a decade, it was the aftermath of 9/11 that we revisited as if in a waking dream. At stake was the question of how to work through this present-past (Gober began the project soon after the Al Qaeda attacks and completed it soon before the last presidential election) – how to be sensitive, at once, to its human tragedy, political exploitation and cultural sentiment.

Entering the gallery, we saw a knotty plank of faux wood in unpainted plaster leaning against a wall, an item somewhere between refuse and relic. Then, in the exhibition space proper, were two stacked garbage cans (also in unpainted plaster) covered by a sheet of plywood on which lay the folded shirt of a priest and a newspaper clipping showing a female delegate to the Republican Convention mocking the Purple Heart awarded John Kerry. This makeshift pulpit opened onto two rows of three dirty-white slabs, which, though bronze, were made to look like leftover Styrofoam. Like a plinth, each slab supported a particular object, which, as is typical of Gober, appeared readymade but was handcrafted. First, to the left, was a plank of faux wood in bronze (malformed, it seemed both molten and petrified) and, to the right, a bag of diapers (made of plaster sealed in commercial packaging that was both meticulously reproduced and slightly altered); then a milk crate with three more diaper bags and another plank (also in bronze); and, finally, two glass bowls filled with large pieces of fruit that looked plastic but were beeswax.

The presentation of these things was at once forensic, like evidence laid out in a police warehouse or morgue, and ritualistic: We walked through the rows as down a chapel aisle. And, in fact, on the far wall hung a crucified Christ (the figure was cement, the cross bronze like the planks, with an artificial robin perched on it). Decapitated as if vandalized, this Jesus was flanked, in the customary positions of the two Marys, by spare tokens of suburban life: a white chair that looked plastic but was glazed stoneware (a yellow rubber glove hung from one arm) and a carton of yellow bug-lights in blown glass. Like additional stigmata turned into tacky spouts, the nipples of the beheaded Christ gushed steady streams of water into a round hole cut roughly into the floor. Clearly, Gober was working with the nastier bits of contemporary American kitsch,

drawing equally on Wal-Mart goods and churchyard displays.[1]

To the sides of this brutal crucifix were two doors wedged open a crack to show spaces bright with light. Peeking in we saw white bathtubs with flowing taps occupied, to the left, by two male legs and, to the right, by two female legs (to the side of each tub lay sections of the *New York Times* given over to the Starr Report). At this point, more than a little puzzled, we turned and noticed, in the opposite corners of the gallery, two torsos in beeswax that mirrored one another, each with one male breast and one female breast. A familiar Gober motif, these bisexed torsos sprouted from the crotch one male leg (dressed with sock and shoe) and three branches in faux wood (bark also appeared on the legs). At this point, too, we saw the four framed pictures hung on each side wall (perhaps like stations of the cross), all made up of individual spreads from the front section of the *New York Times* of 9/12 (on the east wall the pages were literally reversed, as if seen in a mirror). Gober had drawn over the reports and photos of the Al Qaeda attacks with images (in pastel and graphite) of commingled body parts; it was left to each viewer to decide whether they were male, female or both. These nude bodies were locked in different embraces that seemed erotic but, in the context of 9/11, might be deathly as well; they were body parts, after all, and some were shown, clinging in ways that could suggest grief. The pictures seemed to be keys to the work; yet, finally, they were as enigmatic as any other of its elements.

As usual with Gober, the installation is a broken allegory that both elicits and resists our interpretation; that, materially, nothing is quite as it seems adds to our anxious curiosity. We might draw art-historical connections to the assisted readymades and tableaux of Duchamp (especially *Étant donnés*), the paradoxical illusions of images and space in Magritte, as well as to various biblical representations (Gober featured a Virgin with a drainage pipe cut through her middle in his 1997 installation at the Los Angeles Museum of Contemporary Art), the *Bacchus* of Caravaggio (recalled by the bowls of fruit), the severed body parts painted by Géricault, and so on. (Brenda Richardson searches widely for such references in her ambitious catalogue essay for the show.) Yet these associations take us only so far, and, as again usual with Gober, they are complicated, even undercut, by allusions to topical events that are both momentous (9/11) and banal (a soak in a bath). In this way different levels of allegorical reading are set up, from the anagogic to the literal, but they are fragmentary, and the real disrupts the symbolic (the tacky elements around the crucifix) just as the symbolic haunts the real (the amorous bodies over the 9/11 reports). A similar confusion disturbs the oppositions in play between male and female, human and inhuman, public and private, and scared and profane. Almost in a caricature of Lacanian psychoanalysis, the two bathrooms, the emblematic

markers of gender difference, seem to govern all the oppositions, yet each binary is broken down, rendered ambiguous: male and female, human and inhuman, are combined in the grotesque torsos; public and private come into contact in the *Times* pages and through the bathroom doors; and sacred and profane collide in the crucifix scene. In this confusion a subtle ambivalence is created in every object, image and space.

Gober effectively adapts the intrinsic ambiguity of the still life. Usually an offering of food that is also a withholding (for the food is never real), a still life is a cold gift, a *nature* that is precisely *morte*, a *vanitas* whose beauty stings with a reminder of death. Here the beeswax fruit is artificial, the hardened diapers are ominous (they may recall the rat poison or the kitty litter in other Gober installations), the Styrofoam is unrecyclable, and the wood reified; in fact, Gober shows the entire world changed for the worse. The molten material, mortuary slabs and commingled limbs evoke a historical hell that combines the post-attack space of the Twin Towers with the bomb sites of Iraq: It is both hideous morgue and hallowed ground, wasteland and reliquary. Implied here, too, is a political continuum in which the trauma of the 9/11 attacks was troped by the Bush administration into the triumphalism of the war on terror, replete with the rhetorical coercion of the last election (whereby to oppose Bush was to appease the terrorists, to betray the troops, and so on). And Gober implicates us in this debacle: Again, private and public spheres touch (the bathers next to the crucifix), even interpenetrate (the bodies drawn on top of the newspapers); and we readers of the *Times* seem passive compared to the implicit crusaders of the headless Christ. The installation felt like the End of Days from the point of view of those left behind.

Gober treats the new kitsch of post-9/11 America as a cultural program imposed on us. Yet he doesn't mock it: For all the ambiguity of his piece, it contains none of the sophisticated superiority found in camp and little of the secret affirmation sensed in parody. Although kitsch is all about false sentiment, it can possess a damaged authenticity, too, and Gober seems sensitive to the pathos in the expressions of loss after 9/11 (the fruit bowls on the mortuary slabs might call up the flowers, candles and other mementos left at impromptu shrines that sprang up from Trinity Church to Union Square). In this regard he adapts his aesthetic of mourning vis-à-vis the AIDS epidemic to the terrible aftermath of the attacks; and in his commingling of bodies he also suggests a persistence of love as well as of ruins, of Eros as well as of Thanatos.

At the same time, Gober seems aware of the manipulation at work in this kitsch, of the subtle blackmail that acts through its tokens: the ribbons that exhort us to 'remember our troops' (the yellow accents in the installation may key this association), the decals of the towers draped with stars and stripes,

indeed the little flags that appear everywhere from antennae to lapels, the shirts and statuettes dedicated to New York City firemen and police, and so on. These last figures have become heroes in the way that workers were in the Soviet Union (or soldiers in any number of regimes); but rather than the Communist production of a new society, they emblematize a Christian story of sacrifice and wrath – of a violation taken to underwrite a far greater violence. Yet, again, Gober doesn't treat this American kitsch ironically (as, say, Komar & Melamid treated Soviet kitsch); obliquely, he evokes the pathos even as he questions the politics.

Gober prompts us to acknowledge that a new order of totalitarian kitsch is abroad in the culture today. As the Nazis rose to power, Hermann Broch historicized kitsch as the expression of a bourgeoisie caught between an asceticism of puritanical work and an exaltation of romantic feeling; in his view this cultural bind tended kitsch toward a torturous mix of prudery and prurience, which is indeed the character of much Nazi art. A few years later, in 1939, Clement Greenberg specified the capitalist dimension of bourgeois kitsch: In his account it was an ersatz culture produced for a proletariat stripped of folk traditions. Importantly, he also elucidated how kitsch dictates its consumption through pre-digested forms. Finally, in *The Unbearable Lightness of Being* (1984), Milan Kundera elaborated on this aspect of kitsch in his evocation of an authoritarian society in which 'all answers are given in advance'. Could it be that, after the collapse of the Soviet bloc, this dictatorial dimension has returned in our own kitsch culture today? Among the signs are these: the trumping of basic civil rights by dubious 'moral values'; the brandishing of the Ten Commandments at courthouses in open defiance of the separation of church and state; the obligation of politicians to make a show of faith during any national campaign; the appropriation of 'life' (now defined as, optimally, the time between conception and birth and between coma and death) against all those who support personal autonomy on questions of reproduction and dying; and, of course, the clash of all fundamentalists – Christian, Muslim and other. It is this last connection that Gober captures in the brilliant touch of his acephalic Jesus, for condensed here is not only a reminder of the beheaded hostages in Iraq but also a figure of America in the guise of Christ the sacrificial victim turned righteous aggressor, the one who kills in order to redeem.

1 For the US Pavilion at the 2001 Venice Biennale, Gober also orchestrated an installation that mixed the sacred (rooms arrayed like chapels) and the profane (allusions to contemporary events, such as the sodomization of Haitian immigrant Abner Louima with a toilet plunger by New York City police in 1997). The faux Styrofoam plinths appeared there, too [...].

Hal Foster, 'American Gothic: On Robert Gober', *Artforum* (May 2005) 223–5.

Bruce Hainley
Teen Angle: On the Art of Sue de Beer//2004

Witnessing one of Sue de Beer's goth girls intone *I'm going to erase myself and you're going to find me everywhere*, anyone might consider such states of mind a recent phenomenon – psychic rumblings 'explaining' Columbine or Lee Malvo. Yet America has long trafficked in the gothic, been intimate with suicide, doom and destruction. Long before Poe drugged the consciousness with haunted narratives of the nothingness residing at the cold, dark heart of things, and before Hawthorne allegorized the civil state as Dr. Rappaccini keeping his child alive by rearing her on poison, Puritan preacher Jonathan Edwards put the populace in the hands of a angry God, spidery sinners dangling between heaven and the ready fires of hell. Today, television necromancer John Edward may try to provide solace instead of burning brimstone, but let's not forget, he's allowing anyone who wishes to communicate with the dead: The medium is the message, and the message is we're all caught *crossing over*, in between. And if you're still not convinced, consider the scholarship of *Vampire Lectures* author Laurence Rickels, who has augured the erotic, psychic and social hell-mouth potential of the *trans-*, which America has shifted into overdrive as an ontological *raison d'être*: Trans-Am.

In the lovely closing moment of Sue de Beer's most recent video, *The Dark Hearts* (2003), a girl in the driver's seat picks up a gloomy boy from his house for a runaway spin to a blue-screen make-out glen. The goth kiddo Adonis takes off his studded and dangling-chain leather collar and puts it around the girl's neck; she takes her double-stranded necklace of fake, pearly beads and embraces his neck with it. They daintily peck each other. A skull decal looks out at the boy from the passenger-side dashboard. The horror? The horror is the world they live in, which necessitates, instead of diary-keeping, making 'morgue entries' to figure out their lives. This is the world that's been left to them: darkness transacting in between boy parts and girl parts, in between loving and leaving, in between teen loneliness and adult existence.

De Beer's teens resonate with those night shades created by the twentieth-level wizard and theoretician of the in-between as a stat of being, Joss Whedon, the brilliant maestro of *Buffy the Vampire Slayer*. He found in Buffy and the Scooby gang the fittest embodiments for the tumult of nascent adulthood and (as the show and its characters grew) for the brutality of living in the world, where people die or stop loving or disappear or change in ways never thought possible, where the Scoobys came to understand, as they shape-shifted into their adult

selves, that the true horror isn't anything outside but the fractal gruesomeness of dealing with personal demons, psychic slaying often done alone.

De Beer reckons with what it would mean to engage much of the complexity of the show's feminist philosophy lessons and still do something different – using the teenager as both the site of her interests and as her non-site (since non-sites' out-of-context-ness situates uncertainty). In her previous photographic and video work, she's played with the teen demotic idiom of horror and gore films, video games and death metal while skilfully acknowledging artmeisters of such gooey, unstable territories, namely Mike Kelley and Paul McCarthy; but she laces her acknowledgement with the angel dust of the feminine and amps up the guys' contingent vulnerability. An early video, *Loser* (1997), shows a girl – psychic snapshot of the artist as nerd – seeming to hold her breath, tension created by the not breathing as well as by the disconcerting uncanniness of her look (achieved by the weirdly simple device of having shot herself while she hung upside down – hair tightly wound so as not to spoil the effect – but showing herself right side up). Constricting breathing can heighten orgasm, but in a more directly autoerotic self-portrait de Beer French-kisses a static but blankly blinking video image of herself (*Making Out with Myself*, 1997), which sounds straightforward enough but becomes stranger and stranger the longer it's watched: Am I you? Are you me? Is there a way out of the whirlpool of the self? Narcissus fell in love with his own reflected image; de Beer images the love-fall into the self and its infinite allegorical (video) loop. Later, she even did time collaborating with Laura Parnes on an unauthorized sequel to McCarthy and Kelley's *Heidi* (1992; *Heidi 2*, 1999–2000). More recently, in a suite of photo works from 1999-2001, de Beer places herself, at times maimed, bleeding and on the run, in large photographic 'grabs' from horror video games. No matter the strengths and graces of any of these works, they seem like test drives for her Hansel and Gretel, *Hans und Grete* (2002–3).

Guitar solos in bedrooms, tedium in the classroom and ritual sacrifices in the woods make up most of the 'action' in *Hans und Grete*, in which de Beer deploys crucial, intelligent fictive and 'real' examples of teen ontology for her own purposes, shifting even the resonances of her video's title. The two Grimm kids have been split into two pairs – Kip and Kathleen, Seth and Sean – but are played by only two actors. Abstracted, the witch has been transformed into loneliness, her gingerbread cottage – simultaneously a lure, a reprieve from hungers and a trap – into the distraction of sex. *Hans und Grete*, like Warhol's *Chelsea Girls* (1966), is a double projection, but where Warhol worked with actual groovy twenty-somethings (hanging out, waiting, getting fucked up, fucking) as a way of tracing the erotic and political consequence of now, de Beer gazes at teens, fictionalized but emotionally raw, to engage now's affect and mood – trapped in

school, testing any way of escape (music, sex, suicide, drugs, mayhem) figures of the parental present in the shadows. Both artists eschew moralizing and pay keen attention to casting, valuing being over acting – not that it's easy to separate the one transmuting into the other and back. Whatever her works' antecedents may be in portraying imaginary teenage wonder and trauma – Harmony Korine's cat killers from *Gummo*; *A Nightmare on Elm Street*'s Freddy Krueger turning a bed into a vortex of annihilating disappearance; *Tomb Raider*'s collapsing of mental and representational space; *Blair Witch*'s haunted woods; Dennis Cooper's lost muse; George Miles' Hamlet-like poetries of indecision - de Beer's trying to figure out what relation these fictions bear to (or what effect they have on) the actual: the pulverizing non-fiction of Kip Kinkle's engulfing, disruptive sadness and of Ulrike Meinhof's unnecessary demise. De Beer's results unsettle: She pares away until her spooky content reveals the natural spookiness of being in the world. At one point in *Hans und Grete*, the camera travels through a woods at dusk, and the effect is kaleidoscopic and disorienting, anamorphic, as the woods folds into itself. The only sound is of birds and wind, from the Nintendo 64 game Corker's Bad Fir Day, warping nature itself into the sign of everything against nature. It's the bramble of existence and it's a nightmare. [...]

Bruce Hainley, excerpt from 'Teen Angle: On the Art of Sue de Beer', *Artforum* (January 2004) 125–6.

EVERYONE KNOWS HOW THEIR BODY IS ORGANIZED AND HOW MANY OF EACH PART THEY HAVE; THIS IS A GIVEN AND IS NEVER THOUGHT ABOUT. TO BECOME AWARE OF THESE PARTICULARS, ONE MUST IMAGINE ONESELF UN—WHOLE, CUT INTO PARTS, DEFORMED OR DEAD

Mike Kelley, 'Playing with Dead Things: On the Uncanny', 1993/2004

THE UNCANNY: DOUBLES AND OTHER GHOSTS

Sigmund Freud
The Uncanny//1919

I

Only rarely does the psychoanalyst feel impelled to engage in aesthetic investigations, even when aesthetics is not restricted to the theory of beauty, but described as relating to the qualities of our feeling. He works in other strata of the psyche and has little to do with the emotional impulses that provide the usual subject matter of aesthetics, impulses that are restrained, inhibited in their aims and dependent on numerous attendant circumstances. Yet now and then it happens that he has to take an interest in a particular area of aesthetics, and then it is usually a marginal one that has been neglected in the specialist literature.

One such is the 'uncanny'. There is no doubt that this belongs to the realm of the frightening, of what evokes fear and dread. It is equally beyond doubt that the word is not always used in a clearly definable sense, and so it commonly merges with what arouses fear in general. Yet one may presume that there exists a specific affective nucleus, which justifies the use of a special conceptual term. One would like to know the nature of this common nucleus, which allows us to distinguish the 'uncanny' within the field of the frightening. [...]

II

If we now go on to review the persons and things, the impressions, processes and situations that can arouse an especially strong and distinct sense of the uncanny in us, we must clearly choose an appropriate example to start with. E. Jentsch singles out, as an excellent case, 'doubt as to whether an apparently animate object really is alive and, conversely, whether a lifeless object might not perhaps be animate'.[1] In this connection he refers to the impressions made on us by waxwork figures, ingeniously constructed dolls and automata. To these he adds the uncanny effect produced by epileptic fits and the manifestations of insanity, because these arouse in the onlooker vague notions of automatic – mechanical – processes that may lie hidden behind the familiar image of a living person. Now, while not wholly convinced by the author's arguments, we will take them as a starting point for our own investigation, because he goes on to remind us of one writer who was more successful than any other at creating uncanny effects.

'One of the surest devices for producing slightly uncanny effects through story-telling', writes Jentsch, 'is to leave the reader wondering whether a particular figure is a real person or an automaton, and to do so in such a way that

his attention is not focused directly on the uncertainty, lest he should be prompted to examine and settle the matter at once, for in this way, as we have said, the special emotional effect can easily be dissipated. E.T.A. Hoffmann often employed this psychological manoeuvre with success in his imaginative writings.'

This observation, which is undoubtedly correct, refers in particular to Hoffmann's story 'The Sand-Man', one of the 'Night Pieces' (vol. 3 of Hoffmann's *Gesammelte Werke* in Grisebach's edition) from which the doll Olimpia found her way into the first act of Offenbach's opera *The Tales of Hoffmann*. I must say, however – and I hope that most readers of the story will agree with me – that the motif of the seemingly animate doll Olimpia is by no means the only one responsible for the incomparably uncanny effect of the story, or even the one to which it is principally due. Nor is this effect enhanced by the fact that the author himself gives the Olimpia episode a slightly satirical twist using it to make fun of the young man's overvaluation of love. Rather, it is another motif that is central to the tale, the one that gives it its name and is repeatedly emphasized at crucial points – the motif of the Sand-Man, who tears out children's eyes. [...]

E.T.A. Hoffmann is the unrivalled master of the uncanny in literature. His novel *Die Elexiere des Teufels* [*The Elixirs of the Devil*] presents a whole complex of motifs to which one is tempted to ascribe the uncanny effect of the story. The content is too rich and intricate for us to venture upon a summary. At the end of the book, when the reader finally learns of the presuppositions, hitherto withheld, which underlie the plot, this leads not to his enlightenment, but to his utter bewilderment. The author has piled up too much homogeneous material, and this is detrimental, not to the impression made by the whole, but to its intelligibility. One must content oneself with selecting the most prominent of those motifs that produce an uncanny effect, and see whether they too can reasonably be traced back to infantile sources. They involve the idea of the 'double' (the Doppelgänger), in all its nuances and manifestations – that is to say, the appearance of persons who have to be regarded as identical because they look alike. This relationship is intensified by the spontaneous transmission of mental processes from one of these persons to the other – what we would call telepathy – so that the one becomes co-owner of the other's knowledge, emotions and experience. Moreover, a person may identify himself with another and so become unsure of his true self; or he may substitute the other's self for his own. The self may thus be duplicated, divided and interchanged. Finally there is the constant recurrence of the same thing, the repetition of the same facial features, the same characters, the same destinies, the same misdeeds, even the same names, through successive generations.

The motif of the double has been treated in detail in a study by O. Rank.[1] This work explores the connections that link the double with mirror-images,

shadows, guardian spirits, the doctrine of the soul and the fear of death. It also throws a good deal of light on the surprising evolution of the motif itself. The double was originally an insurance against the extinction of the self or, as Rank puts it, 'an energetic denial of the power of death', and it seems likely that the 'immortal' soul was the first double of the body. The invention of such doubling as a defence against annihilation has a counterpart in the language of dreams, which is fond of expressing the idea of castration by duplicating or multiplying the genital symbol. In the civilization of ancient Egypt, it became a spur to artists to form images of the dead in durable materials. But these ideas arose on the soil of boundless self-love, the primordial narcissism that dominates the mental life of both the child and primitive man, and when this phase is surmounted, the meaning of the 'double' changes: having once been an assurance of immortality, it becomes the uncanny harbinger of death. [...]

The analysis of cases of the uncanny has led us back to the old animistic view of the universe, a view characterized by the idea that the world was peopled with human spirits, by the narcissistic overrating of one's own mental processes, by the omnipotence of thoughts and the technique of magic that relied on it, by the attribution of carefully graded magical powers (*mana*) to alien persons and things, and by all the inventions with which the unbounded narcissism of that period of development sought to defend itself against the unmistakable sanctions of reality. It appears that we have all, in the course of our individual development, been through a phase corresponding to the animistic phase in the development of primitive peoples, that this phase did not pass without leaving behind in us residual traces that can still make themselves felt, and that everything we now find 'uncanny' meets the criterion that it is linked with these remnants of animistic mental activity and prompts them to express themselves.[2]

This is now an appropriate point at which to introduce two observations in which I should like to set down the essential content of this short study. In the first place, if psychoanalytic theory is right in asserting that every affect arising from an emotional impulse – of whatever kind – is converted into fear by being repressed, it follows that among those things that are felt to be frightening there must be one group in which it can be shown that the frightening element is something that has been repressed and now returns. This species of the frightening would then constitute the uncanny, and it would be immaterial whether it was itself originally frightening or arose from another affect. In the second place, if this really is the secret nature of the uncanny, we can understand why German usage allows the familiar (*das Heimliche*, the 'homely') to switch to its opposite, the uncanny (*das Unheimliche*, the 'unhomely'), for this uncanny element is actually nothing new or strange, but something that was long familiar

to the psyche and was estranged from it only through being repressed. The link with repression now illuminates Schelling's definition of the uncanny as 'something that should have remained hidden and has come into the open'.

It now only remains for us to test the insight we have arrived at by trying to explain some other instances of the uncanny.

To many people the acme of the uncanny is represented by anything to do with death, dead bodies, revenants, spirits and ghosts. Indeed, we have heard that in some modern languages the German phrase *ein unheimliches Haus* ['an uncanny house'] can be rendered only by the periphrasis 'a haunted house'. We might in fact have begun our investigation with this example of the uncanny – perhaps the most potent – but we did not do so because here the uncanny is too much mixed up with the gruesome and partly overlaid by it. Yet in hardly any other sphere has our thinking and feeling changed so little since primitive times or the old been so well preserved, under a thin veneer, as in our relation to death. Two factors account for this lack of movement: the strength of our original emotional reactions and the uncertainty of our scientific knowledge. Biology has so far been unable to decide whether death is the necessary fate of every living creature or simply a regular, but perhaps avoidable, contingency within life itself. It is true that in textbooks on logic the statement that 'all men must die' passes for an exemplary general proposition, but it is obvious to no one; our unconscious is still as unreceptive as ever to the idea of our own mortality. Religions continue to dispute the significance of the undeniable fact of individual death and to posit an afterlife. The state authorities think they cannot sustain moral order among the living if they abandon the notion that life on earth will be 'corrected' by a better life hereafter. Placards in our big cities advertise lectures that are meant to instruct us in how to make contact with the souls of the departed, and there is no denying that some of the finest minds and sharpest thinkers among our men of science have concluded, especially towards the end of their own lives, that there is ample opportunity for such contact. Since nearly all of us still think no differently from savages on this subject, it is not surprising that the primitive fear of the dead is still so potent in us and ready to manifest itself if given any encouragement. Moreover, it is probably still informed by the old idea that whoever dies becomes the enemy of the survivor, intent upon carrying him off with him to share his new existence. Given this unchanging attitude to death, one might ask what has become of repression, which is necessary if the primitive is to return as something uncanny. But it is there too: so-called educated people have officially ceased to believe that the dead can become visible as spirits, such appearances being linked to remote conditions that are seldom realized, and their emotional attitude to the dead, once highly ambiguous and ambivalent, has been toned down, in the higher

reaches of mental life, to an unambiguous feeling of piety.[3]

Only a few remarks need now be added to complete the picture, for, having considered animism, magic, sorcery, the omnipotence of thoughts, unintended repetition and the castration complex, we have covered virtually all the factors that turn the frightening into the uncanny.

We can also call a living person uncanny, that is to say, when we credit him with evil intent. But this alone is not enough: it must be added that this intent to harm us is realized with the help of special powers. A good example of this is the *gettatore*,[4] the uncanny figure of Romance superstition, whom Albrecht Schaeffer, in his novel *Josef Montfort*, has turned into an attractive figure by employing poetic intuition and profound psychoanalytic understanding. Yet with these secret powers we are back once more in the realm of animism. In Goethe's *Faust*, the pious Gretchen's intuition that Mephisto has such hidden powers is what makes him seem so uncanny:

> *Sie fühlt, dass ich ganz sicher ein Genie,*
> *Vielleicht wohl gar der Teufel bin.*
> [She feels that I am quite certainly a genius, perhaps indeed the very Devil.]

The uncanny effect of epilepsy or madness has the same origin. Here the layman sees a manifestation of forces that he did not suspect in a fellow human being, but whose stirrings he can dimly perceive in remote corners of his own personality. The Middle Ages attributed all these manifestations of sickness consistently, and psychologically almost correctly, to the influence of demons. Indeed, it would not surprise me to hear that psychoanalysis, which seeks to uncover these secret forces, had for this reason itself come to seem uncanny to many people. In one case, when I had succeeded – though not very quickly – in restoring a girl to health after many years of sickness, I heard this myself from the girl's mother long after her recovery.

Severed limbs, a severed head, a hand detached from the arm (as in a fairy tale by Hauff), feet that dance by themselves (as in the novel by A. Schaeffer mentioned above) – all of these have something highly uncanny about them, especially when they are credited, as in the last instance, with independent activity. We already know that this species of the uncanny stems from its proximity to the castration complex. Some would award the crown of the uncanny to the idea of being buried alive, only apparently dead. However, psychoanalysis has taught us that this terrifying fantasy is merely a variant of another, which was originally not at all frightening, but relied on a certain lasciviousness; this was the fantasy of living in the womb. [...]

1 [added footnote] E. Jentsch, 'Zur Psychologie des Unheimlichen', *Psychiatrisch-neurologische Wochenschrift* 1908, no. 22 and 23.

2 [footnote 3 in source] O. Rank, 'Der Doppelgänger', *Imago* 3, 1914.

3 [11] On this topic see Freud's study *Totem und Tabu* ['Totem and Taboo'] (1913) section III of which deals with animism, magic and the omnipotence of thoughts. Here the author remarks, 'It seems that we ascribe the character of the uncanny to those impressions that tend to confirm the omnipotence of thoughts and animistic thinking in general, though our judgement has already turned away from such thinking'.

4 [12] Sigmund Freud, op. cit., on 'taboo and ambivalence'.

5 [13] [Literally the 'thrower' (of bad luck), or 'the one who casts' (the evil eye).]

Sigmund Freud, 'Das Unheimliche', first published in *Imago*, 5 (1919) 5–6; trans. David McLintock, 'The Uncanny', *The Uncanny* (London: Penguin Books, 2003) 123–4; 135–6; 141–3; 147–50.

Mike Kelley
Playing with Dead Things: On the Uncanny//1993/2004

[...] The uncanny is apprehended as a physical sensation, like the one I have always associated with an 'art' experience – especially when we interact with an object or a film. This sensation is tied to the act of remembering. I can still recall, as everyone can, certain strong, uncanny, aesthetic experiences I had as a child. Such past feelings (which recur even now in my recollection of them) seem to have been provoked by disturbing, *unrecallable* memories. They were provoked by a confrontation between 'me' and an 'it' that was highly charged, so much so that 'me' and 'it' become confused. The uncanny is a somewhat muted sense of horror: horror tinged with confusion. It produces 'goose bumps' and is 'spine tingling'. It also seems related to déjà vu, the feeling of having experienced something before, the particulars of that previous experience being unrecallable, except as an atmosphere that was 'creepy' or 'weird'. But if it was such a loaded situation, so important, why can the experience not be remembered? These feelings seem related to so-called out-of-body experiences, where you become so bodily aware that you have the sense of watching yourself from outside yourself. All of these feelings are provoked by an object, a dead object that has a life of its own, a life that is somehow dependent on *you*, and is intimately connected in some secret manner to your life.

In his essay 'The Uncanny' (1919), Freud writes about how the uncanny is associated with the bringing to light of what was hidden and secret, distinguishing the uncanny from the simply fearful by defining it as 'that class of the terrifying which leads us back to something long known to us, once very familiar'.[1] In the same essay, Freud cites Ernst Jentsch, who located the uncanny in 'doubts' about 'whether an apparently animate being is really alive; or conversely, whether a lifeless object might not in fact be animate'.[2] He also lists Jentsch's examples of things that produce uncanny feelings: these include, 'wax-work figures, artificial dolls and automatons', as well as 'epileptic seizures and the manifestations of insanity'.[3] Freud's essay elaborates on, but also narrows, Jentsch's definition of the uncanny, and I will return to it later. When I first read this essay, in the mid-1980s, I was struck by Jentsch's list and how much it corresponded to a recent sculptural trend – popularly referred to in art circles as 'mannequin art'. [...]

It seems that every ten years or so there is a 'new figuration' exhibition of some kind,[4] the most recent being *Post Human* (1992).[5] Obviously, figurative sculpture

is in the air, and there are enough artists committed to new considerations of the figure to devote an entire exhibition to contemporary manifestations of this theme. But what is particular to this current re-evaluation of the figure? According to Jeffrey Deitch, curator of 'Post Human', 'The Freudian model of the "psychological person" is dissolving... There is a new sense that one can simply construct the new self that one wants, freed of the constraints of one's past...'[6] 'New' is the primary adjective in Deitch's essay: the world 'will soon be' and 'is becoming'.[7] It is a world where technological manipulation of body and mind is at our fingertips. This 'distinct new model of behaviour and a new organization of personality'[8] sounds very much like the model offered by early science fiction, or like the modernist version of a technological Utopia. When I look at the work presented in 'Post Human', I don't find myself marvelling at the newness of it, but wondering what differentiates the material it foregrounds from artworks of the past. For me, history is not denied here – it is evoked. [...]

Colour

[...] Certain contemporary works re-examine the tensions between the Platonism of modernism, as signified by monochrome colouration, and an unsettling sensation of the 'real – manifested especially through the evocation of self-conscious body awareness. The recent sculptures of Bruce Nauman, composed of wax casts of human heads in various single colours, and the paintings of Jasper Johns that incorporate cast wax or plaster fragments of body parts participate in this reassessment.[9] In both cases, it is the tactile quality of the material that supersedes the calming effect of monochrome. Wax is so flesh-like in consistency, and has such a long history of usage as a flesh substitute in popular sculpture, that, the various formal tropes utilized in these works notwithstanding, it is impossible to experience them in a purely formal way. The fragmentary nature of the body parts, reinforced by the organic qualities of the wax, strongly suggests the disordering of the body. Indeed, it's difficult to imagine that any ordering principle applied to them could offset the uncanny feelings thus produced. In the case of Nauman, I would say that his minimal organizing strategies make these feelings even stronger. When applied to body parts, basic compositional exercises, like up vs. down or in vs. out, come off as cruelly tongue-in-cheek. These simple organizing gestures cannot help but remind viewers of the actual morphology of the body – and of their living bodies in particular. Everyone knows how their body is organized and how many of each part they have; this is a given and is never thought about. To become aware of these particulars, one must imagine oneself un-whole, cut into parts. Deformed or Dead. [...]

The Part and Lack (The Organs Without Body)

[...] The Surrealist artist, Hans Bellmer, constructed a life-size figure of a young girl in the early 1930s. This figure was fully jointed and came apart in pieces in such a way that it could be put back together in innumerable ways. He also made extra pieces that could be added so that the figure could have, if desired, multiples of some parts. Bellmer's playful dismantlings and reorganizations of this figure were documented in a series of photographs, most hand-tinted in the pastel shades of popular postcards. The 'doll' is a perfect illustration of Bellmer's notion of the *body as anagram*: the body as a kind of sentence that can be scrambled again and again to produce new meanings every time.[10] 'The starting point of the desire, with respect to the intensity of images', Bellmer wrote, 'is not in a perceptible whole but in the detail... The essential point to retain from the monstrous dictionary of analogies/antagonisms which constitute the dictionary of the image is that a given detail such as a leg is perceptible, accessible to memory and available, in short is *real*, only if desire does not take it fatally for a leg. An object that is identical with itself is without reality'.[11] The sentence of experience is recalled through the syntax of remembered moments. For Bellmer, the shifting of attention during the sex act from one body to the next is presented in terms of a kind of Futurist simultaneity – all at once rather than one after the other.

This flow of physical recollection is further intensified by the crossover of one body part into another, as one part becomes associated with or a stand-in for a different part. Freud calls this 'anatomical transgression', a situation in which 'certain parts of the body ... lay claim as it were, to be considered and treated as genitals'.[12] This is even a part of 'normal' sexual practice; the polymorphous perversity of infantile sexuality has found its way into a canon of socially acceptable genital substitutes. 'Partiality' to the lips, breasts and the ass, is not seen as strange at all.[13] [...]

Statues and Death

The issues raised by time-based and body art are too complex to deal with in this short essay. I have decided to limit myself here – and in the *Uncanny* exhibition – to the representation of the inanimate human figure. The long history of figurative sculpture has normalized representations of the body, taking the edge off of our experience of such objects and preventing us from having the same ambivalent relationship to them that we have with Duchamp's readymades. This has not always been the case. The history of Western art is also the history of Christian thought, and this is a history where image-making, and especially statue-making, is fraught with controversy.

> Thou shalt not make to thyself a graven thing
> nor the likeness of anything that is in heaven
> above, or in the earth beneath, nor of those
> things that are in the waters under the earth
> (*Exodus*, 20: 4)

Interestingly, during the Middle Ages it was believed that sculpture was a more recent artistic development than painting, a reversal of the opinion commonly held today.[14] Technical advances in art were equated with an accelerating evil, probably because they were seen as being at a further distance from the simplicity of Eden. All sculpture was dangerous and linked to idolatry; it was seen as a proud attempt to compete with God's creation of man in His own image. [...]

Because of their construction in permanent material, statues, as with the readymade, constantly evoke in viewers their own mortality. Indeed, this could be said to be the main point of Christian statuary: to rub people's noses in their own mortality so that their minds were forever focused on the afterlife. And this is probably why, in the modern era, figurative sculpture is held in such low esteem, for this primitive fear cannot be erased from it. The aura of death surrounds statues. The origin of sculpture is said to be in the grave; the first corpse was the first statue. [...]

The Statue as Stand-In

[...] All popular sculpture – from votive sculpture, which is a representation of the person making sacrifice before a god, to the most mundane worker replacement like the scarecrow or shop-window mannequin – has [a] plebeian quality.[15] Votive sculpture, ranging from life-size wax figures to small depictions of afflicted body parts that a person wants healed, could be said symbolically to represent devotees *themselves* as sacrificial offerings to the gods. Although these replacements are sometimes highly charged emotionally, and this throwaway quality is repressed, they still have one foot in the garbage dump. In the fourteenth century it was not uncommon for the wealthy to have a life-size, wax votive image of themselves set up in a church perpetually to mourn a dead loved one or to show reverence to a religious image. Churches became so crowded with these figures that they had to be hung from the rafters. Of course, this trash-heap of simulated devotees was eventually just tossed out.[16]

The disposability of the venerated substitute has modern correlatives. We know, for example, that the life-size doll modelled after the object of his erotic obsessions, Alma Mahler, commissioned by Oskar Kokoschka was simply torn apart by revellers at a drunken party after his desire waned.[17] The focus of his thoughts for years, this fetish object became as dispensable as an inflatable sex

doll available at the corner sex shop. Then there are whole classes of figures designed specifically to be destroyed in use: car crash test dummies, the effigies of hated political figures hung and burned at demonstrations, the mannequins that people the perimeters of nuclear test sites and the electrified human decoys recently used in India to shock man-eating tigers into losing their taste for human flesh.[18] In a way, all these figures ask to be mistreated. The iconoclast, the one who feels compelled to destroy images, knows: statues invite violence. Like the vampire, they desire a violent death to relieve them of the viewer-projected pathos of their pseudo-life. [...]

Aping the Mirror of Nature

[...] Famous for his super-realist nudes, John de Andrea made several black and white works: one was based on the famous newspaper photograph of a student shot at Kent State University, and another represented an artist casting a model in plaster. Even though these works are drained of colour, the use of monochrome couldn't be further removed from the conventional, timeless colourlessness of heroic sculpture. The 'realism' of black-and-white documentary photography is the obvious referent. This photographic sense of truth captured in the moment is beautifully undermined here, simply through the process of literalization. When the photo is actualized in sculptural form, truth is dispensed with. The photographic 'essence' of the moment takes on the cheesy pseudo-historical feel of every cheap roadside museum. De Andrea and Duane Hanson were some of the first contemporary sculptors willing to make works that evoked the banality of the wax museum.[19] The literalness of the wax figures found at Madame Tussaud's is one emptied of magic. These figures, obviously a secular outgrowth of the magical/religious votive figure, are no longer in sympathetic vibration with the souls of their models. They are as dead as the corpses they portray.

Many artists could now be said to be working with a kind of formalism of conventions. The sense of these formalist strategies having any real base in fixed laws of order has vanished. Rather, they are dysfunctional mirrors of random cultural conventions. In Jeff Koons' polychrome statues, for example, we are presented with a set of historical tropes, now overtly kitsch, that, by virtue of their placement in the art world – instead of on the knick-knack shelf – as well as their huge price tag, demand to be taken seriously. Yet we all know they only ask for, but do not expect, this respect. They only toy with self-importance. If Koons' works are kitsch, is it not the kitsch defined by high modernism, the kitsch of those who subscribe to cultural hierarchy, whose laughter at or hatred of kitsch presupposes a feeling of superiority: they are better than it.[20] I get the sense that most artists now do not think this way. They know all too well that

the lowest and most despicable cultural products can control you, despite what you think of them. You *are* them, whether you like it or not. Cindy Sherman's photographs are a case in point. Rather than photographic odes to pop culture, they are self-portraits of a psychology that cannot disentangle itself from the kaleidoscope of clichés of identity that surrounds it. And one convention is as good as the next. The only test of quality is how well we recognize the failure of the cliché to function as a given.

In Charles Ray's *Male Mannequin* we are presented with exactly what the title announces: a standard, store-bought, nude male mannequin.[21] Yet, the normally neutered figure has been completed with a super-realist cast of male genitals. This proves, quite literally, the figure's 'maleness', something that was determined previously by other outward signs, such as physique and hairstyle, and, in normal usage, the clothing it would be dressed in. By this simple addition, Ray's piece raises a plethora of questions. The realism of the genitals throws the stylization of the mannequin into question, and although we know that mannequins do not *need* genitals – they can't be seen anyway when the mannequin is performing its proper function of displaying clothes – this somehow doesn't seem reason enough to leave them off. We cannot help but see the mannequin as being castrated, a ludicrous idea to apply to something that never *had* genitals. Expectation is the key here: we expect certain things of the male human form; we expect certain things of a mannequin, and we are presented here with something that doesn't meet our expectations. It is problematic. It really doesn't matter that the *Male Mannequin* represents a human body, for it represents a convention, and, as an artwork, it functions similarly to other works Ray has made with non-figurative objects. Though it seems like it, there is nothing 'humanist' about Ray's work. Morals are revealed as determined by the convention. I am reminded of a very controversial work from the late 1970s or early 80s by the artist John Duncan called *Blind Date*. The work consisted of Duncan having sex with a human corpse, and was presented in the form of an audiotape as a kind of concrete music. Duncan said of the experience, 'One of the things this piece showed me was that people don't accept death. Until the body is completely dust, people can't accept the fact that someone is dead. To me the corpse was like solid matter that had nothing do with the person who was occupying it.'[22] To those who hold onto an essential notion of the human body, the corpse is inseparable from the life force that once occupied it; to those that do not, the corpse is simply another material.

The Uncanny

This current tendency of artworks to use as their subject the conventional and the cliché returns us to Freud's conception of the uncanny. Earlier definitions of

the uncanny had described it as a fear caused by intellectual uncertainty – precisely what the decontextualizing strategies used by the various artists I have just described are meant to produce (one of the prime examples given being the confusion as to whether something is alive or dead).

I have already offered a list of objects said to produce an uncanny reaction – these include wax-work figures, artificial dolls and automatons, but also the body itself as a puppet, seemingly under the control of an outside force, which is the impression given by epileptic seizures and manifestations of insanity. Freud's contribution was to link the uncanny to the familiar. He defines the uncanny as the class of the terrifying which leads us back to something long known and once very familiar, yet now concealed and kept out of sight. It is the unfamiliar familiar, the conventional made suspect. This once-familiar thing is the infantile primary narcissism that holds sway in the mind of the child and is still harboured unconsciously in the adult. The narcissistic personality projects its thoughts onto others; others are its double. The alien self can be substituted for its own, by doubling, dividing and interchanging itself. The transitional object is a locus of such ideas. This object is a combination of itself, child and mother, and the psychic doubling that results is an assurance against the destruction of the ego. But when the infantile stage terminates, the double takes on a different aspect. It mutates from an assurance of immortality into a sign in of egolessness – death. Freud equates this change of meaning to a fall from grace, ' … after the fall of their religion the gods took on demonic shapes'.[23] The uncanny is located in the uncomfortable regression to a time when the ego was not yet sharply differentiated from the external world and from other persons. When something happens to us in the 'real' world that seems to support our old, discarded psychic world, we get a feeling of the uncanny. The uncanny is an anxiety for *that which recurs*, and is symptomatic of a psychology based on the compulsion to repeat.

In addition to its more primitive usage as a protector of the ego, Freud also claims that doubling acts as a safeguard against castration anxieties.[24] Multiplication insures that the loss of one part is not *total* loss. Castration anxiety lends the idea of losing organs other than the penis, and the notion of the body as made up of parts, their intense colouring. The fetish, an exaggerated replacement for something that is repressed from consciousness, is subject to these same kinds of doubling procedures (according to Freudian theorists, the fetish is a symbolic replacement for the Mother's missing penis). The compulsion to repeat results in the fetish being collected and hoarded. This kind of collection has been called the fetishist's 'harem'.[25] Whether or not we accept castration theory, Freud's ideas still deserve attention for the light they shed on the aesthetics of lack. It cannot be denied that collecting is based on lack, and

that this sense of lack is not satisfied by one replacement only. In fact it is not quenched by any number of replacements. No amount is ever enough. Perhaps this unquenchable lack stands for our loss of faith in the essential. We stand now in front of idols that are the empty husks of dead clichés to feel the tinge of infantile belief. There is a sublime pleasure in this. And this pleasure has to suffice. No accumulation of mere matter can ever replace the loss of the archetype. [...]

1 [footnote 4 in source] Sigmund Freud, 'The Uncanny' (1919) in *Sigmund Freud: Collected Papers*, vol. 4, trans. and ed. Joan Rivière (New York: Basic Books, 1959) 369–70.

2 [5] Ibid., 387.

3 [6] Ibid.

4 [8] One sequence might begin with The Museum of Modern Art, New York's *New Images of Man*, curated by Peter Selz in 1959, and Robert Doty's *Human concern/personal torment* at the Whitney Museum of American Art, New York, 1969.

5 [9] Jeffrey Deitch, *Post Human*, (Pully/Lausanne: FAE Musée d'Art Contemporain, 1992). The exhibition travelled to Turin, Athens and Hamburg, 1992–93.

6 [10] Ibid., 27.

7 [11] Ibid., 29; 41.

8 [12] Ibid., 38.

9 [33] On Nauman's coloured wax heads, see John C. Welchman, 'Peeping Over the Wall', in *Narcissism: Arts Reflect Themselves* (Escondido: California Center for the Arts Museum, 1996) 19–20; reprinted as chapter 5, 'Peeping Over the Wall: Narcissism in the 1990s' in Welchman, *Art After Appropriation: Essays on Art in the 1990s* (Amsterdam: G+B Arts International, 2001); on Bruce Nauman's later sculpture, see Jörg Zutter, *Bruce Nauman: Skupturen und Installationen 1985–1990* (Cologne: Dumont Buchverlag, 1990); on Johns, see e.g., Richard Francis, *Jasper Johns* (New York: Abbeville, 1984).

10 [41] Hans Bellmer, interview with Peter Webb, in Peter Webb with Robert Short, *Hans Bellmer* (London: Quartet Books, 1985) 38: 'the body is like a sentence that invites us to re-imagine it, so that its real meaning becomes clear through an endless series of anagrams.'

11 [42] Hans Bellmer, *L'Anatomie de l'image* (Paris: Le Terrain Vague, 1957) 38; cited and trans. in Webb and Short, 102.

12 [43] Sigmund Freud, 'The Sexual Aberrations' in 'Three Essays on the Theory of Sexuality' (1905), *The Basic Writings of Sigmund Freud*, trans. and ed. A.A. Brill (New York: The Modern Library, 1978) 566.

13 [44] Wilhelm Stekel discusses 'the field of "partialisms"' in *Sexual Aberrations: The Phenomenon of Fetishism in Relation to Sex* (1922); trans. Samuel Parker (New York: Liveright, 1971) 38f.

14 [47] See Michael Camille, *The Gothic Idol: Ideology and Image-Making in Medieval Art* (Cambridge: Cambridge University Press, 1989) 42.

15 [55] On the scarecrow, see James Giblin and Fale Ferguson, *The Scarecrow Book* (New York: Crown, 1980). On the mannequin, see Nicole Parrot, *Mannequins* (New York: St. Martin's Press, 1983).

16 [56] Max von Beohn, *Dolls and Puppets* (New York: Cooper Square, 1966) 39.

17 [57] See Klaus Gallwitz, *Oskar Kokoschka und Alma Mahler: Die Puppe, Epilog einer Passion* (Frankfurt am Main: Städtische Galerie im Städel, 1992); and Frank Whitford, *Oskar Kokoschka, A Life* (New York: Atheneum, 1986), esp. 124–5.

18 [58] See 'A Shocking Tale About Dummies That Smart', *Discover* (July 1986) 7; (unsigned).

19 [70] See Dennis Adrian, *John De Andrea/Duane Hanson: The Real and the Ideal in Figurative Sculpture* (Chicago: Museum of Contemporary Art, 1974).

20 [71] For the classic statement on the antithesis between avant-garde and kitsch, see Clement Greenberg, 'Avant-Garde and Kitsch' (first published in *Partisan Review*, vol. 6, no. 5 [Fall 1939], in Clement Greenberg, *The Collected Essays and Criticism, vol. 1: Perceptions and Judgements, 1939–1944*, ed. John O'Brian (Chicago: University of Chicago Press, 1986) 5–22.

21 [72] See *Charles Ray*, curated by Paul Schimmel (Los Angeles: Museum of Contemporary Art, 1998).

22 [73] Lewis Mac Adams, 'Sex with the Dead: Is John Duncan's latest performance art or atrocity?', *Wet*, no. 6 (Santa Monica, March–April 1981) 60.

23 [74] Sigmund Freud, 'The Uncanny', op. cit., 389. He rephrases this statement in note 1 to chapter IV of *Civilization and Its Discontents*, trans. and ed. James Strachey (New York: Norton, 1961) 51.

24 [75] Ibid., 387.

25 [76] 'There is in all cases of fetishism a tendency to the formation of series and a sort of harem', Stekel, *Sexual Aberrations*, op cit., 34.

Mike Kelley, excerpt from 'Playing with Dead Things: On the Uncanny', *The Uncanny* (Liverpool: Tate Liverpool/Cologne: Verlag der Buchhandlung Walther König, 2004) 26; 31; 32; 33; 34; 35; 36. This essay was first written for the catalogue of the original exhibition titled 'The Uncanny', curated by Mike Kelley for Sonsbeek '93, Arnhem, The Netherlands (1993). It was revised for the first volume of Mike Kelley's collected writings: *Foul Perfection: Essays and Criticism*, ed. John C. Welchman (Cambridge, Massachusetts: The MIT Press, 2003).

Patrick McGrath
Hand of a Wanker//1988

Babylonia

Entanked in the ill-lit mood lounge of an East Village nightclub called Babylonia, a sleek green lizard with a crest of fine spines and a bright ruff under its throat gazed unblinking into the glassy eyes of Lily de Villiers. Lily peered back and tapped the tank with a talon-like fingernail. On the couch beneath the video screen Dicky Dee languidly eyed young Gunther, who wore only purple lederhosen and had a magnificent physique. Dicky himself was in plastic sandals, khaki shorts, Hawaiian shirt and white pith helmet.

'Lily', he murmured.

The lizard didn't move, and nor did Lily.

'Lily.'

'Oh, what?'

'Fix me a drink, sweetie.'

It was late afternoon, the club was empty, and the bar was open. Lily straightened up and wobbled over on heels like needles. As she reached for the vodka, Dicky's eyes wandered back to young Gunther's pectorals. Upstairs a telephone rang. The air conditioner was humming. It was summer, and no one was in town. Then Lily screamed.

'Oh, good God, what is it?' exclaimed Dicky.

Lily was staring at something in the sink. She picked it up gingerly, then screamed again and flung it on the bar.

'It's real!' she cried.

'What is?' said Dicky, gazing at the ceiling.

'It's a – hand!'

A faint gleam appeared in Dicky Dee's eyes. 'A hand?' he murmured, rising from the couch.

The mood lounge was a long room with a low ceiling and no windows. The bar occupied one end and there was a stuffed ostrich at the other. A few tables and chairs were scattered about the floor. In the permanent gloom one did not notice that the paint was peeling and the linoleum cracking; for usually the place was full of decadent types gossiping in blasé tones about drugs, love and disease. But this was the afternoon; it was summertime; and they were the only ones in there.

Dicky peered at the thing on the bar. It was indeed a hand. The skin was pale, with fine black hairs on the back and, oddly enough, the palm. The blood on the

stump was black and congealed, though the fingernails were nicely trimmed. Dicky looked from Lily to Gunther and back to the hand. Tittering slightly, he took the cigarette from his mouth and put it between the fingers.

'Oh, Dicky!' cried Lily, turning away. 'How could you? It might be someone we know.'

'True', said Dicky, taking back his cigarette. 'Anyway, you need a lung to smoke. Let's go and tell Yvonne. Maybe it's Yvonne's hand.' [...]

When they got to the lounge, the hand was gone.

'It's gone!' cried Dicky.

'What?' said Yvonne.

'There was a severed hand on the bar!'

Yvonne sighed, and began to make himself a drink. Dicky Dee turned to young Gunther, who was still sitting on the couch and still flexing his pecs.

'Gunther, what happened to the hand?' Dicky appeared rattled. He generated emotion.

Gunther shrugged.

'Hands don't just – disappear!' whispered Dicky, blanching.

Yvonne shrugged. Gunther shrugged again. Lily was looking under the bar, joggling the bottles. 'Maybe it slipped down', she said. Then she screamed – for out of the darkness leaped the hand itself!

It scampered across the bar, hurled itself onto the floor, then scuttled down the room and out the door at the end. There was a moment of stunned silence, and then Yvonne dropped his drink. It shattered messily on the floor.

'*Mein Gott*', breathed Gunther. 'The dead hand lives.'

Dicky strode manfully toward the door. 'I'm going after it', he said. Then he stopped, turned and came back to the bar. 'I think I need a little drink first', he said. 'This is extremely fucking weird.' [...]

Patrick McGrath, excerpt from 'Hand of a Wanker' (1988); reprinted in Patrick McGrath, *Blood and Water and Other Tales* (London: Penguin, 1989) 144–5; 146–7.

Carolyn Christov-Bakargiev
The Missing Voice: On Janet Cardiff//2001

III. The Walks

[...] While most of [Janet Cardiff's audio] Walks last from ten to fifteen minutes, *The Missing Voice (Case Study B)* (1999) is 38 minutes long. This piece guides participants from inside the Whitechapel Library in London through the streets around Brick Lane and ends at Liverpool Street station. If the other walks could recall short stories, this one functions like a novel, unfolding in the city of London.

The neighbourhood is closely connected with tales of Jack the Ripper and other Victorian murders, and Cardiff exploits these associations. There are two 'Janets' in this Walk: one walks through the streets holding a recorder (just as you do, as walker/listener), while the other is a played-back recorded voice to which the first 'Janet' is listening. You flip back and forth between two different periods. One 'Janet' follows the other, recorded one ('I found her photograph in the tube station, beside one of those photo booths. A woman with long red hair staring out at me.') 'Janet' is recognized by a detective, or perhaps the Walk is about short-term amnesia and she/you have hired the detective to find the woman wearing the red wig. She/you may paradoxically be searching for herself/yourself. Personal, scary memories of childhood blend with descriptions and narrative fragments. The recorded 'Janet' describes being abducted ('I'm blindfolded, my hands tied behind me. I walk naked across the floor. I can feel his eyes watching my body.') She sees her 'other' self identified as a dead body in a newspaper. She/you walks you to Liverpool Street station, where you are left alone, and must find your way back to Whitechapel on your own. Over the years, Cardiff has learned certain 'recipes' for a 'good' Walk, and some patterns do emerge. Although narrative is open-ended and fragmented, the *routes* of Cardiff's Walks are rigorously pre-defined, and recall the Virtual Reality paths of computer games but set in real locations. Cardiff states that 'the routes are designed to give the participant the physical experience of different types and textures of space'. They also draw on earlier forms of entertainment such as radio plays, science fiction, 'mad scientist' movies, funhouses and the haunted houses of theme parks. At the end of the Walks, a sense of loss and abandonment overwhelms you as you are left in a remote place and must find your way back alone. [...]

Carolyn Christov-Bakargiev, on 'The Missing Voice', excerpt from 'An Intimate Distance Riddled with Gaps: The Art of Janet Cardiff', in Anthony Huberman, ed. *Janet Cardiff* (New York: P.S.1 Contemporary Art Center, 2001) 21–2.

Nancy Spector
a.k.a.: On Douglas Gordon//2001

In Douglas Gordon's work one is never quite sure where the art begins or ends. It is not that real life and the artistic gesture commingle in some kind of Warholian embrace of the low. It's just that fantasy and reality refuse to part company. Gordon perpetuates this confusion between fact and fiction by turning the most mundane forms of communication – letters, billboards, telephone calls – into works of art. Such is the ease with the catalogue accompanying his solo exhibition at Tate Liverpool, 'Douglas Gordon • Black Spot'. Its cover and page trim are the colour of night, punctuated only by a large white 'g' on the front cover and 'd' on the back – for 'Gordon, Douglas', one assumes. Because the book occupies the space between these two letters, the initials can also appear to spell out 'g – d', in the manner that the name is transcribed in orthodox religious doctrines. However, in Gordon's dialectical universe, where polar opposites such as the sacred and the profane collapse into one another, this monogram could also imply its antithesis, i.e., Satan himself. [...]

One critical source – perhaps the elemental source for Gordon's work – is not to be found in this introductory compendium. Rather, it is embedded in the body of the book, in the main section devoted to the artist's linguistic pieces. Amidst reproductions of his letters, short stories, tattoos and installations, Gordon illustrated a double-page spread from James Hogg's Gothic novel *The Private Memoirs and Confessions of a Justified Sinner* (1824), on which he circled the name of the main character, the doomed Robert Wringhim. He then added to this enigmatic layout by superimposing the oddly anachronistic e-mail address robertwringhim@compuserve.com.[1]

It is no secret that Gordon has been inspired by Hogg's classic tale of demonic possession and double identity. He appropriated its title for his split-screen video installation *Confessions of a Justified Sinner* (1995-96), which conflates two exemplary narratives of schizophrenia and the occult with its footage from Rouben Mamoulian's 1931 film *Dr Jekyll and Mr Hyde*. But the attention given to Hogg's novel in the 'Black Spot' catalogue – its facsimile reproduction is located in the very centre of the section chronicling Gordon's text pieces – proves its significance to the artist's work as a whole. It also helps to know, of course, that the e-mail address is Gordon's own. The fictional Robert Wringhim is thus Gordon's *nom de plume*, his literary other, his electronic identity. This revealing but no doubt highly studied inclusion in the catalogue offers a tantalizing clue into the artist's conceptual strategies. Like Hogg's two-part novel about self-

division and supernatural dualism, Gordon's multivalent work circulates around conditions of doubling as both structure and metaphor. Throughout his entire project, he equates content with form, playing one off the other in a provocative game of innuendo and aesthetic affect. The veiled confession about his alter ego – a positively criminal one at that – reveals two other essential facets of the work: Gordon is often present in it, albeit in disguise, and nothing about it should be taken at face value.

Gordon's adoption of 'Robert Wringhim' as a pseudonym indicates less an identification with the character's moral plight – which led from spirituality to criminality – than a fascination with the structure of Hogg's divided narrative. Two entirely separate points of view, which the reader encounters sequentially, relay the plot. Thus the story is told twice. It is premised on the discovery of Wringhim's tormented confessions, which recount his fall from grace.

The bastard son of a fire-and-brimstone Calvinist minister and an extravagantly pious mother, Wringhim had been brought up to believe he was a member of the church's elect and thus predestined for salvation no matter how grievous his sins. His self-righteousness in the face of all he perceived to be less than devout validated his most heinous of acts against friends and family. He was aided and abetted in his crimes by a mysterious friend named Gil-Martin, who resembled him utterly, read his thoughts and fuelled his most destructive tendencies. The question of whether Wringhim's elusive companion was the devil incarnate or the product of a diseased mind is never answered in the book. On the contrary, Hogg's two-part structure intentionally defers such a narrative resolution. The first section is written by the Editor, who provides a rational, legalistic account of the events surrounding Wringhim's wretched life and suicide. The second is constituted by the confessions themselves, which are wholly subjective, impassioned and ambiguous. The structure of the book embodies the doppelgänger theme at its core: religious justification is compared to its heretical double, antinomianism; the by-products of psychopathology are compared to events explained only by supernatural intervention; and scientific reasoning is compared to the wiles of folklore.[2]

The coexistence and interpenetrability of good and evil resonate in Gordon's art, which, as in Hogg's tale, is explicated through a kind of structural doubling or formal repetition that suspends any conclusive reading of its ultimate meaning. In this way, Gordon foregrounds his abiding interest in the fact that 'what seems to be, is probably not'.[3] He demonstrates this paradox in the text piece *Untitled Text (for someplace other than this)* (1996), which inventories sets of divergent concepts – 'hot is cold, attraction is repulsion, blessing is damnation' – by presenting them as equations and then inverting their order in a Möbius strip of an installation, which centres around the doppelgänger-like

phrase: 'I am you, you are me'.

It is from such slippages between perceived opposites, especially self and other, present and past, the dead and the undead, that the 'Uncanny' emerges. Sigmund Freud experienced the Uncanny – that pervasive sense of dread intrinsic to the Gothic novel – when he encountered his own reflection in the mirror while travelling on an overnight train. Not recognizing his double, he wondered who the old gentleman might be. He described the phenomenon as belonging to the 'class of the terrifying which leads to something long known to us, once very familiar'.[4] In his view, the double is a figment of the subconscious that guards against primordial fears of estrangement. Repressed, it eventually returns as a portent, a chilling or uncanny sign that death is lurking. Freud arrived at his explanation of the Uncanny through an analysis of the German word '*heimlich*', the twofold definition of which – something homelike, commonplace and intimate, but also secret, concealed from that view and furtive – coincides with its opposite, '*unheimlich*' – that which is sinister, eerie, uneasy. For Gordon, who mines the territory of the Uncanny, 'the *Unheimliche* is where it is interesting to be'.[5] Schooled in the Gothic literature of his native Scotland, the artist frequently uses his own image (or double) to make the familiar strange or, in a typical Gordonian gesture, to make the strange familiar.

Gordon is an inveterate storyteller. The fictions he weaves extend outward from the actual objects of his art – film, video and sound installations; photographs; and text works – to encompass his own artistic persona. Self-portraiture or, more accurately, Gordon's presentation of a mutable and enigmatic self constitutes a significant component of his practice, a component that is largely performative and indirect. For instance, the biographical essays in a number of his exhibition catalogues are allegedly authored by an unidentified friend or one of the artist's brothers. They offer glimpses into Gordon's private life through highly controlled (or contrived) accounts of his childhood in Glasgow and recent escapades in the world at large.[6] We learn, for instance, that his mother nearly died during childbirth and for this he has experienced lifelong guilt. We also learn that that she left Scotland's Calvinist Church to join the evangelical cult of Jehovah's Witnesses when the artist was six years old and that subsequently he did his share of door-to-door proselytizing. According to his brother David, Gordon was always 'overly concerned by psychological details', a trait he transposed to his art by manipulating the responses of his audience through a certain amount of game playing. And, as one anonymous friend recounts, Gordon lived a 'vampire' existence during residency in Berlin, and claimed to have seen the devil dining at a late-night café.

The artist has adopted a multiplicity of voices to create an image of the real 'Douglas Gordon' that is – as in all good art – part truth and part illusion. In doing

so, he has deliberately blurred the boundaries between himself and the representation of himself. Even his personal e-mail address is a work of art. Gordon's literary conceits emerged in early, site-specific wall texts with moralistic undertones, such as *Above all else...* (1991) [We are Evil]. His texts then migrated out into the world through the (still ongoing) series of letters addressed to unsuspecting members of the art world that range from the ominously accusing – 'I am aware of who you are & what you do' (1991) – to the vaguely romantic – 'From the moment you read these words, until you meet someone with brown eyes' (1993).[7] These missives are signed by the artist, whose voice takes on the authoritative tone of an omnipotent observer. [...]

Gordon restaged the multiple-personality disorder invoked in *Selfportrait* [*as Kurt Cobain, as Andy Warhol, as Myra Hindley, as Marilyn Monroe* (1996)] for the photographic piece *Monster* (1996–97), which shows him in two conflicting but coexistent states: as a normal young man and as a hideous, disfigured creature. He created this grotesque image of himself with the simplest of means: scotch tape pulled every which way on his face so that the wrong features became taut while others, equally disturbingly, became lax. Such is the revulsion of the familiar made strange, of the idea that something so other, so monstrous could lie as close to the surface. This was the case for Dr Henry Jekyll, for whom it was 'shocking ... that that insurgent horror was to knit to him closer than a wife, closer than an eye; lay caged in his flesh, where he heard it mutter and felt it struggle to be born'.[8] In Gordon's picture, there is no sense of before or after; both beings exist simultaneously, like fraternal twins. The lack of struggle between them, the seeming absence of trauma, is perhaps the most uncanny aspect of the work and functions as the *punctum* of the picture.

Gordon cultivates and embraces the sense of unease associated with the double. For a recently initiated, ongoing project, he has actually commissioned his own doppelgänger, a wax effigy of himself from the famed Musée Grévin in Paris. Established in 1882, this museum of waxworks makes the uncanny palpable with its array of historical personages in embalmed states of verisimilitude: Napoleon pauses in his tent during the withdrawal from Moscow; Marie Antoinette beholds a crucifix while awaiting the guillotine; Marat succumbs to death in his bathtub. One can imagine that more recent additions would include John F. Kennedy in his Dallas motorcade or Princess Diana departing from her Paris hotel. The museum's mortuary chill is further intensified in the special underground section devoted exclusively to executions, displaying in detail by gory detail the events leading from violent crime to capital punishment.[9]

Indexical like a photograph, the waxwork is inextricably linked to death. As a cast of its subject's own corporeal presence at one specific moment in time, the

wax figure records for posterity an image of what once had been but no longer is. When a cast is made of a living person, it will forever embody the anterior future when, someday, the subject will no longer exist.[10] This reality is manifested in the fragile nature of wax itself, even when the material is pressed into the service of commemorative portraiture. And herein lies its essential cruelty.[11] Wax is far more delicate than human skin; when cast, it can break apart or easily collapse. And as an isotropic substance, it will melt completely when exposed to heat. Though it can eerily resemble the translucency of living flesh, a waxwork is actually far closer to the body-as-corpse. The innate horror of this phenomenon is manifest in a work that Gordon has already produced in relation to this project entitled *Fragile hands collapse under pressure* (1999). After the initial casting of his body at the Musée Grévin, the wax copy of his hands actually fractured due (according to museum authorities) to the delicate nature of his own limbs. The artist then made a plaster cast of these inverted forms as a kind of treacherous *memento mori*.

Gordon exploits the frozen-in-time, abject quality of the wax figure in the new self-portrait project. Every year, on the same day, in the same place, he will photograph himself alongside his wax double. Intrigued by the concept of 'photographing himself with himself', Gordon will be forced to confront the effects of time on his own appearance.[12] Unlike the mirror, which changes with us as we age, this wax mannequin will remain perpetually young. It will be the constant against which Gordon must measure and record his steady and irreversible drift toward old age and death. This is a fiendish inversion of Oscar Wilde's *The Picture of Dorian Gray* (1891), in which the protagonist retains his youthful beauty while his portrait bears the ravages of time. In this Faustian tale of narcissism, decadence and the occult, Gray initially revels in his portrait's decrepitude. 'He would examine with minute care, and sometimes with a monstrous and terrible delight, the hideous lines that seared the wrinkling forehead, or crawled around the heavy sensual mouth...'[13] But, in the end, he succumbs to the horror of this black mirror, and by murdering the painting, he annihilates himself. One wonders what kind of relationship will unfold between Gordon and his eternally youthful double as the years go by. The bond between them will no doubt be complex. What functions as an external reflection of the artist, as a duplication of his being, may also be read as the symbol for a self divided. This is the dialectic of the double. As Dr Jekyll so painfully recognized about his own other contained within, 'it was the curse of mankind that these incongruous faggots were thus bound together – that in the agonized womb of consciousness, these polar twins should be continuously struggling'.[14] [...]

1 In *Douglas Gordon • Black Spot* (Liverpool: Tate Gallery, 2000) 278. There are actually two e-mail

addresses included on this spread, the second being weir@hermiston.demon.co.uk, which refers to Robert Louis Stevenson's last and uncompleted novel *The Weir of Hermiston* (1896). Though also an important source for Gordon, this essay will focus more specifically on the significance of Hogg's book to the artist's work.

2 For a detailed analysis of Hogg's novel with particular attention to how the structure of the book mirrors its theme of dualism, see Douglas Gifford, *James Hogg* (Edinburgh: The Ramsey Head Press, 1976) 138–84. The motif of the double resonates throughout the literature of Scotland, which in itself is a country of schism, a nation historically divided by its allegiance to either the Catholic or Protestant Church and its long contested capitulation to the British crown. The prevalence of a strong Calvinist belief system and its preoccupations with the presence of evil on Earth also found expression in the metaphor of the dopelgänger, which informs some of the great Scottish novels, including Hogg's *Confessions*, and Robert Louis Stevenson's *The Strange Case of Dr Jekyll and Mr Hyde* (1886), *Kidnapped* (1886) and *The Weir of Hermiston*.

3 This was Gordon's response to a question about his references to doubling and the metaphor behind the video *A Divided Self I and II* (1996). See '… in conversation: jan debbaut and douglas gordon', in *Douglas Gordon: Kidnapping* (Eindhoven, The Netherlands: Stedelijk Van Abbemuseum, 1998) 49.

4 Sigmund Freud, 'The Uncanny' (1919), in *Studies in Parapsychology*, ed. Philip Rieff (New York: Collier Books, 1963) 20.

5 Quoted in Nancy Spector, 'This is all true, and contradictory, if not hysterical. Interview with Douglas Gordon', in *Art from the UK* (Munich: Sammlung Goetz, 1997) 87.

6 See for example the letter to Martijn van Nieuwenhuyzen and Leontine Coelewij from the artist's brother, David Gordon, 'by way of a statement on the artist's behalf', originally published in *Wild Walls* (Amsterdam: Stedelijk Museum, 1995) n.p.; reprinted in *Douglas Gordon • Black Spot*, op. cit., 265–9.

7 *Above all else…* was originally installed as part of the Barclay's Young Artist Award exhibition at the Serpentine Gallery in London in 1991. The correspondence works are titled, respectively, *Letter 1* and *Instruction (Number 10c)*. They also exist as wall texts.

8 [footnote 12 in source] Robert Louis Stevenson, *The Strange Case of Dr Jekyll and Mr Hyde* (1886) (London: Penguin Books, 1979) 95.

9 [13] This term was used by Umberto Eco in his amusing analysis of America's obsession with refabrications of the real. See 'Travels in Hyperreality', in *Travels in Hyperreality* (San Diego: Harcourt Brace & Company, 1986) 10.

10 [14] Photography's relationship to death has been poignantly articulated by Roland Barthes in his book *Camera Lucida*. Because a wax imprint is also an indexical sign, Barthes' mediations can be extended to an analysis of the wax figure's association with mortality. For Barthes, 'the return of the dead' (9) is present in every photograph, each of which is an irreversible reminder that whatever was recorded by the camera no longer exists in the state pictured; the moment rendered is forever gone, save for a fading two-dimensional image. The snapshot cannot lie about the present or the past. It also unnervingly predicts the future. Perusing an old photograph

of a young prisoner sentenced to death, Barthes notes that the man 'is going to die', a reality inherent to all photography, a medium that simultaneously imparts the knowledge that 'this will be' and 'this has been'. Barthes perceived in this photograph an 'anterior future of which death is the stake', a past which is yet to come (96). See Barthes, *La Chambre clair: note sur la photographie* (1980), trans. Richard Howard, *Camera Lucida: Reflections on Photography* (New York: Hill and Wang, 1981) 63–119.

11 [15] I am indebted here to Norman Bryson's analysis of the wax museum as a harbinger of modernism's fragmented self in his essay on Hiroshi Sugimoto's photographs. 'The displeasure of the waxwork is always that of idealization thwarted: it is never realistic enough; it cannot deliver the goods; it is "disappointing" in a deep sense, as though the waxwork's secret loyalty were not to the grand and unitary imago the ego strives for, but to the insidious undoing of that unity, that fusion of subject and image. Lurking just beneath the surface of the portrait waxwork is the sense of the body in pieces and the ego in fragments, not working as unity at all, not coming together as a human being – a sense of the human form melting or breaking from the inside and, as part of that, the half-emergence of an unpleasurable, sometimes hellish form, the body in mutilation and pain, the body as expiring.' Quoted from Bryson, 'Everything We Look at Is a Kind of Troy', in Tracey Bashkoff and Nancy Spector, *Sugimoto: Portraits* (New York: Solomon R. Guggenheim Foundation, 2000) 61.

12 [16] In conversation with the artist, 10 March 2001.

13 [17] Oscar Wilde, *The Picture of Dorian Gray* (1891), in *Complete Works of Oscar Wilde*, introd. V. Holland (London: Collins, 1976) 103.

14 [18] Stevenson, *The Strange Case of Dr Jekyll and Mr Hyde*, op. cit., 82.

Nancy Spector, excerpt from 'a.k.a', in Russell Ferguson, et al., *Douglas Gordon* (Los Angeles: The Museum of Contemporary Art and Cambridge, Massachusetts and London: MIT Press, 2001) 113; 115–21; 126–31.

Stan Douglas
Nu•tk•a//1996

Historical Background

The Gothic romance was typically characterized by a return of the repressed: some past transgression haunts, then destroys the culpable person, family or social order. It is no surprise that these narratives flourished during the era of high imperialism – when remote and exotic areas of the world were being drawn into the European orbit and providing, if not the *mise en scène*, then at least the sublimated object of Gothic anxiety. What would contact and mingling with radically foreign cultures bring? Gothic tales answer: a decrepit clan wallows in decadence awaiting its final annihilation (*Fall of the House of Usher*); a monster appears, threatening to infect the whole social and natural order (*Frankenstein*); the bourgeois individual himself might become infected, and begin to display mortally morbid symptoms (*Dracula*). *Nu•tka•* is a Canadian Gothic.

The project is set in one of the most sublime moments of the romantic period – that of first contact between natives and Europeans on the West Coast of Vancouver Island at Nootka Sound. The Spanish explorer Juan Pérez was the there first, in 1774, but it wasn't until four years later that James Cook, thanks to an abiding misunderstanding, gave the area its name. When asked by the Captain the name of his home and of his people, Chief Maquinna replied to the Englishman's unfamiliar sign language and words, 'Nu•tka•!' – meaning 'go' or 'turn-around' – suggesting that the visitor anchored at Resolution Cove could find safe harbour nearby at Yuquot or, perhaps, that he should go back to where he came from.[1] […]

Project Description

Nu•tka• is a video installation in which two distinct images are interlaced on the same screen – weaving one image track, visible on the 'even' raster lines of a video projection with another, presented on 'odd' raster lines. These video tracks are played from disc, continually looping, with a quadraphonic soundtrack: two disembodied voices that drift around the exhibition space as they recount distinct narratives, which, like the images, are woven into one another, sometimes speaking simultaneously and sometimes in exact synchronization. The work is set in the late nineteenth century at Nootka Sound, with conflicting tales told by the Commandant of Yuquot's first Spanish occupation, José Estéban Martínez, and by his captor, the English Captain James Colnett – each of whom believed he had the right to claim land already occupied by a peculiarly 'absent'

third party, Chief Maquinna and the people of the Mowachaht Confederacy. In monologues derived from historical documents and their personal journals, the delirious Englishman alternates between recollection of his capture and the fantasy of escape, while the Spanish commander betrays signs of paranoia as he becomes increasingly uncertain of his ability to dominate the region.

The two image tracks were shot on 35mm film in two continuous takes from a vantage point on San Miguel Island, the original Spanish defensive site at Yuquot. The interlaced images are mostly in continual motion, panning and tilting, presenting various features of Nootka Sound – but they briefly come to rest, and into exact registration, on six occasions. At these moments, the uncanny apparition of a landscape subject to conflicting winds and opposing tides is seen. Concurrently, one hears Colnett and Martinez describing their respective delusions in exact synchronization with exactly the same words (excerpts from the Gothic and colonial literatures of Edgar Allan Poe, Cervantes, Jonathan Swift, Captain James Cook and the Marquis de Sade). As the narrators go their separate ways – recounting their contempt for one another and inability to endure the situation in which they find themselves – the interlaced image pulls apart also. Outside of the six synchronous moments the narratives, like images, are blurred, doubled, and, at a limit of legibility, sublime. [...]

1 What Maquinna actually said to Cook is uncertain because 'Nu•tka•' is not a complete word; however, Mowachaht words beginning with these two syllables tend to refer to circular motion. *Stan Douglas* (Krefeld: Museum Haus Lange, Museum Haus Esters and Cologne: Oktagon Verlag, 1997).

Stan Douglas, excerpt from 'Nu•tka•', in Scott Watson, Diana Thater and Carol Clover, *Stan Douglas* (London: Phaidon, 1996) 132; 136.

Mark Alice Durant and Jane D. Marsching
Paul Pfeiffer//2006

I think of terror as really a disturbance in one's sense of the normal or disturbance in one's sense of groundedness – who I am and who other people are and what the world is and maybe what the boundary between these things are.
- Paul Pfeiffer

Paul Pfeiffer's digital media works in computer-based videos, photographs and sculptures alter and refigure mass-media spectacles of all kinds, from erasing Muhammad Ali from video clips of three of his most famous fights to doubling a brief clip of a dancing Michael Jackson in a piece palindromically entitled *Live Evil*. The works remind us of how technology has become so deeply embedded in our mass media and individual consciousness. Emphasizing an erasure or fragmentation, the pieces incarnate absence to heighten our awareness of the mechanisms of desire, faith and obsession in pop culture. In a series of pieces that recreate sets of props from Hollywood terror films such as *The Exorcist* or *The Amityville Horror*, Pfeiffer reconstructs scenes in which domesticity is infiltrated by the paranormal. [...] *Poltergeist* (2000) is based on a scene from the 1986 Spielberg film of the same name, where an entity rearranges the kitchen chairs into an eerily beautiful pyramid. Pfeiffer translated this scene using 3-D modelling software into digital code and printed it in a stereo-lithographic process whereby a laser fuses together plastic powder in layers. Two years later Pfeiffer asked craftsmen in Thailand to carve the same object in wax, a former student in New York to weave it out of grass, and a prison inmate in New Mexico to sculpt it out of toilet paper. Endlessly doubling from a fictional original, the *Poltergeist* series takes an American vernacular spectacle of haunted domesticity and releases it into other social registers, where paradoxically individual handwork refashions the digital. The original exchange in the film between the ghost and the mother, between the ordinary and the supernatural, is shifted out of its filmic context to rupture technology's apparently seamless and endless duplication of the self.

Mark Alice Durant and Jane D. Marsching, 'Paul Pfeiffer', in *Blur of the Otherworldly* (Baltimore: Center for Art and Visual Culture, University of Maryland, 2006) 132.

I ALWAYS THINK

ABOUT THE PEOPLE WHO BUILD BUILDINGS AND THEN THEY'RE NOT AROUND ANY MORE. OR A MOVIE WITH A CROWD SCENE AND

EVERYBODY'S DEAD

IT'S FRIGHTENING

Andy Warhol, *The Philosophy of Andy Warhol: From A to B and Back Again*, 1975

CASTLES, RUINS AND LABYRINTHS

Julia Kristeva
Powers of Horror: An Essay on Abjection//1982

A Fortified Castle

Whether it be projected metaphor or hallucination, the phobic object has led us, on the one hand, to the borders of psychosis and, on the other, to the strongly structuring power of symbolicity. In either case, we are confronted with a limit that turns the speaking being into a separate being who utters only by separating – from within the discreteness of the phonemic chain up to and including logical and ideological constructs.

How does such a limit become established without changing into a prison? If the radical effect of the founding division is the establishment of the subject/object division, how can one prevent its misfires from leading either to the secret confinement of archaic narcissism, or to the indifferent scattering of objects that are experienced as false? The glance cast on phobic symptom has allowed us to witness the painful dawning, splendid in its symbolic complexity, of the (verbal) *sign* in the grip of *drive* (fear, aggressivity) and *sight* (projection of the ego onto the other). But analytic reality, mindful of what is called the 'unanalysable', seems to cause experience to arise from another symptom, one that emerges from the same very problematic separation subject/object – but now seemingly at the opposite end of phobic hallucination.

The constituting barrier between subject and object has here become an unsurmountable wall. An ego, wounded to the point of annulment, barricaded and untouchable, cowers somewhere, nowhere, at no other place than the one that cannot be found. Where objects are concerned he delegates phantoms, ghosts, 'false cards': a stream of spurious egos and for that very reason spurious objects, seeming egos that confront undesirable objects. Separation exists, and so does language, even brilliantly at times, with apparently remarkable intellectual realizations. But no current flows – it is a pure and simple splitting, an abyss without any possible means of conveyance between its two edges. No subject, no object: petrification on one side, falsehood on the other.

Letting current flow into such a 'fortified castle' amounts to causing desire to rise. But one soon realizes, during transference, that desire, if it dawns, is only a substitute for adaptation to a social norm (is desire ever anything else but desire for an idealized norm, the norm of the Other?). On the way, as if hatched by what, for others, will be desire, the patient encounters abjection. It seems to be the first authentic feeling of a subject in the process of constituting itself as such, as it emerges out of its jail and goes to meet what will become, but only later,

objects. Abjection of self: the first approach to a self that would otherwise be walled in. Abjection of others, of the other ('I feel like vomiting the mother'), of the analyst, the only violent link to the world. A rape of anality, a stifled aspiration towards an other as prohibited as it is desired – abject.

The outburst of abjection is doubtless only a moment in the treatment of borderline cases. I call attention to it here because of the key position it assumes in the dynamics of the subject's constitution, which is nothing other than a slow, laborious production of object relation. When the fortified castle of the borderline patient begins to see its walls crumble, and its indifferent pseudo-objects start losing their obsessive mask, the subject-effect – fleeting, fragile, but authentic – allows itself to be heard in the advent of that interspace, which is abjection.

It is not within the scheme of the analytic setup, probably because it does not have the power to do so, to linger over that blossoming. Emphasizing it would lead the patient into paranoia or, at best, into morality; now, the psychoanalyst does not believe he exists for that purpose. He follows or diverts the path, leading the patient towards the 'good' object – the object of desire, which is, whatever may be said, fantasized according to the normal criteria of the Oedipus complex: a desire for the other sex.

That, however, is not where we stand with respect to abjection in the case of the borderline patient. It had barely begun to slide the bolt of narcissism and had changed the walls behind which he protected himself into a barely pervious limit – and for that very reason, a threatening, abominable one. Hence there was not yet an other, an ob-ject: merely an ab-ject. What is to be done with this ab-ject? Allow it to drift towards the libido so as to constitute an object of desire? Or towards symbolicity, to change it into a sign of love, hatred, enthusiasm or damnation? The question might well remain undecided, undecidable.

It is within that undecidable space, logically coming before the choice of the sexual object, that the religious answer to abjection breaks in: *defilement, taboo,* or *sin.* [...]

Powerless Outside, Impossible Inside

Constructed on the one hand by the incestuous desire of (for) his mother and on the other by an overly brutal separation from her, the borderline patient, even though he may be a fortified castle, is nevertheless an empty castle. The absence, or the failure, of paternal function to establish a unitary bent between subject and object, produces this strange configuration: an encompassment that is stifling (the container compressing the ego) and, at the same time, draining (the want of an other, qua object, produces nullity in the place of the subject). The ego then plunges into a pursuit of identifications that could repair narcissism – identifications that the subject will experience as insignificant, 'empty', 'null',

'devitalized', 'puppet-like'. An empty castle, haunted by unappealing ghosts – 'powerless' outside, 'impossible' inside.

It is worth noting what repercussions such a foreclosure of the Name of the Father have on language. That of the borderline patient is often abstract, made up of stereotypes that are bound to seem cultured; he aims at precision, indulges in self-examination, in meticulous comprehension, which easily brings to mind obsessional discourse. But there is more to it than that. That shell of ultra-protected signifier keeps breaking up to the point of desemantization, to the point of reverberating only as notes, music, 'pure signifier' to be reparcelled out and resemanticized anew. It is a breaking up that puts a check on free association and pulverizes fantasy before it can take shape. It is, in short, a reduction of discourse to the state of 'pure' signifier, which insures the disconnection between verbal signs on the one hand and drive representations on the other. And it is precisely at such a boundary of language splitting that the *affect* makes an imprint. Within the blanks that separate dislocated themes (like the limbs of a fragmented body), or through the shimmering of a signifier that, terrified, flees its signified, the analyst can perceive the imprint of that affect, participating in the language cluster that everyday usage of speech absorbs but, with the borderline patient, becomes dissociated and collapses. The affect is first enunciated as a coenesthetic image of painful fixation; the borderline patient speaks of a numbed body, of hands that hurt, of paralysed legs. But also, as a motion metaphor binding significance: rotation, vertigo or infinite quest. The problem then, starting with transference, is to tap these remainders of signifying *vectorization* (which the paternal metaphor makes fast and stabilizes into 'normal discourse' in the case of the normative Oedipus triangle, which is here absent) by giving them a desiring and/or deathly signification. In short, one unfailingly orients them toward the other: another object, perhaps another sex, and, why not, another discourse – a text, a life to relive. [...]

Julia Kristeva, excerpt from chapter 2: 'Something to be Scared of', *Pouvoirs de l'horreur* (Paris: Éditions du Seuil, 1980); trans. Leon S. Roudiez, *Powers of Horror: An Essay on Abjection* (New York: Columbia University Press, 1982) 46–50.

Douglas Crimp
On the Museum's Ruins//1993

The German word *museal* [museumlike] has unpleasant overtones. It describes objects to which the observer no longer has a vital relationship and which are in the process of dying. They owe their preservation more to historical respect than to the needs of the present. Museum and mausoleum are connected by more than phonetic association. Museums are the family sepulchres of works of art.
– Theodor W. Adorno, 'Valéry Proust Museum'

Reviewing the installation of nineteenth-century art in the Metropolitan Museum's new André Meyer Galleries, Hilton Kramer derided the inclusion of salon painting. Characterizing that painting as silly, sentimental and impotent, Kramer went on to assert that, had the reinstallation been done a generation earlier, such pictures would have remained in the museum's storerooms, to which they had once so justly been consigned:

> It is the destiny of corpses, after all, to remain buried, and salon painting was found to be very dead indeed.
>
> But nowadays there is no art so dead that an art historian cannot be found to detect some simulacrum of life in its mouldering remains. In the last decade, there has, in fact, arisen in the scholarly world a powerful sub-profession that specializes in these lugubrious disinterments.[1]

Kramer's metaphors of death and decay in the museum recall Adorno's essay, in which the opposite but complementary experiences of Valéry and Proust at the Louvre are analysed, except that Adorno insists upon this *museal* mortality as a necessary effect of an institution caught in the contradictions of its culture and therefore extending to every object contained there.[2] In contrast, Kramer, retaining his faith in the eternal life of masterpieces, ascribes the conditions of life and death not to the museum or the particular history of which it is an instrument but to the artworks themselves, their autonomous quality threatened only by the distortions that a particular misguided installation might impose. He therefore wishes to explain 'this curious turnabout that places a meretricious little picture like Gérôme's *Pygmalion and Galatea* under the same roof with masterpieces on the order of Goya's *Pepito* and Manet's *Woman with a Parrot*. What kind of taste is it – or what standard of values – that can so easily accommodate such glaring opposites?'

The answer is to be found in that much-discussed phenomenon – the death of modernism. So long as the modernist movement was understood to be thriving, there could be no question about the revival of painters like Gérôme or Bouguereau. Modernism exerted a moral as well as an aesthetic authority that precluded such a development. But the demise of modernism has left us with few, if any, defences against the incursions of debased taste. Under the new postmodernist dispensation, anything goes...

It is as an expression of this postmodernist ethos ... that the new installation of nineteenth-century art at the Met needs ... to be understood. What we are given in the beautiful André Meyer Galleries is the first comprehensive account of the nineteenth century from a postmodernist point of view in one of our major museums.[3]

We have here an example of Kramer's moralizing cultural conservatism disguised as progressive modernism. But we also have an interesting estimation of the museum's discursive practice during the period of modernism and its present transformation. Kramer's analysis fails, however, to take into account the extent to which the museum's claims to represent art coherently have already been opened to question by the practices of contemporary – postmodernist – art.

One of the first applications of the term *postmodernism* to the visual arts occurs in Leo Steinberg's 'Other Criteria' in the course of a discussion of Robert Rauschenberg's transformation of the picture surface into what Steinberg calls a 'flatbed', referring, significantly, to a printing press.[4] This flatbed picture plane is an altogether new kind of picture surface, one that affects, according to Steinberg, 'the most radical shift in the subject matter of art, the shift from nature to culture'.[5] That is to say, the flatbed is a surface that can receive a vast and heterogeneous array of cultural images and artefacts that had not been compatible with the pictorial field of either premodernist or modernist painting. (A modernist painting, in Steinberg's view, retains a 'natural' orientation to the spectator's vision, which the postmodernist picture abandons.) Although Steinberg, writing in 1968, did not have a precise notion of the far-reaching implications of the term *postmodernism*, his reading of the revolution implicit in Rauschenberg's art can be both focused and extended by taking his designation seriously.

Steinberg's essay suggests important parallels with the 'archaeological' enterprise of Michel Foucault. Not only does the term *postmodernism* imply the foreclosure of what Foucault would call the episteme, or archive, of modernism, but even more specifically, by insisting on the radically different kinds of picture surfaces upon which different kinds of data can be accumulated and organized,

Steinberg selects the very figure that Foucault employed to represent the incompatibility of historical periods: the tables on which their knowledge is formulated. Foucault's archaeology involved the replacement of such unities of historicist thought as tradition, influence, development, evolution, source and origin with concepts such as discontinuity, rupture, threshold, limit and transformation. Thus, in Foucauldian terms, if the surface of a Rauschenberg painting truly involves the kind of transformation Steinberg claims it does, then it cannot be said to evolve from or in any way be continuous with a modernist painting surface.[6] And if Rauschenberg's flatbed pictures are experienced as producing such a rupture or discontinuity with the modernist past, as I believe they do and as I think do the works of many other artists of the present, then perhaps we are indeed experiencing one of those transformations in the epistemological field that Foucault describes. But it is not, of course, only the organization of knowledge that is unrecognizably transformed at certain moments in history. New institutions of power as well as new discourses arise; indeed, the two are interdependent. Foucault analysed modern institutions of confinement – the asylum, the clinic and the prison – and their respective discursive formations – madness, illness and criminality. There is another such institution of confinement awaiting archaeological analysis – the museum – and another discipline – art history. They are the preconditions for the discourse that we know as modern art. And Foucault himself suggested the way to begin thinking about this analysis. [...]

1 Hilton Kramer, 'Does Gérôme belong with Goya and Monet?', *New York Times*, (13 April 1980, section 2) 35.

2 Theodor W. Adorno, 'Valéry Proust Museum', *Prisms*, trans. Samuel and Shiery Weber (London: Neville Spearman, 1967) 173–86.

3 Kramer, op. cit., 35.

4 Leo Steinberg, 'Other Criteria', *Other Criteria* (New York: Oxford University Press, 1972) 55–91. This essay is based on a lecture presented at the Museum of Modern Art, New York, in March 1968.

5 Ibid., 84.

6 See Rosalind Krauss' discussion of the radical difference between the cubist collage and Rauschenberg's 'reinvented' collage in 'Rauschenberg and the Materialized Image', *Artforum*, no. 4 (December 1974) 36–43. [Both this and Steinberg's essay above are now reprinted in *Robert Rauschenberg*, ed. Branden W. Joseph (Cambridge, Massachusetts: The MIT Press, 2003).]

Douglas Crimp, excerpt from 'On the Museums Ruins', *On the Museum's Ruins* (Cambridge, Massachusetts and London: MIT Press, 1993) 44–8.

Kate Ferguson Ellis
The Contested Castle: Gothic Novels and the
Subversion of Domestic Ideology//1989

[...] Alongside [a] preoccupation with the ideal home, a distinct subcategory of the English novel, the Gothic, began to make its appearance on publishers' lists and on the shelves of circulating libraries. Focusing on crumbling castles as sites of terror, and on homeless protagonists who wander the face of the earth, the Gothic, too, is preoccupied with the home. But it is the failed home that appears on its pages, the place from which some (usually 'fallen' men) are locked out, and others (usually 'innocent' women) are locked in. The theme of 'paradise lost' links the paired strands of literary Gothicism that critics have variously identified as Radcliffian and Lewisite, 'feminine' and 'masculine', 'terror Gothic' and 'horror Gothic'.[1] Either the home has lost its prelapsarian purity and is in need of rectification, or else the wandering protagonist has been driven from the home in a grotesque re-enactment of God's punishment of Satan, Adam and Eve. [...]

The middle-class idealization of the home, though it theoretically protected a woman in it from arbitrary male control, gave her little real protection against male anger. Rather, it was her endangered position that was so ideologically useful, allowing her to stand for the class itself, beset on all sides by aristocratic license and lower-class violence. The Gothic novel of the eighteenth century foregrounded the home as fortress, while at the same time exposing its contradictions. Displacing their stories into an imaginary past, its early practitioners appealed to their readers not by providing 'escape' but by encoding, in the language of aristocratic villains, haunted castles and beleaguered heroines, a struggle to purge the home of license and lust and to establish it as a type of heaven on earth. To this end, they created a landscape in which a heroine could take initiative in shaping her own history. By allowing the heroine to purge the infected home and to establish a true one, by having her re-enact the disobedience of Eve and bring out of that a new Eden 'happier far', these novels provided a mediation between women's experience of vulnerability and the ideological uses to which that experience was put. [...]

The re-conceptualization of womanhood that was being argued out in the culture called forth a parallel discourse about men. If the home is closer to heaven than the world in which he operates, what kind of virtue is appropriate for a man? The solution of the Romantic is to elevate his alienation from the world. This alienation is then viewed as the true shape of the human condition,

rather than as a solution to the crisis of masculinity posed by the redefinition of woman as the repository of 'innocence'. Of course the male artist is alienated also from 'the world' that is supposed to be the province of men. Yet it is a double alienation, from the world *and* from the home, that we see in the work of Godwin and Maturin, with their 'fallen wanderer' protagonists whose distance from the domestic ideal only serves to reinforce its value. Mary Shelley's *Frankenstein*, building on the work of both of her parents, delivers one of the sharpest critiques of the ideology of 'separate spheres' to be found in fiction.

Both the Radcliffian villain and the Lewisite protagonist act out a counterscript in which men rebel against the feminization of the home. But unlike the male heroes of American literature, who go off into the wilderness together to escape the constraints of the female sphere, the English Gothic villains either usurp the castle or try to destroy it from the outside. They then try to reinstate there the 'shame culture' of an earlier era, when the home was not women's sphere.[2] A shame culture stresses the public expiation of wrongdoing, the maintaining or regaining (by men) of honour defined as a public perception of the individual. Its quintessential ritual is what Foucault calls 'the spectacle of the scaffold'.[3] In contrast, women's honour, and the loss of it, are private matters associated with the body, with violations that cannot be undone. Guilt cannot be eradicated by manipulations of public perception. Therefore the Gothic villain wants to return to a shame culture where conscience – embodied in the woman as mother and helpmeet – cannot follow. In his castle, his monastery or his lab, he attempts to establish a base from which he can attack the home, where guilt is produced under the rule of women. [...]

1 The distinction between the two modes derives from an opposition in eighteenth-century aesthetics between 'terror', which Burke treated as an opening to 'the sublime', and 'horror'. Radcliffe used Burke as the theoretical base for her work, as Malcolm Ware shows in 'Sublimity in the novels of Anne Radcliffe: a study of the influence upon her craft of Edmund Burke's *Enquiry into the Origin of Our Ideas of the Sublime and Beautiful*, in *Essays and Studies on English Language and Literature*, no. 25 (English Institute, Uppsala University, 1963). Her preference for terror over horror is expressed in the following often-quoted distinction: 'Terror and horror are so far opposite, that the first expands the soul, and awakens the faculties to a higher degree of life, the other contracts, freezes and nearly annihilates them', *New Monthly Magazine* (1826) 149. Even before the twentieth century, not all critics found her use of terror elevating: see for instance Sir Walter Scott, 'Mrs Anne Radcliffe', *Lives of the Novelists*, 2 vols. (London: H. C. Carey, 1825), vol. 1, 187–241. Montague Summers (*The Gothic Quest: A History of the Gothic* [1938]; reprinted New York: Russell and Russell, 1964, 28–31) employs three categories: terror Gothic, historic Gothic and sentimental Gothic, but does not treat the third. Leslie Fiedler in *Love and Death in the American Novel* (New York: Stein and Day, 1966) and

Judith Wilt in *Ghosts of the Gothic: Austen, Eliot and Lawrence* (Princeton: Princeton University Press, 1980) discuss Gothicism as a flight from community and especially from the domestic sphere ruled by women. Robert D. Hume regards 'sentimental' and 'historical' Gothic as 'misnomers', while 'horror-Gothic' novels are 'at the same time more serious and more profound' ('Gothic versus Romantic: A Revaluation of the Gothic Novel', *PMLA*, 84 [1969]) 282–90.

2 [footnote 7 in source] These terms are borrowed from the anthropologist Ruth Benedict, *The Chrysanthemum and the Stone* (Boston: Houghton Mifflin, 1946).

3 [8] See Michel Foucault, *Surveiller et punir* (Paris: Gallimard, 1975); trans. Alan Sheridan, *Discipline and Punish: The Birth of the Prison* (New York: Vintage, 1979) 32–67. The privatization of criminality, on the one hand, and insanity, on the other, are part of a wider social practice that is manifest in the creation of the prison and the asylum as well as the 'sphere' of home. See Michel Foucault, *Folie et déraison* (Paris: Plon, 1961); trans. Richard Howard, *Madness and Civilization* (New York: Vintage, 1973); Jacques Donzelot, *Police des familles* (Paris: Éditions du minuit, 1977); trans. Robert Hurley, *The Policing of Families* (Baltimore: Johns Hopkins University Press, 1979).

Kate Ferguson-Ellis, excerpt from 'Introduction', *The Contested Castle: Gothic Novels and the Subversion of Domestic Ideology* (Illinois: University of Illinois Press, 1989) ix; xi–xii; xiii–xiv; xvi–xviii.

Umberto Eco
The Name of the Rose//1980

[…] Years later, as a grown man, I had occasion to make a journey to Italy, sent by my abbot. I could not resist temptation, and on my return I went far out of my way to revisit what remained of the abbey.

The two villages on the slopes of the mountain were deserted, the lands around them uncultivated. When I climbed up to the top, a spectacle of desolation and death appeared before my eyes, which moistened with tears.

Of the great and magnificent constructions that once adorned that place, only scattered ruins remained, as had happened before with the monuments of the ancient pagans in the city of Rome. Ivy covered the shreds of walls, columns, the few architraves still intact. Weeds invaded the ground on all sides, and there was no telling where the vegetables and the flowers had once grown. Only the location of the cemetery was recognizable, because of some graves that still rose above the level of the terrain. Sole sign of life, some birds of prey hunted lizards and serpents that, like basilisks, slithered among the stones or crawled over the walls. Of the church door only a few traces remained, eroded by mould. Half of the tympanum survived, and I still glimpsed there, dilated by the elements and dulled by lichens, the left eye of the enthroned Christ, and something of the lion's face. […]

Along one stretch of wall I found a bookcase, still miraculously erect, having come through the fire I cannot say how; it was rotted by water and consumed by termites. In it there were still a few pages. Other remnants I found by rummaging in the ruins below. Mine was a poor harvest, but I spent a whole day reaping it, as if from those *disiecta membra* of the library a message might reach me. Some fragments of parchment had faded; others permitted the glimpse of an image's shadow, or the ghost of one or more words. At times I found pages where whole sentences were legible; more often, intact bindings, protected by what had once been metal studs… Ghosts of books, apparently intact on the outside but consumed within; yet sometimes a half page had been saved, an incipit was discernible, a title.

I collected every relic I could find, filling two travelling sacks with them, abandoning things useful to me in order to save that miserable hoard. […]

Umberto Eco, excerpt from *Il Nome della Rosa* (Milan: Bompiano, 1980); trans. William Weaver, *The Name of the Rose* (London: Vintage, 1983) 499–500.

Jonathan Jones
A House Is Not a Home//2000

[...] In *The Fall of the House of Usher* (1839), Poe's definitive tale of architectural horror, the nineteenth-century psyche found the ripest expression of its phantasms. Roderick Usher, Poe's alter ego, is a man of sensitivity – an artist who paints abstract canvases, plays music and composes verse – who hides himself away in his family's ancient mansion. The house, however, fails to provide rest and seclusion. Its history of incest and perversion – the narrator explains that, since time immemorial, the family have practised a bizarre form of intermarriage – manifests itself in an increasingly oppressive atmosphere. When Usher prematurely buries his sister in the family vault, the very structure of this introverted world begins to tear itself asunder. The narrator, witness to the dissolution of Usher and his domicile, finally flees:

> From that chamber, and from that mansion, I fled aghast. The storm was still abroad in all its wrath as I found myself crossing the old causeway. Suddenly there shot along the path a wild light, and I turned to see whence a gleam so unusual could have issued; for the vast house and its shadows were alone behind me. The radiance was that of the full, setting and blood-red moon which now shone vividly through that once barely-discernible fissure of which I have before spoken as extending from the roof of the building, in a zigzag direction, to the base. While I gazed, the fissure rapidly widened – there came a fierce breath of the whirlwind – the entire orb of the satellite burst at once upon my sight – my brain reeled as I saw the mighty walls rushing asunder – there was a long and tumultuous shouting sound like the voice of a thousand waters – and the deep and dark tarn at my feet closed sullenly and silently over the fragments of the 'House of Usher'.[1]

Poe has haunted modern art from the beginning. In fact, there's something unearthly about the extent to which he prefigured modernism in so many ways and was then mined by successive generations. Poe's alcoholic life and melancholy death were an inspiration to the very idea of the avant-garde. Baudelaire's translation of his tales in 1856–57 led to Poe being adopted by Parisian artists as the supreme Bohemian hero. Manet made a plaintive portrait of him in the early 1860s and illustrated Mallarmé's translation of *The Raven* (1875). The Poeism of the Surrealists can be seen most obviously in Magritte's 1937 portrait of Edward James, the English collector and patron of Dalí, entitled *Not To Be Reproduced*, in which James stands with his back to us, before a mirror that

repeats the same view. On the shelf, under the mirror, is a French translation of Poe's only novel, *The Adventures of Arthur Gordon Pym* (1838). [...]

But perhaps the strangest haunting of twentieth-century art by this drunken southern Gentleman is the connection between Poe's writings and those kinds of art, which, since the 1960s, have adopted site, architecture and interior as their media. His obsession with interiors and their destruction – the Gothic core of his writing – is a constant, unspoken presence in this art.

In 1968 Robert Smithson invoked the ghost of Poe: 'One's mind and the earth are in a constant state of erosion', declared Smithson in an article that was a manifesto for an art that acknowledges entropy, that gives in to time, that abandons the rational, individualist desire to draw strong boundaries between self and world. Smithson sees the modern artist, making rigid forms in the protected shut-off space of the studio, as the epitome of this closure, this resistance to time and reality. He prophesies the doom of this art, the disintegration of perfection, as steel cubes rust, bright industrial objects fall apart and the psyche of modernism implodes: 'The modern artist in his "studio", working out an abstract grammar within the limits of his "craft", is trapped in but another snare. When the fissures between mind and matter multiply into an infinity of gaps, the studio begins to crumble and fall like "The House of Usher", so that mind and matter get endlessly confounded.'[2]

In 1974, Gordon Matta-Clark cut a comforting, nostalgic American clapboard house in two. Slicing it down the middle, he opened up a fissure like the one that admitted the moonlight in Poe's 'House of Usher'. Photographs of Matta-Clark's *Splitting* show the light burning through the huge crack, which opens from bottom to top in a wedge of intrusive space. One side of the house is tilted a little so the building appears to be in motion; it appears to be the beginning of an accelerating process and suggests that powerful forces are rending the house asunder. But are those forces coming from inside or out?

In Poe's story there is no force outside the house; it is doomed by its own incestuous domesticity. In Smithson's reading of Poe, modern art disintegrates because it tries to ignore reality outside the studio. For Smithson, the House of Usher stands on shifting ground; the earth is not a solid platform but in flux. This is an image of society as a fluid, powerful constellation of forces. The House of Usher, that mansion of the private self, ignores these forces, and they tear Smithson's building apart, pulled rather than pushed in two. The enclosed, private world of the nineteenth-century individual is attacked by a larger social whole that will not permit privacy.

How do you inhabit a world that does not permit privacy, that no longer offers any space in which the individual can hide? We are all on the street, like Poe on his final bender in Baltimore. The opaque windows of Rachel Whiteread's

House (1993) were straight out of *The Fall of the House of Usher*: 'I looked upon the scene before me – upon the mere house, and the simple landscape features of the domain – upon the bleak walls – upon the vacant eye-like windows ... with an utter depression of soul...'[3] But when destruction came, it was from outside as the house was rent asunder by a demolition crew. Gregor Schneider's house in Rheydt, on the lower Rhine, is permanently permeable to the outside world. It's a private space that is also a public spectacle: he rebuilds his disorientating rooms – one revolves very slowly, others have false natural light – in public exhibitions, recently reconstructing his dank, dark cellar for the Royal Academy's 'Apocalypse' (2000).

Andy Warhol's 27-room townhouse on the Upper East Side was a private space, but it was also a mausoleum. Warhol filled it with his different collections, and each night, before going to bed, he would put the lights on in each room and look inside. The rest of the time, most of the rooms were locked. Each individual room was consistent – the East Parlour, for example, was fitted out in Federal period style, with furniture contemporary with Poe, but which he could never have afforded. Yet, Warhol's house disintegrates in the imagination: each room was different and irreconcilable, one contained his art deco objects, another his cookie jars. The boundary between inside and outside dissolved explicitly at the original 1960s Factory, Warhol's official residence, where, in the silvery environment of perpetual partying (with Warhol as Prince Prospero in his palace) the making of art went on among everything from gossip to attempted assassination. The walls of the studio vanished like the House of Usher sucked into the tarn.

Perhaps Warhol was a twentieth-century Poe – if the latter had prophesied the doom of the private self, it was Warhol who recorded domesticity's final dissolution. In 1977, he lent items from his collection of Americana to the Museum of Folk Art in New York. He said his favourite exhibit was a blue-painted door and frame from an eighteenth-century house. It was set up in the museum so it could be opened, closed, and walked through. 'I like the door best', said Andy, 'you can go in and out of it and still go nowhere'.

1 [footnote 2 in source] Edgar Allan Poe, *The Fall of the House of Usher and Other Writings* (London: Penguin, 1986) 157.

2 [3] *Artforum* (September 1968); reproduced in Charles Harrison and Paul Wood, *Art in Theory* (Oxford: Blackwell, 1992) 866–7.

3 [4] Ibid., 138.

Jonathan Jones, excerpt from 'A House is Not a Home', *frieze*, issue 55 (November–December 2000); www.frieze.com/features.asp.

Jeff Wall
Dan Graham's *Kammerspiel*//1985

[...] The glass house, understood as a symbolic system, solicits this state of terror in order to complete itself as a symbol. Its romanticism and its rootedness in structures of power and anxiety impel it to dominate the entire natural cycle.

The regime of theoretical invisibility and blissful absorption are, in the daytime, the outcome of the excessive openness of the house to the natural spectacle it dominates as property. This excessive or power-protected openness is in turn the result of the magnification of the generic identity of the house as princely pavilion, belvedere and retreat, in short of its generic links with the residues of aristocratic life, which, in the Romantic era, were rewoven into a rococo tapestry of the ideal bourgeois existence. The rococo setting of the little house in a private park is itself the purest expression of the mandarinesque fantasy at the centre of bourgeois ideals of elegance in the face of nature. But if daylight is the mechanism which sustains this particular symbolism, in the absence of daylight, at night another symbolism is necessarily invoked, a symbolism closely allied with that of the isolated pavilion and the disembodied, theoretical being who occupies it. So it follows, as night follows day, that the equally Romantic, and equally cryptic fantasy of vampirism must constitute the regulation of the house's game with itself in the hours of darkness.

At night, the lonely pavilion becomes the abandoned crypt of Gothic tales, and the theoretical invisibility of the occupant, his aversion from reflections, indicates his affinity with the vampire, one of the supreme theoretical beings which inhabit the imagination.

Graham's project diverges from and intervenes in the structural order of the glass house most strikingly in its re-imposition of the mirror. The symbolic system of his *Alteration* is centred on the exposure and enlargement of the veiled vampiric discourse which suffuses the Romantic schemata of the glass towers.

The vampire is neither alive, nor dead, but exists in an accursed state of irremediable tension and anxiety. Although his symbolic identity is complex and goes beyond its function in the analysis, he embodies a certain sense of cosmic grief which is a diffracted image of a concrete historical uneasiness. The most relevant aspect of his symbolism for our purposes is that, from the point of view of liberal Romanticism, the vampire signifies not simply the unwillingness of the old regime to die, but for the fear that the new order has unwittingly inherited something corrupted and evil from the old, and is in the process of unconsciously engineering itself around an evil centre. The presence of the

phantasm of the vampire in the consciousness of modern, liberal men signifies the presence of an unresolved crisis in the creation of the modern era itself. The vampiric symbolism persists as a codified form of expression of unease regarding the inner structure of the modern social order and the psyche corresponding to it, particularly its commitment to calculation and rationality. The role of vampiric symbolism as the expression of uneasiness about the effects of calculation brings it very close to the symbolism of the robot, the spellbound automaton, which the victims of the vampire's curse often resemble. The vampiric symbolism is a disturbance in the historical process of construction of theoretical beings – abstract citizens – through techniques, planning, contracts and 'value-free' calculation. The crisis of the mirror is the crisis of self-consciousness of such beings. Vampirism is the inner speech of that being – the ruler, the caesar, the prince – whose theoretical invisibility is constructed as the task of tragic modern architecture, the undead art.

By day, the vampire sleeps in his crypt and temporarily cedes the world to the living and to nature. By day, the glass house creates the phantasmagoria of blissful absorption into nature. Just as memory or fear of the vampire afflicts the daily activities of his potential victims, the symbolic system of the house has afflicted the possibilities of unity with nature. Behind the glass walls, nature, as picture, has already somewhat withdrawn from man. It is property, and, if property had memory, it would be afflicted by it.

The mirroric state remains in partial abeyance by day. It takes effect primarily on the external surface of the glass and so is visible only to people outside the house, to passers-by. But, symbolically, there are no passers-by. There may be guests, in that the house plays the part of a rococo pavilion. But if there are guests, they imitate the prince who is their host. Guests create a rococo comedy in which the prince plays all the parts. But, essentially, guests have a strictly subordinate role to play in this fantasy of abandonment. In Johnson's scheme, they are inured in an almost windowless guesthouse.

In the absence of observers outside the house, only the eye of nature itself is subjected to the reflection emitted by the glass walls. And nature's withdrawal behind glass from the viewpoint of the occupant is complemented by its own withdrawal from itself, into reflection. The eye of nature is trapped and immobilized by reflection; it is blinded to a certain extent by the consequences of its own energy, light, which is turned into a means of domination over it. Asymmetry is affirmed in the double immobilization of nature which is carried out complementarily on each surface of the glass. Anxiety is suppressed, and the serene fantasy of selfless absorption plays itself out, as domination blissfully loses sight of itself in its own effects.

By night, the occupant descends into a coolly contained state of terror, into a

state of anxious arousal deriving from the reversal of the optical axes. Nature having withdrawn, its eye now invisible, appears nowhere on the glass where it had earlier appeared everywhere. Absorption is cancelled by the departure of its object, and what remains is only the mechanism of anxiety-suppression itself, which now becomes an object of contemplation. Artificial light is introduced, transforming the entire interior into a mirror. The occupant now sees himself reflected in every surface, and may even see reflections of reflections, depending on the intensity of the lighting.

At night, the vampire awakens. But the glass house is a trap for him, for at every glance, he is traumatized by reflections, which reveals his impossibility, the travesty of the life he signifies – but also, his deep abandonment and loneliness. Like nature during the day, the vampire at night is immobilized by the mechanism of the house. A parallel appears then, between the spectacle of nature withdrawn into a state of property and the spectacle of the vampire trapped inside a mirrored crypt. The mechanism of the hours is the trap which vampirism springs upon itself. This self-induced vampiric trauma, this onanistic paroxysm of the vampire symbology in which the asymmetry of theoretical invisibility is apparently reversed into an excessive visibility, forms the climax of the fantastic, Igitur-like drama of occupancy invented by the house. The spectacle of the self-conscious revelation of the vampiric essence of the state of mastery implied by theoretical invisibility is the Romantic climax: an image of liberating trauma. In the trauma of self-revelation, the occupant, the vampiric eye, fantasizes its own liberation from the anxiety of abandonment. The vampiric eye is voluptuously crushed by the hallucinatory 'truth' produced by the mirror which shatters the travesty of naturalness which was that eye's illusion of bliss and selflessness. Trauma and bliss are fused together in the vain masochistic tableau of transfixed vampirism in the extended moment of the hallucinatory return of asymmetry to its source.

In this extended moment of excessive visibility, the power of absorptive gazing, of inspection, is transferred to the invisible eye of nature. Nature abruptly takes on vampiric powers, since it is now unreflected, indeed, cannot be reflected in the glass. Nature, which at night is actually invisible, is thus endowed with an inverted vampiric intelligence, a tragic memory of alienation inflicted upon it. The immobility of the vampiric trauma is complemented with a new mobility of nature. The vampiric text often includes an episode of the assault on crypt or castle by the terrified villagers whom the vampire has driven to frenzy with his attacks. These villagers are the fantastic incarnation of Nature afflicted with something of the intelligence of vampirism. They are the symbolic, but in that sense also the historic 'other' of the vampiric trauma, and when they attack the crypt they embody simultaneously an inspired revolutionary daring,

but at the same time a frenzied, compulsive violence which seems more like vampirism the more ferociously it attacks it.

In the specific system of the glass house, this assault is dramatized by drawing the curtains. Drawing the curtains ends the bliss of onanistic trauma, and it reconstitutes conventional privacy. This assumption of privacy is a disaster; it is the admission of defeat because the real curtain for the house is the boundary line of the property on which it is located. Drawing the curtains is a last-ditch ploy when the spectacle of vampiric trauma becomes overwhelming, but it in fact provides no relief. This is because it exposes a lack of confidence in the security of the boundary line: it is a gesture which indicates panic, panic that the boundary has been crossed by the 'other', that property relations have been breached and that the game of domination and submission has been broken by an uncontrollable force, the mob. Drawing the curtains is the historical defeatism of the ruling class. With the curtains drawn the house shrinks to the status of a private home whose social dominance is unwarranted and unenforced. It waits to be swept away by history. [...]

Jeff Wall, 'Dan Graham's *Kammerspiel*' part 2, *Real Life Magazine*, no. 15 (Winter 1985/86) 34–6; reprinted in *Jeff Wall: Selected Essays and Interviews* (New York: The Museum of Modern Art, 2007).

Anthony Vidler
A Dark Space: On Rachel Whiteread//1995

[...] Whiteread's *House* is modernist to the core, and would naturally arouse the ire of the entire postmodern, neo-traditionalist and heritage movements in Britain and elsewhere, movements dedicated to the notion that 'abstraction' equals 'eyesore'. But it seems also true that this project touched another nerve entirely [...] Whiteread touched, and according to some commentators, mutilated, the house, by necessity the archetypal space of homeliness. Article after article referred to the silencing of the past life of the house, the traces of former patterns of life now rendered dead but preserved, as it were, in concrete if not in aspic. [...]

Nineteenth- and twentieth-century writers and literary critics, from E.T.A. Hoffmann to Henry James, subsumed this horror of domestic interment/disinterment in the popular genre and theory of the uncanny, a genre that was often evoked in the discussion of Whiteread's project. This characterization would have it that the very traces of life extinguished, of death stalking through the centre of life, of the 'unhomeliness' of filled space contrasted with the former 'homeliness' of lived space (to use the terminology of the phenomenologist and psychologist Eugène Minkowski), raised the spectre of demonistic or magic forces, at the very least inspiring speculation as to the permanence of architecture, at most threatening all cherished ideals of domestic harmony – the 'children who once played on the doorstep' variety of nostalgia so prevalent among Whiteread's critics. Colin Wheeler's cartoon of the impression of Rachel Whiteread's 'cast' body in the wall of the Turner Prize exhibit echoes this sensibility; unwittingly it stems from a line of observations on the uncanny effects of impressions of body parts beginning with Chateaubriand's horrified vision of the volcanically 'cast' breast of a young woman at Pompeii: 'Death, like a sculptor, has moulded his victim', he noted.

Added to this, many writers have noted what they saw as the disturbing qualities of the 'blank' windows in *House*, this might be traced back to romantic tropes of blocked vision, the evil eye, and the uncanny effect of mirrors that cease to reflect the self; E.T.A. Hoffmann and Victor Hugo, in particular, delighted in stories of boarded-up houses whose secrets might only be imagined. The abandoned hulk of Whiteread's *House* holds much in common with that empty house on Guernsey, so compelling for Hugo's fantasies of secret history in *Les travailleurs de la mer*. It is perhaps not accidental that the use of the word 'uncanny' to denote supernatural power cited by the Oxford English

Dictionary is that of the transcendental Ralph Waldo Emerson, who quoted on the 'uncanny stones' of Stonehenge, an especially hermetic grouping of solids that refuses to give up its secrets easily.

Psychoanalysis, however, and especially since the publication of Freud's celebrated article on 'The Uncanny' in 1919, has complicated such romantic reactions by linking the uncanny to the more complex and hidden forces of sexual drives, death wishes and Oedipal fantasies. Taking off from the difficult formulation hazarded by Schelling in the 1830s that the uncanny was 'something that ought to have remained secret and hidden but which has come to light', Freud linked this sensation to experiences of a primal type – such as the primal scene witnessed by Little Hans – that had been suppressed only to show themselves unexpectedly in other moments and guises. Joined to such primary reactions, the causes of uncanny feelings included, for Freud, the nostalgia that was tied to the impossible desire to return to the womb, the fear of dead things coming alive, the fragmentation of things that seemed all too like bodies for comfort. Here, we might recognize themes that arose in some of the responses to *House*, among which the literal impossibility of entering into the house itself, as well as the possibility that its closed form held unaccounted secrets and horrors. [...]

Freud's analysis of the sources of the uncanny, however, has always seemed wanting precisely when confronted with terms that imply a non-object based uncanny – an uncanny generated by space rather than its contents. Despite a late recognition that space might be less universal than Kant had claimed, Freud remained singularly impervious to spatial questions and it was left to phenomenologists from Minkowski to Binswanger to recognize that space itself might be psychologically determined and thereby to be read as a symptom, if not an instrument, of trauma and neurosis. Tellingly, Minkowski writes of 'black' or 'dark' space, that space which, despite all loss of vision – in the dark or blindfolded – a subject might still palpably feel: the space of bodily and sensorial, if not intellectual, existence. It is such a space that Whiteread constructed, a blindingly suffocating space that, rather than receiving its contents with comfort, expelled them like a breath. [...]

In Whiteread's world, where even the illusion of return 'home' is refused, the uncanny itself is banished. No longer can the fundamental terrors of exclusion and banishment, of homelessness and alienation, be ameliorated by their aestheticization in horror stories and psychoanalytic family romances; with all doors to the *unheimlich* firmly closed, the domestic subject is finally out in the cold forever.

Anthony Vidler, excerpt from 'A Dark Space', in James Lingwood, ed., *Rachel Whiteread: House* (London: Phaidon, 1995) 68-72.

Jonathan Jones
Species of Spaces: On Mike Nelson//2000

[...] In horror literature, the narrative quality of buildings is made literal in the form of the 'haunted house': the house with a story to tell. With *To the Memory of H.P. Lovecraft* (1999) at the Collective Gallery, Edinburgh, Nelson allowed something terrible to haunt a space that was about to close for renovation. Building false walls that replicated the look of an archetypal modern art gallery, he then unleashed a beast to slash and tear the place apart, its claw marks on the walls apparently traces of some unspeakable horror.

The part of London's East End that is home to Matt's Gallery, the location of Nelson's most recent piece, *The Coral Reef* (1999–2000), has been torn up and fenced in, and is undergoing a process of being tarted up into a twenty-first-century park – a green space with its own flyover allowing trees to float above the traffic on Mile End Road. That any installation could compete with the madness of a city in the throws of such rebuilding is doubtful. At first, the labyrinth of rooms that comprised *The Coral Reef* (built inside the space over a three-month period) seemed almost too Gothic, too calculated, to be disconcerting. It was brilliant theatre, which is not always the best thing you can say about art. Nelson constructed a tangle of perfectly detailed, cinematic rooms/sets with a multitude of different ethnic and cultural decors, complemented by appropriate details that ranged from an American eagle to Muslim publications. There was even a white-walled reception room with a visitors' book, yet this too was a fabrication, a lie. It led into a place with an Islamic calendar on the wall and the wire grill frontage of a minicab company's reception. You might have been in any city on earth, feeling it was the last place on earth you belonged. There was a closed-in shed of a room full of car parts and tyres, an off-white corridor leading to an alcove with an old arcade machine.

Nelson lured the visitor not just into one, but fifteen false entrances and fictive vestibules; a suite of lobbies, interstitial spaces and limbo corridors. What you felt, in the depths of this labyrinth, was intense pleasure: the pleasure you feel when watching a film and the narrative kicks in and you no longer have to think about anything else. [...]

Nelson's architecture stays in your mind long after it has ceased to exist in reality, as if it only assumes its authority as a legend, a myth – like Babylon, like Thelema. It's a real place – there are photographs to prove he did build *The Coral Reef* – and yet it is most pungent as a mental image. When I think back, it must have been like that from the start. The moment you entered, the moment you

agreed to the fictional game – signing the visitors' book as if signing a contract – you were agreeing to have an implant planted in your head. The apparently playful decision to go along with Nelson's Gothic fantasy and walk from room to room was, in fact, an acceptance of an imaginative virus that you would not be able to purge from your memory. Somewhere in your mind, always, would be this place, a place that has no edges.

It's the lack of boundaries that makes the recollection so unnerving. In the depths of *The Coral Reef* it was impossible – and it has become increasingly so – to identify the shape of the space, as unthinkable as conceiving the shape of London when you are on the Tube. At one point you reached the exit – but it was just a replica of the exit. Of course, it was easy enough to get out, really, but that sense of shapelessness lingers unsettlingly in the mind. It is the image of a city as an underground warren, a system of catacombs; like living deep inside the Tower of Babel and never knowing what it looks like from the outside.

The trick Nelson performs is to fold falsehoods within falsehoods. The visitors' book – was it part of the real or false world? On signing it, to what did I commit myself? I don't know, except that I feel lost and unsettled, here in the first courtyard, looking up at the blue brick towers, waiting in the hot desert air for the next gate to open.

Jonathan Jones, excerpt from 'Species of Spaces', *frieze*, issue 53 (July-August 2000) 75–6.

Tacita Dean
Palast//2004

It is the building that always catches and holds the sun in the grey centre of the city: its regime-orange reflective glass mirroring the setting sun perfectly, as it moves from panel to panel along its chequered surface, drawing you in to notice it on your way up the Unter den Linden to Alexanderplatz. For a time, when Berlin was still new to me, it was just another abandoned building of the former East that beguiled me despite its apparent ugliness, tricking and teasing the light and flattering the sensible and solid nineteenth-century cathedral opposite with its reflections. Only later did I learn that it was the Palast der Republik and former government building of the GDR, a contentious place that concealed its history in the opacity of its surface, but had now been run-down, stripped of its trimmings and was awaiting the verdict on its future.

It was built on the site of a grand baroque palace that was demolished in 1950. The revivalists want the palace back; they want to rebuild it in its wedding cake finery and pretend it was never not there. They want to re-imagine history and erase the Palast der Republik, so that we, in the future, can no longer guess at a past.

And then there are those who are fighting to keep the Palast standing who believe to level such a building is to level memory, and that a city needs to keep its scars within the fabric of its architecture in order to preserve what our finite human memory will soon forget. Berlin needs to keep evidence of that other place: that country, and its corrupt mismanagement of a Utopia, that has now been crossed out as a mistake in the reckoning of history.

And then there are others, like me, who are attracted to the Palast for aesthetic reasons: the totalitarian aesthetic. We, who have no inkling of what the building meant when it had meaning, had no reason to look upon it and know the monster it contained – when the copper-tinted mirrored glass was not about catching reflections and deflecting the sun, but about looking in one direction only; about being observed without leave to observe.

When the Palast der Republik was first opened in 1976, it was clad in white marble with 180 metres of windowed façade, triumphant in its transparent splendour and so-named 'the house of a thousand windows'. There is now no trace of the white marble; the structure is raw wood and the windows are tarnished like dirty metal. It is as if the state is letting time make up its mind – letting entropy do the job and make the decision it is loath to make. But the sore in the centre of the city is too public, and so a month ago, the wedding cake won

and the Palast der Republik was condemned. The revivalists were triumphant. Soon Museum Island will be homogenized into stone white fakery and will no longer twinkle with a thousand setting suns.

Tacita Dean, 'Palast' (2004), in Jean-Christophe Royoux, Marina Warner and Germaine Greer, *Tacita Dean* (London and New York: Phaidon, 2006) 133.

Andrew O'Hagan
The Living Rooms: On Gregor Schneider//2004

There was a tenement flat in the Glasgow of my youth that seemed haunted to me. I'm speaking of a time before I knew how it is people not buildings which become haunted, and walking down West Princes Street three times a week I would stop at a certain corner and look up to find the yellow window at 15 Queens Terrace. I suppose I must have been nervous in those days, uncertain whether I'd ever cope in the adult world, but the light in the tenement flat made me frightened of ghosts. It made me realize that absence was just another presence.

On 21 December 1908, beyond the yellow window, an elderly spinster called Marion Gilchrist was murdered in her dining room and a broach was stolen. In what was understood by Conan Doyle and others to be a case of rank anti-Semitism, a down-at-heel Jew called Oscar Slater was arrested and later convicted of the murder on circumstantial evidence. Some claimed to have seen a man 'like' Slater running from the house in a hurry at the time of the murder. In fact, people more often described seeing another man, and those who testified against Slater later admitted they were pressured to give the evidence they gave. Slater was also condemned for seeming guilty and for having a pawn ticket for a broach about his person, though the item represented by Slater's ticket was lodged at a date before the crime was committed. Slater appeared to have some sort of doppelgänger, so did his conscience, so did his belongings. The case was fascinating, but I have to say it was the house that summoned the mysteries for me: we like to think that bricks have memories, that windows are eyes or the retinas of eyes, and the flat in Queens Terrace came to seem to me like a repository of hidden truths about human nature. It was a museum of the uncanny.

The same feeling struck as I approached 14 Walden Street, the home of the Familie Schneider [by Gregor Schneider, 2004]. The black front door and weathered bricks made me realize very quickly that I was looking at a contained narrative, a deeply embedded work of suggestion and memory and wonder, and putting the key into the lock I imagined, among other things, that I was opening Proust's great book. There was an immediate sense of the basement, whose windows had peeped onto the street as if embarrassed – certainly shy – of what remains below. The atmosphere of the basement crept into every area of the Schneider houses, and in the hall of number 14, with its poor English light and brown panels, one felt that the world had suddenly been sucked into a void at one's back with the closing of the door.

Proust wrote that dreams and reality are made of the same substance. The

kitchen made me think so. I saw the woman at the sink and the window in front of her, shining out like a vision of the future, and the woman seemed almost to belong there, surrounded by her things, her plates, her cutlery, a tin of air-freshener. I didn't want to impede her or disturb her in any way and I didn't want to reason with her. I simply wanted to experience this woman standing at the sink washing dishes with a circular motion of her left hand. [...]

One doesn't feel with the family Schneider that one is seeing ghosts – no, one feels that one is a ghost oneself, haunting these people in the middle of their heartbreaking routines. When I finally came before a mirror in the Schneider house I half-expected not to see myself reflected; I felt I floated from room to room, seeing but not being seen. Someone once described *Waiting for Godot* as a play in which nothing happens twice. The Schneider project is like that, a nothingness that one inhabits twice over, and on each occasion you discover a core strangeness about yourself that must be the signature feeling for ghosts. The houses did not frighten me straightforwardly: they made me realize that I myself am capable of being a cause of fear, like a voyeur in the guise of an intruder, like an actor in a nightmare.

The living room had no people in it, but it had the threat of life: a two-seater sofa, a glass table with a doily under the ashtray, a framed picture turned to the wall, as if images were not to be trusted. Were those glasses in the corner cupboard, waiting for some small, efficacious, social event? Was that two bags of shopping left on the floor under the television set? And was that a couple of paperbacks, or did I make that up? On leaving the houses behind, I found that I hadn't left them at all: these dwellings were dwelling in me, and I kept adding things I was sure I had seen there. Class means many things in Britain – a certain way of speaking, a certain attitude towards debt – but when it comes down to it class is an inventory of objects. The doily under the ashtray is a piece of evidence; the books, if they existed, are evidence too; the patterned rug is a dead give-away: these unspeaking people are caught in the middle of their lower-middle-class lives, and each room offers a narrative of limited aspiration. This is just another element, though, for the main force of the Schneider houses is philosophical. I realized that as I stood in the living room and looked at the fireplace: there is nothing in life so cold as a cold fireplace.

Gregor Schneider is a poet of the ominous. His work gives new meaning to the term 'life-threatening'. When people use that phrase they usually mean that something poses a danger to life, but Schneider might use it differently, for his work suggests that life itself is a threat, an ominous activity, and that living is a desperate act of repetition where one breath must follow another in a seemingly involuntary drama of survival. In the middle of life itself we are stranded. Going up the stairs in each house, I was suddenly overwhelmed by the appearance of

weak lighting on gloss-painted doors. If the dead sing lullabies, I heard one just then, and I thought of James Joyce's story *The Dead*, the part where Gretta is standing on the stairs being watched by her husband, just as she listens to an old song coming down from a room overhead. [...]

On the first floor landing of 14 Walden Street – and again at number 16 – you hear water trickling in the bathroom, and stepping into that room you find a man hunched under a weakling shower, his back turned, and you see by his movements that he is masturbating. A cake of green soap sits on the washbasin beside a half-squeezed tube of Colgate toothpaste. Like a fresh new chapter in a novel of desire, the sight of the man prompts you to enlarge the story: is this the dishwashing woman's husband? What's the relationship between the woman's domestic glare into the middle distance and this man's not-entirely-happy-seeming posture in the shower? Connecting the routines, you find yourself embarrassed, for what is more embarrassing than being a spectator to the incidentals of other people's loneliness? Standing there, eyeing the green soap, I thought what a prison we make of the objects that surround us.

Herr Schneider knows enough to make the viewer, the participant, the visiting ghost, enter into dialogue with his or her own domestic past, and the results are neither cosy nor forgettable. I swear there was something murderous in those houses. From the gloss paint-work, the locked doors, the efforts at comfort which only conveyed discomfort – coal fires, convector heaters, a gas fire and central heating, in each of the houses – one felt that there was something in the atmosphere that was both terribly familiar and deeply grotesque.

We might call it the mythic strain. We might call it the force of the uncanny. Why does the story of Peter Pan get so perfectly under our skin, if not because of its mythic power, the fact that the germ of its psychology (the demand to live forever in childhood) is so embedded in us? Why do the stories of missing persons chime so deeply with what we know about ourselves, if not because of its uncanny force, the fact that we all exist with the fear of not existing at all. What is it about *The Strange Case of Dr Jekyll and Mr Hyde*, if not that its mythical, uncanny strangeness already has a place and a language in our conscience, so that its argument comes to us not as a matter of persuasion but as a test of recognition? This is also how we respond to the mythical large canvases of Mark Rothko: we recognize them; we accept them for what they are. For me, walking into the bedroom of the Schneider houses, particularly the first one, was like walking through a door into an exact moment from my own past, and knowing, when I arrived, that this room had been waiting for me, unchanged, unbidden.[...]

Andrew O'Hagan, excerpt from 'The Living Rooms' in James Lingwood, ed. *Gregor Schneider: Die Familie Schneider* (London and Göttingen: Artangel and Steidl Mack, 2004) 156-9.

Biographical Notes

Nike Bätzner is a German art historian and curator based in Berlin. She is the author of *Andrea Mantegna* (1998) and *Arte Povera* (2000), and the editor of *Arte Povera: Manifeste, Statements, Kritiken* (1995).

Jean Baudrillard (1929–2007) was a French cultural and social theorist and philosopher. His works include *Le système des objets* (1968), *Pour une critique de l'économie du signe* (1972; *For a Critique of the Political Economy of the Sign*, 1981), *Simulacres et simulations* (1981; *Simulations*, 1983), *Cool Memories* (1987) and *The Conspiracy of Art* (2005).

Elisabeth Bronfen is Professor of English and American Studies at the University of Zurich. Her works include *Over Her Dead Body: Death, Femininity and the Aesthetic* (1992), *Death and Representation* (1993), *The Knotted Subject: Hysteria and its Discontents* (1998), *Feminist Consequences: Theory for the New Century* (2000) and *Home in Hollywood: The Imaginary Geography of Cinema* (2004).

Edmund Burke (1729–1797) was an Anglo-Irish statesman, political theorist and philosopher. His works include *Vindication of Natural Society* and *Philosophical Inquiry into the Origin of our Ideas of the Sublime and Beautiful* (both 1756), and *Reflections on the Revolution in France* (1790).

Carolyn Christov-Bakargiev is Chief Curator at the Castello di Rivoli, Turin, and Curator of the 2008 Biennale of Sydney. As an art historian she is internationally recognized as an authority on post-war Italian art and culture. Her works include *Arte Povera* (1999). Exhibitions she has curated include major solo shows of Janet Cardiff (2001), William Kentridge (2004), Pierre Huyghe (2004) and Franz Kline (2004), and the art-historical survey exhibition 'Faces In the Crowd' (co-curated with Iwona Blazwick, Whitechapel Gallery, London; Castello di Rivoli, Turin, 2004–5).

Carol J. Clover is Professor in the Departments of Rhetoric, Scandinavian and Film Studies at the University of California, Berkeley, where she has taught courses on film theory, film and law and film genres (horror, film noir, courtroom drama). Her writings include *Men, Women and Chainsaws: Gender in the Modern Horror Film* (1992) and the Focus essay in *Stan Douglas* (1998).

Michael Cohen is an American curator and senior correspondent at *Flash Art* magazine. Among the exhibitions he has curated are the American section of the 2002 Seoul Biennial, South Korea.

Beatriz Colomina is an architectural historian and theorist, and the Founding Director of the Program in Media and Modernity at Princeton University. Her works include *Architectureproduction* (1988), *Sexuality and Space* (1992), *Privacy and Publicity: Modern Architecture as Mass Media* (1994) and *Domesticity at War* (2006).

Douglas Crimp is Professor of Art History, Visual and Cultural Studies at the University of Rochester. An early exponent of postmodernist criticism in the 1980s, he was among the founders of the discipline of visual studies. His works include *On the Museum's Ruins* (1993), *AIDS: Cultural Analysis/Cultural Activism* (1998) and *Melancholia and Moralism* (2002).

Richard Davenport-Hines is a British writer and historian whose interests encompass literature and the history of commerce. His works include *Gothic: Four Hundred Years of Excess, Horror, Evil and Ruin* (1999) and *The Pursuit of Oblivion: A Global History of Narcotics 1500–2000* (2001).

Tacita Dean is a British artist best known for her 16mm films which explore uncanny places or artefacts evoking in-between conditions of temporality, fact and fiction. Solo exhibitions include Witte de With Center for Contemporary Art, Rotterdam (1997), Institute of Contemporary Art, Philadelphia (1998), ARC Musée d'art moderne de la Ville de Paris (2003), Schaulager, Basel (2006) and the Solomon R. Guggenheim Museum, New York (2007).

Jacques Derrida (1930–2004), the Algerian-born French philosopher and literary theorist, is best known as the founder of the deconstructive reading of texts, set out in works such as *De la grammatologie* (1967; *Of Grammatology*, 1976). In his later writings he frequently addressed the subject of death, either implicitly or directly in texts such as *Donner la mort* (1993; *The Gift of Death*, 1995) and *The Work of Mourning* (2001).

Stan Douglas is a Canadian artist based in Vancouver who works in photography, film and video installation, exploring dimensions of memory, repetition and the uncanny to investigate social alienation and psychic states. His work has been included in Documenta X and 11, Kassel (1997; 2002) and the Venice Biennale (2001; 2005). Major solo shows include Vancouver Art Gallery (international touring retrospective, 1999–2000), Serpentine Gallery, London (2002), and Wiener Secession, Vienna (2006).

Mark Alice Durant is an American artist, writer and faculty member at the University of Maryland, Baltimore County, where he co-curated 'Blur of the Otherworldly: Contemporary Art, Technology and the Paranormal'. He has exhibited at the Los Angeles County Museum of Art, the Museum of Contemporary Art, Chicago, and Artist's Space, New York.

Jane D. Marsching is an American artist and lecturer whose work explores belief, the paranormal and science. She is Assistant Professor at Massachusetts College of Art and co-curator of 'Blur of the Otherworldly: Contemporary Art, Technology and the Paranormal' (University of Maryland).

Richard Dyer is a British writer on film theory and popular culture. His works include *Gays and Film* (1977), *Only Entertainment* (1992), *White: Essays on Race and Culture* (1997) and *The Culture of Queers* (2002). He is Professor of Film Studies at King's College, University of London.

Umberto Eco is an Italian semiotician, medievalist and novelist, who since 1999 has been President of the Scuola Superiore di Studi Umanistici, University of Bologna. His works related to the Gothic include 'Sviluppo dell'estetica medievale', in *Momenti e problemi di storia dell'estetica* (1959; *Art and Beauty in the Middle Ages*, 1985), *Storia della bellezza* (2004; *History of Beauty*, 2004) and his popular novels, such as *Il nome della rosa* (1980; *The Name of the Rose*, 1983).

Mark Edmundson is Distinguished Teaching Professor of Romantic Poetry and Literary Theory at the University of Virginia. His works include *Towards Reading Freud: Self-Creation in Milton, Wordsworth, Emerson and Sigmund Freud* (1990) and *Nightmare on Main Street: Angels, Sado-Masochism, and the Culture of Gothic* (1997).

Bret Easton Ellis is an American novelist whose fiction was highly influential on the 'generation X' culture of the early 1990s. His novels include *Less Than Zero* (1985), *The Rules of Attraction* (1987), *American Psycho* (1991; adapted for the film directed by Mary Harron in 1999), *Glamorama* (1998) and *Lunar Park* (2005).

Kate Ferguson Ellis is Associate Professor of English at Rutgers University, New Jersey. Her works

include *The Contested Castle: Gothic Novels and the Subversion of Domestic Ideology* (1989) and *Crossing Borders* (2001).

Trevor Fairbrother is an independent curator and scholar based in Boston, Massachusetts. Former Curator of Modern Art at the Seattle Art Museum (1996–2001), he is a noted Sargent scholar and author of *John Singer Sargent: The Sensualist* (2001). Exhibitions he has curated include 'Beuys and Warhol: The Artist as Shaman and Star', Museum of Fine Arts, Boston (1991).

Alex Farquharson is a British art critic and curator who teaches on the Curating Contemporary Art course at the Royal College of Art, London. He has published numerous catalogue and monograph essays and is a regular contributor to *frieze*, *Art Monthly* and *Artforum*. Exhibitions he has curated include the British Art Show (with Andrea Schlieker, 2005) and 'If Everybody Had an Ocean', Tate St Ives, Cornwall (2007).

Hal Foster is Townsend Martin Professor of Art and Archaeology at Princeton University, an editor of *October* and a contributor to *Artforum* and the *London Review of Books*. His works include *Recodings: Art, Spectacle, Cultural Politics* (1985), *Compulsive Beauty* (1993), *The Return of the Real: The Avant-Garde at the End of the Century* (1996) and *Prosthetic Gods* (2004).

Michel Foucault (1926–84), the French philosopher and historian of systems of thought, transformed the social sciences and humanities with his critiques of social institutions and the operations of power in discourse, such as *Folie et déraison* (1961, *Madness and Civilization*, 1973), *Surveiller et punir* (1975; *Discipline and Punish: The Birth of the Prison*, 1977) and the three-volume *Histoire de la sexualité* (1976–84; *The History of Sexuality*, 1978–86).

Sigmund Freud (1856–1939), the Viennese co-founder of the psychoanalytic school of psychology, theoretically expounded many of the concepts leading to current readings of the Gothic, such as his notions of the 'id', the double and split personality, and the uncanny. His works are collected in *The Standard Edition of the Complete Psychological Works of Sigmund Freud* (24 vols).

William Gibson is an American science fiction novelist who is considered the founder of the cyberpunk genre. His works, many of which have been adapted into films, include *Neuromancer* (1984), *Count Zero* (1986), *All Tomorrow's Parties* (1999) and *Spook Country* (2007).

Christoph Grunenberg is Director of Tate Liverpool. Exhibitions he has curated include 'Gothic: Transmutations of Horror in Late Twentieth-Century Art', Institute of Contemporary Art, Boston (1996), 'Summer of Love: Art of the Psychedelic Era', Tate Liverpool (2006) and 'Jake and Dinos Chapman: Bad Art for Bad People', Tate Liverpool (2007).

Bruce Hainley is an American writer, curator and poet. Associate Director of Graduate Studies in Criticism and Theory at Art Center College of Design, Pasadena, he is a contributing editor to *Artforum*, *frieze*, *Parkett* and *The Nation*, and has curated numerous exhibitions, including the film retrospective 'Warhol on Screen', The Museum of Contemporary Art, Los Angeles (2002).

Judith Halberstam is Professor of English and Director of The Center for Feminist Research at the University of Southern California. Focussing on queer studies, gender theory, art and film, her books include *Female Masculinity* (1998), *Skin Shows: Gothic Horror and the Technology of Monsters*, and *In a Queer Time and Place: Transgender Bodies, Subcultural Lives* (both 2005).

Damien Hirst is a British artist who, as an art student in 1988, famously launched the 'young British

artists' phenomenon with the group exhibition 'Freeze' which he organized in a London warehouse. Death is the central theme in most of his work. Major solo exhibitions include Institute of Contemporary Arts (1991) and the Venice Biennale (1993). He was included in 'Sensation' (1997) and 'Apocalypse: Beauty and Horror in Contemporary Art' (2000), both at the Royal Academy of Art, London. Exhibitions he has curated include 'Some Went Mad, Some Ran Away', Serpentine Gallery, London (1994) and, also at the Serpentine, 'In the Darkest Hour There May Be Light: Works from Damien Hirst's Murderme Collection' (2006).

Gianni Jetzer is Director of the Swiss Institute, New York, and was formerly Director of the Neue Kunst Halle, St Gallen, Switzerland (2001–6), where exhibitions he curated included 'Anti Pure: Angel Blood' (2003). He is a regular contributor to art journals such as *Parkett*.

Amelia Jones is an American art historian, critic and curator. Her works include *Postmodernism and the En-Gendering of Marcel Duchamp* (1994), *Body Art: Performing the Subject* (1998) and the Survey essay in *The Artist's Body*, ed. Tracey Warr (2000). Exhibitions she has curated include 'Sexual Politics', UCLA/Armand Hammer Museum, Los Angeles (1996). She is Professor of Art History at Manchester University.

Jonathan Jones is a British art critic who has written for *The Guardian* newspaper since 1999. He is also a regular contributor to art journals such as *frieze* and to exhibition catalogues and publications on both traditional and contemporary art.

Mike Kelley is a Californian artist whose work encompasses installation, performance, sculpture, video, writing and curating. Emerging into the late 1970s punk-goth scene with his band Destroy All Monsters, he became highly influential on the area of practice described as abject art in the late 1980s and early 1990s, and has also made collaborative works with artists such as Paul McCarthy and Tony Oursler. Solo exhibitions include the Whitney Museum of American Art (retrospective, 1993) and Gagosian Gallery, New York (2005). In 1993 he curated 'The Uncanny' at the Gementeemuseum, Arnhem, The Netherlands, for Sonsbeek '93. He presented a revised and updated version of the exhibition at Tate Liverpool, England, in 2004.

Stephen King is an American novelist in the horror genre who also writes under the pseudonym Richard Bachman. His novels include *Carrie* (1974), *The Shining* (1977), *The Running Man* (1982), *Misery* (1987) and *Needful Things* (1990). Many of his books have been adapted into films.

Julia Kristeva is a Bulgarian-born French philosopher, scholar of literature and practising psychoanalyst, who is a leading feminist exponent of post-structuralist critique. Her works include *Soleil noir: Dépression et mélancolie* (1987; *Black Sun: Depression and Melancholy*, 1989) and *Pouvoirs de l'horreur* (1980; *Powers of Horror: An Essay on Abjection*, 1982).

Jacques Lacan (1901–81) was a French post-Freudian psychoanalyst whose seminars and writings were influential on the Surrealists in the 1930s and on the emergence of post-structuralism in the 1960s. Key translated collections of his writings include *The Language of the Self: The Function of Language in Psychoanalysis* (1968) and *The Four Fundamental Concepts of Psychoanalysis* (1977).

Patrick McGrath is a British Gothic novelist whose works include the story collection *Blood, Water and Other Tales* (1988) and six novels: *The Grotesque* (1989), *Spider* (1990), *Dr Haggard's Disease*

(1993), *Asylum* (1996), *Martha Peake: A Novel of the Revolution* (2000) and *Port Mungo* (2004).

Kobena Mercer is a cultural critic concerned with the politics of representation in African diasporic visual arts. He is a contributor to *Screen*, *Artforum* and *Sight & Sound*. He is the author of *Welcome to the Jungle: New Positions in Black Cultural Studies* (1994) and *Race, Sexual Politics and Black Masculinity: A Dossier* (1998), and the editor of *Pop Art and Vernacular Cultures* (2007).

James Meyer is Associate Professor of Art History at Emory University, Atlanta. He is the author of *Minimalism: Art and Polemics in the Sixties* (2001) and *Minimalism* (2001). Works he has edited include Gregg Bordowitz, *The AIDS Crisis is Ridiculous and Other Writings 1986–2003* (2004) and Carl Andre, *Cuts = Texts 1999–2004* (2005).

Shamim M. Momim is Curator at the Whitney Museum of American Art at Philip Morris, New York, where she initiated 'Contemporary Artists on Contemporary Art', a series in which emerging artists create new work in response to selections from the Whitney Museum's contemporary collection. She was co-curator, with Chrissie Iles and Debra Singer, of the 2004 Whitney Biennial.

Andrew O'Hagan is a Scottish writer and novelist. He is a contributing editor to the *London Review of Books* and *Granta*. His works include *The Missing* (1995), *Our Fathers* (1999), *Personality* (2003) and *Be Near Me* (2006).

Edgar Allan Poe (1809–49) was an American poet, short story writer and essayist whose works exploring a Gothic-Romantic sensibility, against the grain of American Transcendentalism, were highly influential on the later nineteenth-century aesthetic movements in France and Britain. His most influential works in the Gothic genre are the two-volume collection of short stories, *Tales of the Grotesque and Arabesque* (1839) and the poem 'The Raven' (1845).

Anne Rice is an influential American novelist who focuses on Gothic or religious themes. Her works include *The Vampire Chronicles* (1976–2003), *New Tales of the Vampires* (1988–99), and *Christ the Lord: Out of Egypt* (2005).

Andrew Ross is Professor of American Studies in the Department of Social and Cultural Analysis at New York University. He is a contributor to *Artforum*, *The Nation* and *The Village Voice*. His works include *Strange Weather: Culture, Science and Technology in the Age of Limits* (1991). He is co-editor, with Constance Penley, of *Technoculture* (1991).

Jerry Saltz is a distinguished American art critic based in New York. A collection of his writings as senior art critic at *The Village Voice* (*Seeing Out Loud: The Village Voice Art Columns, 1998–2003*) was published in 2003.

Eve Kosofsky Sedgwick is an American theorist specializing in gender studies, queer and critical theory. Her writings include *Between Men: English Literature and Male Homosocial Desire* (1985), *Fat Art, Thin Art* (1995) and *Touching Feeling: Affect, Pedagogy, Performativity* (2003).

Mary Wollstonecraft Shelley (1797–1851), the British Romantic and Gothic novelist, was the daughter of the feminist and writer Mary Wollstonecraft. Her writings include *Frankenstein, or The Modern Prometheus* (1818), *The Last Man* (1833), and *Lodore* (1835).

Nancy Spector is Curator of Contemporary Art at the Solomon R. Guggenheim Museum, New York, where she has organized major shows of artists such as Felix Gonzalez-Torres and Matthew Barney. In 1997 she was Adjunct Curator of the Venice Biennale and co-organizer of the first

Berlin Biennale. She is Curator of the United States Pavilion for the 2007 Venice Biennale.

Gayatri Chakravorty Spivak is the Avalon Foundation Professor in the Humanities at Columbia University. Her scholarship of deconstructive textual analysis is combined with a committed feminist critique of colonialism. Her books include *The Post-Colonial Critic* (1990) and *A Critique of Postcolonial Reason: Towards a History of the Vanishing Present* (1999).

Robert Louis Stevenson (1850–1894), the Scottish poet, novelist and essayist, was a leading exponent of Neo-Romanticism. His writings in the Gothic genre include *The Strange Case of Dr Jekyll and Mr Hyde* (1886) and *The Body-Snatcher* (1895).

Anthony Vidler is Department Chair and Professor of Art History at the University of California, Los Angeles. His works include *The Writing of the Walls: Architectural Theory in the Late Enlightenment* (1990), *The Architectural Uncanny: Essays in the Modern Unhomely* (1992) and *Warped Space: Art, Architecture, and Anxiety in Modern Culture* (2002).

Jeff Wall is a Canadian artist based in Vancouver whose work since the 1970s has explored dialogues between photography and pictorial narrative in painting and cinema. Major solo exhibitions include Galerie nationale du Jeu de Paume, Paris (1995), Whitechapel Gallery, London (1998), Museum für Moderne Kunst, Frankfurt am Main (2001) and Tate Modern, London (2005).

Marina Warner is a novelist, short story writer and cultural critic whose work focuses on folklore and mythology from a feminist perspective. Her works include *Alone of All Her Sex: The Myth and the Cult of the Virgin Mary* (1976), *Joan of Arc: The Image of Female Heroism* (1981), *The Lost Father* (1988) and *Phantasmagoria* (2006).

Anne Williams is Professor and Head of English at the University of Georgia, specializing in Romanticism, the Gothic, feminist literary theory, and opera and literature. Her works include *Prophetic Strain: The Greater Lyric in the Eighteenth Century* (1984) and *Art of Darkness: A Poetics of Gothic* (1995). She has also edited *Three Vampire Tales* (2002).

Slavoj Zizek is a Slovenian psychoanalytic philosopher, sociologist and cultural critic, based at the University of Ljubljana. Among his prolific writings on many subjects, those most relevant to visual studies include *Looking Awry: An Introduction to Jacques Lacan through Popular Culture* (1991), *Everything You Always Wanted to Know About Lacan ... But Were Afraid to Ask Hitchcock* (1993), *The Plague of Fantasies* (1997) and *The Art of the Ridiculous Sublime: On David Lynch's Lost Highway* (2000).

Bibliography

Further Reading. For the anthology bibliographic references please see citations at end of each text.

Allende, Isabelle, *House of the Spirits*, Bantam, New York, 1985

Arruda, Fernanda and Clifton, Michael, eds, *Scream*, Anton Kern Gallery, New York, 2004

Baldick, Chris, ed., *The Oxford Book of Gothic Tales*, Oxford University Press, Oxford, 1992

Barthes, Roland, 'Textual Analysis of Poe's "Valdemar"', in *Modern Criticism and Theory: A Reader*, ed. David Lodge, Longman, London, 1988, 173–95

Bataille, Georges, *Literature and Evil* (1957), trans. Alastair Hamilton, Marion Boyars, London, 1973

Benezra, Neil and Viso, Olga M., *Regarding Beauty: A View of the Late Twentieth Century*, Smithsonian Institution, Washington, D.C., 1999

Botting, Fred, *Gothic*, Routledge, London and New York, 1996

Botting, Fred, ed., *The Gothic*, D.S. Brewer, Cambridge, 2001

Bourgeois, Louise, *Destruction of the Father, Reconstruction of the Father. Writings and Interviews, 1923–1997*, ed. Hans Ulrich Obrist and Marie-Laure Bernadac, Violette Editions, London, 1998

Bovier, Lionel, ed., *Olaf Breuning: Home*, text by Brian Kerstetter, J.P. Ringier, Zurich, 2004

Brea, José Luis, *The Last Days*, Pabellón de España, Seville, 1992

Bronfen, Elisabeth and Kavka, Misha, eds, *Feminist Consequences: Theory for the New Century*, Columbia University Press, New York, 2000

Bronfen, Elisabeth, 'Chryptotopias. Secret Sites/Transmittable Traces', in *Gregor Schneider: Dead Haus ur 1985–97*, Städtisches Museum Abteiberg, Mönchengladbach, 1997

Bronfen, Elisabeth, *Over Her Dead Body: Death, Femininity and the Aesthetic*, Manchester University Press, Manchester, 1992

Burton, Tim, *The Melancholy Death of Oyster Boy & Other Stories*, Faber & Faber, London, 1998

Butler, Judith, *Bodies that Matter: On the Discursive Limits of 'Sex'*, Routledge, New York and London, 1993

Cabinet, 'Evil', issue 5, Winter 2001; 'Doubles', issue 14, Summer 2004; 'Ruins', issue 20, Winter 2005/06; 'Shadows', issue 24, Winter 2006–07

Carroll, Noel, *The Philosophy of Horror or Paradoxes of the Heart*, Routledge, London and New York, 1990

Carter, Angela, *The Infernal Desire Machines of Dr Hoffman* (1972), Penguin, Harmondsworth, 1982

Cavallaro, Dani, *The Gothic Vision: Three Centuries of Horror, Terror and Fear*, Continuum, London, 2002

Cixous, Hélène, 'Fiction and its Phantasms: A Reading of Freud's *'Das Unheimliche'*, *New Literary History*, 7, no. 3, 1975, 525–48.

Clover, Carol J., 'Der Sandmann', in *Stan Douglas*, Phaidon Press, London, 1998, 70–7

Connor, Steven, *The Book of Skin*, Cornell University Press, Ithaca, New York, 2003

Cooper, Dennis, *Frisk*, Grove Press, New York, 1992

Creed, Barbara, 'Horror and the Monstrous-Feminine: An Imaginary Abjection', *Screen*, 27, January/February 1986, 44–70

Creed, Barbara, *The Monstrous-Feminine: Film, Feminism, Psychoanalysis*, Routledge, London and New York, 1993

De Beer, Sue, 'Artists on Artists: Banks Violette', *Bomb*, no. 88, Summer 2004, 52–53

Derrida, Jacques, *The Work of Mourning*, ed. Pascale Anne Brault and Michael Naas, University of Chicago Press, Chicago, 2001

Derrida, Jacques, *The Gift of Death*, University of Chicago Press, Chicago, 1996

Dijkstra, Bram, *Idols of Perversity: Fantasies of Feminine Evil in Fin-de-Siècle Culture*, Oxford University Press, New York, 1986

Douglas, Mary, *Purity and Danger: An Analysis of Concepts of Pollution and Taboo*, Routledge & Kegan Paul, London, 1966

Farquharson, Alex, Vaillant, Alexis, et al., *Le Voyage Interieur*, Espace EDF Electra, Paris, 2005

Fer, Briony, *The Infinite Line*, Yale University Press, New Haven and London, 2004, 71–2

Fiedler, Leslie, *Love and Death in the American Novel* (1960), Anchor Books, New York, 1992

Fogle, Douglas, 'A Scatalogical Aesthetics for the Tired of Seeing', in *Chapmanworld*, Institute of Contemporary Arts, London, 1996

Foster, Hal, 'Obscene, Abject, Traumatic', *October*, no. 78, 1996, 107–24

Foucault, Michel, 'The Eye of Power', in *Power/Knowledge* (1975); Penguin Books, London, 1991

Foucault, Michel, *The History of Sexuality, Vol. I: An Introduction*, trans. Robert Hurley, Vintage, New York, 1980

Gelder, Ken, *Reading the Vampire*, Routledge, London and New York, 1994

Gelder, Ken, ed., *The Horror Reader*, Routledge, London and New York, 2000

Goodlad, Lauren M.E and Bibby, Michael, eds, *Goth: Undead Subculture*, Duke University Press, Durham and London, 2006

Greenberg, Clement, *The Collected Essays and Criticism, Volume 2: Arrogant Purpose, 1945–1949*, ed. John O'Brian, University of Chicago Press, Chicago and London, 1986, 166

Gudis, Catherine, ed., *Helter Skelter: LA Art in the 1990s*, The Museum of Contemporary Art, Los Angeles, 1992

Halberstam, Judith, and Livingston, Ira, eds, *Posthuman Bodies*, Indiana University Press, Bloomington and Indianapolis, 1995

Heller, Terry, *The Delights of Terror: An Aesthetics of the Tale of Terror*, University of Chicago Press, Urbana and Chicago, 1987

Hoffman, E.T.A, *The Golden Pot and Other Tales* (1814), trans. Ritchie Robertson, Oxford University Press, Oxford, 1992

Hogg, James, *The Private Memoirs and Confessions of a Justified Sinner* (1824), Oxford University Press, Oxford, 1999

Hogle, Jerrold E., ed., *The Cambridge Companion to Gothic Fiction*, Cambridge University Press, Cambridge, 2002

Horner, Avril and Zlosnik, Sue, *Gothic and the Comic Turn*, Palgrave, London, 2005

Houser, Craig, et al., *Abject Art: Repulsion and Desire in American Art*, Whitney Study Program, Whitney Museum of American Art, New York, 1993

James, Henry, *The Turn of the Screw* (1898), Penguin, London 2003

Jarman, Derek, 'Black Arts', *Chroma*, Overlook Press, Woodstock, New York, 1995

Latham, Rob, *Consuming Youth: Vampires, Cyborgs and the Culture of Consumption*, University of Chicago Press, Chicago, 2002

Lewis, Matthew Gregory, *The Monk* (1796) ed. Howard Anderson, Oxford University Press, Oxford, 1980

Lloyd-Smith, Allan, 'Postmodernism/Gothicism' in Sage Victor and Lloyd Smith, Allan, eds, *Modern Gothic: A Reader*, Manchester University Press, Manchester, 1996

Lovecraft, H.P., and Derleth, August, *The Lurker at the Threshold* (1945), Victor Gollancz, London, 1989

Massé, Michelle, *In the Name of Love: Women, Masochism and the Gothic*, Cornell University Press, Ithaca and London, 1992

Massé, Michelle, 'The Gothic's Vile Bodies', *Gothic Studies*, 2:1, 2000

Miles, Christopher, 'David Altmejd', *frieze*, issue 88, January/February 2005

Molon, Dominic, *Out of Place*, Museum of Contemporary Art, Chicago, 2002

Myrone, Martin, 'Fuseli to Frankenstein: The Visual Arts in the Context of the Gothic', in *Gothic Nightmares: Fuseli, Blake and the Romantic Imagination*, Tate Publishing, London, 2006

Nietzsche, Friedrich, *Beyond Good and Evil* (1885), in *Basic Writings of Nietzsche*, trans. Walter Kaufmann, Random House, New York, 1968

Oates, Joyce Carol, 'American Gothic', *The New Yorker*, May 1995, 35–6

Oates, Joyce Carol, *Haunted Tales of the Grotesque*, Dutton, New York, 1994

Peake, Mervyn, *Gormenghast* (1950), Penguin, Harmondsworth, 1969

Pinder, David, 'Ghostly Footsteps: Voices, Memories and Walks in the City', on Janet Cardiff, in *Ecumene. A Journal of Cultural Geographies*, vol. 8, no. 1, 2001, 1–19

Princenthal, Nancy, 'Willing Spirits: Art of the Paranormal', *Art in America*, February 2006, 104–13

Punter, David, *Gothic Pathologies: The Text, the Body and the Law*, Macmillan Press, Houndsmills, 1998

Punter, David, *The Literature of Terror: A History of Gothic Fiction from 1765 to the Present Day*, Longman, London, 1980; also Volume 2, *The Modern Gothic*, revised second edition, Longman, London, 1996

Punter, David, ed., *A Companion to Gothic*, Blackwell, Oxford, 2000

Radcliffe, Anne, *The Mysteries of Udolpho* (1794), ed. Bonamy Dobrée, Oxford University Press, Oxford, 1980

Roos, Rita, 'Death Angels on the Catwalk', *siksi*, 11, Autumn 1996

Rosenthal, Norman, Archer, Michael, Bracewell, Michael, Hall, James and Kernan, Nathan, *Apocalypse: Beauty and Horror in Contemporary Art*, Royal Academy of Arts, London, 2000

Ruskin, John, 'The Nature of Gothic', from *The Stones of Venice* (1853), in Rosenberg, John D., ed., *The Genius of John Ruskin; Selections from his Writings*, University of Virginia Press, Charlottesville and London, 1998, 170–96

Sade, D.A.F, Marquis de, 'Reflections on the Novel' (1800), in *One Hundred and Twenty Days of Sodom*, trans. Austryn Wainhouse and Richard Seaver, Arrow Books, London, 1989, 91–116

Scarry, Elaine, *The Body in Pain: The Making and Unmaking of the World*, Oxford University Press, New York, 1985

Schorr, Collier, 'Andy Warhol's *Frankenstein*', *frieze*, issue 16, May 1994, 46–47

Searle, Adrian, 'Monsters Inc', on Douglas Gordon, *The Guardian*, 5 November 2002

Spooner, Catherine, *Contemporary Gothic*, Reaktion Books, London, 2006

Spooner, Catherine, *Fashioning Gothic Bodies*, Manchester University Press, Manchester, 2004

Stafford, Barbara Maria, *Artful Science: Enlightenment, Entertainment and the Eclipse of Visual Education*, The MIT Press, Cambridge, Massachusetts, 1994

Stoker, Bram, *Dracula* (1897), ed. Maurice Hindle, Penguin, Harmondsworth, 1993

Sullivan, Catherine, 'Grisley Notes and Tones (A Strawman´s Excerpt)', *Spring Journal*, vol. I, Quality Press, Los Angeles, California, 1998

Sullivan, Catherine, 'Through the Scattered Glances', *Spring Journal*, vol. II, 2000

Three Gothic Novels, Horace Walpole, *The Castle of Otranto* (1764); William Beckford, *Vathek* (1786), Mary Shelley, *Frankenstein* (1818), with an introduction by Mario Praz, Penguin, London, 1968

Tudor, Andrew, *Monsters and Mad Scientists: A Cultural History of the Horror Movie*, Blackwell, Oxford, 1989

Vidler, Anthony, *The Architectural Uncanny: Essays in the Modern Unhomely*, The MIT Press, Cambridge, Massachusetts, 1992

Wakefield, Neville, 'Keith Edmier', *Artforum*, December 1995, 89

Walker, Hamza, *All the Pretty Corpses*, The Renaissance Society, Chicago, 2005

Warner, Marina, *Managing Monsters: Six Myths of Our Time*, Vintage, London, 1994

Warner, Marina, '"Ourself behind Ourself, Concealed": Ethereal Whispers from the Dark Side', *Tony Oursler: The Influence Machine*, Artangel, London, 2000

Warner, Marina, *Phantasmagoria: Spirit Visions, Metaphors and Media*, Oxford University Press, Oxford, 2006

Williams, Gilda, 'Jane and Louise Wilson in Light of the Gothic Tradition', *Parkett*, 58, 2000, 15–18

Williams, Linda, 'Learning to Scream', *Sight and Sound*, December 1994

Williams, Linda, 'When the Woman Looks' (1993), in *Film Theory and Criticism*, ed. Gerald Mast, et al., Oxford University Press, New York, 1992

Zizek, Slavoj, 'Grimaces of the Real, or When the Phallus Appears', *October*, no. 58, fall 1991, 44–68

Zizek, Slavoj, *The Plague of Fantasies*, Verso, New York and London, 1997

ACKNOWLEDGEMENTS

Editor's acknowledgements

With thanks to Iwona Blazwick, Ian Farr, Hannah Vaughan, Stuart Smith, Christoph Grunenberg, Clare Woods, Hannah Collins, Alex Farquharson, James Woodward, Nat Foreman and Patrizia Dander.

Publisher's acknowledgements

Whitechapel is grateful to all those who gave their generous permission to reproduce the listed material. Every effort has been made to secure all permissions and we apologize for any inadvertent errors or ommissions. If notified, we will endeavour to correct these at the earliest opportunity.

We would like to express our thanks to all who contributed to the making of this volume, especially: Nike Bätzner, Elisabeth Bronfen, Carolyn Christov-Bakargiev, Carol J. Clover, Beatriz Colomina, Douglas Crimp, Richard Davenport-Hines, Tacita Dean, Stan Douglas, Mark Alice Durant, Richard Dyer, Mark Edmundson, Bret Easton Ellis, Kate Ferguson Ellis, Trevor Fairbrother, Alex Farquharson, Hal Foster, Douglas Gordon, Christoph Grunenberg, Andrew O'Hagan, Bruce Hainley, Richard Hawkins, Damien Hirst, Gianni Jetzer, Amelia Jones, Jonathan Jones, Mike Kelley, Stephen King, Julia Kristeva, Jane D. Marsching, Kobena Mercer, James Meyer, Shamin M. Momim, Anne Rice, Jerry Saltz, Eve Kosofsky Sedgwick, Nancy Spector, Gayatri Chakravorty Spivak, Anthony Vidler, Jeff Wall, Marina Warner, Anne Williams, Slavoj Zizek. We also gratefully acknowledge the cooperation of: Artangel, London; Artforum, New York; Baltimore Center for Art and Visual Culture; University of Maryland, Washington, D.C.; Cass Sculpture Foundation, London; Chicago University Press; Columbia University Press, New York; DACS, London; Duke University Press, Durham, North Carolina; Éditions Galilée, Paris; Everyman's Library, London; Farrar, Straus & Giroux, New York; frieze, London; Frith Street Gallery, London; Georges Borchardt, Inc., New York; Kunstverein fur die Rheinlande und Westfalen, Dusseldorf; Institute of Contemporary Art, Boston; Harper Collins, New York; Harvard University Press, Cambridge, Massachusetts; Hodder Headline, London; Lawrence & Wishart, London; The Museum of Contemporary Art, Los Angeles; Museum Boijmans Van Beuningen, Rotterdam; Oxford University Press; Penguin, London and New York; Phaidon Press, London and New York; Prestel Verlag, Munich; Princeton University Press; P.S.1 Contemporary Art Center, New York; Random House, London; Schirmer/Mosel Verlag, Munich; Simon & Schuster Inc., New York; Solomon R. Guggenheim Museum, New York; The MIT Press, Cambridge, Massachusetts; University of Illinois Press, Chicago; Verlag der Buchhandlung Walther König, Cologne; Verso,

London and New York; The Village Voice, New York; Vintage, New York; A.P. Watt Ltd, London; White Cube Gallery, London; Whitney Museum of American Art, New York.

Whitechapel Gallery

whitechapelgallery.com

Whitechapel Gallery is supported by
Arts Council England